SUZUKI SEIJUN AND POSTWAR JAPANESE CINEMA

SUZUKI SEIJUN AND POSTWAR JAPANESE CINEMA

WILLIAM CARROLL

Columbia University Press
New York

Columbia University Press
Publishers Since 1893
New York Chichester, West Sussex
cup.columbia.edu

Copyright © 2022 Columbia University Press
All rights reserved

Library of Congress Cataloging-in-Publication Data
Names: Carroll, William (William James), author.
Title: Suzuki Seijun and postwar Japanese cinema / William Carroll.
Description: New York: Columbia University Press, [2021] | Includes bibliographical references and index.
Identifiers: LCCN 2021038671 (print) | LCCN 2021038672 (ebook) | ISBN 9780231204361 (hardback) | ISBN 9780231204378 (trade paperback) | ISBN 9780231555500 (ebook)
Subjects: LCSH: Suzuki, Seijun, 1923–2017—Criticism and interpretation. | Motion pictures—Japan—History—20th century. | Motion pictures—Social aspects—Japan—History. | Cult films—Japan—History and criticism. | B films—Japan—History and criticism. | Motion picture producers and directors—Japan—Biography.
Classification: LCC PN1998.3.S89 C37 2021 (print) | LCC PN1998.3.S89 (ebook) | DDC 791.4302/33092—dc23
LC record available at https://lccn.loc.gov/2021038671
LC ebook record available at https://lccn.loc.gov/2021038672

Cover design: Elliott S. Cairns
Cover image: TCD/Prod.DB/Alamy Stock Photo

As an auteur, Suzuki Seijun stands on a single point in space: one without time, thickness, or expanse, where things and colors swing and sway without direction.

—Hasumi Shigehiko

CONTENTS

Acknowledgments ix
Note on Names, Images, and Translations xiii

Introduction: Why Suzuki Seijun? 1

1 1968 and the Suzuki Seijun Incident 13

2 Suzuki Seijun and the Impossibility of Cinema 38

3 Postwar Japanese Genre Filmmaking
 and the Nikkatsu Action Sylistic Idiom 62

4 The Emergence of the Seijunesque 91

5 The Authorial Voice of Suzuki Seijun 125

Coda 155

Appendix 1. Filmography 159
Appendix 2. Unfilmed Projects 215
Appendix 3. Guryū Hachirō Extended Filmography 223
Appendix 4. Suzuki Seijun as Assistant Director 227
Appendix 5. Commercials Directed by Suzuki Seijun 229
Appendix 6. Books Written by Suzuki Seijun 231
Notes 233
Bibliography 253
Index 265

ACKNOWLEDGMENTS

This project began so long ago, I'm no longer sure when to start counting. It's been shaped not only by my own research and viewing experiences, but also by innumerable conversations I've had with people over the years in both formal and casual settings about the films of Suzuki Seijun and other, related topics that come up in this book. Additionally, there are many other people who assisted me, knowingly or not, in a variety of other ways. It would be impossible to thank everyone, but I will do my best to thank as many as I can.

I will begin by thanking my mentors who oversaw different stages of the project. My first attempt to take up Suzuki's films in a scholarly setting was as an undergraduate in the East Asian Studies Department at Wesleyan University, under the guidance of Miri Nakamura. I first encountered Hasumi Shigehiko's *Cinema 69* essay on Suzuki Seijun in a graduate seminar on Japanese film theory at the University of Chicago taught by Phil Kaffen. It would be difficult to overstate how much this shaped the project as it now exists, or how much Phil's class affected the subsequent direction of my work. Tom Gunning, Michael Bourdaghs, Daniel Morgan, and Chika Kinoshita oversaw an earlier version of the project. Tom has influenced my understanding of film through his scholarship since long before I met him, and he has provided encouragement and consistently asked thought-provoking questions. Michael helped me contextualize my work more broadly within Japanese history and regularly reminded me that this project can, and should, try to speak to non–cinema scholars of Japanese culture and history. He also helped me find a publisher. Dan found

time to scrutinize every chapter and was happy to share his expertise in the French film theory and culture of the 1950s and 1960s that so influenced Hasumi Shigehiko. I especially thank Chika for her advice as a Japanese cinema scholar. She met with me on each of my research trips to Japan and on her conference visits in North America, and she also helped introduce me to the various archival institutions in Japan whose help I needed to conduct my research. She has a thorough knowledge of the history of Japanese cinema and Japanese film theory and told me in a straightforward way when I misunderstood things, made dubious logical jumps or connections, or overlooked important details of those histories. This work has been greatly improved by her suggestions, and whatever oversights remain are mine alone. I also learned from many other faculty at Chicago, including Xinyu Dong, Judy Hoffman, Jim Lastra, Allyson Nadia Field, Noa Steimatsky, Yuri Tsivian, and Takuya Tsunoda in the Department of Cinema and Media Studies, and Paola Iovene, Reggie Jackson, and Hoyt Long in the Department of East Asian Languages and Civilizations.

Numerous other mentors helped shape the project at earlier stages of development. I began studying film at Wesleyan, and the rigorous approach to film form and film history that I learned there from Jeanine Basinger, Scott Higgins, and Lisa Dombrowski has stuck with me ever since. Steve Collins gave me the opportunity to think about films from the position of filmmaker, and to understand the labor and thought process that goes into every choice of camera placement, lens length, and costume and set design. My work with primary materials in Japanese would not have been possible without some very patient and effective Japanese language instructors: Etsuko Takahashi-Collins, Yōko Katagiri, Harumi Lory, Sakakibara Yoshimi, and Satō Ari. I especially thank Aoki Sōichi, who helped accustom me to reading academic Japanese texts.

My research was made possible in part thanks to the financial support of the University of Chicago's Center for East Asian Studies, which funded research trips to Japan and supported the film-screening events I conducted at the university. I am grateful to Michael Raine for building out CEAS's film library collection, and in particular its collection of postwar Nikkatsu films. My research drew on archives and libraries in Japan: the National Film Archive of Japan, the National Diet Library, Waseda University's Empaku Library, Kōbe Planet Film Archive, and Hirosaki University's library. Yasui Yoshio and Paul Caspers tracked down rare materials for me, and Joshua Solomon facilitated my visit to Hirosaki University. I picked up tips for materials to seek out from Japanese cinephiles on twitter: @BontenMaru10 and @callmesnake1997. I was aided by Ueno Kōshi's book *Suzuki Seijun zen'eiga* more than a mere bibliographic entry or my discussion of the arguments therein would indicate; I found the majority of Japanese print materials thanks to Ueno's book. I also thank my friends

Nick Artushin, Ana Chiu, J. J. Delserra, Carter Frank, John Macdonald, and James Rosenow, who housed me on research trips.

Thanks to the assistance of numerous film programmers, archivists, and collectors, I had the good fortune to view all of Suzuki's directorial efforts, with the exception of *There Is a Bird Within a Man*. In many cases I was able to see these films on 35mm or 16mm in a theatrical setting, through retrospectives at the Film Society of Lincoln Center, the Gene Siskel Film Center, Brattle Theater, Harvard Film Archive, *Shin-bungeiza*, Jinbochō Theater, and Cine Nouveau. I hosted screenings at the University of Chicago's Film Studies Center and at Doc Films, the student film society at Chicago. This would not have happened if not for Tom Vick—I contacted him out of the blue during his touring Suzuki retrospective, requesting booking information for one of the films for a Film Studies Center event. He came out for the event and put me in touch with Kanako Shirasaki, and later Sanae Tani, of Japan Foundation, who facilitated our use of Japan Foundation film prints. Julia Gibbs and Michael Phillips walked me through the logistics of planning for screenings, and Ben Ruder and Shanice Casimiro projected the films beautifully. Marc Longenecker of Wesleyan University, Ryan Cook at Emory University, Aiko Masubuchi at Japan Society, and Will Morris at American Cinematheque very kindly coordinated with us; Brian McKendry acted as an intermediary to work with American Cinematheque. Tien-tien Jong successfully lobbied for the series while I was away on a research trip. Ben and Kathleen Sachs convinced Chicago's cinephiles to see, on a weekly basis, films they had never heard of, and Ariel Schudson blogged about the series in Los Angeles. I am grateful to attendees who shared their thoughts on the films, and to the humane but determined Doc undergrads whose work made the screenings possible: Ted Davis, Alexander and Alfredo Fee, Brady Findell, Antonia Glaser, Laura Hicks, Lilian Huang, Alex Kong, Serin Lee, Noah Levine, Margaret Oley, Amélie Pavel, Hasti Soltani, and Zachary Vanes. Bryce Prewitt also provided assistance and enthusiasm for the series.

My work has benefited immensely from colleagues who have read portions of it and attended workshops and conferences where I have presented parts of it. My writing group has reviewed my work on an almost weekly basis and has helped keep me meet deadlines throughout the process. Members have included Hannah Frank, Matt Hubbell, Ian Jones, Mikki Kressbach, Nicole Morse, Jordan Schonig, and Ling Zhang. I particularly regret the premature loss of Hannah, a wonderful friend who shared her invaluable thoughts and commentary on my work. Our field lost years of scholarship with her passing. Daniel Johnson, Pao-Chen Tang, Junko Yamazaki, and Yuqian Yan, fellow travelers in the CMS-EALC joint program, helped guide and support me from my early years at Chicago until today. I am grateful to the coordinators and attendees of my

presentations at Art & Politics in East Asia and Mass Culture Workshops, including many I have already mentioned, as well as Dave Burnham, Helina Mazza-Hillway, Katerina Korola, David Krolikoski, Kyle Peters, Susan Su, Brian White, and Emily Jungmin Yoon. Thanks also to my conference panel chairs and copanelists, particularly Belinda He, Yuta Kaminishi, Chie Niita, Franz Prichard, and Chenshu Zhou.

Portions of the first two chapters appeared previously in my article "'I Don't Masturbate, I Fight!': The Spectre of Kita Ikki in Suzuki Seijun's *Kenka Ereji* (*Fighting Elegy*, 1966)," *Journal of Japanese and Korean Cinema* 10, no. 1 (2018): 47–60, DOI: 10.1080/17564905.2018:1450471, and are reprinted with permission. Parts of chapter 3 appeared in my "The History of a Broken Blue *Fusuma*: Colour in Suzuki Seijun's Nikkatsu Films," *Cinéma&Cie: Cinema and Mid-Century Colour Culture*, ed. Elena Gipponi and Joshua Yumibe, 19, no. 32 (Spring 2019): 15–26. I thank the respective editors, Michael Raine and Jinhee Choi, and Elena Gipponi and Joshua Yumibe, and the anonymous peer reviewers for each. I also appreciate my many colleagues, mentors, and friends at Kinema Club for creating a welcoming community of Japanese cinema scholars. I am especially grateful to Julia Alekseyeva, who first introduced me to the group and has been a consistent source of support and encouragement since our first meeting, and to Earl Jackson, for his thoughtful feedback and for talking up my work to anyone who would listen.

The last few years of my writing process for this book were beset by a variety of difficulties, chief among them being the global COVID-19 pandemic and, more personally, my own precarious status in the academic world. I am indebted to numerous people who went out of their way to help ensure my survival, particularly Scott O'Bryan at Indiana University-Bloomington and Leo Ching, Shai Ginsburg, Guo-Juin Hong, and Nayoung Aimee Kwon at Duke University. I also thank Marsha Wright at IU, who helped me reallocate funds originally intended for a research trip in May 2020 to having bulk materials shipped from Japan. I appreciate Drew Kraniak, David Kunz, and Dan Vlasic, who kept my social life alive in my year of isolation. My parents, James and Perry Carroll, and sister, Christina, have provided love and support throughout my long academic career.

Finally, I thank Philip Leventhal and Monique Briones, as well as the editorial board and staff at Columbia University Press, for their willingness to work with me and publish this book and their help throughout the process, and Anita O'Brien for copyediting the book. Two anonymous peer reviewers provided thorough and thoughtful feedback that has improved the book immeasurably. It goes without saying that this book would not exist without their support and assistance.

NOTE ON NAMES, IMAGES, AND TRANSLATIONS

Japanese names appear family name first, given name last, in accordance with Japanese custom. Exceptions are made for scholars whose primary work is in English. A complete filmography for Suzuki Seijun is listed in appendix 1 with an English title and a transliterated Japanese title for each film, along with information about any films with which they were initially double-billed. An extended filmography of other projects by his "Guryū Hachirō" collaborators is listed in appendix 3, and Suzuki's filmography as assistant director is listed in appendix 4, again with English titles, transliterated titles, and the names of the films' directors. These films are referred to by the English title in the text. Other Japanese films are written in their first text appearance in the following format: *English Title* (*Transliterated Japanese Title*, director, year), excluding any information already in the text, and are referred to by the English title thereafter.

Images not included in the book can be found at https://sites.google.com/view/williamcarroll/book-images.

All translations are mine unless otherwise noted.

SUZUKI SEIJUN AND POSTWAR JAPANESE CINEMA

INTRODUCTION

Why Suzuki Seijun?

In a scene in *Tokyo Drifter*, Tetsu the Phoenix (Watari Tetsuya) pursues rival *yakuza* boss Otsuka (Esumi Eimei) and his underlings, including Tetsu's arch nemesis, Tatsu the Viper (Kawaji Tamio). Otsuka, Tatsu, and the other villains walk to the back of the frame, and an elevator door closes in front of them. Within the same shot, Tetsu rushes forward, pries the door open, and enters the reopened space in the background. Suddenly, he inexplicably falls out of frame. The following shot shows Tetsu from overhead, on the floor. A wooden plank then drops over him, and the villains walk across it to exit the scene (fig. I.1).

From a narrative perspective, the scene is absurd on its face. It makes little sense for Otsuka to have constructed his office to have a false elevator behind it just to trick pursuers into falling into a trap, as Tetsu does here: one would think a less convoluted scheme would be more reliable. One would also think that, even if the audience were incapable of seeing the gap in front of where the villains are standing, Tetsu himself would notice the hole in front of him before he went running into it. The performers, however, remain stone-faced as the stoic hero clumsily falls, unaware of the absurdity of this state of affairs.

Since I first saw *Tokyo Drifter* some twelve years ago, I have watched it several times with theater audiences and with friends and relatives at home, and this moment has never failed to elicit a laugh. There are several explanations why the scene might be funny. In the many films with stoic gangster and hitmen protagonists made in the late 1960s all over the world, physical comedy is not usually incorporated in such a way. If Alain Delon slipped on a banana peel

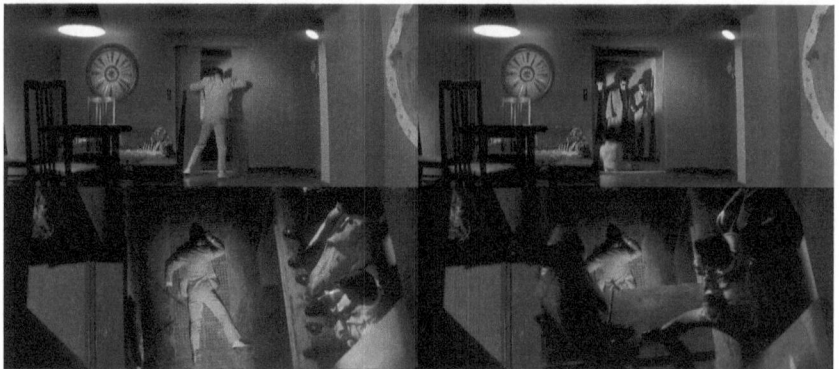

I.1 Tetsu's fall in *Tokyo Drifter*

in Jean-Pierre Melville's *Le Samouraï* (1967), or if Lee Marvin ran face-first into a pane of glass in John Boorman's *Point Blank* (1967), we might react the same way. In the immortal words of Homer Simpson, "Man fall down. Funny." All the more so when the man seems dignified.

There is more at work in this gag, however, than a simple incongruity between the apparently dignified Tetsu and his clumsy fall. The first shot is from a straight-on angle, framed so that the villains are looking toward us directly as they shut the door. Tetsu runs from off-screen, behind the camera, into the depths. The depths, of course, are not real. The film is a two-dimensional image, projected onto a flat surface. Light and shadow move along its surface and rely on linear perspective to create the illusion of the depths. But Tetsu's forward momentum, which ought to carry him further into the depths, is suddenly, inexplicably interrupted. The illusion of depth carries our vision toward the farthest recesses of the frame and leads us to overlook the absence of a floor beyond the door after Tetsu opens it. In truth, the joke is on us as much as it is on Tetsu.

The image that follows, showing Tetsu face down, pressed on the floor, is a retroactive explanation of what has happened: the floor has been pulled up from where he was running. But it also creates the precisely opposite effect of being pulled into the depths: it shows a body pressed up against an unforgiving, flat surface. Together, the two shots form a shocking juxtaposition of depth and flatness. The prominent Japanese poststructural theorist Karatani Kōjin describes this kind of sensation thus: "As we look at a painting done according to the laws of linear perspective, the scene extends unbroken in our direction. In such a picture, whatever the subject matter, we have the feeling that we can enter into the scene. When perspective is inconsistently applied, we lose that feeling."[1] Though cinema is not Renaissance painting, scholars have argued that the use

of the monocular lens is a way of organizing vision into linear perspective.[2] Additionally, the sense of linear perspective in cinematic composition and its sudden disruption were, in fact, the grounds on which Japanese cinephile critic (and frequent debater with Karatani on the subject of poststructural theory)[3] Hasumi Shigehiko celebrated Suzuki Seijun's *Youth of the Beast* in 1969 in the pages of the journal *Cinema 69* (*Shinema 69*).[4] Hasumi would revisit Suzuki's work over the following decades, admiring the way its formal play articulates the physical properties of the cinematic image: its flatness and its horizontal and vertical boundaries. In characteristically enigmatic fashion, Hasumi writes: "Each time he [Suzuki] invents an innovative film, he does not bring us to the limitless possibility of cinema, but to the impossibility of cinema" (see figs. I.2 and I.3).[5]

This simple sequence of two shots in *Tokyo Drifter* contains most of the basic elements of what is interesting about the filmmaker Suzuki Seijun: the careful

I.2 Flatness in *Youth of the Beast*

I.3 Frames within frames in *Born Under Crossed Stars*

laying out and shocking upheaval of audience expectations, the striking juxtaposition of opposing stylistic extremes, and a sense of humor that masks the formal complexity of what is taking place. Suzuki's belated reception outside of Asia has tended to pigeonhole him as a cult curiosity, a genre filmmaker who managed to make some eccentric and amusing films in spite of their subject matter.[6] Suzuki's films, however, are not "triumphs of form over content," as has often been posited in English-language commentary; rather, his subject matter has always been the media he has worked in: first cinema, but later television and video. Plays between the inherent flatness of the cinematic image and the illusion of depth it produces, or with the boundaries through aperture framing, can be found throughout Suzuki's filmography. Suzuki consistently finds ways to turn conventions of cinematic forms against themselves and mislead viewers in the way he constructs space and meaning in sequences before suddenly revealing them, in a shock, to be something very different. The effect is sometimes comic, but it invariably forces viewers to reconcile their initial misunderstanding with the surprising revelation at the end, and in so doing to confront cinematic form more directly, and to rely less on the preconceptions that led them to the misunderstanding in the first place. His formal experimentation is an interrogation of these media: their physical properties and limitations, the formulas by which they interact with their spectators, and the role they play in the environments in which they are made and seen.

Career Overview

Suzuki Seijun entered the film industry in 1949, just as the studio system that had formed in the 1920s and 1930s was recovering from the war. Like most industry professionals at the time, he rose through the studio ranks from a low-level assistant director and apprenticed as first assistant director—primarily under Iwama Tsuruo at Shōchiku and under Noguchi Hiroshi at Nikkatsu—before directing his own films. His most prolific period was between 1956 and 1967, when he made forty films at Nikkatsu. Not coincidentally, the Japanese film industry as a whole was at its commercial peak during this period (specifically, from around 1958 to 1959), as was Nikkatsu popular cinema (from around 1959 to 1961). By the mid-1960s, however, the Japanese studio system, which had survived since the 1920s, was in irreversible decline thanks to diminishing theater attendance. The studios began to downsize, collapse, or branch into television and pornographic production. Nikkatsu, like the other major studios, was in crisis. It was around this time that Nikkatsu's president, Hori Kyūsaku, fired Suzuki.

Suzuki's firing proved to be a decisive moment for both the filmmaker himself and the Japanese film industry as a whole. Though he had already gained a

following among student cinema clubs starting in the mid-1960s, when Nikkatsu fired him and blocked his films from being shown in a retrospective, both the New Left and a burgeoning group of cinephiles suddenly embraced him. Still, the partial recounting of this event has led to serious misconceptions about why Suzuki was fired, and its implications for his work more generally. Much has been made of the word *wakaranai*—often translated as "incomprehensible"—which Hori used to describe Suzuki's films in his statement announcing the firing. As an interview subject, Suzuki himself has frequently reinforced this perception, giving evasive and perhaps sometimes playfully misleading answers to questions about his own thought process behind his stylistic decisions. These, in turn, are reinforced by the way they have been transcribed and interpreted among Suzuki's fans abroad. To give one prominent example, since beginning this project, I have frequently noticed an interview screenshot circulating on social media among English-speaking Suzuki fans.[7] I also see its subtitle, "I make movies that make no sense and make no money," regularly attributed to Suzuki as a self-description.

In the full Japanese audio of this interview, Suzuki explains that this is the reason he was given for his firing; at no point does he make the claim that he personally believes his films "make no sense and make no money." It is misleading to treat this as an artistic declaration of principles. Before being fired, Suzuki directed popular films at Nikkatsu for more than a decade, featuring some of the studio's biggest stars; some were even quite successful. Further, if we look more closely at the circumstances of his firing, Hori's statement was less an honest and straightforward reason for firing Suzuki than an after-the-fact rationalization for a decision that had already been made, and the frequently quoted line is a partial translation taken out of context. Finally, the perception of Suzuki as a director of "incomprehensible" films is undermined by the fact that if one actually bothers to watch all his Nikkatsu films, it quickly becomes apparent that the majority of them *do* make narrative sense, or at least as much sense as other Nikkatsu films from the time.

After the "Suzuki Seijun Incident" (*Suzuki Seijun mondai*), as it came to be called, the filmmaker transitioned, at least temporarily, to television work: over the following decade, his primary output was television commercials, with a handful of episodes of television shows (one of which was pulled before it aired). A group of his closest collaborators continued making films for Nikkatsu's *roman poruno* line in the 1970s and produced a large number of screenplays in hopes that Suzuki would direct them; for various reasons, they were all either delayed, taken up by other filmmakers, or left unmade. Finally, one of these projects, scripted by Suzuki's longtime collaborator Yamatoya Atsushi, was greenlit by Shōchiku and released in 1977 as *A Tale of Sorrow and Sadness*, marking Suzuki's return to theatrical filmmaking after ten years. He spent the final three decades in his career making films for major studios and

independent production companies, but he continued working on television commercials and episodes of shows, and he made two V-Cinema (direct to video) projects. Some postwar filmmakers, like Kurosawa Akira or Ōshima Nagisa, had gained enough international prominence by the time they exited the studio system that they could rely on producers in Europe or the United States to fund their later filmmaking projects for release on the international art house circuit, insulating them from transitions in the Japanese film industry. Since Suzuki became known in these circles only belatedly, his later career more closely follows the course of the industry in Japan as a whole.

Suzuki also became involved with the animated television series *Lupin III* around the same time as his return to theatrical filmmaking. He was recruited to be supervising director of the second *Lupin III* television series: his tenure in that capacity began in 1978 and lasted until the end of the series in 1980. Later, he scripted an episode for the third series of *Lupin III* and codirected one of the films, *Lupin III & The Legend of the Gold of Babylon*, both in the mid-1980s. This aspect of Suzuki's career rarely gets attention, likely in part because it is difficult to determine his precise creative influence as either supervising director or codirector. We should at least observe, however, that several regular Suzuki screenwriting collaborators were also involved with the *Lupin III* animated series, and that Suzuki's continued involvement in the series suggests a more sustained role than has generally been acknowledged.[8]

Suzuki's output slowed in the 1990s, but he continued to make commercials, television episodes, and theatrical films, some marketed locally and others toward the international festival circuit. He released his final film, *Princess Raccoon*, in 2005. The film has a contradictory relationship to the rest of his filmography: totally unlike anything he had made before, and, strangely, bringing together strands from every phase of his career. It was a throwback to the long-forgotten genre of *tanuki* musicals that was virtually unknown abroad (and reached its commercial peak around the time he began his career), and yet it featured the internationally popular Chinese actress Zhang Ziyi in its title role and opened at the Cannes Film Festival before playing mainly on the international festival circuit. It was also scripted by Urasawa Yoshio, whom Suzuki had met as a *Lupin III* staff writer.

Across five decades, Suzuki worked from the height of Japan's studio system to its collapse, through the transition to television production, with independent production companies that emerged in the 1980s, in the international art-house circuit, in mainstream studio productions after the system's decline, and in V-Cinema. He also had close collaborative ties to influential *pinku* and *roman poruno* filmmakers in the 1960s and 1970s. It is difficult to think of a filmmaker whose career so closely traced the shifts in the Japanese film industry during this period, or who worked in so many different parts of the industry.

The Interplay of Theory and Practice

All this makes Suzuki a filmmaker of particular interest to recent turns in Japanese film studies: the upsurge of interest in the enormous, still largely untranslated body of Japanese film theory, and the consideration of cinema within Japan's broader media environment. Scholars including Yuriko Furuhata, Aaron Gerow, and Abé Mark Nornes have been taking on parts of a broader project to translate, historicize, and perhaps canonize Japanese film theory within English-language film studies.[9] Since the intellectual discourse on cinema within Japan has been neglected, and even denied, for so long, this is a necessary corrective, particularly considering how closely intertwined that intellectual history often is with the history of filmmaking in Japan. The fact that Suzuki became the object of focus for multiple strands of Japanese film theory makes him an ideal filmmaker through which to look at this interplay.

However one may define the term *theory*, there is almost certainly an intellectual discourse on cinema anywhere that films have been made or seen. Non-Western discourses on cinema are ignored not because they have less intrinsic value, but because few scholars other than area specialists have ever engaged with them even to know what they contain. There are obvious reasons that the study of non-Western film theory has largely been performed by area studies specialists within English-language film studies: notably, little has been translated into English, so few scholars other than such specialists can even engage with it. However, this presents a risk of further entrenching national, linguistic, and cultural boundaries, which are often already overdetermined in discussions of non-Western cinema, by suggesting, for example, that Japanese films should be studied with only Japanese film theory, and that Japanese film theory should be applied only to Japanese films. In truth, given the wide circulation of American and European films in Japan in the prewar period compared with the almost total lack of circulation of Japanese films in the United States and Europe, Japanese filmmakers and film theorists had a fuller (if still incomplete) picture of global cinema than their counterparts in the West. Since Japanese film theorists never limited their study to Japanese films, there is no reason that we should impose such a limitation when applying their theory.

Two groups, each associated with a distinct strand of Japanese film theory, took up Suzuki's cause in the wake of the Suzuki Seijun Incident. As the study of Japanese film history is finally catching up to include the history of Japanese film discourse, criticism, and theory, it should now be clear that Suzuki is a much more central figure in Japanese film history than has generally been recognized. This book looks at Suzuki Seijun's films and their relationship to both the New Left–affiliated film theorists who had dominated Japanese film

theory in the early 1960s and the newly ascendant cinephile theorists who formed at the end of the 1960s around the short-lived journal *Cinema 69*, but who would go on to dominate discussions of Japanese cinema in the following decades. How these two discourses on cinema take up Suzuki and understand his films in their writing helps elucidate their broader understanding of cinema and how it relates to society. They also help to shed light on Suzuki's films by looking at how they have been understood historically and opening up possible ways of looking at them.

These two groups of film theorists were at different stages of development when the Suzuki Seijun Incident took place: the New Left was at its most influential stage and had already developed much of its broader theory of cinema. The cinephiles were publishing their first writings on cinema, and as such I argue that Suzuki and his films are more instrumental in helping them form their broader theory of cinema and spectatorship than they could have been for the New Left. In taking up these questions, however, it is not my purpose to argue that one group was right and the other was wrong, or to impose a teleology on the history of Japanese film theory to suggest that more recent developments are necessarily more complex or better than earlier ones. Nor is my goal simply to historicize Suzuki's films, or to end my analysis of them with their influence on film theorists. Rather, I analyze them together to see how they can illuminate each other.

This is partly a historical project—I correct misconceptions and fill in notable gaps in knowledge about Suzuki's career and these groups of theorists—but that is not my sole purpose. I engage with Suzuki's films, and with the film theories of both the New Left and the cinephiles, because I think they can teach us about cinema as a medium, as an art form, and as a social instrument. What political potential did filmmakers like Ōshima Nagisa, Matsumoto Toshio, and others of the New Left see in Suzuki Seijun or his films, and what can that teach us about the political potential of cinema as they understood it? What aspects of Suzuki's films attracted the cinephiles' attention, and how did these help to shape their understanding of the cinema? And how, in turn, can they help us with our own understanding of cinema's political potential, or simply cinema itself? These are questions I hope to answer.

Of these two strands of film theory, the New Left has received more attention within English-language scholarship on Japanese cinema. This is likely because of the close relationship between theory and practice in this generation, which is to say that some of the most influential writers at this time were also filmmakers who are now internationally renowned, among them Ōshima Nagisa, Matsumoto Toshio, and Yoshida Kijū. These filmmakers considered the relationship between cinema and its broader role in society, and the possibility of bringing about political change in Japanese society through cinema, which is reflected in their films and writings. Since these writers are also

known internationally as filmmakers, some of their writings have been translated and are likely better represented in English translation than any other strand of Japanese film theory.[10] These writers were interested in cinema's relationship to society more generally, which also extended to new media, such as television, so their writings and films have also been taken up by scholars addressing cinema's role in Japan's broader multimedia environment since the 1960s, Notably, Matsumoto and Ōshima feature prominently in Furuhata's *Cinema of Actuality*.

The second strand, the cinephiles who originated around the *Cinema 69* journal, have had few of their influential writings translated into English, but their work is not entirely unknown. The most prominent and influential member of this group, Hasumi Shigehiko, who is fluent in multiple languages, has contributed to international cinephile projects in recent decades, including Jonathan Rosenbaum and Adrian Martin's *Movie Mutations* and writing for the online cinephile journals *Rouge* and *LOLA*. (Hasumi was the subject of the October 2016 issue of *LOLA*.) He has also achieved a kind of indirect fame through some of his former students who have become internationally recognized filmmakers. Indeed, the fit may seem natural: Hasumi and his fellow travelers were arguing against a style of film criticism that restricted itself to interpreting a film's narrative. Like auteurists in France, England, and the United States, they championed genre filmmakers whom conventional critics would have considered low-brow, and they particularly prized moments that cut against the narrative grain for what they revealed about cinema: both the material basis of film itself and the encounter between film and spectator that could never quite be satisfyingly articulated in criticism. Certain affinities with the kind of "cinephiliac moments" that cut against the grain of narrative and bring us closer to the material nature of film celebrated by cinephile scholars Christian Keathley or Rashna Wadia Richards are likely already apparent.[11] Given the call for a more inclusive cinephilia by *LOLA* coeditor Girish Shambu, it is not surprising that *LOLA* would seek out a thinker like Hasumi, who shares a similar interest in cinema to that of English- and French-speaking cinephiles.[12]

It should be stressed, however, that Hasumi's writings published in these places are not primarily translations of his most influential work in Japanese but new writings, aimed specifically at an international cinephile audience. Though his methodology in these writings has its roots in his earlier work, it is difficult to understand its origins: where it emerged from, and whom and what he was arguing against. In contrast to both mainstream film criticism that strictly interpreted narratives and the film theorists of the New Left and their focus on ideology, Hasumi celebrated eccentric flourishes of film form, such as those found in Suzuki's films, as a way of enhancing our perception of what immediately faces us and helping us to overcome our preconceptions of

narrative, ideology, and other things that prevent us from simply seeing what is in front of us. Scholars of Japanese cinema, including Ryan Cook, Phil Kaffen, and Aaron Gerow, have written on this earlier part of Hasumi's career, but, curiously, there has been little attempt to link the film theorist Hasumi Shigehiko known to Japanese cinema scholars with the critic Shigehiko Hasumi known to contemporary English-speaking cinephiles who read *LOLA*. In this book I look primarily at the earlier writings of Hasumi and other influential *Cinema 69* critics, such as Ueno Kōshi and Yamane Sadao, and focus on how elements of their framework were shaped by encountering Suzuki's films. However, I contextualize their methodology in lineages of cinephilic and formalist discourses on film in Japan and abroad, which helps to understand how such a connection could be formed.

Beyond looking at their significance for Japanese film theory, I also offer the first complete account of Suzuki's career as a filmmaker. Though we could hardly call him unknown, his filmography has never satisfactorily been addressed in scholarship. Much of what is available in English is limited to program booklets and essays published in DVD releases, and these tend to address a very limited portion of Suzuki's career: namely, his final films at Nikkatsu (roughly, *Youth of the Beast* in 1963 through *Branded to Kill* in 1967), and those later films that were released on the international festival circuit (the Taishō films, *Pistol Opera*, and *Princess Raccoon*). There has been some improvement in recent years, with the publication of Tom Vick's study, *Time and Place Are Nonsense*, and the release of some of Suzuki's long unavailable early films in box sets from Arrow Video. Large parts of Suzuki's filmography, however, are still unavailable and underaddressed, such as his television and video work, and the selection of the early filmography that has been made available—earlier crime films—seems chosen to reinforce the existing narrative about Suzuki. Earlier films that might challenge, or at least complicate, that narrative, including the whaling musical *Pure Heart of the Sea*, the social melodrama *Young Breasts*, and the romantic *kayō* (ballad) film *Love Letter*, are still largely unknown, even though they are among his most fascinating early films. I not only explicate and analyze these undiscussed films but also show how they fit into broader trends in the formal experimentation that both theorists of the New Left and cinephiles admire in Suzuki's work.

I historicize Suzuki's experimentation—not just the theoretical context but also the generic and industrial context in which his films were made and released. Informed by the work of scholars Michael Raine and Jasper Sharp and critics Watanabe Takenobu and Mark Schilling on Nikkatsu popular cinema, and popular Japanese cinema of the era more broadly, I show how Suzuki picks up on generic tropes and technological shifts and incorporates these into his formal experimentation. This context is necessary to distinguish between where

Suzuki is unique and where he is similar to other coeval filmmakers, but it also helps to identify where his experimentation comes from, and when his plays on common tropes would have been recognizable to contemporaneous audiences but not to viewers at a historical and cultural remove.

There are several sources of tension in this study. I am attempting to draw attention to, and indeed champion, critical and theoretical traditions from Japan that are understudied in English-language scholarship and frequently at odds with each other. At the same time, by looking at Suzuki's films myself, I challenge some of these critics' writings and draw attention to the limitations of their respective frameworks. With some historical distance, it becomes possible to consider these strands of film theory as complementary rather than antagonistic, as they each provide useful, if incomplete, analyses of the films. I demonstrate the usefulness of their observations and propose ways to use the concepts they introduce to the study of cinema that overcome the limitations of their own frameworks. In looking at both the films and the film theories, I show how Suzuki's films helped shape, and can help demonstrate, the writings of these two groups of theorists and in turn demonstrate how those writings can help to elucidate the films of Suzuki Seijun. Though my book has a significant historical component, I will show that these films and film theories still have things to teach us about the possibilities of cinema and cinematic expression, even at our historical remove.

The first chapter discusses how Suzuki formed a relationship with filmmakers and theorists of the New Left in the wake of the Suzuki Seijun Incident. It addresses how they understood him and his films in terms of their own goals and theories. It also shows how Suzuki could be seen as engaging the New Left's concerns even before they championed him. I discuss the history of the student movement of the 1960s and its critique of the established left, and I read Suzuki's *Story of a Prostitute* (1965) against an earlier adaptation of the same source material, Taniguchi Senkichi's *Desertion at Dawn* (*Akatsuki no dassō*, 1950). I also consider the film's relation to the New Left's critique of the Old Left. I analyze how Suzuki's film *Everything Goes Wrong* (1960) can be seen in relation to other media, a common theme of 1960s New Left theory that Furuhata introduced in *Cinema of Actuality*. I also compare the film formally and thematically with Ōshima Nagisa's *Cruel Story of Youth* (*Seishun zankoku monogatari*, 1960) from the same year.

The second chapter addresses Suzuki's relationship to the group of cinephiles who emerged at *Cinema 69*: Hasumi, Ueno, and Yamane. It gives an overview of their history and influences and explains two of their key concepts, *omoshirosa* (interestingness, or source of interest) and *dōtai shiryoku* (the skill of seeing movement), showing that they began developing these ideas in the wake of the Suzuki Seijun Incident. In particular, I use the film *Youth of the Beast* to elucidate both their film theory and Suzuki's relationship to it and closely

analyze Hasumi's first published writing on Suzuki from 1969 against the visual structures he discusses in *Youth of the Beast* and *Branded to Kill*.

The third chapter offers an evolution of Suzuki's filmmaking practice within the context of the postwar Japanese film industry. A broader discussion of Japanese popular cinema from the 1950s to the 1960s demonstrates how Suzuki's style was formed in this historical context. I consider how the framework of "industrial genres" offered by Alex Zahlten elucidates Suzuki's relationship with Nikkatsu.[13] I argue that Suzuki was neither an inexplicable aberration nor strictly a product of his time and place but formed a distinct style that has recognizable roots in his social and industrial context. I also correct the assumption that Suzuki was strictly an action filmmaker at Nikkatsu by incorporating other generic contexts he was working in, such as the kayō film and the melodrama. I draw on recent Japanese scholarship on his early career by Kōno Marie and Nagato Yōhei.

This argument is expanded in the fourth chapter, which takes up the concept of *zure* (deviation) offered by Ueno Kōshi as a potential definition of the Seijunesque.[14] Through formal analysis of images and sequences in films across Suzuki's career, I argue that this sense of deviation is created by a careful set of formal choices to conceal from the audience what is actually taking place in front of them, or to mislead them deliberately, only to have the rug pulled out from under them all at once.

Finally, in the fifth chapter I tackle Suzuki's relationship to narrative. While the New Leftists venerated him in spite of the narratives of his films rather than because of them, and while the cinephiles tended to eschew narratives in their analyses of his films, I argue that Suzuki's relationship to narrative, and in particular his processes of narration, relate back to the process of *zure* discussed in the previous chapter. My interest here is less in the subject matter of the films' narratives per se and more in the processes of narration: how they relay or refuse information, and the kinds of relationships Suzuki sets up between the audience and the characters in the film. These help us to understand that Suzuki's meta-cinematic games, celebrated by the cinephiles, at times can be seen as considerations of film's role in Japan's broader mediascape, or as relating to the ethics of image-making and the theoretical considerations of the New Left in the 1960s.

CHAPTER 1

1968 AND THE SUZUKI SEIJUN INCIDENT

It is perhaps fitting that at the height of the Suzuki Seijun Incident, Suzuki's cause was taken up by two entities: the Director's Guild of Japan (Nihon eiga kantoku kyōkai) and the Suzuki Seijun Joint Struggle Committee (Suzuki Seijun mondai kyōto kaigi). The Director's Guild was a trade union, representing the interests of filmmakers working at the major Japanese film studios, and thus very much part of the Japanese film industry as it then existed. When it sued Nikkatsu on Suzuki's behalf, it was headed by Gosho Heinosuke, a prestigious Shōchiku filmmaker of Ozu's generation known primarily for his contemporary-set melodramas. The latter Joint Struggle Committee was a protest movement without a clear leader, drawing together members of student film societies, independent filmmakers, and protestors broadly associated with the New Left. Was Suzuki an ordinary studio director done wrong by his studio? Was he a stylist transforming studio projects into avant-garde pop art? Was he a covert radical bringing down the system from within? Suzuki himself never claimed any of these positions that activists or observers projected on him, but each one helps elucidate some aspect of how he and his films relate to the immediate social, historical, and industrial context in which the films were made and received.

The period of Suzuki's tenure at Nikkatsu, 1956–1967, was one of high economic growth, political upheaval, a waning film industry, and a waxing film culture. Contrary to designations of Suzuki as a low-level filmmaker of B action movies, his output ranged in both prestige and genre: he made kayō films less than an hour in length and serious social melodramas with high production

values along with the action films for which he is now best known. He would eventually be embraced by both Tokyo's cinephile culture and the student movement, which, despite periodic intersections during the Joint Struggle Committee, would come up with very different reasons to embrace him: the former would find his eccentric and eclectic use of film form to be an exciting embrace and exploration of the possibilities of the cinematic medium, while the latter would celebrate his antiauthoritarian impulses as those of a kindred spirit in their struggle to reshape Japanese society. It is not my intention to argue that Suzuki is more authentically a cinephile filmmaker or a New Leftist filmmaker. Rather, members of each group saw something in the figure of Suzuki, in his films, or in the circumstances of his firing that resonated with them.

History of the Suzuki Seijun Incident

Suzuki Seitarō entered the film industry shortly after the end of the Second World War. By his own account, his career in filmmaking was quite accidental: he had failed the entrance exams to the University of Tokyo and decided to enroll in a film course at Kamakura Academy, where several directors and screenwriters employed at Shōchiku were offering classes.[1] He rose to the rank of assistant director at Shōchiku, and after Nikkatsu resumed film production in 1954, he took advantage of the lack of personnel by moving to the latter studio, where he could more quickly rise to the rank of full director.[2] He directed his first feature, *Harbor Toast: Victory Is Ours*, in 1956, and directed forty films and one television episode for the studio between 1956 and 1968.[3]

Suzuki's first films received relatively little critical attention, often with nothing more than synopses written about them in *Kinema junpō*. However, he had gained at least one critical champion as early as 1958: reviewing *The Boy Who Came Back* for *Eiga hyōron* (whose editorial staff was more receptive to appraisals of program picture directors and the tastes of younger audiences than that of *Kinema junpō*), Tayama Rikiya singled him out as a filmmaker whose formal ingenuity was able to overcome a formulaic and unconvincing screenplay. Observing that the film's narrative fit a standard pattern of humanist social dramas depicting the improbable redemption of a juvenile delinquent thanks to the help of social workers, Tayama found moments in the film where Suzuki's directorial choices helped overcome the sense that Nobuo (Kobayashi Akira, playing the juvenile delinquent boy) and Keiko (Hidari Sachiko, playing the social worker) were stock types and could enable audiences to sympathize with them as people rather than types. Tayama identified subtle formal choices that he found striking; for example, midway through the film, Keiko takes Nobuo to the beach along with his two siblings and Nobuo's former girlfriend Chie (Asaoka Ruriko), even though it has been established that Keiko has become

romantically attracted to Nobuo by this point. At one point, Keiko goes in search of Chie and discovers that she and Nobuo are making out. Keiko is visibly pained by seeing this, but Suzuki, rather than following the standard method of showing Keiko's face, followed by a point-of-view shot of Nobuo and Chie making out, followed by Keiko's reaction shot, instead shows a single shot of Keiko walking forward toward the camera, reacting with a pained facial expression, and then running away, followed by another extended shot of her running along the beach with a pained face, and another, more distant shot of her running. After emphasizing her reaction in three shots without showing what caused it, Suzuki reveals the reason in the final shot of the sequence: an extreme long shot showing Nobuo and Keiko kissing on a rock formation in the distance. Tayama uses this as an example of the way the film comes to prioritize Keiko's emotional arc as a character over the hackneyed redemption story that was ostensibly its subject, and identifies Suzuki as a newcomer filmmaker to watch.[4]

It would be several years before serious critical discussions of Suzuki Seijun's work would begin appearing more regularly in *Eiga hyōron*, and the terms in which Tayama celebrates *The Boy Who Came Back*—for the way that it foregrounds a character's emotions and garners sympathy for her from its audience—seems in many ways to be antithetical to the kinds of films that Suzuki is now best known for, and the reasons he would later gain a cult following. Some elements of Tayama's review, however, foreshadow terms in which his work would be celebrated in the future. Specifically, the claim that Suzuki's formal inventiveness is enough to overcome a formulaic and unconvincing screenplay is a theme that continues to be echoed in appraisals of his Nikkatsu films to this day. Further, the specific stylistic play at work in this sequence—the initial elision through editing of motivating information that is only revealed in retrospect—is a stylistic device that Suzuki would develop in much more forceful terms in his later work, which I discuss in chapters 4 and 5.

Many of Suzuki's earliest films demonstrate a solid filmmaking craft, and collectively they exhibit an ability to work fluidly between genres, often even within the same film. However, *Youth of the Beast* (1963) is frequently identified as the film in which he graduated from being a mere competent craftsman to become an idiosyncratic filmmaking force that could not be contained by the limitations of the studio system.[5] His next film, *The Incorrigible* (1963), a more prestigious literary adaptation set in Taishō-era Kansai, united Suzuki with art designer Kimura Takeo for the first time. Suzuki himself has emphasized the importance of Kimura in particular as a collaborator for him, saying, "*The Bastard* [previously the more common English title for the film] was the real turning-point in my career, more so than *Youth of the Beast*, which I made just before. It was my first film with Kimura Takeo as designer, and that collaboration was decisive for me. It was with Kimura that I began to work on ways

of making the fundamental illusion of cinema more powerful."[6] It was the latter goal that Suzuki shared with Kimura, and it would later become the basis of the cinephiles' celebration of him. Kimura became an important collaborator for Suzuki and would work as his art director for each of his remaining Nikkatsu films and many of his independent films thereafter. He would also be credited as screenwriter for Suzuki's *The Flowers and the Angry Waves* and *Capone Weeps with Passion* and would be an uncredited collaborator on screenwriting for *Fighting Elegy* and *Branded to Kill*. Suzuki encouraged him to indulge in his most baroque tendencies as they collaborated, one result of which was the success of *Gate of Flesh*.

Suzuki slowly began to earn a cult following over the early 1960s among independent filmmakers and college-aged cineastes, just as important transformations were taking place in film exhibition that were making these groups more influential. Alongside the rising political movements of the 1960s, film spectatorship venues and practices were changing rapidly by the mid- to late 1960s.[7] The "five-studio system"[8] had controlled not only film production but also film distribution and exhibition in first-run theaters throughout the country, but the decline in theatrical attendance opened a weak spot in their stranglehold on the industry. At this same moment both independent filmmakers and groups of film viewers pushed for new conceptions of the individual filmmaker's role in film production and cinema's relationship to the spectator and society at large. Film societies and art-house movie theaters, particularly in Tokyo, became more influential in providing an alternative to the standard routes of distribution in mainstream commercial cinema. The most famous of the Tokyo art house theaters, the Art Theater Guild (ATG), eventually also went into independent film production.[9] Independent film societies, many affiliated with colleges, also began emerging and would circulate both independent films as well as studio films that they found worthy of more attentive viewing than they had received in their initial run. Though the existence of such groups in Japan predated the 1960s, their rise to prominence at this moment was especially threatening to studios, who were already having enough difficulties keeping audiences attending first-run studio releases. The fact that these alternative venues and film societies gave space to new, independent filmmakers operating outside of the studio system (such as Matsumoto Toshio and Wakamatsu Kōji), as well as filmmakers who had broken from the studio system after public, politically inflected disputes (such as Ōshima Nagisa and Yoshida Kijū), made them even more of a threat.

It is difficult to say precisely when Suzuki's films caught the attention of these groups, given the dearth of materials remaining from most of them.[10] Usually the watershed moments identified in Suzuki's recognition are *Youth of the Beast* in 1963 or *Gate of Flesh* in 1964. However, Suzuki had at least one champion in Tayama five years earlier, and Ishigami Mitsutoshi claimed to

have first "discovered" him as a distinct filmmaker as early as 1960, when he saw the film *Fighting Delinquents*.[11] Then a college student, Ishigami would self-publish *OFF*, an early celebration of Suzuki's work, in 1965.[12] Matsuda Masao has written that he first became conscious of Suzuki Seijun as an individual filmmaker after *Youth of the Beast*, though he subsequently realized that he had seen many of Suzuki's earlier films, including *The Wind-of-Youth Group Crosses the Mountain Pass* and *Million Dollar Smash-and-Grab*, several years before this.[13] Adachi Masao has written that he first became a Suzuki Seijun fan after seeing *Gate of Flesh* in 1964, when he was a college student and member of the Nihon University Cinema Club. Adachi claims that there was even a subsection of devoted Suzuki fans with members from different cinema clubs in Tokyo who called themselves the "Seijun Group"; other members included Waseda University students Yamatoya Atsushi and Tanaka Yōzō.[14]

Beginning in 1964, articles praising Suzuki Seijun's work began appearing more regularly in *Eiga hyōron*, though they were initially primarily reader submissions rather than critics on the journal's writing staff. In July 1964 a reader named Kajiwara Ryūji praised the juxtaposition of deliberately theatrical staging with purely cinematic visual effects in the climax of *Kanto Wanderer* (which it contrasts with Kinoshita Keisuke's *Ballad of Narayama* [*Narayama bushikō*, 1958], which the author says simply imitates theatrical staging on the screen), as well as the skillful editing and blocking in a similar scene in *The Flowers and the Angry Waves*.[15] In November of the same year, a young experimental filmmaker named Ōbayashi Nobuhiko (writing under the pen name Kazuki Ryōsuke) wrote that in *Gate of Flesh*, Suzuki had struck on a novel kind of lyricism with the film: not a kind of sentimentality on the part of either the filmmaker or characters, but "the lyricism that underlies moving pictures" themselves.[16] By the middle of the decade, Suzuki had attracted the interest of numerous filmmakers and cineastes associated with independent film production and distribution and had become an icon to Tokyo's burgeoning student cinephile culture.

Somewhat belatedly, a *Kinema junpō* article from 1967 addresses Suzuki's rise to prominence among college cine-club members, along with that of another filmmaker, Katō Tai. Suzuki and Katō, the article observes, had managed to find an audience with the young viewers most devoted to filmgoing at the moment when theatrical filmgoing was declining as a whole. The article acknowledges that both filmmakers had been working for over a decade and made more than thirty films, but that neither had seen a single film make it on *Kinema junpō*'s annual "ten-best" list. Their work, however, featured prominently in the "Ten Best of 1966" lists of the major college cine-clubs: Waseda University's listed Suzuki's *Fighting Elegy* (2), *Carmen from Kawachi* (3), and *Tokyo Drifter* (5); the University of Tokyo's listed *Fighting Elegy* (7); and Keio

University's and Gakushuin University's both listed *Fighting Elegy* as the best Japanese film of the year. Other films that placed well among these groups were Katō Tai's *Nothing but Bones* (*Hone made shaburu*), *The Lonely Yakuza* (*Yūkyō ippiki*), *By a Man's Face Shall You Know Him* (*Otoko no kao no rirekisho*), and *Hell Squad: Charge!* (*Jigoku butai totsugekiseyo*), as well as Ōshima Nagisa's *Violence at Noon* (*Hakuchū no tōrima*) and Nakajima Sadao's *Yakuza Hooligans 893* (*893 gurentai*). The article profiles the two filmmakers, and characterizes them as stylists who bring formalist innovation to standard program picture material, but it contrasts the temperaments of their films by referring to Suzuki's style as *kawaita* (dry, in this context meaning "unsentimental") and Katō's as *nureta* (wet, or "sentimental"). The article then goes on to describe events in which the directors (on separate occasions) sat on discussion panels put on by the cine-clubs, with members of the film societies of different colleges across Tokyo in attendance. The authors cite tension between different factions of cine-club members, some of whom sought ideological readings of the films and others of whom were more formally inclined, with the filmmakers disavowing any political intentions of their work, without foreclosing the possibility that they could be read that way. The article ends by suggesting that by finding ways to appeal to young cineastes while working in the traditional studio system, Suzuki Seijun and Katō Tai may be just the kinds of filmmakers who could rescue the Japanese film industry as it was failing.[17]

As Suzuki's films began attracting the interest of college cine-clubs and independent filmmakers in the early 1960s, his stylistic experimentations grew bolder. Some of his fans among student groups even became his collaborators and pushed his work in thematic and stylistic directions that seemed to cater directly to these audiences. Suzuki's one-time second assistant director, Sone Yoshitada, had by the mid-1960s begun working as a screenwriter at Wakamatsu Kōji's independent Wakamatsu Production Company, under the pen name of Sone Chūsei. Wakamatsu was a pioneer of *pinku* films that wedded soft-core pornography to political messaging and avant-garde stylistic tendencies; as an independent studio, it was also a place where daring and ambitious young filmmakers could launch their own film careers outside of the traditional studio system. As such, it attracted numerous filmmakers who had grown out of Japan's nascent college cine-club culture, including ardent Suzuki fans Adachi Masao, Yamatoya Atsushi, and Tanaka Yōzō. Sone formed a close relationship with several other screenwriters at Wakamatsu, including Yamatoya, Tanaka, Hangai Yasuaki, and Yamaguchi Seiichirō. Beginning in 1964, this group of screenwriters collaborated on projects at the production company, including *Resume of Love Affairs* and *Season of Treachery*.

Sone recruited Yamatoya, Tanaka, Hangai, and Yamaguchi to write screenplays covertly for Suzuki under the pen name Guryū Hachirō, meaning "Group of Eight," alongside Suzuki himself, Kimura Takeo, and Okada Yutaka.[18] The

group was first officially credited as the screenwriters of *Branded to Kill*, but according to Sone, its members had significant influence as uncredited screenwriters for some of Suzuki's other late Nikkatsu films, particularly *Fighting Elegy*.[19] The group wrote several other screenplays and treatments for Suzuki projects prior to his firing that were never made into films, including sequels to *Fighting Elegy* and *Branded to Kill*, a Taishō-set "traveling gambler" film called *Assassination-Counting Song* (*Hitokiri uta*), and a film called *Red Lion of the Ghost Town* (*Gosuto Taun no akai shishi*) about gangsters on the run who accidentally stumble on a ghost town under the control of a strange cult. Suzuki's collaboration with these screenwriters is indicative of the fact that his appeal to student cine-club members was not all accidental: by the end of his Nikkatsu career, he was actually working with people who had entered filmmaking through the cine-clubs and independent production, which arguably helped push him toward making films that were ever more appealing to cine-clubs and ever less appealing to Nikkatsu.

As college cine-clubs and independent movie theater venues rose in the 1960s, Kawakita Kazuko and Shibata Shun founded the Tokyo-based Cine-Club Study Group (Shine-kurabu kenkyūkai) to act as a liaison for screenings of important films for these alternative filmgoing venues. Kawakita was part of a family with deep connections in the film industry: her parents had founded Kamakura Film Academy (where Suzuki had been educated in the late 1940s) as well as the Japan Film Library Council, which helped distribute Japanese films abroad. The Kawakitas had turned their interest to independent production in the 1960s, however, and were instrumental in founding and funding the Art Theater Guild.[20] In February 1967 Cine-Club arranged a screening of *Tokyo Drifter* at Sōgetsu Hall, which met such a response that the club arranged to have a larger retrospective of Suzuki's work in May of that year, which was to be the first directorial retrospective of its kind in Japan.[21]

In spite of these developments in film production and spectatorship in Japan in the 1960s, Suzuki was still under contract to Nikkatsu, which was still very much part of the so-called five-studio system that was in irreversible decline. The studios began to downsize, collapse, or branch into television or pornographic production. Nikkatsu, like the other major studios, was in crisis. At the same time, Suzuki came to blows with the studio head, Hori Kyūsaku. Suzuki's closest ally in Nikkatsu's management, Emori Seijirō, was fired in 1966, leaving no one to defend him among the management team.[22] Suzuki was summarily fired in 1968 by Hori, more than a year after directing his final theatrical film for the studio.

The exact reports of his firing are themselves somewhat contradictory. At the beginning of April 1968, Suzuki received a phone call from Nikkatsu's office informing him that he would not be receiving his salary as usual because his name was absent from their register. No one in the office seemed to be sure of

the reason why until an executive named Kobayashi Tetsuo asked President Hori directly, to which Hori responded: "We don't keep directors who give us nothing but red ink under contract."[23] When these events transpired, Cine-Club's Suzuki Seijun Retrospective had already been announced in the *Yomiuri shinbun*, and print rentals for his films had already been negotiated with Nikkatsu's office. Suzuki's firing had not been announced publicly, so when Kawakita Kazuko contacted Nikkatsu to procure the prints of Suzuki's films on April 26, neither she nor anyone outside of Nikkatsu was aware that he no longer worked there. She was informed that Nikkatsu would not loan the prints to Cine-Club but was not told why until she contacted Hori himself.[24] Hori issued the following infamous statement, which Cine-Club quoted in its notice to members explaining the cancellation of the retrospective:

> Suzuki Seijun is a director who makes incomprehensible films. As such, Suzuki Seijun's films are bad films, and to screen them publicly would be an embarrassment for Nikkatsu. Nikkatsu cannot have an image as a company that produces films that are only comprehensible to a single faction of people. Nikkatsu dismissed Suzuki Seijun as of April 25. We henceforth forbid any screening of Suzuki Seijun films, not only from Cine-Club but also from any other movie theater or public venue.[25]

Whereas Suzuki's firing could ostensibly have been explained by simple monetary concerns—the studio needed to cut back costs wherever it could, including from its contracted directors—the refusal to circulate his films at the request of Cine-Club could not be explained in this way, as it would have been lucrative for the studio given the scale of the proposed retrospective. Could it have been that Hori was too embarrassed to allow the retrospective, since it would have been akin to admitting that he had made a mistake in dismissing Suzuki? Or was this evidence that there had been an ulterior motive behind the initial decision to dismiss Suzuki in the first place? Ueno Kōshi offers the former explanation in his account, writing that Hori was simply "a totalitarian figure, unused to withdrawing statements or complying with other people's requests."[26] However, Ryan Cook has noted that several Suzuki films were being aired on television as the blockade was announced, and he suggests that the blockade of film prints may have been as much an attack on Cine-Club, and on alternative forms of film exhibition, as it was on Suzuki.[27] Certainly, Hori's specific charge that Suzuki's films were "only comprehensible to a single faction of people" seems pointed toward groups like Cine-Club that were championing him at the time. It might even be that Hori's dislike of these groups and their alternative exhibition practices could help explain his motivation for firing Suzuki, a filmmaker who was catering to these audiences in his later Nikkatsu films. But whatever the motivation, Hori's statement ultimately reframed the dispute

as one of artist versus studio and transformed Suzuki from a mere victim of his studio's financial problems into a kind of radical, particularly as his dismissal came to echo the creative disputes that had led politically radical studio filmmakers like Ōshima Nagisa and Yoshida Kijū to exit the studio system (in their case, Shōchiku) earlier in the decade.[28]

As a result of Suzuki's firing and Nikkatsu's decision to block his films from circulation indefinitely, the Director's Guild of Japan filed a lawsuit against Nikkatsu, charging the studio with wrongfully terminating Suzuki and suppressing his freedom of expression by blocking the circulation of his films. On May 2, 1968, Gosho Heinosuke issued the following statement as board chairman of the Director's Guild:

> Regarding the Contractual Violation—The sudden, unilateral action is a grave violation of the contractual agreement. This kind of feudalistic action must not be permitted.
> Regarding the Blockade of Films—This action violates the constitutionally guaranteed right of free expression. Although the aforesaid films are products of a company, they are at the same time cultural artifacts. As such, rather than follow the proper procedures and fulfill its social duty to supply these films to be screened, the company has acted improperly and treated these cultural artifacts as their private possessions.[29]

The Director's Guild attempted to negotiate a settlement with Nikkatsu to give Suzuki severance pay, allow his films to circulate again, and have Hori publicly withdraw his claim that Suzuki's films were incomprehensible, the belief being that that statement was discouraging other studios or independent financiers from backing Suzuki's future filmmaking pursuits. These negotiations failed, however, apparently because of Hori's refusal to comply. Thus Cine-Club president Kawakita Kazuko opted to hold a demonstration against Nikkatsu in the hopes of getting the studio to release the prints of the films.

Although Cine-Club initiated the demonstration, it would ultimately be joined by a diverse group of filmmakers, screenwriters, and artists in other media who were broadly affiliated with the New Left, as well as by several factions of 1960s student movements. The film critic Kawarabata Yasushi described the development of the protest in his diary. Kawakita had never been involved in street demonstrations and even went to the trouble of obtaining a permit from the police to use certain sections of Tokyo roads for the demonstration. The police informed her that the street immediately in front of Nikkatsu's Tokyo Headquarters could not be blocked for protesting, so she arranged to march from Cine-Club's office, through the Hibiya Theater District, dispersing at Hibiya Park, and only reconvening immediately in front of Nikkatsu's building to avoid marching in that street and obstructing traffic.[30]

Cine-Club's participants came on the day of the protest carrying placards of stills from Suzuki films and were joined from the outset by an impressive array of film talent—Ōshima Nagisa, Shinoda Masahiro, Wakamatsu Kōji, Adachi Masao, Fujita Toshiya, and others.[31] En route, they encountered about two hundred red-helmeted student protestors, led by Matsuda Masao, an ardent Suzuki fan and future editor of the leftist film journal *Eiga hihyō*.[32] Kawarabata describes the impressive dynamics of the student demonstrators' synchronous movements, marching in a regimented arrangement while chanting "Nikkatsu funsai! Seijun kaese!" (Crush Nikkatsu! Restore Seijun!) in unison. In an indication of the divisions between the different groups participating in the march, their preferred methods, and their agendas, Matsuda and the student demonstrators wanted a more confrontational approach than Cine-Club's police-approved march; apparently, they hoped to stage a sit-in at Nikkatsu's office. They were eventually convinced to follow Cine-Club's initial plan for the protest, but their involvement in the march ensured that the student movement would play a large role in the movement that followed.[33]

The participants of this march formed the Suzuki Seijun Joint Struggle Committee. In their first meeting, they issued the following statement:

> *Foremost, as of July 13, 1968, we who have convened at the formation rally of the Suzuki Seijun Joint Struggle Committee, from the perspectives of a union of film professionals as well as that of individual film spectators, do declare the following.*
>
> *Foremost, we fight against the reckless actions of the public company Nikkatsu, which has blockaded the films of Suzuki Seijun and unilaterally torn up his contract.*
>
> *Foremost, we do not believe that the Suzuki Seijun Problem is simply a controversy over the lending of the films of an individual filmmaker. That is, it is a violation of an author's copyright and right of lifestyle, a blunt insult to all spectators, and it confirms our fight with the structure of authority that has continued to oppress the creative movement.*
>
> *Foremost, we are aware that this is a fight over the control of the future of Japanese Cinema, and we have assembled a united front on the lines of battle, and we are extremely determined to fight.*
>
> *Foremost, we will win without fail.*
>
> *That is our declaration.*
>
> *Suzuki Seijun Joint Struggle Committee*
> *July 13, 1968*[34]

Thus the contract genre filmmaker with a small cult following suddenly became a central political figure in the heat of Japan's "season of politics."

But were Suzuki's films themselves political, or had he merely been politicized?

The participants in the Suzuki Seijun Joint Struggle Committee overlapped significantly with participants in other leftist political causes, ranging from the signing of the *Anpo* security treaty with the United States earlier in the decade to the destruction of farmland to build Narita Airport at the end of the decade. Many young filmmakers who emerged in the late 1950s and early 1960s had aligned themselves with such causes. These included independent filmmakers making avant-garde films at the fringes of the industry like Hani Susumu and Matsumoto Toshio, but also filmmakers who began in the studio system making narrative films with political themes before becoming independent, such as Ōshima Nagisa, Shinoda Masahiro, Yoshida Kijū (all at Shōchiku), and Imamura Shōhei (at Nikkatsu). The fact that some of these filmmakers had broken acrimoniously with their studios in creative disputes helped make Suzuki seem like a natural fit.

Suzuki has typically either sworn off political meaning in his films or ignored the question of politics entirely; however, the filmmaker's own claims did not prevent the New Left from taking up his cause. In Ōshima Nagisa's account, many participants in the Joint Struggle Committee saw the movement as an opportunity to help bring about broader change in the film industry by helping it move away from the five-studio model to an industry based more on independent production.[35] Matsumoto Toshio went further, arguing that the Suzuki Seijun movement had less to do with freedom of artistic expression (whether Suzuki's or some other aspiring filmmaker's) than with taking on the studio system's monopoly on cinematic image production in Japan. He saw this as tied to other forms of institutional power; in his mind, the movement was inextricably linked to the other political causes against other institutions of power in 1968.[36] Thus, to some participants in the Suzuki Seijun Joint Struggle Committee, Suzuki Seijun himself was a relatively minor figure in a much larger political struggle. As a result, the political meanings (or lack thereof) in his films were not relevant to taking up his cause.

Other participants, however, saw a connection between Suzuki's formal playfulness and the broader cause of the New Left. An article on his firing in the journal *Masucomi shimin* (Mass communication citizenry) celebrated his "rebellious spirit" as a filmmaker—"Not the kind that directly challenges the authority of the state, but that unconsciously rebels against the existing regime based on feelings of resentment."[37] Certainly *Fighting Elegy* takes up questions of masculine identity, its relation to violence, and its role in fascist indoctrination in the early Shōwa period. Though less obviously political, *Branded to Kill* depicts a hit man, a figure equated with solitary individualism in the genre, and shows how his ambitions and fate are shaped by an unseen system that he himself contributes to, and that ultimately works to consume and destroy him. It

is not too difficult to read the film as an allegorical depiction of Suzuki's status at Nikkatsu, or the capitalist system of production and consumption in postwar Japan more generally. Matsuda Masao suggested that Suzuki's formal experimentation was a (perhaps unconscious) way of rebelling against the studio system's unjust treatment of him and other talents they saw as expendable. Matsuda argued that Suzuki's style was an articulation of the contradiction between the illusion of a "dream factory" that studio films give audiences and the feudalistic nature of the studio system and its production process. In Matsuda's conception, Suzuki's style was a self-reflexive move whose irrationality exposed these internal contradictions, leading Matsuda to call him an "irrational documentarist" or "documentarist of irrationality" (*higōri no dokyumentarisuto*), which was why his films posed a threat to Nikkatsu as a capitalist enterprise. Matsuda allows for the possibility that Suzuki's rebellion against Nikkatsu was not a consciously political project and even speculates that the stylistic experimentation may have arisen from hallucinations that the director began to have as a result of being overworked.[38]

There was not necessarily a consensus among cinephiles and filmmakers, whether they were formalistically or politically inclined, as to what, if any, political meaning there was behind Suzuki Seijun's films, or whether the filmmaker had intentionally put them there if there were any. However, regardless of whether Suzuki's formal play had political intentions or effects, or whether he was simply a victim of the system onto whose cause others could latch their own political designs, he became a cause célèbre at the height of Japan's season of politics, and the moment of transformation in Japan's film industry and culture.

The Unseasonal Interpretation

Suzuki himself has shied away from overly serious interpretations, though it is always difficult to discern how sincere his own interview answers and writings are. But there are also film critics and theorists who have pushed back against his politicization. One of these was Hasumi Shigehiko, who wrote his second published essay in 1969 about Suzuki in the immediate wake of the Suzuki Seijun Incident and would continue to write on the filmmaker over the course of his career. Looking back at Suzuki's oeuvre in 1991, Hasumi wrote an essay called "Suzuki Seijun, or the Absence of Seasons" (Suzuki Seijun, mata wa kisetsu no fuzai), and even the title gives away his disavowal of political meaning in Suzuki's films. To the reader unfamiliar with leftist discourse from 1960s Japan, it may seem innocuous, and indeed, the essay begins with a reading of the use of seasonal imagery in Suzuki's films, arguing that it does not correspond in meteorological conditions but rather exists as simple

stylistic flourishes. In this context, however, the Japanese word *kisetsu* (season) has an additional meaning as well, from its use in the phrase *seiji no kisetsu* (season of politics), referring more broadly to the political moment of 1968 Japan, of which the Suzuki Seijun Incident itself was a part. By the end of the essay, Hasumi addresses this second meaning, arguing that the political meanings were projected onto Suzuki's films, rather than meanings that the films themselves possess. "While the films do not contain allusions to the politics of the era, somehow it was thought that they fanned the flames of the spirit of rebellion in 1968," Hasumi writes. When he describes the formation of Guryū Hachirō, he argues that the political rebellion they saw (and ultimately took part in creating) was not something that was initially in Suzuki's films themselves but something of their own creation: "It was as if he drew young people to rebellion without saying a word, as he depicts Kita Ikki doing in *Fighting Elegy*."[39]

The comparison of the student movement to the young people driven to rebellion by Kita Ikki is itself a provocation that might be lost on those with a limited familiarity with Japanese history. Kita was the embodiment of Japanese fascism, a former leftist intellectual whose writings in support of the Japanese imperial project and militarization of the Japanese nation-state in the 1930s draw heavily from his notion of socialism. Kita's writings would inspire an attempted coup d'état in 1936, which failed and got him shot, though much of the transformation that he envisioned for Japanese society came to pass anyway. That Hasumi would compare the student movement to the young men roused to rebellion by Kita is either indicative of his reading of the political content of Suzuki's films as too naïve to distinguish between the fascist revolutionaries of the 1930s and the New Leftist student movement in the 1960s, or an indication that the student movement by the late 1960s had devolved into something much less attractive than its initial vision. That it would soon lapse into a cultish and self-destructive movement gives credence to the latter reading.

In asides like these we can catch a glimpse of politics in Hasumi (and the reason he is sometimes regarded as a reactionary) as well as in Suzuki. *Fighting Elegy* is a film that largely concerns itself with a young man, Kiroku, who is expelled from his school in Tokyo to the countryside for fighting. Though his violent nature initially seems rebellious, in the countryside he enters into a systematized arrangement of fighting clubs winkingly encouraged by adults in positions of authority. The sudden, surprising appearance of Kita, the reference to the rebellion he inspired, and his brief, strange shot/reverse shot with Kiroku all suggest that the apparently rebellious impulses of this young man are actually being channeled into a looming project of fascism. This is not to say that Suzuki is making a deeply considered political point, or that he is comparing the young rebellious fighter of his film to the student movement, as Hasumi

does. Nevertheless, Hasumi's aside here is a kind of tacit admission that these elements of politics are present even as he denies their significance.

Hasumi and his fellow travelers and acolytes find a different reason to praise Suzuki. Building from a close analysis of visual motifs across his oeuvre, Hasumi locates his interest in Suzuki in his deployment of the mechanisms of cinema itself: "Suzuki allows us to peek at the cruel contradictions of the essence of cinema. What is revealed is tangible film, a surface whose state of being is one of pure movement, but at the moment that we arrive at its tangibility, the film is wrapped in an abstract expression, and it cannot help but reveal the impossibility of cinema."[40] Suzuki, in other words, was primarily interesting for what his films tell us about the nature of cinema rather than the political conditions of Japan in the 1960s. Thus Suzuki's films were foundational for the way that Hasumi and others with him came to think about cinema, and, as we will see, his early writings on Suzuki in the wake of the Suzuki Seijun Incident show him working through the ideas that would later shape his broader theory of cinema.

But for now, I would like to stress the way that Suzuki's films, which had been ignored for the first eight years of his career, were now at the center of everyone's attention, with both leftists and cinephiles attempting to claim the filmmaker as one of their own. Over the years since his firing from Nikkatsu, his emergence as a countercultural figure in Japan, his entering into the international art house circuit, and his belated international reception, Suzuki himself has given a great number of interviews and public talks and published a great number of essays and books. But even in these, he never offers anything resembling a straightforward film theory: he may explain why he made a single stylistic decision but would deny making decisions within a film as part of a broader aesthetic plan, and would certainly deny any connection to politics.[41] Even when he was called to give testimony on behalf of Ōshima when the latter's film *In the Realm of the Senses* (*Ai no korida*, 1976) was accused of violating decency laws, Suzuki claimed that his own view of filmmaking differs fundamentally from Ōshima's politicized filmmaking:

> I myself have also always made films for entertainment; I believe that film is a spectacle. Arousing the spectator's curiosity, dressing up the unreal to make it look real, fooling the spectator, that's what a spectacle is all about. The spectacle is a game in which you know from the start that you are being fooled—and not a bad word about the spectator who thinks the fake is real; the one who sees the falsehood for what it is and does not get angry, but laughs about the nonchalance with which he has bought his ticket.[42]

His explanation here would appear to validate Hasumi's take on him—that he is most interesting for his mobilization of cinematic techniques to interact with

the spectator rather than to reflect some broader social or political zeitgeist. That Suzuki regularly expresses these sentiments in interviews and essays makes it difficult for those who want to argue that he is a political filmmaker, at least in the same way as a filmmaker like Ōshima, who regularly discusses his views about the relationship between film and politics. Within this same testimony, however, it is possible to detect the kind of attack on authority that the *Masukomi* article claimed to see in Suzuki, as he ends his testimony with the following declaration: "Ōshima is innocent. This means that the book burners, the public prosecutor, and the police are guilty. From the very start I've found it strange that these murderers, who made an error of judgment, are allowed to walk around in broad daylight with impunity. It would only be fair if they were to be punished severely."[43] Though he does not tie this sentiment to any broader political message, nor does he claim that this sentiment in any way affects, or affected, his filmmaking practice, the contempt for authority rises from an apparently prepolitical impulse.

I borrow the term *prepolitical* from Eric Hobsbawm's study *Primitive Rebels*, which considers the aspirations of medieval bandits and their more recent equivalents. He defines prepolitical as people "who have not yet found, or only begun to find, a specific language in which to express their aspirations about the world."[44] The New Left was political in that they had specific aspirations for changing the broader social order within Japan, often in response to immediate issues, such as the re-signing of the *Anpo* treaty or the clearing away of farmland for the construction of Narita Airport. Filmmakers of the New Left were explicitly political in that they sought to invent a new film form that would help bring about these social changes that the New Left aspired to. I call Suzuki's impulse *prepolitical* because he did not make his films initially with this explicit purpose of bringing about social change or to announce a position on airport construction. Rather, he made these films in a social and historical context in which the issues were being debated and, in reacting to this environment (or merely existing in it), Suzuki's films inevitably picked up traces of the debates or were viewed in light of them. Whether unconsciously or stemming from a simple impulse to shock his spectators by any means available, many of Suzuki's late Nikkatsu films somehow retain the ability to lay bare and challenge viewers' assumptions on subjects ranging from wartime guilt (in *Story of a Prostitute*) or survival as a commodified woman in the war, occupation, and economic boom eras (*Story of a Prostitute*, *Gate of Flesh*, and *Carmen from Kawachi*). This impulse made his filmmaking experimentation a vehicle for more explicitly political ends for his Guryū Hachirō collaborators in his final Nikkatsu films.

A simple example of the way that Suzuki's prepolitical impulse could end in an engagement with underlying ideology can be seen in the progression from *The Incorrigible* to *Fighting Elegy*. The films are similar in subject matter: both

tell of young men in the early twentieth century (mid-1910s in the former; mid-1930s in the latter) who relocate from major cities to rural Japan. In each case, the protagonist finds himself in a strange new community governed by organizations of young men who use the groups as a thin cloak of self-righteousness to excuse their violent and destructive tendencies. This is subtler with the "Public Morals Bureau" in the former film than with the fight clubs of the latter one. Further, the protagonist in each film confronts youthful romance and his own burgeoning sexuality.

There is, however, a minor comic moment, one likely improvised during the filming of *The Incorrigible*,[45] that is fleshed out dramatically in *Fighting Elegy*. Early in the former film, the protagonist Konno Togo has his first sexual experience with a geisha, Ponta, who has seen through Togo's swagger and recognized that he is a virgin. In the middle of the sequence, as his sexuality awakens, Togo reacts to Ponta's advances by bursting out into the Japanese Imperial Anthem. Though in the context of the film it may be seen as simply a comic non sequitur, this strange moment is a central theme of *Fighting Elegy*. In that film, Suzuki makes the connection between the protagonist Kiroku's violence and his discomfort with his blossoming sexuality even more explicit (at one point, he declares: "I don't masturbate; I fight!"). Further, Kita Ikki, the symbol of Japanese fascism, makes an unexpected appearance between fight sequences in the middle of the film and shares a strange, unexplained shot/reverse shot with Kiroku before he is identified at the end of the film. The overall impression given is that Kita, an old man, is drawing on the vigor and repressed sexuality of Japanese youths in order to drive Japan toward imperialism and fascism.

The potential for this reading exists within the bizarre non sequitur of *The Incorrigible*, but it is never developed nor directly connected with the Public Morals Bureau's violent repression of the underclassmen. However, the creative impulse that gave rise to that moment in the former film allowed it to be developed in the latter. Though it may not have been Suzuki's intention to examine the connection between youthful rebellion and fascism in either film, his artistic impulses nevertheless brought him to a place where he could depict it.

A Brief Intellectual History of the New Left in Japan

The student movement, a collection of different politically mobilized groups known collectively as *zengakuren* (short for Zen Nihon gakusei jichikai sōrengō, or All-Japan Federation of Students' Self-Governing Associations), was founded in 1948 and by the 1960s would be at the center of the Japanese New Left. Throughout the late 1940s and 1950s, zengakuren's relationship with the Japanese Communist Party (JCP), the establishment left, veered

between alliance and cold hostility. The JCP, significantly, was part of the system of government and, despite the fact that it was perpetually out of power, held seats in the National Diet; it was thus entrenched in Japan's postwar political system. In some instances, such as during the "red purge" of the early 1950s, zengakuren had worked in unison with the JCP, but frequently the students found the JCP's methods too tepid in its responses.[46] Things came to a head with the renewal of the *Anpo* (U.S.-Japan Joint Security Treaty) in 1960. Disillusioned by the JCP's inability to block the re-signing of the treaty, which symbolized to zengakuren Japanese complicity in the broader geopolitical agenda of the United States during the Cold War, protestors affiliated with zengakuren entered the National Diet, an action that the JCP denounced.[47] Zengakuren concluded that the JCP had failed to stem the tide of American consumerism or Japan's hypocritical position of claiming to be antiwar in its constitution, while its security treaties with the United States had made it function as a stooge of the U.S. war in Korea (and later Vietnam) in exchange for economic benefit. Meanwhile, the intellectuals of the Old Left were hopelessly caught up in written and spoken debates among themselves that had no effect because they were ignored by both the ruling Liberal Democratic Party (LDP) and the public at large. Some polemicists of the New Left compared, or conflated, the postwar JCP with the prewar left that was incapable of stopping fascism and Japan's Imperial Project.

Zengakuren and the broader New Left, by contrast, existed outside the established government and political institutions. To the extent that it had any institutional affiliation, the various student groups that formed it were student clubs affiliated with universities (primarily in Tokyo), but they existed outside the normal machinations of power. Instead of attempting to alter the policies of the Japanese government through entering the system of government itself, they opted to gain influence in the street through protests that made their critiques visible to the public at large, particularly in the new media environment that included daily television news. A new generation of artists, including filmmakers, also sought new ways to effect social change through art.

This is not to say that artists or filmmakers prior to the 1960s had been universally uninterested in politics. It is important to note, however, that while many postwar films may appear to contemporary Anglophone viewers to have left-leaning political messages—Kurosawa Akira's *No Regrets for Our Youth* (*Waga seishun ni kuinashi*, 1946) or Kinoshita Keisuke's *Twenty-four Eyes* (*Niju-shi no hitomi*, 1954), for example—these films were in fact promoting a sentimental humanism that might have originated from the offices of the Supreme Commander for Allied Powers (SCAP) and were thus seen as reactionary to the New Left. But the New Left did not limit this criticism to filmmakers within the political and industrial mainstream; in fact, as we will see, Ōshima would even make this charge of the avowed leftist filmmaker

(and JCP member) Imai Tadashi, who would come to be regarded by New Leftist filmmakers like Ōshima in more or less the same way that the JCP would be regarded by zengakuren.

It is worth looking briefly at the work of Yoshimoto Takaaki, whom we might call the intellectual figurehead of the Japanese New Left. In spite of his importance, little of his vast body of work has been translated into English. Lawrence Olson has described his critiques in the following way: "Yoshimoto's writings of the late 1950s were marked by their high-pitched tone and their irritation at the way, or so he believed, intellectuals of various persuasions shifted their positions in a kind of ideological vacuum without reference to the 'actual tendencies of the thought of the people.' "[48] In one (in)famous essay, Yoshimoto argues that the responsibility for Japan's descent into fascism lies more with the prewar leftist intellectuals who refused to commit *tenkō* (ideological conversion) than with those who did, because the intellectuals who refused to commit *tenkō* had been too caught up in moral and intellectual narcissism to be aware of the thoughts of the people. The intellectuals who committed *tenkō* had at least responded to the way that the public had reacted to economic stagnation and other social ills, while those who had refused had failed even to notice the transformation in Japanese society around them, much less to effect a change to it; as such, they made themselves irrelevant.[49] This also resulted in a new definition of the political, and, for that matter, the nonpolitical. William Marotti has noted the significances for the New Left (particularly by 1968) of the *nonpori*, a term that derives from the English "nonpolitical." The *nonpori* came to be seen not as apolitical but rather as potentially political.[50] They were an audience that the New Left intended to win over (and recruit for demonstrations), but also a group whose work could be thought of, at least subconsciously, as political action. It was in this way that a stylistically bold but apparently apolitical filmmaker like Suzuki could be taken up by the student movement, or by New Left filmmakers like those of the Wakamatsu Production Company.

Suzuki's films, even before the embrace of the members of Guryū Hachirō or the student movement, already contained some affinities with the New Left. Comparing his film *Story of a Prostitute* with an earlier adaptation of the same Tamura Taijirō novel, one can see the film making the kind of critique of the earlier film that zengakuren made of the JCP, or that Ōshima made of Imai. Both films follow the unlikely romance between a soldier, Mikami, and a comfort woman, Harumi, who attempt to escape the army together on the Manchurian Front. The earlier adaptation, Taniguchi Senkichi's *Desertion at Dawn*, was made in the simplistic humanist mode favored by the U.S. Occupation government; the heroes are thus very neatly and clearly marked by their skepticism of the Japanese Imperial Project. In Suzuki's film, however, Mikami is unwaveringly, naively, and infuriatingly committed to the Japanese imperial cause until the end of the film, to the point that he even attempts

to return to the army for punishment after having been saved by Harumi and placed in the care of the Chinese Nationalist Army. Though the earlier film is perhaps more straightforward in marking the good versus bad characters and the corresponding ideologies of each, the later film more convincingly confronts the moral issues that would have faced a soldier in Mikami's position: he would not likely have been an enlightened postwar humanist but would be blind to the cruelties of Japanese imperialism and the ideology to which he was committed. While *Desertion at Dawn* would merely flatter its postwar audience and their enlightenment in comparison to the evil imperialists depicted in the film, *Story of a Prostitute* would invest its viewers in a character who was himself devoted to a horrifying ideology, presenting more of a provocation by both making the audience more aware of the ideological challenge as it faced the Japanese during the war itself and necessitating that the audience confront its own ideological assumptions rather than merely flattering them.[51]

In the face of a film like *Story of a Prostitute*, Hasumi's apolitical reading of Suzuki is insufficient. We might also observe that there are deep thematic resonances between *Story of a Prostitute* and Suzuki's other Nikkatsu films with less obvious political content. For all Suzuki's reputation as a freewheeling anarchist, unbound by convention and unable to be contained by the rigidity of the studio system, it is precisely in characters like Mikami that his films are most frequently interested. The central male characters in his late Nikkatsu career are all ultimately outcasts, but before they are outcasts they are conformists, deeply committed to the systems (*giri* in *Tokyo Drifter*, the ranking system in *Branded to Kill*, the Japanese military in *Story of a Prostitute*) that will ultimately betray them. In this respect, *The Incorrigible* and *Fighting Elegy* can be seen as their inverse in that their lead characters, who define themselves as rebels, are actually, as we will ultimately discover, being shaped by institutions and political machinations without realizing it.

The New Left and Film in 1960s Japan

The New Left was an important force in filmmaking in 1960s Japan. Many important filmmakers of the era participated directly in political protests and wrote extensively about the relationship between politics and art, and these considerations are reflected in their filmmaking practices. Two canonical books have been written on this subject, though I should note that I have some reservations about the first, and the specificity of the second does not totally align with that of my project. The first of these is David Desser's treatment of the "Japanese New Wave" in *Eros Plus Massacre*. Desser defines the Japanese New Wave as "films which take an overtly political stance in a general way or toward

a specific issue, utilizing a deliberately disjunctive form compared to filmic norms in Japan."[52] I find this definition too vague to be very useful; it leaves both "overtly political" and "disjunctive form" undefined, allowing us to be able to interpret them to mean almost anything. At the same time, it is indicative of the lack of a unified formal or political intervention from filmmakers broadly affiliated with the New Left.

Yuriko Furuhata has, more recently, offered a more narrow way to consider the relation of politics to film in 1960s Japan through what she has called *eizō* discourse. Furuhata argues that in the 1960s, Ōshima's and Matsumoto's films "are marked by their shared investment in the journalistic domain of actuality and the intermedial appropriation of non-cinematic media, bearing witness to the concurrent theorization of the image in film theory."[53] As a term, Furuhata writes that eizō "was often invoked in order to articulate cinema's relation to television, the newly dominant medium that generated strong sensations of actuality."[54] As it emerged as a term in this era, Furuhata writes that "the *eizō* refers to a particular kind of image created and mediated by technological means, including cinema, television, photography, and computer imaging."[55] She argues that the emergence of the concept is related to a broader turn toward consideration of the significance of the image in cinema, and also toward the consideration of cinematic images as they related to other kinds of images.

In some cases, this meant radical experiments with film form and narrative structure, such as Matsumoto's *Song of Stone* (*Ishi no uta*, 1963) or Ōshima's *Diary of a Yunbogi Boy* (*Yunbogi no ikki*, 1965) and *Band of Ninja* (*Ninja bugeichō*, 1967), all of which construct films out of still images and push against conventional narrative structures. In other cases, though, these filmmakers explored this relationship within popular generic frameworks, either by self-consciously subverting common narrative tropes or by embedding the discourse around image construction within narrative films. By the middle of the decade, Matsumoto was writing about the possibilities contained within the concept of a "nested diegesis" (*geki chū geki*), or a fictional, artistically constructed world contained within another fictional, artistically constructed world such as a play-within-a-play, a film-within-a-film, or a play-within-a-film. Writing on Jean Genet's common use of the "play-within-a-play" trope, Matsumoto observed the way that Genet used the device to demonstrate the process of his own artistic construction and its power over the audience by showing the power of a similar artistic construction over an audience contained within the play.[56] Shortly thereafter, Matsumoto and Ōshima both played heavily with nested diegeses in their own films—Matsumoto in *Funeral Parade of Roses* (*Bara no sōretsu*, 1969), Ōshima in *Death by Hanging* (*Kōshikei*, 1968) and *The Man Who Left His Will on Film* (*Tōkyō sensō sengo hiwa*, 1970)—as ways to explore the formal process of the construction of narratives through images and the ideological implications therein.

Additionally, emerging from the mainstream studio industry himself, Ōshima sought ways to channel the popular appeal of mainstream narrative films and genres to his desired political ends. In his celebratory writings on popular cinema, he notes that he is not fascinated with it in general, but with those films that break with traditions. He critiques both filmmakers of the postwar humanist vein like Kinoshita Keisuke and the committed establishment leftists like Imai Tadashi because, in spite of the purported messages of their films, the films failed to challenge their audiences in a meaningful way and relied too much on the same forms that predated the war. By contrast, he saw a different set of postwar filmmakers, whom he called the modernists, such as Nakahira Kō and Masumura Yasuzō, developing radical new forms whose energy he wanted to channel for his own purposes. What Ōshima admired about these filmmakers was that "they decided to shock their audiences rather than persuade or move them," through their explicit depictions of sexuality and violence. But while he admired their attack on their audience's complacency, he found their attack needed to take more direct aim at the political moment: "Their next challenge is to progress further, to the level of content, innovating and modernizing as they confront the premodernity of Japanese film and society."[57] Around the same time, Ōshima's Shōchiku colleagues Yoshida Kijū and Shinoda Masahiro were similarly experimenting with techniques used by these "modernist" filmmakers, in particular the *taiyō-zoku* (sun-tribe) genre inaugurated by Nakahira's *Crazed Fruit* (*Kurutta kajitsu*, 1956).[58]

In his earliest films, including *A Town of Love and Hope* (*Ai to kibo no machi*, 1959), *The Sun's Burial* (*Taiyō no hakaba*, 1960), and *A Cruel Story of Youth* (*Seishun zangoku monogatari*, 1960), Ōshima mounts an attack on his audience's sensibilities. He takes up the shocking stylistic elements and thematic concerns of filmmakers like Nakahira or Masumura and weds them to a political consciousness while reworking or discarding popular tropes (like the lovers' suicide) in favor of the creation of a new form.[59] In this respect, Ōshima's popular genre films take up the New Left's critique of postwar humanism for its political and moral narcissism and solipsism and the need to engage with the masses. Thus I argue that genre filmmaking not only could be seen in relation to the New Left but was a crucial component of the way the New Left functioned in the 1960s.

I do not mean to discuss these two tendencies—working within popular genre cinema and the avant-garde experiments with actuality associated with eizō discourse—as though they are mutually exclusive. Indeed, *Cruel Story* works through eizō discourse by incorporating elements of what will be the "cinema of actuality" into the film's opening with a newsreel of student protests in Korea,[60] as well as incorporating Japanese student protests of the *Anpo* treaty filmed on location. The latter portion folds neatly into the film's narrative, as

both one of Kiyoshi's friends and Makoto's elder sister are affiliated with the student movement and serve as a counterpoint to the nihilistic relationship of Kiyoshi and Makoto themselves. Thus it is important to recognize that these approaches are not antitheses of each other but rather that they coexisted and could even interact within the same film.

At least at first, the major studios were eager to promote this kind of radical filmmaking. We often hear the New Leftist filmmakers lumped together somewhat amorphously as the "Japanese New Wave," as in the previously cited work by David Desser. Given the fact that the major filmmakers wrote film theory and criticism alongside making films, and given the way that the leading filmmakers had political commitments similar to those of, say, Jean-Luc Godard, this analogy to the French New Wave may seem apt enough. However, the filmmakers of the Japanese New Wave, as defined in Desser's book, were more loosely connected than the filmmakers of the French New Wave. The French New Wave filmmakers shared the lineage of Bazinian thought (even if some of them eventually turned against their former teacher) and had written for *Cahiers du cinéma* before becoming filmmakers. By contrast, the Japanese New Wave filmmakers did not share a teacher figure like Bazin, nor were they connected as critics before starting to make films. In fact, before anyone spoke of the Japanese New Wave, Shōchiku advertised its own "Shōchiku *Nouvelle Vague*";[61] that is to say, the very notion of a "New Wave" (which both Ōshima and Yoshida reject in their own writings) was a marketing decision made by Shōchiku studios, popular enough that Nikkatsu reacted by marketing its own filmmaker Imamura Shōhei as their New Wave counterpart. The term *Japanese New Wave* simply expands Shōchiku's marketing technique to include filmmakers at other studios, and often some working entirely outside of the studio system, like Matsumoto or Hani.

Like Imamura, Suzuki also worked at Nikkatsu and, in fact, several of his films were featured as the B film in double billings with films made by Imamura in the mid-1960s.[62] Nikkatsu did not market Suzuki as a New Wave filmmaker, or any comparable designation. Nevertheless, it is important to note that the context of his filmmaking in the 1960s was partly defined by the fact that he was working within the same generic and industrial context as these other filmmakers, though he did not have their critical stature, at least not until after the fact. Thus, like Ōshima in *Cruel Story*, Suzuki in 1960 was working in the same vein of *taiyō-zoku* films with his films *Fighting Delinquents* and *Everything Goes Wrong*. It is perhaps possible to dismiss these ventures for the same reasons that Ōshima was ultimately skeptical of the films of the modernists; that, despite their "depictions of sex and violence permeated by the sense of a stifling situation," the "impatience with the status quo in these films remains quite superficial and abstract."[63] However, I find that Suzuki's *Everything Goes Wrong* will make a useful point of comparison with Ōshima's *Cruel Story*, made

the same year, demonstrating Suzuki's complex relationship to New Left filmmaking while he was making films at Nikkatsu.

In addition to the shared heritage of the *taiyō-zoku* film, *Cruel Story* and *Everything Goes Wrong* overlap significantly in subject matter: Suzuki's film not only focuses on juvenile delinquent characters but includes the blackmailing of a wealthy businessman by a young woman, in part to pay for the termination of an unexpected pregnancy. Several specific scenes resemble ones in *Cruel Story*—notably, when the protagonist, Jirō, is beaten by gangsters, the end in an automobile accident, and, most jarringly, the strange interaction between a visual performance of sexual and romantic relations counterpointed by a simultaneous discussion of the films' thematic underpinnings (handled in slightly different ways by Ōshima and Suzuki).

In several ways, *Everything Goes Wrong* is a more apparently conventional *taiyō-zoku* film than *Cruel Story*. The motivation for protagonist Jirō's delinquency does stem from a parent-child relationship, as Mitsuhiro Yoshimoto observes is common.[64] Specifically, Jirō's teen angst apparently derives from his *Hamlet*-like familial relations; his widowed mother is carrying on an affair with Nambara, a still-married wealthy businessman who has also looked after them financially since Jirō's youth. To complicate matters, the businessman owned a weapons manufacturing business during the war, in which Jirō's father died (by being run over by a Japanese tank), leading Jirō to blame Nambara personally and explicitly for his father's death. While this motivation is familial on the one hand, it explicitly ties the familial motivation to lingering guilt for the war; that Jirō's would-be stepfather is still a successful businessman, moreover, suggests continuity between the authority figures of wartime and postwar Japan. As such, Jirō's rebellion against his father figure is not general or abstract but bears a direct relevance to the political moment.

It is not just subject matter that relates *Everything Goes Wrong* to films that Ōshima and other leftist filmmakers were making at the time. It also begins with a film-within-a-film sequence that foregrounds the environment of mass media in which the film takes place and is received. *Everything Goes Wrong* was filmed in a 2.35:1 aspect ratio, but for this sequence the sides of the frame are blacked out, leaving the center image at academy ratio (1.33:1). The sequence combines wartime documentary stock footage of battles with a brief reenactment, showing an injured Lieutenant being treated before running off into the jungle, which is followed by more stock footage of explosions and tanks. Suddenly, the film cuts to the image (now in 2.35:1) of a college student in 1960s Tokyo walking out of a movie theater advertising a film called *The Last Battle* (*Saigo no kōgeki*) with the tagline "Fight until the last drop of blood!" While this contains the sequence as a mere film-within-a-film, it performs several other functions: when we learn of the backstory of Jirō's father's death—not only that he died in battle but that he was run over by a Japanese tank—it comes to

function as a kind of flashback depicting this event, as editing the lieutenant disappearing in the jungle followed by shots of tanks leaves open the possibility that he was crushed by a tank. It stresses a thematic link between the war and the present day—though the title *Everything Goes Wrong* ostensibly refers to the events of the film, the title itself appears over an image of explosions not yet contextualized as being part of a film-within-a-film: initially, these explosions appear instead to be an abstract expression of the title. This brings the specter of the war into relation with the rebellion of the teenagers that the film portrays, which will be reinforced by the fact that Nambara, the film's troubled patriarch, himself has a connection to the war.

Made a half-decade before Matsumoto began writing on *geki chū geki*, and nearly a full decade before Matsumoto's or Ōshima's own experiments with the technique, this nested diegesis shows Suzuki working within a similar context of media hyperconsciousness as these filmmakers. The incorporation of both stock and found footage of actual battles into fiction films can be seen in both wartime propaganda films and postwar films, though this is generally not interpreted as a meta-cinematic or meta-medial commentary so much as a way of covering difficult battle footage that would be expensive to re-create. Thrown into the space of the film-within-the-film, however, the discrepancy becomes heightened. Moreover, Suzuki's decision to put the film within a film in the same aspect ratio as television (when, being a film shown in a theater, it could easily have been in CinemaScope) makes the found footage shots that bookend the film-within-a-film give the effect of a television broadcast of an actuality (especially since it is not shown to be at a movie theater until after the sequence ends). Its further ambiguous state as being both a nested diegesis and also, functionally, a subjective flashback for Jirō further hints at the way that Jirō's subjective understanding of his father's death has been shaped by its depiction in media, just as the young viewers watching the film have had their understanding of the war shaped in a similar way.

Instantly, this sequence places Suzuki in dialogue with the discourses of the New Left that articulated cinema's relation both to actuality and to other emerging media at the time. I do not claim that Suzuki was necessarily directly influenced by these writings, or that he was intentionally inserting himself into these debates, but because he was operating in the same studio and genre system that a filmmaker like Ōshima was, he was able to pick up on some of these same ideas and reshape them for his own interests. Even if it was not a conscious decision on Suzuki's part to enter into the political filmmaking of the New Left, it is not surprising that New Leftist filmmakers could look back at Suzuki's work retrospectively after his firing and see resonances with their own work. On the other hand, the circulation of these ideas within genre filmmaking more generally also made it so that these same filmmakers had been able to pass over Suzuki's work without noticing it while he was still working at

Nikkatsu. Suzuki's reflection on cinematic construction in the opening film-within-the-film foreshadows an attitude toward screen space that Suzuki would develop over the course of his late films at Nikkatsu. It was this side of Suzuki that would be taken up and celebrated by the critic-theorists of a newly forming cinephile faction, who would also help shape his reception after the Suzuki Seijun Incident.

Given that it occurred at the height of Japan's "season of politics," it was perhaps inevitable that the Suzuki Seijun Incident would transform into a political struggle independently of its proximate causes. Like the Langlois Affair in France the same year, the movement quickly became part of a broader political struggle that seemed only tangentially related to Suzuki Seijun or his films. It may thus be tempting to conclude in retrospect that it was a mere historical accident that Suzuki and his films became a cause for the New Left, particularly in light of the apparently frivolous subject matter of the handful of his films that are most readily available to English-speaking cinephiles. As a closer examination shows, however, there are elements of Suzuki's Nikkatsu films that resonate with their political moment and relate to the work being done by explicitly political filmmakers like Ōshima in the way that they revise generic tropes, film and spectator relations, and the understanding of recent Japanese history. Suzuki's own protestations aside, it is thus unsurprising that filmmakers of the Wakamatsu Production Company would see him as an effective vehicle for them to develop their formal experimentation and political filmmaking, and it is fitting that protestors would use Suzuki as a figure to mount their attack on the structure of the film industry as it then existed in Japan.

CHAPTER 2

SUZUKI SEIJUN AND THE IMPOSSIBILITY OF CINEMA

At its root, the term *cinephile* refers to someone who loves cinema, but what specific form that love takes on is a subject for debate. Often it is used to refer to people who have an encyclopedic knowledge of films: filmmakers like Jean-Luc Godard or Jacques Rivette, or critics like Adrian Martin and Jonathan Rosenbaum. This knowledge can take the form of extensive citation and cross-referencing, comparing small fragments of films made in wildly different historical or social contexts and at times without reference to their narrative contexts. To the uninitiated, these citations and cross-references may seem to be stream-of-consciousness, nonsensical, or a pedantic way of demonstrating the expansiveness of the cinephile's viewing experience. In many cases, this is at least partly because the horizon for citation or cross-referencing will be unintuitive, or even absent, to a noncinephile. This horizon leads us to the deeper meaning of the term. It is not merely a knowledge of film history or the experience of having seen many films, but a fascination with the cinema itself, and thus unique applications of film form and their revelation of the properties and history of the medium. Cinephilia is not simply the act of seeing and loving films, but a unique relationship to the cinema that entails a specific way of looking at films.

What does it mean for a filmmaker to be a cinephile? Perhaps it simply refers to a cinephile who also happens to be a filmmaker. Outside of their own filmmaking projects, many filmmakers have demonstrated their cinephilia by writing about cinema. Ozu Yasujirō famously kept a diary of his filmgoing habits, while contemporary filmmakers like Kurosawa Kiyoshi and Aoyama

Shinji regularly publish articles and books about film, considering their own perspectives as film viewers as much as filmmakers, as was true of Godard and Rivette.

Unlike these filmmakers, Suzuki did not leave an extensive record of his own filmgoing habits, nor did he ever claim to have an extensive knowledge of films or film history. In writings and interviews in which he discusses other films, his own film viewership and knowledge of film history seem to be much more casual than those of the aforementioned filmmakers. Names like John Ford and Alfred Hitchcock periodically appear when he is asked what filmmakers he admires, but he rarely elaborates or is even able to recall how many of their films he has seen. The one time he participated in *Sight and Sound*'s poll selecting filmmakers' ten favorite films, Suzuki provided the following list in his ballot:

Congress Dances (Erik Charell, Germany, 1931)
The Blue Angel (Josef von Sternberg, Germany, 1930)
Stagecoach (John Ford, USA, 1939)
Pépé le Moko (Julien Duvivier, France, 1937)
The Third Man (Carol Reed, UK, 1949)
Arsenic and Old Lace (Frank Capra, USA, 1944)
The Red Shoes (Michael Powell and Emeric Pressburger, UK, 1948)
Singin' in the Rain (Stanley Donen and Gene Kelly, USA, 1952)
Rear Window (Alfred Hitchcock, USA, 1956)
Daibosatsu Tōge (Inagaki Hiroshi, Japan, 1935–6)[1]

Suzuki's list contains films from a variety of countries, and a number of his chosen films are from auteurs who tend to be favored by cinephiles: Josef von Sternberg, John Ford, Michael Powell and Emeric Pressburger, and Alfred Hitchcock. They also reveal his taste for films with a heavy emphasis on spectacle: four of his selections feature major musical and dance sequences, and *Daibosatsu Tōge* is a two-part *chanbara* (swordfighting) epic, similarly placing spectacle at the center of its interest. *Pépé le Moko* and *The Third Man* suggest a fondness for noir thrillers. These are speculative inferences, however, that we must glean from a relatively small number of glimpses of his taste, since he rarely articulated what it was that he liked about others' films. Confluences of taste aside, Suzuki's reticence looks quite different from what we traditionally expect from a cinephile filmmaker.

Another possible way to identify a cinephilic filmmaker is by the practice of cinephilic citation and cross-referencing within the filmmaker's own films. Filmmakers like Godard, Quentin Tarantino, and Jim Jarmusch regularly incorporate such references in the form of dialogue, similarly staged or edited sequences, or the presence of images or sequences from other films into their own. Further, Godard's extensive *Histoire(s) du cinéma* project can be seen as

the practice of cinephilic film criticism through filmmaking. More subtly, Ozu would frequently cite other films by placing movie posters in the backgrounds of his films, noticeable only to viewers who were scanning the frame closely enough. The presence of these posters would often comment ironically on the narrative of his own films.[2]

Again, Suzuki would not fit this definition of a cinephile filmmaker. He did not regularly cite other specific films or filmmakers within his own films. This is not to say that he never cited other filmmakers: one of his earliest films, *Eight Hours of Fear*, takes many elements from *Stagecoach*, and another early film, *The Naked Woman and the Gun*, is a Hitchcock pastiche that plays on Hitchcock's frequent doppelganger motif, takes on the narrative arc of Hitchcock's wrong-man-on-the-run thrillers, and recognizably draws several scene setups from *Rear Window*. However, these are anomalous in the greater context of his career: by the time Suzuki was making the films for which he would ultimately become famous, he had dropped these kinds of direct references. The films from his late Nikkatsu period tend to incorporate, invert, or parody tropes of specific genres, as he does in *Kantō Wanderer* with the *ninkyō* genre (discussed in the next chapter). In these cases, Suzuki is not explicitly citing any individual film so much as he is using tropes that are widely shared across films in the genres.

One exception from his Nikkatsu period is in *Youth of the Beast*, in which the Sanko mob's headquarters is housed in a movie theater, with films playing in the background in every scene that takes place in this space. The exterior of the space is marked by the presence of movie posters and the faces of movie stars. But unlike in *À Bout De Souffle*, in which there is an interaction between Jean-Paul Belmondo and a poster of the deceased movie star Humphrey Bogart in the form of an apparent shot/reverse shot, the poster outside the Sanko headquarters that the protagonist Jōji walks past includes the face of Shishido Jo, the actor portraying him. The poster, further, is advertising Nikkatsu Action Cinema, the studio and genre of the film *Youth of the Beast* itself. The films playing in the background of these scenes, further, are less a reference to specific films or comments on the development of the films being watched. They appear instead as generic Nikkatsu action films in the background (fig. 2.1). What they reveal is not any kind of intertextuality with the specific films being played in the Sanko theater, but rather a self-conscious attitude toward the dimensions of the film frame, not only its length and width but also its flatness. In this sense, it relates to a visual motif that recurs throughout the film: Suzuki's tendency to break the frame of his own film into subframes, and to break down the apparent depth of the image into individual flat planes that appear to exist one on top of another.

This leads us to an understanding of what makes Suzuki, if not a cinephile himself, at least an ideal filmmaker for cinephiles and helps to shed light how

2.1 Enframed film projection in *Youth of the Beast*

his work became foundational to Japanese cinephilia as it emerged in the late 1960s. Suzuki's filmmaking style, particularly toward the end of his Nikkatsu career, is frequently meta-cinematic in this sense. He never goes out of his way to show off an extensive knowledge of film history (which he may or may not have had) but rather uses the properties of the cinema to reflect on its own properties and limitations. It is precisely this tendency in his filmmaking practice that would be the basis of the newly emerging cinephiles' admiration of his films.

Cinema 69 and the Suzuki Seijun Incident

The Suzuki Seijun Incident coincided with an important turn in Japanese film theory and criticism at the end of the 1960s. In the self-description of Ueno Kōshi, film criticism up to that point had tended to summarize a film's narrative and analyze it in terms of humanistic, social, or political meaning. What had been missing was any attention to the moving image itself, the thing that made cinema cinema, or to the experience of encountering these moving images. This new generation of film critics focused not only on the techniques of film, but also on the devices by which films could produce interest. In Ueno's own words, "while criticism had once aimed to seek out a hidden meaning, it now began to try instead to grasp the lively movement of the image itself."[3] Ueno himself began this process in the newly minted film journal *Cinema 69* (later *Cinema 70* and *Cinema 71*). In a series of essays on the yakuza film as a genre, he developed one of the key terms, *omoshirosa* (which could be translated as "interestingness" or "source of interest"), and would ultimately write about it more extensively in the essay "Eiga no omoshirosa to iu koto" (What is called

a film's *omoshirosa*) in the same journal, and deploying it regularly throughout his career. Another important term was *dōtai shiryoku* (the skill of seeing movement), which emphasizes the significance of simply *watching* the movements before you, and also the fact that this act of watching is a skill (and often one that Ueno and his allies accused rival critics of lacking).

The timing of the Suzuki Seijun Incident ensured that Suzuki was at the center of attention at the moment of their rise, ensuring that he would be a significant figure in their early writing. *Cinema 69*'s second issue placed Suzuki at its center, containing articles by Hasumi Shigehiko and Yamane Sadao, as well as interviews with Suzuki and Kimura Takeo, and one essay by Suzuki himself. I argue that their writings on Suzuki contain the seeds of their later broader theory of cinema, particularly within Hasumi's writing. This is only because Suzuki, though none of his writings can properly be called "film theory," was similarly interested in exploring the properties of the cinematic image and their relationship with the audience's viewing experience. We can see this by looking at the initial articles by Hasumi and Yamane in *Cinema 69* (among the first works published by each author), which contain elements of these notions of *dōtai shiryoku* and *omoshirosa*, even if the authors themselves do not yet use the words.

Japanese Cinephilia in a Global Context

The brand of cinephilia in Japan that arose out of *Cinema 69* shares a common lineage with Anglophone cinephilia, though the two grew independently of each other. Genealogies of Anglophone cinephilia tend to look back to *Cahiers du cinéma* critics of the 1950s as their model, whose tastes and methods were adapted into English by Robin Wood, Victor Perkins, and Andrew Sarris, among others.[4] The *Cahiers* critics were also a key influence on the generation of cinephiles that emerged in Japan at the end of the 1960s. This was particularly true for Hasumi Shigehiko, who had lived in France in the early 1960s while studying French literature. Ryan Cook has written that *Cinema 69*'s editors first approached Hasumi for his familiarity with French film culture,[5] and his first and third published articles in *Cinema 69* (sandwiching his first writing on Suzuki) were about the French New Wave filmmakers Alain Resnais and Jean-Luc Godard. Further, looking at his tastes in international filmmakers, one can very distinctly see the influence of *Cahiers du cinéma*. His *Eizō no shigaku* (Poetics of cinema) devotes chapters to many of their favorite filmmakers (John Ford, Howard Hawks, Jean Renoir, etc.), and his choice of Japanese filmmakers to champion, from Fukasaku Kinji to Katō Tai to Makino Masahiro to Suzuki himself, can be seen as applying similar standards to genre filmmakers in the Japanese studio system that *Cahiers* had applied to Hollywood.

In the Japanese context, this lineage comes directly from the French and was not mediated by its Anglo-American acolytes. While Hasumi and other cinephiles of his generation translated the writings of *Cahiers* into Japanese, the work of critics like Wood, Perkins, and Sarris remains largely untranslated to this day. As these Anglo-American critics were likewise unaware of the Japanese critics, these turns in film criticism grew in parallel to each other.

It may be tempting to look at *Cinema 69* as the Japanese equivalent of *Movie*, and Hasumi, Ueno, and Yamane as Japanese equivalents of Wood, Perkins, and Sarris, but there are important differences between what the Anglophone and Japanese cinephile traditions drew from *Cahiers*. To understand these differences, we will look briefly at Francois Truffaut's canonical essay "On a Certain Tendency in French Cinema" to see what each group drew from it. Truffaut's essay polemicized against a "tradition of quality," a critical method that ascribed artistic value to films based on a preexisting thematic or literary quality. Truffaut countered that the primary artistic intervention in a film comes at the point of filming rather than at the point of scriptwriting. Against the "tradition of quality," he offered the "tradition of the auteur," championing directors who asserted their authorship in the deployment of mise-en-scène. This term, *mise-en-scène*, referred to the process of visual arrangements made in the process of direction, and implied that they exceeded the preconceived scripted meaning of a scene or film. If they did not, the director was a mere *metteur-en-scène* rather than an auteur.

Though the terms *mise-en-scène* and *auteur* were first used by French critics in *Cahiers* and adopted untranslated into English-language criticism, this arguably masks some definitional and methodological differences between different groups of auteurist critics. In particular, UK-based auteur critics who wrote for the film journal *Movie*, including Wood and Perkins, were associated with a rigorous formalism. Analyzing Wood's use of mise-en-scène, John Edward Gibbs has written that it "is almost synonymous with direction."[6] In its original French usage, *mise-en-scène* was related to film form, but its invocation contained a certain magical quality, and it was associated with something that could never quite be adequately articulated with words. Its conceptual roots lie in a declaration made by Alexandre Astruc:

> Every film, because its primary function is to move, i.e., to take place in time, is a theorem. It is a series of images which, from one end to the other, have an inexorable logic (or better even, a dialectic) of their own. We have come to realize that the meaning which the silent cinema tried to give birth to through symbolic association exists within the image itself, in the development of the narrative, in every gesture of the characters, in every line of dialogue, in those camera movements which relate objects to objects and characters to objects. All thought, like all feeling, is a relationship between one human being and

another human being or certain objects which form part of his or her universe. It is by clarifying these relationships, by making a tangible allusion, that the cinema can really make itself the vehicle of thought.[7]

When *Cahiers* critics invoked mise-en-scène, it was something closer to this formulation by Astruc than simply the recognizable stylistic techniques at work in a sequence—though it certainly included all of those. "If I say the subject of a film matters very little to me, it is because I am convinced that *mise-en-scène* can transfigure it. And if I add that the whole of cinema is ultimately *mise-en-scène*, it is precisely because that is how everything is expressed on the screen," wrote Fereydoun Hoveyda.[8] It encompassed the visual arrangements on screen in their entirety, but only when they possessed a certain attractive power.[9] This allowed mise-en-scène to transcend a mere formalist style, the auteur to transcend the real, historical figure of the director, and, as with the concept of *photogénie* from French critics several decades earlier, the critic to defer to the inability to articulate its true power and to resign itself to expressing its inexpressibility in words. "How can one describe in words what *mise-en-scène* can convey in a few seconds?," Hoveyda asked.[10]

For the English-language critics influenced by *Cahiers*, the primary contribution that critics who wrote for *Cahiers* made was auteurism. This came to refer to a method that celebrates filmmakers who developed unique, personal, and effective visual styles rather than those based on preconceived topical themes or value ascribed to a film's source material, which in turn often meant the championing of what were thought to be low-grade genre films over, say, adaptations of prestigious works of literature. This authorship was not found in production notes but rather in the formal techniques associated with a specific filmmaker, and it views the figure of the author less as a historic individual than as a group of formal and thematic associations. Peter Wollen would later claim that an auteur was not so much a physical human being as the locus of a structure that underlaid a filmmaker's body of work.[11] The term *mise-en-scène* was frequently invoked but was not nearly as mystical; as such, the method became more empiricist.

Though this method is not entirely unlike that of the *Cinema 69* critics, the context in which Hasumi, Ueno, and Yamane were intervening was not identical to the one in which the *Cahiers* critics or the Anglo-American auteurists were interceding. In fact, the practice of "authorism" (*sakka shugi*) in Japanese film criticism is one that long predates the founding of *Cahiers du cinéma* in France, much less Japanese critics' awareness of it. Starting in the 1930s, the film critic and screenwriter Kishi Matsuo had written essays and books extensively detailing the formal methods of filmmakers like Shimizu Hiroshi and Yamanaka Sadao; one of his acolytes, Murakami Tadahisa, extended this method to include genre filmmakers like Itō Daisuke and Inagaki Hiroshi in

Nihon eiga sakka ron (Book of Japanese film authors, 1937). In their straightforward formalist method, this earlier group of critics was arguably methodologically closer to Wood or Perkins than were the *Cinema 69* critics. Thus the intervention that Hasumi had picked up from the auteurist critics of *Cahiers du cinéma* was less the championing of authors themselves than the way of ascribing value to films as being products of the film's production rather than its preexisting narrative or literary qualities.

That is not to say that his criticism is a mere translation of French auteurist criticism or the application of its methods to Japanese cinema. But it does draw a heritage from auteurism's focus on the artistry of a vulgar, commercial cinema and locates that artistry outside of the film's narrative, in the arrangements and movements on the screen. Where Peter Wollen's auteurism was structuralist in that it sought to identify a singular underlying structure in the filmography of a single filmmaker, Hasumi's can be thought of as poststructuralist, identifying multiple structures, techniques, or registers that underlie a director's filmography in varying combinations, with varying emphases, and not necessarily all simultaneously present, perhaps most similar to Barthes's latter-day method of poststructuralist analysis following his interventions in *S/Z*. Where it differs is in its movement from discussions of individual films or groups of films (like Ueno's series of articles on yakuza cinema, or the articles on Suzuki in *Cinema 69*'s second published edition) toward a broader theory of cinema as an encounter between the film and the spectator. Further, contrary to Wollen's structural auteurism, which saw a single overarching structure repeated or inverted in each film by the director, Hasumi opted to identify motifs that recur as microstructures at individual moments across multiple films. As a result, Hasumi hardly ever "reads" a film as a single, self-contained text, instead looking to broader visual motifs that cut across a filmmaker's oeuvre.

Finally, the inability to articulate mise-en-scène in words, a preoccupation of the French critics largely ignored by their English-language followers, is another important overlap with the critics of *Cinema 69*,[12] but in the latter case this takes on an added complication. In the writings of the *Cahiers* critics, the primary issue had been translating a visual art form into writing while arguing that writing does not supersede the moving image. This is also very much present in the writings of the *Cinema 69* critics, but added to it is the issue of narrative: these critics had to translate an attractive power of visual movement that they argued was not narrative into narrative writing. As Ryan Cook puts it, reading film criticism is to "encounter films through the mediation of narratives that attempt to make sense of nonsense. This is the 'tragic' dilemma of Hasumi's own undertaking as a film critic: he must recreate by means of narrative (writing) the non-narrative encounters he seeks with films."[13] Hasumi and Ueno regularly fixate on both the inadequacy of words to articulate the

power of moving images and the limitations of narrative writing in describing the nonnarrative experience of encountering a film.

Hasumi is one of the few non-Western cinephiles who has managed to move into the sphere of Anglophone cinephilia with some success, thanks largely to his fluency in English and French and the availability of a small number of his Japanese writings in translation, mainly into French. Notably, he has published essays in the online English-language cinephile journals *Rouge* and *LOLA* and has even been the subject of an entire *LOLA* issue.[14] Before this, he was featured as both an interview subject and author of an essay in *Movie Mutations*, a collective work edited by Jonathan Rosenbaum and Adrian Martin. As such, he is the only *Cinema 69* critic whose work has been received meaningfully by Anglophone cinephiles.

Since Hasumi has moved into the orbit of English-language cinephilia, his method of film criticism has mainly been noted for a tendency toward looking at visual motifs, often seemingly unrelated to narrative, that accumulate across a film or a director's filmography. Richard I. Suchenski, whose published volume on Hou Hsiao-hsien includes a Hasumi essay on *The Flowers of Shanghai*, would later describe Hasumi's critical method thus: "It operates by a quietly rigorous process of accumulation, beginning with the close observation of small details and gradually generating layers of associations that provide insight into the nature, structure, and experience of cinema, even as they make the films themselves seem more mysterious."[15] This critical tendency is in keeping with what I call Hasumi's poststructural auteurist method that dates back to his earliest writings at *Cinema 69*. It should be stressed, however, that most English-language commentaries on Hasumi's work by non-Japanese-speaking cinephiles tend to focus on his more recent criticism, which is more readily available in English and French, than on the writings that initially brought him to prominence in Japan. Nakamura Hideyuki has described Hasumi's overall method as something akin to a literary *critique thématique* that is "close to free-association based on an individual 'film experience' or cinematic memory." Nakamura characterizes the shift in Hasumi's *critique thématique* as one in which "the focus of his interest has moved to precisely describing and analyzing particular scenes, as opposed to the old version, in which the brilliant intertextual references were dominant."[16] Moreover, little if any attention is paid to the historical context in which Hasumi first rose to prominence as a film critic and theorist in Japan, and what critical and theoretical traditions there he was inheriting and reacting against.

None of the essays from the most influential period of Hasumi's career have been translated into English. For many years, the primary piece of "vintage" Hasumi writing available in French was the book-length study *Kantoku Ozu Yasujirō* (The director Ozu Yasujirō).[17] The dearth of Hasumi essays available in English has sometimes led to a skewed understanding of his work in the

English-speaking world. In *A Critical Handbook of Japanese Film Directors*, for example, Alexander Jacoby refers to him as an "Ozu specialist."[18] Though Hasumi's book on Ozu is perhaps the definitive one book in Japanese and even for French-reading film scholars, this designation is extraordinarily limiting given the scope of Hasumi's career. Further, out of the original context of Hasumi's arguments, certain nuances are lost in translation. We can see an example of this in Rosenbaum's essay on Ozu's *A Hen in the Wind*, which draws heavily from Hasumi's analysis of the film in *Kantoku Ozu Yasujirō*, as well as from Satō Tadao's discussion of the film. Though Satō and Hasumi both defend the film, Hasumi's analysis criticizes Satō's culturalist reading of the film. While Satō reads the film allegorically about the brutality of the war,[19] Hasumi stresses Ozu's use of space and, in particular, the ominous use of a staircase shot that appears across the film before Shūichi climactically pushes Fusako down the stairs. In Hasumi's original book, he stresses the similarity between this moment and a similar stair-pushing scene in *Gone With the Wind*. In Rosenbaum's essay, this moment becomes evidence of the influence of American cinema on Ozu, pitted against the notion that Ozu is an exclusively "Japanese" filmmaker. It is certainly true that the notion of Ozu being quintessentially Japanese is one that Hasumi repeatedly pushes back against, but what is at stake for Hasumi at this moment is not whether the scene from *A Hen in the Wind* was inspired by *Gone With the Wind*.[20] "What is so moving," he writes, "is that an image from an extravagant prewar Hollywood epic is so boldly used to reflect upon the impoverished domestic environment in postwar Japan."[21] It is, rather, that cinematic expression, composed of movement and screen space, is powerful enough to transcend nationality, the subject matter of the two different films, and the social conditions under which they were made. For Hasumi, whether Ozu was inspired by the scene in *Gone With the Wind* is beside the point.

It is worth remembering the unique context in which this cinephilic turn in film theory and criticism emerged, what it was reacting to, and what specifically its practitioners considered the stakes of their intervention. Their emphasis on the act of film viewing as one of encounter between a film and spectator derives from the context in which they were writing, in which intellectual discourse was dominated by the New Left, and by no figure more so than Yoshimoto Takaaki, discussed in the previous chapter. In a way, the shift toward a focus on the source of a film's interest (*omoshirosa*) and the ability to watch the physical movements (*dōtai shiryoku*) that composed the film was a strange reworking, or perhaps appropriation, of Yoshimoto's critique of the Old Left. As discussed in chapter 1, Yoshimoto had criticized intellectuals of the Old Left for isolating themselves too much from the *taishū* (masses). In the cinephiles' view, both traditional forms of film criticism and politically or culturally oriented film theorists and critics likewise failed to understand the experience of watching a film by imposing assumptions about how to read films (either

narratively or ideologically) from the outside. They argued that to understand either the cinema in general or groups of films determined by author, genre, or other categories, or even individual films, one had to articulate the experience of viewing. Though they viewed this as an ultimately impossible enterprise, the ultimate goal of film criticism was getting as close to this impossible goal as possible.

Omoshirosa: The Cultivation of Audience Interest

"Movies are interesting." This claim in and of itself seems banal, and perhaps condescending to the possibilities of film as an art form. Nevertheless, conceptually, the term *omoshirosa* became one of the central concepts of the cinephilic turn in Japanese film theory and criticism at the end of the 1960s. The word derives from the adjective *omoshiroi*, which is typically translated as "interesting." *Omoshirosa*, however, is a noun. Its most literal translation would be something like "interestingness"; more idiomatically, we might call it the "source of interest" or "essence of interest." It is significant that it is the noun form rather than the adjectival form of the word that was conceptualized. The conceptualization of omoshirosa was not simply concerned with identifying films as either *omoshiroi* or not. Rather, it began with a consideration of whether the films were interesting and then sought to extract, identify, and analyze those elements of the film that *made* it so. Those elements were what composed the film's omoshirosa.

Among Ueno's contributions to *Cinema 69* was a series of articles on the yakuza film, and within this series of articles Ueno begins to isolate something he called the omoshirosa of these films and ultimately begins to theorize what it is. He published his first article in the series in the first issue of *Cinema 69* as "Yakuza eiga: Hana to okite o jōnen no hiyu toshite" (Yakuza films: Flowers and codes as metonymy for sentiment). Critics had been lamenting that, with the rise of genres like the yakuza film, Japanese cinema was in decline, as demonstrated by the genre's recurring dependence on the same basic narrative and character formulas, which they saw as a sign of creative stagnation. Ueno countered, however, that this was the wrong criterion by which to judge the genre. In this first essay, he lays out the problem thus:

> Yakuza films are interesting [*omoshiroi*]. This is a strange manner of speaking, but it is the only suitable way to talk about the feeling of yakuza films. . . . I have gone to see several yakuza films at second-run theaters on weekday mornings. The theaters have been so overcrowded that I could feel the collective body heat of the audience while watching the film. As far as the people congregating in these theaters are concerned, the yakuza and erotic films that play at these

theaters have value irrespective of claims that Japanese cinema is in decline, or for that matter any critical claims in defense of the films. Their perspective is neither hostile nor dependent on film criticism, but is rather a silent choice to see a film based on whether or not it looks interesting. Thus, the yakuza film genre is not just defined by a limited number of masterpieces but is composed of a countless number of films that are made, released, and disappear into the night leaving only the essence of their interest [omoshirosa] behind.[22]

A film's omoshirosa is thus the thing that draws patrons into the hot, overcrowded theater, and it is, further, the thing that leaves the strongest impression after the end of the film. As an intervention in critical practice, Ueno's shift toward omoshirosa as the foundation of his criticism is a move away from simply analyzing film narrative according to a preexisting notion of literary value toward analyzing it on the basis of how it interacts with its spectators. The uncovering of omoshirosa does not reach a preconceived conclusion but instead is a process of discovering the relationship between a film and a viewer. In a later essay, "Eiga no omoshirosa to iu koto" (What is called a film's omoshirosa), Ueno writes: "In a manner of speaking, everything is determined by what is interesting [omoshiroi], the most primal and unaffected reaction we have to the film. From the side of the viewer, it is the shock of being touched by the work, and from the side of the work, it is nothing less than the entire reason for its movements; its essence is that relationship."[23] Thus, omoshirosa is a property of the film even though it is contingent on a reaction of the audience. And while it would be easy to dismiss the interest of the spectator as trivial, simple, or contingent on the individual's own preconceived interests, Ueno argues that whether we are conscious of it or not, our interest is informed by our interaction with the entire form of the film; thus even if it is simple to claim that a film is interesting or uninteresting, the means by which a film produces interest is not.

Ultimately, it is this question of how a film produces interest that fixates Ueno and provides the framework for how he thinks and writes about cinema. Even though he maintains that omoshirosa exists in the interaction between film and viewer, Ueno is not interested in the personal, biographical details of audience members that might make a certain aspect of a film *omoshiroi* to one individual audience member but not to another. Even as he stresses the importance of the film/audience relationship, his emphasis is on one side of that relationship: the film, and the things that we fixate on as spectators not for personal reasons, but because we *must* fixate on them, because the film forces us to fixate on them. As a result, his methodology tends to be perhaps unwittingly personal (in that he extrapolates from his own personal experiences as if they were universal) and to analyze the essence of interest as if it were solely a characteristic of the film.[24]

Ueno's procedure for identifying the omoshirosa of a film often begins from a specific moment that strikes him or sticks in his memory. We can see an early instance of this methodology at work in this earliest essay, when he writes about Watanabe Yusuke's film *Night Women* (*Nihiki no mesu inu*, 1964):

> The image of Ogawa Mayumi brushing her teeth still comes to mind distinctly. That is a little weird. The film's use of Ogawa's action of brushing her teeth is less a means of expressing the woman's beauty or a self-conscious reflection of the actress's performance as a performance as she faces the sink (like an actress preparing for the show) than it is an observation of character by means of close observation of the casual behavior of ordinary life. Within this brief sequence that the camera could easily have cut away from, the woman's state of existence suddenly becomes exposed. When I look back on the film, it is only this impression that arises; as for the story, I cannot re-create it no matter how persistently I may try.[25]

This can be seen as a prototype for the kind of analysis that Ueno frequently performs using omoshirosa to critique or analyze films. Significance is accorded to the moments that leave the strongest impression rather than to ones that are related to the film's narrative or that fit into a prescribed meaning for the film.

For a film to be *omoshiroi*, it must possess an omoshirosa that arouses the interest, emotions, or thoughts of its viewers. It is in this sense that omoshirosa becomes a productive concept. To analyze or critique a film in terms of omoshirosa is not just to celebrate its presence or to decry its absence, but to build an analytical framework that begins from the mechanisms that engage the audience. The analysis of an individual film, film genre, or filmmaker's filmography must always begin by determining what its omoshirosa is because there is no singular way that a film can engage its viewers. Thought about this way, the kind of literary criticism that Ueno and his colleagues at *Cinema 69* took up as a polemical target had assumed from the outset that the omoshirosa of any narrative film was the narrative itself. Starting by uncovering the film's individual omoshirosa, on the other hand, allows a critic to discover what is significant based not on preconceived assumptions but instead on the elements of the film that reach out to and stay in the viewer's mind. It allows the film itself to determine the hierarchy of what is most and least significant rather than relying on preconceived frameworks, and as a result it better reflects the spectator's experience of encounter with the film. Omoshirosa is not identified by a single recurring technique, plot point, or character type. Rather, it must be identified by a process of discovering the film on its own terms through the relationship it sets up with its viewers.

The antinarrative gesture that Ueno makes in his discussion of *Night Women* might look familiar to readers aware of Keathley's or Richards's recent writings

on cinephilia. Indeed, Ueno persistently writes that a film's omoshirosa is not connected to its narrative, and the critical turn that he and his colleagues at *Cinema 69* initiated is often referred to as a cinephilic turn. Still, his discussion of omoshirosa is not necessarily restricted to fetishizing a series of individual moments out of context. It may be so in cases like the scene he discussed from *Night Women*, but Ueno argues that a more sophisticated filmmaker is able to produce omoshirosa systematically throughout a film, creating an alternate structure that may overlap or intersect with the film's narrative structure, but it may just as easily push against the narrative. In his earliest column on the subject, Ueno elaborates on the concept in discussing Katō Tai's *Blood of Revenge* (*Meiji kyokyakuden: Sandaime shumei*, 1965).

Ueno emphasizes the significance of two scenes in Katō's film: the opening credit sequence and the ceremony of succession within a yakuza clan that takes place about two-thirds of the way into the film. Ueno contends that these scenes are *omoshiroi* for their striking visual presentation of ceremonies that depict the sense of *jingi* that holds the yakuza clan together. At first, this might seem to be an impressionistic narrative analysis of the film, but if we look more closely we will see that something else is at work. The opening credit sequence is an extended overhead shot of the clan performing a ceremony together; we will later learn that this is in the context of a local festival, but it appears to us out of context and totally depersonalized by the framing. Katō transforms the performance of the ceremony into a kind of abstract movement that is visually pleasing as it sets up a visual structure of ceremonies that recur throughout the film. We can see this structure, for example, in the funeral of the clan's leader, during which a fight erupts between the deceased boss's right-hand man, who has been designated heir to the position, and his son, who believes himself to be entitled to it. Throughout the sequence, though the characters who are most significant remain visible, the overall composition of images emphasizes the neat ordering of the yakuza attentively sitting as the ceremony takes place. This begins as the widow first makes the announcement of who will succeed the boss, and it continues even as the physical fight breaks out between the two rival heirs. This tendency culminates in the film in the actual ceremony of succession, the other scene that Ueno highlights, in which, again, the compositions favor the neat ordering of the yakuza, to the point that even close-ups of the major characters' faces become ceremonial figureheads, as they are abstracted by their neat symmetry stoically facing the camera, and ceremonial ornaments regularly overwhelm Katō's compositions.

In this case, the film presents a structure of omoshirosa that overlays, counteracts, and periodically intersects with the film's narrative structure, which fixates more conventionally minded film critics. The film's main narrative thrust—the clan's rivalry and eventual war with another yakuza clan—actually forms the main narrative thread, while the conflict over leadership of the clan

would conventionally be thought of as a subplot. Ueno, however, restricts his discussion of the film to its ceremonial moments, the first of which serves no obvious narrative purpose, and the latter two of which are related to the subplot rather than the major narrative thread.

We can see Yamane Sadao operating within a similar framework in his discussion of Suzuki in the second issue of *Cinema 69*. Like Ueno, Yamane refuses to seek out narrative meaning in analyzing Suzuki's films, instead placing the horizon of analysis on what attracts us to them as viewers. "The depiction of action is what attracts us," he writes; it is "the locus of what promises us spectacle in a Suzuki Seijun work." Yamane begins by discussing the action sequences in *Youth of the Beast* and observes an unusual tendency. Suzuki films rarely have extended action sequences that grow naturally out of the narrative; instead, the action comes in the way of abrupt explosions of action that suddenly break apparent stalemates but disappear almost as quickly as they appear. Our interest, he writes, does not arise out of an investment in the characters or a continuously developed progression of action.[26] Underlying Yamane's claim here is an important observation of the relationship that Suzuki's technique of filming action sequences sets up between his protagonist and audience.

In *Suzuki Seijun zen'eiga* (published in 1986, more than a decade and a half after the first publication of *Cinema 69*), Ueno opens the book with an essay considering the overarching omoshirosa of Suzuki's filmography. After cataloging some of Suzuki's most aggressive and memorable formal techniques, such as his use of bright colors, sudden shifts in color and lighting, and reflections, Ueno concludes that what ultimately defines the Seijunesque omoshirosa is not so much any of these elements themselves as *zure*, or "deviance" from our expectations set up by generic or social conventions. It is his tendency to startle us, leaving us with "the strange feeling of being attacked by confusion."[27] This sense of being startled resonates significantly with Yamane's earlier discussion of Suzuki's method of depicting action in *Cinema 69*, demonstrating how Yamane's consideration of Suzuki contributed to both critics' development of the concept of omoshirosa, even though Yamane had not yet adopted the term.

Dōtai Shiryoku: The Skill of Seeing Movement

As Ueno and Yamane addressed cinema in terms of its methods of engaging the spectator, Hasumi drew his focus to the process of viewing films. Criticizing Tsurumi Shunsuke's *Shisō no kagaku* (Science of Thought), a group of academics associated with cultural studies who frequently wrote on cinema, Hasumi said: "If your basis of criticism is 'the masses' or whatever else, you end up writing about film as an object however you like and without addressing the

problem of *kineticism*."²⁸ This "problem of kineticism" is central to Hasumi's understanding of cinema, and his concept of *dōtai shiryoku* will help us understand that.

The phrase *dōtai shiryoku*, frequently used by Hasumi to draw attention to the problem of kineticism, is often translated as "kinetic visuality," though that phrase loses a certain nuance. It is composed of four characters: 動 (*dō*, "movement'), 体 (*tai*, "body"), 視 (*shi*, "vision"), and 力 (*ryoku*, "ability"). The term is most frequently used to describe an attribute of athletes: in baseball, for example, the batter must have a strong *dōtai shiryoku* in order to swing at the ball at the correct time. It refers to the ability to see, deduce, and infer from a moving object. A critic like Tsurumi Shunsuke or Satō Tadao could thus be criticized as having a weak *dōtai shiryoku* for failing to see the moving image in front of them, distracted as they were by their preconceived frameworks.

In his tracing of Hasumi's early theory of cinematic spectatorship and criticism, Ryan Cook argues that, for Hasumi, the ideal process of watching a film is "to attempt to surrender one's thought to the system of a film, to submit to the movement at a film's surface."²⁹ Even more than with Ueno's use of omoshirosa, there is a necessary erasure of the subjectivity of the viewer in the process of viewing, as the viewer must enter a state of nonknowledge (or, in Cook's words, stupidity) in order to restore the ability to see the image. Building from two of Hasumi's seminal essays, "Cinema as a System" and "Cinema and Criticism," Cook contextualizes Hasumi's surface critique of cinema in terms of Hasumi's broader academic intervention, his "fundamental critique of thought and freedom" drawing from the writings of Jean-Paul Sartre, Michel Foucault, and Gilles Deleuze (the latter two of whom Hasumi helped introduce to Japan). In "Cinema as System," Hasumi discusses the way that cinematic systems, which Cook defines as "a scheme establishing order, determination, and ultimately meaning," create the illusion of greater freedom while actually imposing greater *limitations* on cinematic form.³⁰ "Cinema and Criticism" construes criticism as a self-effacing act of surrendering to the moving image. Functionally, this means that the viewer must abandon preconceived frameworks of interpretation in order to encounter the film properly.³¹ Even though Hasumi's film criticism rarely mentions the work of the poststructuralist theorists he helped introduce to Japan, Cook concludes that his conception of film viewing and criticism are best understood in similar terms to those interventions. But if Hasumi's thoughts on self-effacement as a practice of viewership were informed by Foucault, Deleuze, and other poststructuralists, his encounter of the cinematic medium, and of the systematicity of cinematic systems, was at least as informed by his own practice of viewing films in this self-effacing way. And we can see Hasumi's earliest practice of discovering the systematicity of cinematic systems in his first essay on Suzuki Seijun, published in 1969 in the immediate wake of the Suzuki Seijun Incident.

The initial *Kinema junpō* review of *Youth of the Beast*, by one Fukasawa Tetsuya, was dismissive. Fukasawa picks up on some of Suzuki's stylistically bold choices but accuses the film of using them superficially. He mentions the film's two-way mirror sequence and the early black-and-white sequence with a handful of selected items in color before bursting into a bold color palette. Fukasawa writes that while these certainly leave an impression, they have "no particularly deep meaning" (*tokubetsu fukai imi wa nai*).[32] In Fukasawa's estimation, this lack of depth is assumed to be a limitation of the film.

In the second issue of the new film journal *Cinema 69*, published in May 1969, *Youth of the Beast* was featured prominently in Hasumi's first article about Suzuki; what was once dismissed as a simplistic genre picture now came to be regarded as a major achievement and turning point in the director's career. But what is most revealing when comparing the initial dismissal of the film in the *Kinema junpō* review and the reappraisal by Hasumi is what they have in common. Both the early, primarily black-and-white sequence and the two-way mirror sequence feature prominently in Hasumi's evaluation. But perhaps more remarkably, his assessment echoes Fukasawa's in the parts where the latter had dismissed the film, such as Fukasawa's declaration that the stylistically bold techniques have no particularly deep meaning. "What upholds the work of Suzuki Seijun," Hasumi argues, "just as with any form that is extraordinarily rich, is not some deep meaning hidden in the background, nor is it the height of repeated reflective thought anticipating the work." Far from uncovering a deep meaning to Suzuki's form that Fukasawa had overlooked, Hasumi evaluates the film based on its systematic beckoning toward an illusory visual depth that is repeatedly denied, what he calls the film's "depthless depths" (*fukasa no nai fukasa*), which form the film's central visual motif in Hasumi's estimation.[33]

Hasumi makes clear from the outset that the purpose of his essay is not limited to a reading of Suzuki's films. The essay begins not with a discussion of Suzuki, Nikkatsu, the Suzuki Seijun Incident, or some other discussion specific to Suzuki and his films, but with a broad discussion of film form, authorship, and perception. In the second paragraph, Hasumi articulates the relationship among these three: "Just as a marble sculptor's tools change its expression, reshaping anew its outer form, ultimately each manner of form defines itself through its limits, the contours created where it rejects the imposition of the human."[34] The scope of Hasumi's essay involves a radical reconfiguration of the understanding of authorship, spectatorship, and film form and meaning that he will demonstrate through Suzuki's films. Or perhaps he could not adequately discuss Suzuki's films without first reconfiguring our understanding of these things.

Hasumi has been called a formalist, and while his pondering the meaning of form here would appear to verify that claim, there are some important

differences from, say, the Russian formalism of Viktor Shklovsky that are worth considering. In Shklovsky's configuration, form is the artist's active intervention taken against a material that shapes its meaning and defines it as a work of art.[35] In Hasumi's description, however, form is something that preexists the artist's intervention; the action of the artist is a reshaping of form rather than shaping of it. Hasumi's example of a sculptor chipping away at marble to create a statue might also seem ideal for describing Shklovsky's formalism, in which the material (marble) is shaped by the sculptor's action of sculpting, resulting in the final form of the statue. But Hasumi's description of the process shows that his interest is less in the finished form of the statue and more in the fundamentally unaltered material that remains after the artist's intervention. The marble is a form both before and after the artist's intervention, and importantly, the resulting statue is not the artist's creation but rather the one portion of the original material that the artist has left untouched. "The contours" he writes, are "created where it [the form] rejects the imposition of the human." Ultimately, the artist's intervention cannot create anything new by sculpting: the new form only reinforces the inviolable properties of the material on which it was enacted.

This claim may seem self-evident when discussing the sculpting of statues, but it takes on a decidedly more abstract form when applied to filmmaking. The process of filmmaking is not simply one of chipping away and displaying the remains; it involves, at the very least, the complex process of staging and selecting what to film in front of the camera and the rearrangement of individual shots through editing. While editing is at least partly a process of removal, what is being removed and rearranged is not a preexisting form, but one that has been given shape since its inception by the filmmaker. Nevertheless, Hasumi asserts that "the construction of form through the mediation of the camera . . . becomes none other than a destructive operation that is nonetheless impossible, eternally incomplete." Even though filmmaking is apparently a creative rather than destructive practice (in the literal sense that it creates something that did not previously exist), Hasumi argues that these creative processes of filmmaking nevertheless do nothing more than reveal the properties and limitations of the film medium itself. The material in this case is the film frame itself: its inherent flatness, its vertical and horizontal boundaries, and what the process of filmmaking can register on the film stock. Filmmaking is, like sculpting, a destructive process when looked at at the level of a frame of film stock. Prior to the filmmaking process, a film frame will have emulsion on it that is eaten away at when it is exposed to light through the camera during the filmmaking. A film frame completely exposed to light would become blank; the image is ultimately composed of the parts of the frame in which the emulsion is not eaten away.

Within the context of his first Suzuki essay, Hasumi works this conception of cinema through his discussion of *Youth of the Beast*'s "depthless depths," as

well as through *Branded to Kill*'s "heightless heights." He best articulates this tension between the apparent depth of the image and its actual flatness in describing the film's magic mirror sequence (fig. 2.2).

> The camera follows Shishido's steps into a building, capturing the owner's room of the cabaret which serves as the office for Nomoto Industries, drawing out the hero's tough talk from within an even tighter arrangement of characters in the space with precision; but even within this hermetic and artificial space, through a peculiar staging device—an enormous transparent glass through which the entirety of the customers' seats is visible— the heretofore vertical alignment of the composition is maintained completely even inside.
>
> Also in this scene, the axis in which both the movements of the naked woman dancing on stage in the background and the high-octane confrontation on this side of the glass appears to establish a perspectival world. But Shishido falls into crisis; as the noise-blocking button is pushed and the music we had heard from the seating area completely ceases, the body of the dancer all at once seems to lose its force, as if floating in a world without gravity, and the seating area that should have existed in the background disappears gradually into utter darkness.
>
> This expansion toward the depths is cut off by a change in lighting and sound effects; it loses its depth even more thoroughly once the stage shifts to the office, separated from the seating area by no more than a single screen. This is because the characters who are visible through the silver screen loom much larger than the figures of Shishido and the others who occupy the foreground, completely destroying any perspectival organization.[36]

Hasumi argues that Suzuki uses the illusory depth of the image to multiply the apparent depths of the movement. However, rather than use the extreme depth for narrative purposes, he uses the additional movement to guide us away from the narrative in the foreground toward the bizarre dance in the distance. Further, the use of the magic mirror as a surface abstracts the extreme depths of the image, transforming the dance from an action taking place in the deep distance from the camera into what looks like a flat moving image (which is, of course, precisely what the cinema is). Suzuki stages this scene in extreme depth but divides the depth into individual flat surfaces and ultimately abstracts them into sheer surface movement, indulging himself and his audience completely in the illusory power of the cinema. The push toward depth, which can only be illusory in an inherently two-dimensional image, necessarily ends with the unsatisfying revelation of flatness.

This emphasis on the flatness of the image would become a preoccupation of Hasumi's, and it relates to a different, conceptual kind of flatness: the non-hierarchical aspect of the way that Hasumi looks, and asks us to look, at the

2.2 Depth separated into flat planes in *Youth of the Beast*

image. The recognition that both the "foreground" fight scene and the "background" dancer are in fact on the same two-dimensional plane is, on the one hand, a rejection of perspectival depth but, on the other hand, also a rejection of narrative hierarchy since it refuses to favor the fight scene, which is critically important to the film's overarching narrative structure, over the dancing scene, which is scarcely relevant at all. This relates to the broader influence that this turn in film criticism has on postmodern thought in Japan. The emphasis on flatness would be taken up by artists and theorists with respect to other arts. This can be seen in pop-artist Takahashi Murakami's (in)famous essays "Superflat Manifesto" and "A Theory of Superflat Japanese Art."[37] Theorist Hiroki Azuma has similarly taken up the concept of the "hyperflat" in relation to new media in Japan, relating it to a computer screen that is encountered as a single, flat surface but is in fact composed of multiple overlapping planes (the interface, the binary code, etc.) that exist in a nonhierarchical relationship to each other.[38] These connections take something away from the romanticism surrounding cinema itself that is supposedly embedded in Hasumi's argument, but also from accusations of medium specificity sometimes made at Hasumi and his fellow travelers.

In the same essay, Hasumi argues that the "heightless heights" of *Branded to Kill* reinforce the vertical boundaries of the cinematic image. Here, the film's first image is a rising airplane that reveals the film's credits; again, an image of little relevance to the narrative that appears even before the narrative has begun signals the overarching visual design of the film that is allegorically replicated by the film's narrative. "The dynamic structure of *Branded to Kill*" he writes, "is characterized by the will to reach ever higher."[39] Not necessarily the protagonist Hanada's will, nor the audience's; in fact, Hasumi is referring to both. Hence we have the repeated imagery of butterflies, birds, and the rising steam

from a rice cooker, as well as Hanada assassinating a target by firing up a pipe leading to a bathroom sink, and escaping from another assassination on an advertising balloon that rises just above a window frame in the background. But the recurring images of birds and butterflies give way to the dead birds and butterflies in Misako's apartment and the downpour (or shower water shot to look like rain) that always accompanies her appearance. Likewise, the primary driving forces of the narrative are along a vertical axis; Hanada kills to rise in the ranks and falls when he fails to do so. The film culminates in the final image of Hanada, who, having killed the top-ranked killer, can now declare himself number one but is nevertheless incapable of even rising out of the wrestling ring.

Perhaps even more than in *Youth of the Beast*, the formal tension that Suzuki builds along a vertical axis aligns with the vertical axis of the film's narrative. In *Youth of the Beast*, many of the prime instances in which Suzuki pulled us into the apparent depths of the frame, such as the dancer behind the two-way mirror, the action films in the background of the Sanko hideout, and the beating of the Nomoto mistress in the desert, were at best tangentially related to the narrative. In *Branded to Kill*, however, the motifs of the butterflies, birds, and rain "are all gathered around the enigmatic woman Mari Anne [the actress who plays Misako]; . . . while displaying the force that brings him down to the ground, they function to build up the untimely tension on the screen."[40] *Branded to Kill* is generally thought to be the most abstract and furthest from conventional narrative cinema of Suzuki's Nikkatsu films, but when thought about in these terms, it may be the most perfect alignment of his formal abstraction with narrative, precisely because it is the formal abstractions that govern the narrative. The film's most decisive moment—when a butterfly obstructs the scope on Hanada's sniper rifle at the exact moment that he fires, obstructing his view and causing him to slip—appears initially as either a coincidence or plot contrivance, but when we recognize the association of the butterfly with Misako, this freak accident turns into a more abstract way of playing out a conventional narrative of a gangster's fall for his obsession with a woman. However, Hasumi locates the fascination with Suzuki in the visual tension created by his formal style itself rather than in its narrative significance; hence the narrative either is irrelevant or must be read as an allegory of its own negation.

Hasumi concludes the article with the following declaration: "If a work is eternal, it is so not due to the projected freewheeling imagination of an author, but rather . . . through the dynamics of the work itself in trying to reach for a more perfect structure." The "rich forms" of these films finally "do not retain the shape in which they were born at some point in the past but ceaselessly give shape to the space of everyday life in which we inhabit an eternal present."[41] Here, Hasumi notes, this holds equally true for both the filmmaker and the audience, in the one moment in the article that he directly refers to the latter's

existence. It should be clear enough how the rich form of film gives shape to the present where the audience is concerned—indeed, this claim resonates with a later one he will make that the experience of watching a film is an encounter with the film and with the present. But he also argues that this is where the author exists: not as the intelligent force behind the creation of the film's form but as perpetually being created by the film's form as it is experienced by viewers.

What makes Suzuki an ideal filmmaker for the cinephiles is not his own knowledge of film history or his references to films. It is, rather, his awareness of the fundamental properties of the film frame and the way that he manipulates, indulges, and pushes back on them. It was this tendency, further, that Hasumi would later argue brought Suzuki into conflict with Nikkatsu. In Hasumi's analysis, Nikkatsu was disturbed by Suzuki's innovative films because they "do not bring us to the limitless possibility of cinema, but to its limitations," in particular, cinema's limits by "the standard of an organized system."[42] Hasumi returns to the argument about depth in *Youth of the Beast*, verticality in *Branded to Kill*, and a new, similar argument about horizontality in *Tokyo Drifter*.[43] He argues that Suzuki developed these films according to these motifs "in order to restore a sense of movement and tension to a cinema that had come to lose these qualities because of its psychological dilution and formal repetition.... What is important is that this synthesis is a repudiation of development and Suzuki only arrives at the inabilities of the act of filming." More than a political or anarchic filmmaker, Hasumi argues, Suzuki is an "ethical" filmmaker for his constant concern with the essence and limitations of the medium.[44] The reason that Suzuki's films were such a threat to Nikkatsu was thus not their political content nor their alleged incomprehensibility, but rather because "a film studio is itself an apparatus designed to conceal the impossibility of the cinema."[45] What Hasumi finds revolutionary about Suzuki's style is the way that the visual and narrative structure of the film forces us to encounter their form as form, making us ever more acutely aware of the form that perpetually surrounds our existence.

Though this turn can be regarded as one away from the political activities of the New Left at the time, it also quickly calls to mind "politics" as the term was defined by Jacques Rancière: as an "extremely determined activity antagonistic to policing," and as something that "makes visible what has no business being seen, and makes [one] hear a discourse where once there was only place for noise."[46] In Hasumi's description, Suzuki's films were antagonistic not just to Nikkatsu Studio but to the entire regulatory practice of the Japanese studio system of maintaining cinema's illusory power, and in so doing he brought visibility to a new discourse on the material properties of the projected image. Moreover, the reframing of cinema from a narrative to be interpreted to an encounter to be experienced arguably has roots in the phenomenological

arguments advanced by Yoshimoto Takaaki that provided the intellectual framework for the New Left's critique of the Old Left.

* * *

The cinephilic turn in Japanese film theory offered a set of new means by which to judge films as works of art by discarding narrative (a critical technique regarded as overly literary) and social or ideological value (too often imposed on the films by the viewers themselves) in favor of alternate structures of movement and attractive power. In one respect, this puts it in line with other global cinephilias. To pick the most canonical example, Truffaut's famous rejection of the cinema of quality in favor of the cinema of the auteur was a turn away from literary value toward not just authorship, but authorship as defined through cinematic expression, particularly those artistic expressions that are unique to the cinema rather than hand-me-downs from other arts (in particular, literature) and ends in themselves rather than a means to an end. Ryan Cook has suggested that these cinephiles' auteurism is at odds with their indifference to the identity of the author, but this, to me, seems like a misunderstanding, albeit a common one, of the auteurist intervention by *Cahiers du cinéma*. Though often dismissed as a naïve romanticization of the figure of the author, auteurism was never interested in reading the auteur's films in terms of their biography, or even in proving authorial intent through production history. Rather, the auteurs that they celebrated—John Ford, Howard Hawks, Alfred Hitchcock, Nicholas Ray—referred to recurring themes or techniques expressed in a uniquely cinematic way rather than to the biological entities who directed the films. Peter Wollen described this as a movement away from the authors themselves toward a conception of the author as a structure signified by the name of the auteur. While some other auteurist critics (notably Robin Wood) found Wollen's imposition of structuralism onto auteurism too rigid, even in Wood's more flexible case these same auteurs were not structures, nor were they agents who expressed a sense of interiority through their art; they were still more like sensibilities that manifested themselves through film than the biological filmmakers.

The auteurism of Yamane, Ueno, and especially Hasumi can be thought of as a poststructuralist auteurism in the same way that Wollen's was a structuralist one. Hasumi's *Kantoku Ozu Yasujirō* demonstrates this most simply, devoting each chapter to a separate visual structure or motif that exists in Ozu's filmography, which coexist and overlap often within the same film. Though his and his colleagues' writings on Suzuki were gradually written over the course of several decades rather than compiled in the same place, collectively they function in the same way: an accruing of different kinds of structures of visual movement.

Looking through Suzuki's filmography, or reading their writings on him, it is not difficult to see what made Suzuki of particular interest to them. His constantly inventive formal style ultimately reveals the properties, and by extension the limitations, of the cinema by exploring its possibilities to their limits. In his first essay on Suzuki, Hasumi shows how the exploration of depth in *Youth of the Beast* and patterns in vertical movement in *Branded to Kill* only end in revealing the limitations: the inherent flatness of the frame in the former and its vertical boundaries in the latter. When he revisited this theme decades later, he would add to this an analysis of *Tokyo Drifter* considering the horizontal movements in that film. In subsequent essays, Hasumi would explore the dichotomous world of separation and world of connection that inevitably collide (curiously recasting *A Tale of Sorrow and Sadness* as a near remake of *Branded to Kill*, at least at the level of its most abstract visual movements), as well as the director's use of seasonal imagery abstracted from any apparently realistic sense of meteorological conditions, revealing the status of the imagery as stylistic flourishes and ultimately visual abstraction. In a slightly less abstract fashion, Ueno's and Yamane's analyses explore the ways that Suzuki's films arouse our interest and stay in our minds. While this may begin as a mere cataloging of recurring formal techniques, it ends in producing its own alternate structure around the film's essence of interest.

Hasumi's cinephilia may have been drawn in part from the auteurism of *Cahiers du cinéma*, just as Suzuki may resemble the kind of overlooked studio genre filmmaker that auteurists routinely championed. However, the unique qualities of this particular cinephilia that emerged in late 1960s Japan also align with the unique traits of Suzuki's filmmaking and overarching auteurist sensibility, even more so than other Japanese genre filmmakers that these same critics would champion, such as Fukasaku Kinji, Katō Tai, or Makino Masahiro. What holds Suzuki's filmography together more than any recurring narrative theme or technique is the constant exploration and consideration of cinema as a medium, which was ultimately the interest of the cinephiles themselves.

CHAPTER 3

POSTWAR JAPANESE GENRE FILMMAKING AND THE NIKKATSU ACTION STYLISTIC IDIOM

The climax of *Underworld Beauty*, Suzuki's first film in cinemascope and the first film for which he was credited with the pen name of "Seijun" rather than his given name, Seitarō, is exemplary for its classicism. The protagonist has infiltrated the villain's warehouse, where the villain is holding the titular underworld beauty hostage. To rescue her, he decides to confuse his enemies by shooting out the lights so that they are unable to see his path of escape with the woman: shooting out the lights thus serves a straightforward narrative purpose. However, it also serves an additional purpose of formal articulation by motivating a visual transformation from a bright, broad lighting scheme to a low-key one that creates a darker atmosphere for the film's final shootout. Suzuki's narrative and expressive purposes meet perfectly in the lighting.

It is scenes like this one that make one recognize that, had he so desired, Suzuki could have made an effective genre filmmaker in a classical narrative mode. Indeed, despite his subsequent reputation as Nikkatsu's rebellious problem-child, he *was* an effective genre filmmaker in this classical mode for the better part of his Nikkatsu career. Suzuki put out an impressive set of such films at Nikkatsu: *Satan's Town, Underworld Beauty, Eight Hours of Terror, Passport to Darkness, Tokyo Knights, Living by Karate, Teenage Yakuza, The Ones Who Bet on Me, The Incorrigible*, and others successfully wed the film's narrative ends to his own at times idiosyncratic cinematic expressions.

Coming into the public eye, however, as he did in the midst of the controversy of his firing in 1968, Suzuki retroactively became known primarily for the

final films he made at Nikkatsu, and among those for the most formally bold—we might say the most anticlassical—elements of his most anticlassical films. By framing the discussion of Suzuki's Nikkatsu career around the way it ended, the director gets cast in a familiar role as an iconoclast, unable to be constrained by the studio system and thus inevitably coming into conflict with it. Moreover, he came into the limelight at the moment that his films were forbidden from being seen, preventing critics, whether Matsuda Masao or Hasumi Shigehiko, from reevaluating his earliest films. These are the critics who largely shaped the narrative of Suzuki's career, and they did so in a context when he was at war with Nikkatsu, and when they could not look back to his earliest films. Thus the twenty-seven theatrically released features Suzuki directed between 1956 and 1963 have largely been overlooked, even though many of them exhibit a stylistic experimentation that would blossom in his final films at the studio.

In overlooking Suzuki's earlier Nikkatsu films in favor of the later ones, we lose more than just a handful of interesting classically constructed genre films. We miss the extent to which Suzuki's subversive stylistic tendencies actually have their roots in these earlier films. It is thus the purpose of this chapter to examine those roots to trace out the development of what we might call a Seijunesque style out of the generic and industrial context in which he was working, and to see what it can teach us about even those later works. Aspects that may seem unique to him to viewers approaching his films in retrospect are, at times, more indicative of his generic and industrial context than they are specific to Suzuki. At other times, individual films play with generic tropes or the associations made with individual stars that will not be obvious to those who are unfamiliar with Nikkatsu's output, particularly Nikkatsu Action Cinema, and its various series, performer cycles, and subgenres. What we find is not so much that Suzuki's style is a radical departure from the norm, nor that his style is simply a product of Nikkatsu Action's stylistic idiom. Rather, we can see Suzuki expanding on the possibilities of an inherited style in his early films that he gradually refines into a unique and powerful stylistic voice.

The Beginning of Suzuki's Filmmaking Career

After studying filmmaking at Kamakura Academy, Suzuki entered the film industry at Shōchiku's Ōfuna studio, where he spent his first four years (1949–1953) as an assistant director. Suzuki worked under several of the studio's stalwarts, including Shibuya Minoru, Ōba Hideo, Nakamura Noboru, Ieki Miyoji, and Sasaki Yasushi, though not on any of their biggest films. He also never worked with the studio's top directors, Ozu Yasujirō, Gosho Heinosuke, and Kinoshita Keisuke. The filmmaker Suzuki worked with most frequently at

Shōchiku was the unheralded Iwama Tsuruo, who worked primarily in the kind of postwar melodramas that Shōchiku Ōfuna studios was known for. Though Suzuki's assistant director credits at Shōchiku include a Hibari Misora musical and a period comedy starring Shimizu Kin'ichi ("Shimikin"), the majority of the films he worked on were in the Ōfuna melodramatic mode.[1]

After his four years at Shōchiku, Suzuki began work at Nikkatsu in 1954 as an assistant director. Often referred to as Japan's oldest film studio, Nikkatsu originally opened in 1912 and became a vertically integrated film company, controlling film production, distribution for its films, and an exhibition chain. It continued to be one of the major Japanese film studios until 1942, when its production facilities were absorbed into the Greater Japan Motion Picture Production Company (Dai Nihon eiga seisaku kabushiki gaisha, abbreviated as Daiei) at the orders of the government in 1942, then centralizing the film industry as part of its war effort. Through the remaining war years, Nikkatsu functioned exclusively as an exhibitor, and through the U.S. Occupation period, it distributed foreign films without producing its own. In the early 1950s the studio's ambitious president, Hori Kyūsaku, decided to turn it into a production studio again largely by recruiting talent from other studios. Its first two postwar releases were *Thus I Dreamed* (*Kakute yume ari*, 1954), a contemporary drama directed by Chiba Yasuki, poached from Shōchiku, and *Chuji Kunisada* (*Kunisada Chūji*, 1954), a period action film directed by Takizawa Eisuke, who had been directing since the 1920s and was most recently employed by Tōhō, often directing similar period action films.[2] Suzuki left Shōchiku for Nikkatsu around this time, apparently in hopes that he would be able to rise in the ranks to director more quickly at the newly reopened studio. His first job at Nikkatsu was as a low-ranking assistant director on Takizawa's *Chuji Kunisada*.[3]

At the risk of over generalizing, there was a strong association between individual film studios and specific genres in the Japanese film industry at the time: while Shōchiku's Ōfuna studio specialized in melodramas, the revived Nikkatsu quickly began making a name for itself with action films. Initially these were primarily derivative period action films and hard-boiled crime films that betray a heavy influence of American film noir. Suzuki's first films there as assistant director, screenwriter, and, ultimately, director reflect this. Takizawa's *Chuji Kunisada* was a new adaptation of a perennially reused narrative in sword-fighting films; perhaps the most famous version is still Itō Daisuke's *Chūji's Travel Diary* (*Chūji tabi nikki*, 1927). From there, Suzuki had his first credit as first assistant director at Nikkatsu in Yamamura Sō's *Black Tide* (1954), which depicted newspaper reporters investigating a murder.[4] His next film at Nikkatsu was Saeki Kiyoshi's *Trifoliate Orange Flower*, a biography of poet Kitahara Hakushū, the same year, in which he worked directly under the film's first assistant director, Noguchi Hiroshi. Later in 1954 Noguchi began

directing his own films at Nikkatsu, and Suzuki continued to be his assistant director until 1956.[5] The first film under the "Director Noguchi and Assistant Director Seitarō" system was *My Gun Is Quick*, a film about a hard-boiled private detective that became a series with five entries, running from 1954 to 1956.[6] These films are early entries in what has been retrospectively called "Nikkatsu noir": they are urban crime films that combined location shooting (primarily in Tokyo and Yokohama) with inexpensive studio sets and used low-key light design both as mood lighting for the gritty subject matter and as a way of masking the cheapness and shallowness of the set designs. The next year producer Okada Hiroshi allowed Suzuki to write a screenplay for one of Noguchi's films, *The Final Duel*, a period film modeled on Fred Zinneman's *High Noon*. Suzuki's last film under Noguchi was *Reward for Evil*, a noir thriller released just two months before Suzuki would direct his first three films.[7]

Both Shōchiku and Nikkatsu used an apprenticeship system, where Suzuki, as assistant director, was not only assisting production but also learning how to direct films from the filmmakers he was working under; this is one of the reasons he was frequently assigned to work with the same filmmaker (Iwama at Shōchiku, Noguchi at Nikkatsu).[8] Suzuki's experience at both Shōchiku and Nikkatsu made him a versatile filmmaker from early on. Even in his earliest films, Suzuki demonstrates an adeptness for moving between genres and dramatic registers both between and within films. He has also claimed that he picked up the practice of "cutting with the camera" (only shooting the footage planned to be used in editing and not providing alternate camera angles for flexibility in the editing room) from working at Shōchiku, where this was commonly practiced and even encouraged by the studio as a way of saving expensive film stock.[9]

The prevailing wisdom is that Suzuki was both consistently at the bottom of Nikkatsu's hierarchy of directors and was a perennial thorn-in-the-side of the studio for the duration of his career. This impression is partly the result of projecting the unceremonious end to his work at Nikkatsu retroactively onto the thirty-nine films he made there prior to *Branded to Kill*, but Suzuki's own claims have played a role in this mythmaking process. For example, he has shared stories about being regarded as a "good-for-nothing" since the early stages of his directing career who only narrowly averted being fired much earlier.[10] Much has also been made of the fact that Suzuki never directed a film with Ishihara Yūjirō, Nikkatsu's biggest star, as an indication of Suzuki's relatively low placement at Nikkatsu.[11]

When we look at his actual forty-film output at Nikkatsu, however, the picture becomes substantially more complicated. Even though Suzuki did not direct films with Ishihara, he *did* make films with each of the subsequent stars of Nikkatsu's "Diamond Line" (the group of stars following in Yūjirō's wake): Kobayashi Akira, Akagi Keiichirō, and Wada Kōji, along with the studio's

"pinch-hitters," Nitani Hideaki and Shishido Jō.[12] Further, the apparent budgets of several of his pre-1963 films suggest that Suzuki's ranking in the Nikkatsu hierarchy of directors is not nearly as low as the conventional wisdom would suggest. That is not to say that the studio ever considered Suzuki a top director—in their initial release, his Nikkatsu films did not have the prestige of Imamura Shōhei's nor the box office clout of Inoue Umetsugu's, Kurahara Koreyoshi's, or Masuda Toshio's. It might be more accurate to say that Nikkatsu treated Suzuki as a reliable enough cog in its machine through the early 1960s.

Though "Nikkatsu Action Cinema" persisted as a form throughout Suzuki's career at the studio, both the idiom and the industrial context he was working in underwent significant changes over the course of his career there. He made his first films as director as Nikkatsu Action was ascending and had his most prolific period when the genre was at its popular peak in the early 1960s. In the early stages of Suzuki's Nikkatsu career, all his collaborators (screenwriters, technical crews, and casts) were contract employees at the studio. By the end of his Nikkatsu career, Suzuki had formed a tight-knit group of collaborators, what assistant director Sone Chūsei referred to as the *Seijun-gumi*, or "Seijun Group."[13] This included collaborators who would continue to work with Suzuki in his post-Nikkatsu career, such as cinematographers Nagatsuka Kazue and Mine Shigeyoshi, editor Suzuki Akira (no relation), art director Kimura Takeo, and assistant director Sone Chūsei, all of whom were contracted at Nikkatsu, as well as cast members Watanabe Misako, Kawazu Yūsuke, Okada Masumi, Shishido Jō, Isao Tamagawa, Miyagi Chikako, Wada Kōji, Noro Keisuke, and Nogawa Yumiko, who each would appear in at least one of Suzuki's post-Nikkatsu works. Moreover, he had begun working with his Guryū Hachirō collaborators, some of whom were not even technically employed by Nikkatsu. Though still distributed by Nikkatsu, his films were more celebrated by cineclubs who were offering a new model of theatrical distribution and spectatorship than they were by conventional audiences or channels of film criticism.

While discussions of genre in cinema have tended to focus on shared thematic, stylistic, or other traits inherent to the filmic texts themselves, Alex Zahlten has argued for an industrial definition of film genre that considers the industrial practices of production and reception, the effects these have on what goes into the filmic texts themselves, and how audiences receive them.[14] By this definition, our understanding of Nikkatsu Action Cinema should not only consider its recurring themes, character types, and narrative structures, or its recurring stylistic tendencies. It must also take into account industrial practices, ranging from the technological processes that went into filmmaking (the shifts to widescreen and color, as well as the different widescreen and color processes it used), the cross-medial nature of its star system, and the place of cinema in general and the genre system in particular in Japan's overall media

ecology as television and pornographic filmmaking were rising as alternatives (and possible replacements) for traditional theatrical filmmaking.

Each of these would affect Suzuki's filmmaking practice. His shift from the 1.33:1 aspect ratio in his earliest films to NikkatsuScope (2.35:1) in 1958 was not by choice but a top-down decision made by the studio. Likewise, his shift between black-and-white and color films was the result of decisions made by the studio for him; these decisions, in turn, were affected by the overall health of Nikkatsu as a studio as much as Suzuki's own status within Nikkatsu. The cross-medial nature of Nikkatsu's star practice can be seen in the large number of Suzuki films where the star has at least one song on the soundtrack; in several cases (*Harbor Toast: Victory Is Ours*, *Pure Heart of the Sea*, and *Tokyo Drifter*), the films were ostensibly made to accompany existing popular songs. As an industrial genre, Nikkatsu Action Cinema also incorporates its exhibition practices: the films were initially released in mainstream movie theaters, usually as part of a double bill.

Once we begin to consider exhibition as part of generic practice, however, we come to realize that a film's genre, when conceived of this way, can shift over time. Even as the films were being released, when Suzuki's work became an object of cult affection by the mid-1960s, cine-clubs practicing new, alternative forms of exhibition began showing his films in retrospectives. As they began to be viewed in this new paradigm, they fit into a new industrial genre that we might call "cine-club films" at the same time that they were categorized as Nikkatsu Action films. At a further historical and geographic remove, viewers who first encounter Suzuki films outside of Japan, through either international film festivals like Edinburgh or Rotterdam, boutique home video labels like Criterion Collection or Masters of Cinema, or retrospectives at prestigious cinematheques in Paris or New York, are not watching the films as Nikkatsu Action Cinema at all; in this context, they have become incorporated into new genres that are invented by these new exhibition contexts.[15] If we look at Nikkatsu Action Cinema through this lens, we find that even though the name is consistent, the functioning of the genre on an industrial level shifts substantially over the course of this eleven-year period, with serious consequences for both how Suzuki was able to make films and a resulting shift in style over the course of this period. In this context, a rupture emerged between Nikkatsu's assembly-line filmmaking and traditional distribution methods and the gradual move toward creative independence and alternative exhibition practices by the cine-clubs who were celebrating Suzuki by the end of his career.

The industrial context of Nikkatsu Action underwent significant changes during the 1960s. Many of these, such as the overall decline in theatrical attendance across Japan and the rise in popularity of Tōei Studio's ninkyō (chivalry) genre, were beyond Suzuki's control but would nevertheless affect the kinds of

films he was asked to make and the resources at hand to make them. Other shifts, like the rise in alternative spectatorship practices of which the cine-clubs were symptomatic, which would culminate with the turn in film criticism seen with the *Cinema 69* critics, are ones that Suzuki himself took part in initiating with his mid- and late 1960s films. Looking at Suzuki's career in the context of Nikkatsu Action Cinema historically, I argue that Suzuki's own maturation as a filmmaker within that context was closely intertwined with the transformation of the genre and its own industrial context.

The Rise and Fall of Nikkatsu Action Cinema

In secondary literature, Suzuki is frequently referred to as a filmmaker of B movies. Before evaluating that claim, it may be worthwhile to define what a "B" movie is. The term is frequently used casually to refer to low-budget films, films to be perceived of low quality, or simply genre films broadly, but this is not accurate in the term's historical use. The terms *B movie*, *B product*, or *B feature* come from Hollywood's practice of block-booking beginning in the 1930s and referred to the films that fit the bottom half of a double feature.[16] Beyond that, there were a number of basic prerequisites for B movies in Hollywood that Hollywood historian Brian Taves observes. They did not feature major stars, they had limited budgets and shooting schedules that were typically between one and three weeks, and their runtimes were generally no longer than seventy-five minutes; in many cases, they were much shorter than that.[17]

Nikkatsu also released films in double features during the period when Suzuki worked there, and each of Suzuki's Nikkatsu films was screened as part of a double feature in its initial release.[18] While sources do not designate which film fit into the A slot as opposed to the B slot, frequently one longer, higher-profile feature with one or more popular stars was combined in a double feature with a shorter, lower-profile one with no (or less popular) stars, or, in the case of kayō (ballad) films, the main star was one who was primarily known for musical performance rather than for film acting. There were cases in which Suzuki's film was clearly the cheaper and less prestigious one in a double feature; his first film for Nikkatsu, *Harbor Toast: Victory Is Ours*, was a sixty-five-minute kayō film that played alongside Abe Yutaka's *Confessions of Love*, starring Tanaka Kinuyo and Masayuki Mori. His third film, *Satan's Town*, played in the same double feature as Nakahira Kō's *Crazed Fruit*, and his forty-minute kayō film *Love Letter* from 1959 played alongside Tasaka Tomotaka's *The Stream of Youth*, a two-hour romance starring Ishihara Yūjirō and Kitahara Mie. There are also cases, however, where Suzuki's film is clearly the *more* prestigious, higher-budget of the two films being shown. In 1958 Suzuki directed two lengthier social melodramas starring Kobayashi Akira—*The Boy*

Who Came Back (ninety-nine minutes) and *Young Breasts* (ninety minutes)—that boast extensive crane shots and other high production values and were paired with films that were well under an hour. His film *The Flower and the Angry Waves* also starred Kobayashi (by then Nikkatsu's second-biggest star) and featured an elaborately designed Taishō-era Tokyo set; it was paired with the short kayō film *Beautiful Teenage Years*, directed by Yoshimura Ren.

The distinction between an A feature and a B feature could also be quite murky in some of these cases. Many of Suzuki's films at Nikkatsu were in a gray zone between 80 and 95 minutes that could be paired with shorter films as an A feature (such as Suzuki's 88-minute *Passport to Darkness*, paired with the 54-minute *O-Yae the Substitute Maid* in its initial release). These films could also be paired with a longer film as the B feature (such as Suzuki's 92-minute *Voice Without a Shadow*, with midlevel stars Minamida Yōko and Nitani Hideaki, paired with Takizawa Eisuke's 109-minute *The Last Song*, with higher-ranking stars Kobayashi Akira and Asaoka Ruriko). Alternatively, a film could be paired with another one of comparable length, with comparably ranked stars, where neither was the clear A or B feature (such as Suzuki's 80-minute *Fighting Delinquents*, starring Wada Kōji, initially paired with Yamazaki Tokujirō's 79-minute *Rampaging Vagabond*, starring Kobayashi Akira) or could bounce between A billing and B billing during its run as it switched being paired with longer and shorter features. For example, Suzuki's 85-minute *The Sleeping Beast Within*, featuring Nagato Hiroyuki, was initially double-billed with the 106-minute-long A feature *Blossoms of Love*, directed by Takizawa Eisuke and starring Ishihara Yūjirō, but was later paired with the 53-minute *Detective Stories: The Face Caused by the Sound of the Gun*. There is not a clear trajectory in Suzuki's Nikkatsu career: he continued to make films both at the top and bottom half of double bills through the end of his tenure there. The majority of his Nikkatsu films, however, were in the 80–95 minute range and featured at least one noteworthy Nikkatsu star, including the films that were screened as B pictures: perhaps most famously, *Kanto Wanderer* with Kobayashi Akira filled the B slot with Imamura Shōhei's *The Insect Woman* in 1963. Though certainly not as prestigious in Nikkatsu's eyes as Imamura's film, *Kanto Wanderer* was a 90-minute-plus film with one of the studio's biggest stars. It is difficult to imagine a comparable film in Hollywood being a B film.

Another term used to describe Suzuki's work at Nikkatsu, frequently interchangeably with B pictures but actually somewhat broader in definition, is *program picture*. Program pictures were also tied to industry practice and describe films that were neither designed to be particularly prestigious for the studio nor assumed to be major box office draws. The studio system operated in this period in Japan similarly to the way it had in Hollywood: with contracted stars, supporting cast members, and crews who needed to be working constantly, and by filling screening slots at first-run theaters in order to keep

anyone outside the studio system from gaining a foothold in the commercial film industry. Program pictures were ones that were designed to "fulfil booking obligations and supply regular vehicles for its [Nikkatsu's] contract talent."[19] It was common at the time for films to play for only a single week in their initial run, with larger box office draws being held for longer and some of the more cheaply made films playing for only half a week. Nikkatsu tended to save the films it considered its biggest potential box office draws for the end/beginning of the year, or for Golden Week (running from April 29 to May 5), and none of Suzuki's films were given these most favorable release dates. Several, however, were held for longer than a week in their initial run: in particular, most of his Wada Kōji vehicles between 1960 and 1962 played for between one and a half and two weeks, while his most successful films, *The Flower and the Angry Waves* and *Gate of Flesh* in 1964, played for more than two weeks.

Given the studio's block-booking practices, it can be difficult to determine how financially lucrative program pictures were in the original run, but if the primary goals of the film were only to fill a programming hole and keep some cast and crew members working, a film's box office draw is not necessarily what would determine whether Nikkatsu would consider a film "successful." The fact that Suzuki was, at times, directing very short programmers on a cheap budget that played for only four days in their first run (as was the case for *Everything Goes Wrong* and *Teenage Yakuza*) could be indicative of his middling stature but not necessarily of a conflict with the studio: Nikkatsu needed films like these to fill gaps in their release schedule, and Suzuki was not the only filmmaker directing such films. They also need to be weighed against his higher-budget projects with longer runs, such as his Wada Kōji films, and more prestigious projects like *The Incorrigible* or *The Flowers and the Angry Waves*.

Though Suzuki was neither as prestigious as Imamura Shōhei nor as popular as Inoue Umetsugu, Kurahara Koreyoshi, or Masuda Toshio, his stature was not nearly as low as much secondary literature would imply. Though he did not make a two-hour-plus prestige picture like some of the Imamura films he was double-billed with, the studio did give him what were, in their eyes, more serious and prestigious projects, such as *The Boy Who Came Back*, *Young Breasts*, and *The Incorrigible*.

The competing, often oversimplified stories of how Suzuki came to be at odds with the studio heads, and with Hori Kyūsaku in particular, near the end of his Nikkatsu career have been explored in previous chapters. According to Sone Chūsei, however, a turning point came at the end of 1964 with audiences', and the studio's, cool reception to *Our Blood Will Not Forgive*.[20] Sone's account accords with some aspects of the way that Suzuki's career unfolded the years following the film: it was the last film he directed for the studio starring Kobayashi Akira, and it precedes the later films in which Nikkatsu would make unexpected budget cuts, for example, deciding immediately before films went

into production to film in black-and-white as opposed to color, or, in the case of *Tokyo Drifter*, forcing a reshoot of the film's final, postaction sequence by the assistant director because it found Suzuki's initial ending too eccentric.[21] The fact that *Our Blood Will Not Forgive* was also one of the more ambitious projects that the studio gave Suzuki (it starred not only Kobayashi and Matsubara but also the up-and-coming Takahashi Hideki, immediately followed two of his most successful films at the studio, and, at ninety-eight minutes, has one of his longest runtimes at the studio) also makes it more likely that Nikkatsu's studio brass would have been paying attention to the film and particularly sensitive to an unfavorable reception. That said, it would not necessarily have been obvious how precarious Suzuki's position at the studio was at this point: after all, he continued to make films in the vein of previously successful Nikkatsu projects (*Born Under Crossed Stars* following *The Incorrigible*, and *Story of a Prostitute* following *Gate of Flesh*). He was also briefly considered to direct a quasi-remake of Inoue Umetsugu's *The Winner* (*Shōrisha*, 1957) that was to feature the studio's top female star, Yoshinaga Sayuri, opposite the up-and-coming Watari Tetsuya.[22] In short, the idea that Suzuki was either an unheralded, bottom-of-the-barrel filmmaker at Nikkatsu or a consistent thorn in the studio's side throughout his career there is largely a hindsight projection.

What is clear is that, even in these cases, the films Suzuki made prior to *Branded to Kill* were not projects of his choosing but assignments given him by the studio. By and large, he did not write the screenplays for his Nikkatsu (or even post-Nikkatsu) films, with the exception of *The Age of Nudity* and (uncredited as a member of Guryū Hachirō) *Branded to Kill*. Certain practices by the studio, however, designed with the intention of cutting costs, inadvertently gave Suzuki and other Nikkatsu filmmakers creative control: the rapid production schedules inhibited the studio's oversight of the production process, and filmmakers were actively discouraged from providing coverage in the interests of saving expensive film stock.[23] This meant that Suzuki and his cinematographers together would conceive of the way a sequence would be edited during the filming process, and if a scene were shot in a particularly eccentric way or deviated seriously from the screenplay, the editor would not easily be able to remove this footage from the final film. The studio would be reluctant to reshoot scenes from films made on such a tight schedule except in extreme circumstances, and if the film had primarily been shot on the studio's soundstage, the soundstage would likely be in use for a new film immediately after production wrapped and thus would be unavailable for extensive reshoots.

Comparing the finished Suzuki films with their published screenplays, we can see some significant changes between the screenplays and what ended up in the film.[24] There are some individual moments within scenes that were inserted in the filmmaking process, such as the moment in *The Incorrigible*, discussed in the previous chapter, when Konno Tōgō begins chanting

the imperial anthem after his first sexual experience. More rarely, there are entire sequences that do not appear in the screenplays as published, such as the flashback when Konno's mother tells him off with an abstract indoor wind effect in the same film. There are cases where the order of scenes, or events within scenes, changes in the process of filmmaking and editing, such as in *Born Under Crossed Stars*, in which the order of a conversation scene between the protagonist's parents and his father's friend is reversed so as to stage a comic accidental revelation. However, by far the most common change that Suzuki made to screenplays, either in the filming or the editing process, was simply to remove substantial portions of the script, usually the transitional material bridging scenes together. As a consequence, the narration in his films becomes more elliptical than the original screenplay versions, but the effect of these elisions is not necessarily the same on the original audiences of Nikkatsu Action Cinema as it is on international audiences receiving the films in an art house context or on boutique home video labels. Suzuki was able to do away with scene set-ups partly because the material he worked with was so programmatic that the films' original audiences would be able to fill in the elided material with comparable scenes they would have seen in other, similar Nikkatsu films, possibly even as part of the same double billing. To international audiences today, who are less likely to be well-versed in Nikkatsu Action as a whole, they appear as more striking elisions, and it becomes more difficult for these audiences to know how to fill them in.

Nikkatsu Action Cinema first took shape with *Season of the Sun* (*Taiyō no kisetsu*, Furukawa Takumi) and *Crazed Fruit* in 1956, rising further the following year with the popularity of films like Kurahara Koreyoshi's *I Am Waiting* (*Ore wa matteru ze*) and particularly Inoue Umetsugu's *The Stormy Man* (*Arashi o yobu otoko*). Like the earlier films, *I Am Waiting* and *The Stormy Man* both starred Ishihara Yūjirō, and their popularity was closely tied to the two films' theme songs, both sung by Ishihara.[25] Thereafter musical tie-ins became an important marketing practice for the Nikkatsu Action stars, who developed singing careers alongside their film careers. Even films with a less obvious musical theme than *The Stormy Man* would often feature a theme song sung by its leading star. Additionally, the aesthetics of the stage space and, more specifically, the modern, Ginza nightclub stage space, would become foundational to other aspects of the genre's aesthetics.

Over the following years, the genre would form around Ishihara's star persona and the "Diamond Line" of male stars who were molded after him. These stars, like Ishihara, were all young at the point of reaching stardom and relative newcomers to the cinema. In general, they would be given supporting roles in the major Ishihara films while starring in their own, smaller-budget films until they could reach full stardom with a major hit. For example, Kobayashi Akira can be seen starring in Suzuki's *The Boy Who Came Back* and *Young*

Breasts in 1958, the same year he appeared as a supporting cast member in bigger Ishihara films like *The Rusty Knife* (*Sabita naifu*, 1958). It was not just the stars, however, who were young newcomers to the film scene. With few exceptions, the major Nikkatsu Action filmmakers were relatively young filmmakers who began directing their first films in the mid-1950s, around the same time that the genre first emerged.[26] Though Nikkatsu had attempted to poach directing talent from other studios when the company re-formed in the early 1950s, veteran action filmmakers like Makino Masahiro and Takizawa Eisuke were assigned to direct more traditional period action films.[27] Nikkatsu largely reserved these youthful, contemporary action films for new and young filmmakers like Nakahira Kō, Inoue Umetsugu, Saitō Buichi, Masuda Toshio, Kurahara Koreyoshi, and, of course, Suzuki himself, all of whom had been born in the mid-1920s and none of whom had directed a film before 1953.[28] It thus provided an opportunity for new filmmakers like Suzuki to rise quickly in the ranks.

I have adopted the periodization of Nikkatsu Action Cinema that Watanabe Takenobu outlines in *The Wonderful World of Nikkatsu Action Cinema* as a way of looking at Suzuki's development alongside the development of the Nikkatsu Action Cinema:

Incubation Period (1954–1956): This period included the assembly of the filmmakers, casts, and crew who would ultimately become associated with the genre. It culminated in the release of the earliest films in the genre (the aforementioned *Season of the Sun* and *Crazed Fruit*).[29] The period overlapped perfectly with Suzuki's own career: he moved to Nikkatsu in 1954 and worked as an assistant director under Noguchi Hiroshi in 1954 and 1955, and began writing screenplays with Noguchi's film *The Final Duel* (1955). In 1956 he released his first three films: *Harbor Toast: Victory Is Ours*, *Pure Heart of the Sea*, and *Satan's Town*.

Rise to Prominence (1957–1958): Ishihara Yūjirō's star rose with the release of a series of enormously successful films: Kurahara Koreyoshi's *I Am Waiting* and Inoue Umetsugu's *The Stormy Man*, both in 1957, and Masuda Toshiō's *The Rusty Knife* and *Red Pier* (*Akai hatoba*), both in 1958. Future stars Kobayashi Akira and Shishido Jō began appearing in supporting roles in Ishihara star vehicles in this period. Several supporting cast members in these films (including Kobayashi and Nitani Hideaki) also began starring in their own films. Starting in June 1958, all Nikkatsu Action films were made in CinemaScope. Color was reserved for only the highest-budget films (like *The Stormy Man*).[30] It was during this period that Suzuki firmly began working within Nikkatsu Action Cinema, albeit at a lower place on the food chain than Inoue, Masuda, or Kurahara: notably, beginning with this period his casts primarily comprised actors associated with Nikkatsu Action Cinema. In 1958 he stopped getting credited by his birth name, Suzuki Seitarō, and adopted the pen name Suzuki Seijun. That year also marked the first time Suzuki directed two clear A

features at Nikkatsu: *The Boy Who Came Back* and *Young Breasts*, two social melodramas starring Kobayashi Akira as a troublesome youth and featuring high production values. (This was by no means a permanent rise to A features, as he would go back to making two films under the sixty-minute mark the following year.) He released three films in 1957—*An Inn of Floating Weeds, Eight Hours of Terror, The Naked Woman and the Gun*—and four in 1958: *Underworld Beauty, The Boy Who Came Back, Young Breasts,* and *The Voice Without a Shadow*.

Height of Popularity (1959–1962): This era marked the formation of the so-called Diamond Line following in Ishihara's wake: Kobayashi Akira, Akagi Keiichirō, and Wada Kōji were each raised as stars who were a slight variation on the Ishihara persona, and each formed a subgenre as a result.[31] The success of Saitō Buichi's 1959 *Farewell to the Southern Tosa* (*Nangoku tosa wo ato ni shite*) and *The Rambling Guitarist* (*Gitā wo motta wataridori*) confirmed Kobayashi Akira's position as a major star; the two films also marked the start of the Nikkatsu Western subgenre, which often began with Kobayashi strolling into a remote Japanese town on horseback in a cowboy outfit. Akagi's first starring role was in Suzuki's *The Age of Nudity* as a kind of father figure to a group of orphaned children who live on an abandoned U.S. army base and survived by petty theft and challenging other youths to motorcycle races, culminating in the character's death in a motorcycle crash. Of the three "Diamond Guys" who followed in Ishihara's wake, Kobayashi best replicated Ishihara's matinee idol qualities, Wada was the lightest and most youthful and energetic, and Akagi was the one whose persona grew out of the rougher and more dangerous edge seen in Ishihara's earliest films.[32] Michael Raine has argued that Ishihara's path to stardom from *Crazed Fruit* to *The Stormy Man* involved a serious softening of Ishihara's initial image from the earlier film.[33] Akagi can be seen as harkening back to this earlier persona. By contrast, Wada (who was only fifteen in 1959, in his first starring role) became associated with comic action films with a lighter touch than the films starring Kobayashi or Akagi, and Wada's roles were frequently that of a young troublemaker with a heart of gold. Color went into much wider use in this period, though some lower-budget films were still filmed in black-and-white. It should not be too surprising that this was Suzuki's most prolific period, given the resources available for Nikkatsu Action Cinema at the time: though he only directed three films in 1959 (two of which were less than an hour long), he made five features in 1960 and six in 1961. Suzuki's own rise lagged somewhat behind that of the Nikkatsu Action Cinema, as indicated by the fact that his output did not increase until 1960, and he did not direct any films in color until the end of that year. However, this was the moment when he began working regularly with members of the Diamond Line, Wada in particular. He also first directed films in color, allowing for another element of stylistic experimentation: *Love*

Letter, Passport to Darkness, The Age of Nudity (1959); *Take Aim at the Police Van, The Sleeping Beast Within, Smashing the 0-Line, Everything Goes Wrong, Fighting Delinquents* (1960); *Tokyo Knights, Living by Karate, The Man with a Shotgun, The Wind-of-Youth Group Crosses the Mountain Pass, Blood-Red Water in the Channel; Million Dollar Smash-and-Grab* (1961); and *Teenage Yakuza* and *Those Who Bet on Me* (1962).

Overripe Period (1963–1967): Nikkatsu Action films lost ground in popularity to the burgeoning ninkyō genre, a competing genre of action movies set in the early modern (late Meiji, Taishō, or early Shōwa; roughly 1890–1930) period. In addition to this and competition from television, Nikkatsu Action faced major setbacks in its Diamond Line: Akagi Keiichirō died suddenly in 1961 in a go-kart accident, and Wada Kōji's star status faded quickly after 1961 (though he would continue to work for the studio as a supporting actor), leaving Kobayashi as the only successor to Ishihara to transition into maturity as a star.[34] The studio began moving away from youth-oriented action films. A newly emerging subgenre was the "mood" action genre, which combined elements of the romantic drama with action; notable entries included Kurahara Koreyoshi's *Ginza Love Story* (*Ginza no koi no monogatari*, 1962) and Masuda Toshio's *Red Handkerchief* (*Akai hankachi*, 1964). Shishido Jō, primarily a supporting actor in the previous period, emerged as a star of the "hard-boiled" action genre with films like Suzuki's *Youth of the Beast* and Furukawa Takumi's *Cruel Gun Story* (*Kenjū zankoku monogatari*, 1964), as well as in a brand of particularly goofy action-comedies such as Nakahira Kō's *Danger Pays* (*Yabai koto nara zeni ni naru*, 1962) and Suzuki's *Detective Bureau 2–3: Go to Hell, Bastards!* Finally, Nikkatsu responded to the growing popularity of Tōei's ninkyō genre with its own take on the ninkyō film, beginning with Matsuo Akinori's *Emblem of a Man* (*Otoko no monshō*, 1963) starring Takahashi Hideki, which would later become its own series of films. Takahashi and Watari Tetsuya also became stars in this period. As budgets dropped, the use of color became more sparing, particularly toward the end of this period.[35] Suzuki's output dropped back down to an average of a mere three feature films per year. This is generally the period of Suzuki's career that gets emphasized, when he made the boldest films stylistically of his Nikkatsu career. In terms of his placement in the studio hierarchy, he began at a high point: in 1963 he directed his most prestigious (at the time) Nikkatsu project, *The Incorrigible*; he made three films with now mega-star Kobayashi Akira in 1963 and 1964; and he directed *Gate of Flesh*, the biggest financial success of his Nikkatsu career. After 1964, however, his stock declined until he was fired: *Detective Bureau 2–3: Go to Hell, Bastards!, Youth of the Beast, The Incorrigible, Kanto Wanderer* (1963); *The Flowers and the Angry Waves, Gate of Flesh, Our Blood Will Not Forgive* (1964); *Story of a Prostitute, Born Under Crossed Stars, Tattooed Life* (1965); *Carmen from Kawachi, Tokyo Drifter, Fighting Elegy* (1966); and *Branded to Kill* (1967).

Revival Period (1968–1971): Nikkatsu Action Cinema mounted something of a comeback in this era, with the rise of "New Action"—films that were often grittier and more violent than the comparatively romanticized gangster films Nikkatsu had made earlier in the decade, with films like Masuda Toshio's *Outlaw: Gangster V.I.P* (*Burai yori daikanbu*, 1968) series and Hasebe Yasuharu's *Retaliation* (*Shima wa moratta*, 1968) and *Bloody Territories* (*Kōiki bōryoku: Ryūketsu no shima*, 1969). Toward the end of the era, Nikkatsu edged closer to straightforward exploitation pictures with films like Hasebe's and Fujita Toshiya's *Stray Cat Rock* (*Nora neko rokku*) series.[36] Since Suzuki was fired in 1968, he directed no films at Nikkatsu during this period. He did, however, direct a single twenty-five-minute television episode for *Aisai-kun, konbanwa* (*Good Evening, Dear Husband*): "Aru kettō" ("A Duel") (1968).

Beyond the broadly defined umbrella of Nikkatsu Action Cinema, there are several more specific subgenres that Suzuki worked in whose narrative tropes and aesthetic tendencies he experimented with in these films. There are also films he made that would not necessarily fall under the Nikkatsu Action category. It is worth examining these subgenres to understand Suzuki's work within them.

Kayō Films

Many of Suzuki's earliest films fell into the genre of kayō (literally "ballad") films: films that were based on and named after a popular song and featured the song's musical performers, who would perform it at some point in the film. The genre was not exclusive to Nikkatsu but formed a significant portion of the studio's B features and of Suzuki's early output: *Harbor Toast: Victory Is Ours*, *Pure Heart of the Sea*, *An Inn of Floating Weeds*, and *Love Letter* were all kayō films. A kayō film's subject matter, what role the musical performer played in the narrative, and its narrative's relation to the song it was named after varied from film to film. In *Harbor Toast: Victory Is Ours*, the title song has little relation to the film's narrative: the film is bookended by sequences at the harbor that relate to its nautical title, but its primary action takes place on shore and deals with gangsters who rig horse races and the rescue of a woman from the gang boss who has designs on her. The musical performer, Aoki Kōichi, has only a minor role as a guitar player at a tavern frequented by the film's main characters. By contrast, in *Pure Heart of the Sea*, singer Kasuga Hachirō is the film's main character, and the film's narrative relates closely to the title song, about a sailor who remains true to his love in spite of the advances of many other women. Another model is offered by Imamura Shōhei's *Nishi Ginza Station* (*Nishi ginza eki*, 1958), in which the musical performer, Frank Nagai, acts as the film's narrator.

Many popular Nikkatsu films had theme songs that were performed by the lead performer, but a kayō film featured one or more songs that had been popularized prior to the film's conception. The films are often assumed either to be very thin storylines conceived for the sole purpose of giving a pretense for singing the song or to feature narratives so distant from the songs performed in them that they do not successfully wed the spectacle of the song sequence to their narratives; as such, they were not held in high critical esteem and were frequently very short B films: *Harbor Toast: Victory Is Ours*, *Pure Heart of the Sea*, *Love Letter*, and Imamura's *Nishi Ginza Station* are all roughly an hour or less.[37] It is not necessarily true, however, that the films were all artistically unsuccessful at wedding their musical numbers to the mood and thematic concerns of the narrative: from this perspective, *Love Letter* quite effectively uses its title song. Intercutting Frank Nagai's performance of the song with his coperformer's return trip after discovering the lover she had corresponded with by mail had died years before, the mournful ballad of lost love underscores her emotional state at the loss with Nagai's character's own feelings of unrequited love for her. Additionally, Michael Raine has observed that clever filmmakers working in the kayō genre were often playfully reflexive.[38] We can see this in particular in *Pure Heart of the Sea* and *An Inn of Floating Weeds*, both of which feature Kasuga Hachirō. In the former Kasuga plays a sailor on a whaling vessel who is also named Hachirō, and the other characters in the film regularly ask him to sing songs Kasuga popularized, blurring the distinction between performer and character. The effect is amplified by the frequent decision to leave the source of music off-screen when it is first heard: when the source is finally identified, sometimes it is Hachirō's character performing the song, and sometimes it is a radio playing the prerecorded song. The film thus derives some of its humor by drawing attention to its own use of prerecorded popular music for its soundtrack, and its use of a preexisting musical star in its casting.

A different form of playful reflexivity can be found in the musical numbers of *An Inn of Floating Weeds*, also starring Kasuga Hachirō, from the following year. Unlike *Pure Heart of the Sea*, where both Kasuga and the title song were central to the film's narrative, the narrative of *An Inn of Floating Weeds* is closer to a crime thriller: it concerns a man named Shunji (Nitani Hideaki) who flees Japan after being framed for a murder and returns several years later as a sailor under a false name to try to find his long-lost lover, only to uncover a smuggling operation between his own ship captain and the men who set him up years ago. The lyrics to the title song, and several others that Kasuga sings in the film, are about the memory of a former flame, which is the only connection they have to the narrative. Appearing in what initially seems to be a supporting role, Kasuga sings several songs in ways that comically intrude on the film's narrative. During one scene, a hit man is attempting to stake out Shunji's hotel room, but every time the hit man believes he has

found a secluded hiding spot, Kasuga appears somewhere in the background singing a new verse of "The Solitary Cedar of Parting" ("Wakare no ippon-sugi"), forcing hitman to find a new spot. While kayō films were frequently criticized for not successfully integrating music and dance into their narratives along the model of the American musical,[39] in *An Inn of Floating Weeds* Suzuki uses the musical and narrative elements to undermine each other deliberately for comic effect: Kasuga's mournful ballad undercuts the mood of the suspense sequence, while the hit man's escapades interrupt Kasuga's song so that it gets performed only in fragments.

Though Suzuki largely left the kayō genre after *Love Letter* in 1959,[40] Nikkatsu's practice of multimedia stardom meant that musical numbers and themes continued to play a significant role in Suzuki's Nikkatsu films. Beginning with Ishihara Yūjirō, the stars of Nikkatsu's Diamond Line all had singing careers alongside their acting careers, often singing theme songs or musical numbers that were released with the film, cultivating a new kind of multimedia stardom.[41] Many of Suzuki's films with Diamond Line stars follow suit: Wada Kōji sings the theme songs of *Fighting Delinquents* and *Tokyo Knights*, Kobayashi Akira sings it for *Kanto Wanderer* and *The Flowers and the Angry Waves*, and Watari Tetsuya sings it for *Tokyo Drifter*. Additionally, Shishido Jō shares a stage song in *Detective Bureau 2-3: Go to Hell, Bastards!* that was released as a single,[42] Nogawa Yumiko has her "Habanera" number in *Carmen from Kawachi*, and Nitani Hideaki also sings "Otoko no erejī" (Elegy for a man) on the soundtrack for *Tokyo Drifter*. In other cases, supporting performers released a single that was included in the film: Shimakura Chiyoko and Inoue Hiroshi sing the theme song for *The Wind-of-Youth Group Crosses the Mountain Pass*, while Sugiyama Toshio and Tashiro Midori sing "Ikarechatta" on the soundtrack of *Teenage Yakuza*. As a result of this integration of popular music into Nikkatsu Action Cinema and the practice of multimedia stardom at play, music plays a prominent role in many of Suzuki's Nikkatsu films.

Nikkatsu Noir

Just as "film noir" was not recognized as such in Hollywood in its own heyday but was, rather, a category created in retrospect, "Nikkatsu Noir" is not a category of Nikkatsu films that existed at the time the films were released. It is a category created in retrospect, specifically by non-Japanese distributors trying to market the films to non-Japanese viewers.[43] However, it helps to mark off a group of urban crime films made by Nikkatsu in the 1950s and 1960s that has strong formal affinities with both French and Hollywood film noir and intersects and overlaps with broader Nikkatsu Action Cinema, but which is nevertheless distinct from other films in the genre. The genealogy of Nikkatsu Action

Cinema traced by Watanabe and Schilling begins with the success of *Crazed Fruit* in 1956, but Nikkatsu's urban crime films predate this: earlier examples include a number of the films for which Suzuki acted as assistant director between 1954 and 1956 (for example, Yamamura Sō's *Black Tide* and Noguchi Hiroshi's *My Pistol Is Quick*, *Kiss of Hell*, and *Reward for Evil*), Inoue Umetsugu's *Crossroads of Death* (*Shi no jūjirō*, 1956), and Suzuki's own *Harbor Toast: Victory Is Ours* and *Satan's Town*. David Desser has pointed out that many of the most canonical Hollywood noir films were not widely released or celebrated in Japan until after these Nikkatsu films were made,[44] but there are other influences to consider beyond postwar Hollywood films noir. They include popular Japanese pulp literature from both the interwar and postwar periods (*Crossroads of Death* was adapted from an Edogawa Ranpō story, for example) and *ankokugai* (underworld) films of the 1930s, which likewise portrayed the criminal underworld of Japan's new urban centers with nighttime location shooting and high-contrast lighting.[45] Daisuke Miyao has pointed out another possible influence on the films' style that marks a point of convergence with Hollywood B noirs, if not necessarily an influence: the films used lighting sparsely in order to save costs and hide cheaply designed sets.[46]

Broadly defined, the word *noir* has also been used by Western critics to describe more prestigious postwar projects, such as Kurosawa Akira's *Drunken Angel* (*Yoidore tenshi*, 1948) and *Stray Dog* (*Nora inu*, 1949) or Mizoguchi Kenji's *Women of the Night* (*Yoru no onnatachi*, 1948) and *Street of Shame* (*Akasen chitai*, 1956).[47] Indeed, while the phrasing "Nikkatsu Noir" provides alliteration to publicists promoting the films abroad at a remove of more than fifty years, some of the most influential crime films from Japan in the late 1950s and early 1960s that have aesthetic affinities with film noir were not Nikkatsu films. In particular, Ishii Teruo's "line" films made for Shin-Tōhō followed outsiders (usually newspaper reporters) who would infiltrate the underworld and uncover the different stages of a particular racket, like the drug trade or human trafficking, frequently using the location shooting and high-contrast black-and-white lighting associated with film noir. Ishii's first film in the line series was *Secret White Line* (*Shirosen himitsu chitai*) in 1958. Shortly thereafter, Nikkatsu began making its own, similar brand of crime thrillers following the investigation into the underworld. Like Ishii's line films, the investigations in these films often trace the different stages of a criminal racket, starting in the seediest districts of Tokyo or Yokohama but gradually tracing the flow of illicit capital to the wealthiest districts of the same city. In the Nikkatsu take on this genre, however, the investigators, whether reporters or other outsiders for the underworld, often had a more personal connection to the initial crime they investigated. Kurahara Koreyoshi's *The Third Blind Spot* (*Dai san no shikaku*, 1959) is a good example of this trend, and several of Suzuki's noirish crime films over the following years, including *Passport to Darkness*, *Take Aim at the Police*

Van!, *The Sleeping Beast Within*, and especially *Smashing the o-Line*, resemble Ishii's series in plot points and aesthetic traits.

Melodrama

Though neither Nikkatsu nor Suzuki is typically associated with melodrama, melodrama is an important part of both Suzuki's origins as a filmmaker and his early Nikkatsu filmography. Kōno Marie, a specialist on Japanese melodrama, has pointed out that many aspects of Suzuki's style have close affinities to the melodrama—brightly colored set design, carefully placed mirrors, and the histrionic use of environmental factors like artificial rain, snow, and scattering flowers—which she attributes partly to Suzuki's background as an assistant director at Shōchiku Ōfuna.[48] Two of Suzuki's early features for Nikkatsu, *The Boy Who Came Back* and *Young Breasts*, were also melodramas and were notable as the first conventionally prestigious films in his filmography: both films were scripted by accomplished screenwriters with experience in melodrama. *The Boy Who Came Back* was coscripted by Terada Nobuyoshi, whose credits included Kawashima Yūzō's *Suzaki Paradise: Red Light* (*Suzaki Paradaisu: Akai shingō*, 1956) and Ieki Miyoji's *Tomoshibi* (1954) and *Stepbrothers* (*Ibo kyōdai*, 1957), while *Young Breasts* was coscripted by Tsuji Yoshiro, a longtime Shōchiku screenwriter whose credits had included Shimizu Hiroshi's *Record of a Woman Doctor* (*Joi no kiroku*, 1942) and Kinoshita Keisuke's debut film, *Port of Flowers* (*Hana saku minato*, 1943). The two films' higher budgets can be seen not only in their casts and lengthier running times, but also in their more ornate interior set designs and their frequent use of elaborate crane shots. The influence of melodrama can also be seen, however, in decidedly less esteemed projects, such as the forty-minute kayō film *Love Letter*, which likewise uses a combination of elaborate camera movements by dollies and cranes (in the snow, no less), sculpting a mournful romantic melodrama of lost love onto the frigid, lonely landscape of a snowy mountain. Somewhat more anomalously, his short film *The Age of Nudity*, coscripted by Terada Nobuyoshi and Suzuki himself, combines elements of social melodrama about abusive and exploitive parenting that rest strangely alongside the film's indulgence in the allure of criminal life and the almost magical benevolence of an old man neighboring the surrogate family's home.

Hasumi has argued that Suzuki's *The Incorrigible* demonstrates a more subdued mastery of the melodrama, in particular in Suzuki's use of landscapes and weather, than we generally attribute to the director, comparing the film favorably to the work of Naruse Mikio.[49] Hasumi subsequently traced Suzuki's use of the kinds of flourishes that Kōno highlighted, such as artificial rain and waves, in a more subdued way in the film's romance scenes, highlighting the

ways that Togo and Emiko exchange an umbrella in the rain, or the way that their first kiss is set against a background of a reflective water surface at sunset.[50] Though the film may seem like an aberration within Suzuki's filmography, Kōno's reading of Suzuki's broader relationship to melodrama suggests that this is merely a more subdued version of a tendency that exists more broadly in Suzuki's work.

Nikkatsu Westerns

Nikkatsu Westerns were set in contemporary Japan but drew their iconography heavily from the Hollywood Western. These films frequently featured a solitary gunfighter as protagonist, who, along with his rival, would dress like cowboys from Westerns. A number of them even open with the protagonist riding a horse into town. Their settings were some variation of the frontier: far-flung rural locations that were undeveloped compared to the urban centers, and where the rule of law had relatively little influence. Though there were no spaces precisely resembling the deserts of the American Southwest, where many Hollywood Westerns were shot, filmmakers were creative with geography, using forests, mountains, volcanic black-sand beaches, and, frequently, the open sea to stage their action. "In these renderings," writes Hiroshi Kitamura, "the outlaw protagonists often appeared on horseback, dressed with cowboy hats and tasseled leather jackets, at diverse rural backdrops—from the high planes in Ōita and the green forests in Aichi to the picturesque lakefronts of Hokkaido."[51] The smaller cities of Japanese Westerns were likewise treated as frontier towns: their watering holes look more like Western saloons than like the Ginza nightclubs of other Nikkatsu Action films, and their civilian inhabitants tend to be portrayed as relatively simple small-town folk being pushed around by a well-endowed, exploitive business interest with one or more hired gunmen.[52] Watanabe marks 1959 as the genre's starting point, with the release of *Farewell to the Southern Tosa* followed shortly by *The Rambling Guitarist*.[53]

The Hollywood Western had been influential on Japanese cinema well before the advent of Nikkatsu's Westerns. Previously, however, the generic influence of the Western had been primarily on period pieces. Suzuki's first scripted film, *The Final Duel*, had been modeled on *High Noon*, but examples date back to the prewar era. What distinguished Nikkatsu's brand of Westerns was their modern setting: not just that they happened to be set in modern Japan, but that they were so closely related to other Nikkatsu Action films that indulged the hedonistic pleasures of modernity. In a period piece, a samurai or ronin protagonist could stand for an antiquated socio-moral code in much the way that a gunfighter hero in a Hollywood Western could. Nikkatsu's Westerns dealt

with violent developers pushing around helpless villagers in rural Japan who had to be defended by a warrior, similar to George Stevens's *Shane* (1953) or Kurosawa Akira's *The Seven Samurai* (Shichinin no samurai, 1954). Unlike those films, however, Nikkatsu's protagonist was not a figure of a dying era; in fact, more often than not, the protagonist's backstory, not revealed until late in the film, identified this character as originating in the city and becoming a drifter after the violent death of a girlfriend or family member. The genre's reconfiguration of Western iconography was thus somewhat different from that of Western-influenced period films: a self-contradictory combination of modern origins with premodern moral codes, of characteristics derived from Western gunfighters and earlier sun-tribe and Nikkatsu Action films, these protagonists were an apparent contradiction of influences and characteristics.

Though it was released two years prior to *Farewell to the Southern Tosa* and does not feature an obvious gunfighter figure, Suzuki's first film that placed elements of the Hollywood Western in contemporary rural Japan was *Eight Hours of Terror*. Following an assortment of passengers on a bus across dangerous territory after a typhoon has washed out the railroad tracks, the film closely resembles John Ford's *Stagecoach*.[54] Beyond the overarching narrative arc, a trip through dangerous wilderness territory, *Eight Hours of Terror* resembles *Stagecoach* in providing a cross-section of different archetypes, some of which come straight out of *Stagecoach* itself (the arrogant businessman, the liquor salesman), and some of which are versions of archetypes modified for the postwar Japanese setting (the sex worker who works on U.S. Army bases, the returnee doctor, and the student activists). *The Man with a Shotgun* more closely follows the mold of *Farewell to the Southern Tosa* and is the film in Suzuki's Nikkatsu filmography that most incorporates the setting, costuming, and character motivations of American Westerns: a saloon is one of the film's most prominent settings, the hero and villains wear cowboy outfits, and the film culminates in a shootout on a volcanic beach that makes effective use of the mountainous landscape. The same year, Suzuki's *Blood-Red Water in the Channel* offers a different take on the genre: like *The Man with a Shotgun*, the film is set on a remote island village with a Western-style saloon, but, like numerous other Nikkatsu Westerns, it uses the open sea to stand in for the frontier rather than landscapes. Western-style saloon fights and shootouts are also incorporated into numerous other Suzuki films, both at Nikkatsu and afterward.

The Wada Kōji *Kozō* (Youngster) Action Cycle

The overarching genre of Nikkatsu Action Cinema can be identified by a variety of shared stylistic traits, narrative formations, and personnel (both cast and crew). The height of the genre's popularity was also its most formulaic period:

when Nikkatsu schematized the genre into a variety of subgenres with surprisingly little variation between films. Several of these subgenres were billed as series, like the *Wataridori (Rambling Guitarist)* series starring Kobayashi Akira or the *Kenjū buraicho (Fast-Draw Ryū)* series starring Akagi Keiichirō, in which the protagonist was ostensibly the same character in each film, though with no implied continuity between films. If the number of films in these series released in such a short time frame seems redundant, remember that most Nikkatsu films during this period would play for only a single week during their initial run (two weeks for particularly successful films), and there was no easy way for audiences to re-view films that were not playing in theaters. Thus the redundancy between films compensated for audiences' inability to access the earlier films in the series. Further, because of the quick turnover between films, it could not be assumed that audiences for the latest *Wataridori* film would necessarily have been able to see every previous entry in the cycle; hence a very loose continuity between entries in the series allowed Nikkatsu to use the established formula to continue to attract audiences without keeping new audience members who had not seen the previous entries from enjoying the films.

Films in these series/subgenres recycle the same basic settings, plots, and character types, who are frequently played by the same actors across the entire subgenre or series, albeit with different names in each film. For example, in the films of the *Wataridori* series (primarily directed by Saitō Buichi), Kobayashi plays the titular rambling guitarist who wanders into a remote Japanese town. Landscape shots and Western-style saloons are prominent. A wealthy developer (usually Kaneko Nobuo) is bullying a group of powerless locals with a development project that infringes on their land. Asaoka Ruriko plays the love interest caught in the middle of the dispute, and Shishido Jō plays the rambler's rival: a gunfighter of equal or near-equal ability, whose side in the dispute is left undetermined until near the end of the film. One common scene is an apparent Western-style duel between Kobayashi and Shishido in which, at the exact moment the characters are about to draw their guns on each other, they recognize Kaneko's henchmen aiming at them and quickly join forces. The similarities go beyond the narrative formulations to the formal articulations of these formulaic narratives: this sequence tends to be edited so that it is impossible to tell whether Shishido is actually firing at Kobayashi, or at some henchmen lurking behind him, until the reaction shot. The film ends with Kobayashi killing Kaneko's evil developer and henchmen, either with Shishido's assistance or in a duel with Shishido. Though Asaoka begs Kobayashi to stay and settle down with her at the end, he leaves again (usually by horse) and continues to ramble. Between 1959 and 1962 Kobayashi starred in six films in the *Wataridori* series, all of which followed this same basic format.

The *Kenjū buraicho* series, starring Akagi and directed by Noguchi Hiroshi (of which there were four films in 1960–1961, cut short by Akagi's death)

followed a similar format: Akagi as a gunfighter, opposing a villain involved in some smuggling scheme (usually Sugai Ichirō), Asaoka or Sassamori Reiko as the love interest, and Shishido Jō again as the rival gunfighter. There are differences with the *Wataridori* series: the setting tends to be metropolitan and favor modern Ginza (or Ginza-style) night clubs, back alleyways, docks, and warehouses, the villain's plot generally involves smuggling rather than development, and Akagi's hero is more visually rugged and morally ambiguous than Kobayashi's. Certain aspects of this series, however, are strikingly similar to those of the *Wataridori* series: notably, each film has a showdown-type scene with Shishido similar to those mentioned earlier, and they share several other periodically recurring character types.

During this period, Suzuki directed a cycle of youth-action comedies starring Wada Kōji: *Fighting Delinquents, Tokyo Knights, Living by Karate,* and *The Wind-of-Youth Group Crosses the Mountain Pass*. These do not quite constitute a series the way that the *Wataridori* or *Kenjū buraicho* series do, which is to say that Wada plays a character with a different name in each of them, and they do not have the same word or group of words in each title. Otherwise, however, these films function similarly to the way that the other series do in that they recycle the same plots, locations, and character types, often played by the same performers across films. Wada is a high school student entering a new environment as an outsider. His love interest, Shimizu Mayumi, is a fellow high school student but also an insider in the environment, and a member of a group of friends that Wada will enter and become a de facto leader of. Wada has an estranged mother figure, frequently played by Minamida Yōko. Eventually, Wada and his group of friends find themselves pitted against a villain, usually a developer like those of the *Wataridori* series, and discovers that his estranged mother is implicated through a romantic attachment or previously unknown family connection without knowing the villain's scheme. In the climax, the villain takes the mother and/or one member of the youth group hostage, while Wada leads the rest of the group to rescue them and thwart the scheme.

But beyond these main character types, there are further, minor characters who recur, frequently played by the same actors. The group of youths accompanying Wada and Shimizu will include a younger sister figure (usually Nezu Yoshiko) as well as a friend who looks up to Wada, secretly loves Shimizu, and whose cowardice is used for comic relief (usually Sugiyama Hajime). Sometimes a lecherous fellow student (usually Noro Keisuke) will also function as a minor antagonist. Suzuki uses these character types across the first four films in his Wada Kōji youth-action-comedy cycle, as well as (with different cast members) in *Teenage Yakuza*. In his final three films with Wada (*Blood-Red Water in the Channel, Million Dollar Smash-and-Grab,* and *The Ones Who Bet on Me*), Suzuki reconfigures them somewhat: for example, in *The Ones Who Bet on Me*, Minamida's character is a wealthy backer of Wada

(a boxer in the film) whose relationship with him uncomfortably moves between motherly and romantic.

It is common to discuss genre films in terms of themes and variation, though in Suzuki's youth-action comedy cycle, like the *Wataridori* and *Kenjū buraicho* series, it has to be admitted that there is more theme than variation. However, I bring up these formulaic, recurring character types (and actors to play them) less to discuss their use in this original cycle of films themselves than to consider their legacy in Suzuki's later, more major, works at Nikkatsu. Though ostensibly a more prestigious project than any of these films, *The Incorrigible* draws on the same character types for its minor roles, played by the same actors, as the ones in Suzuki's youth-action-comedy films. Though featuring different stars and a few flourishes of prestige in the casting (like casting Takamine Mieko, who had starred in numerous Ozu, Naruse, and Kinoshita Keisuke melodramas, as the main character's mother), Konno Tōgo's fellow students in *The Incorrigible* are played by the same character actors who were featured in the earlier cycle of films, and playing off of the roles that they had established earlier in the decade. In particular, Noro Keisuke and Sugiyama Hajime play variations on their characters from the earlier Wada films.

Given the industrial context in which these films were made, it was inevitable that there would be overlap in cast members across these different films. But by reusing these character types in *The Incorrigible*, Suzuki links that film to a tradition of youth-action comedies in spite of its setting in the Taishō era and its more prestigious literary origins. These become more obvious in the film's quasi-sequel, *Born Under Crossed Stars*, which features the same leads as the earlier film and a similar rural Taishō-era setting, but whose final showdown between the lead and some local yakuza more closely resembles the endings of the Wada films, and finally in *Fighting Elegy*, which again reuses Noro and Sugiyama in their supporting roles.

Nikkatsu and *Ninkyō* (Chivalry) Films

The decline in the Nikkatsu Action film's popularity after 1962 and the corresponding rise in popularity of the ninkyō, or chivalry, genre led to some important changes in the kinds of films made at Nikkatsu. Though they are sometimes referred to as simply yakuza films, yakuza (who had also been featured in Nikkatsu Action films, though generally as villains) were a necessary but insufficient element of the ninkyō film. In these films, the central protagonist was himself a yakuza, often with motivations conflicted between a sense of duty to the boss and a desire to break free of a life of violence, or between a sense of duty and a conflicting romance or family tie. Conflicts between yakuza clans over turf or over which clan can perform the local festival

are frequent, but what was at stake in these conflicts was not a matter of material greed (at least for the protagonist's clan) so much as the clan's honor. Beyond the recurrences of narrative, however, the films of the genre expressed these conflicting sentiments with formal emphasis on symbolism and ritual. It is no coincidence that Nikkatsu's first entry in the ninkyō genre was titled *The Symbol of a Man*. These are the terms in which Ueno would celebrate some of the genre's later entries that refined these tendencies more fully, like Katō Tai's *Blood of Revenge* and Yamashita Kōsaku's *Red Peony Gambler* (*Hibotan bakuto*, 1968), but these elements were already present in the genre's earlier entries.

Though the groundwork began to be laid for the genre in the early 1960s with films like Tanaka Tokuzō's *Tough Guy* (*Akumyo*, 1961), perhaps the prototypical film of the genre was Sawashima Tadashi's *Theater of Life: Hishakaku* (*Jinsei gekijo: Hishakaku*, 1963).[55] Made at Tōei (the studio most closely associated with the ninkyō genre) and featuring Tsuruta Kōji and Takakura Ken (the two stars who would most closely become associated with the genre), the film's narrative follows Hishakaku (Tsuruta), a loyal yakuza whose piety causes him to launch an attack on a rival clan and to turn himself in for the murder of one of their members. In so doing, he leaves behind his wife Otoyo (Sakuma Yoshiko), who has to take a new lover, Ninomiya (Takakura), from the same clan while he is in prison in order to keep from being shipped to Manchuria as a comfort woman. After Hishakaku is released from prison, Ninomiya discovers that Otoyo had been Hishakaku's wife, and Ninomiya's sense of duty obligates him to mount a futile attack against the rival clan that had been responsible for Hishakaku's jailing in the first place. He is killed in the process. Upon learning this, Hishakaku must then launch an attack against the same clan out of obligation to Ninomiya, who died avenging him.

Though punctuated with scenes of intense action, *Theater of Life: Hishakaku* and other ninkyō films were strikingly different from the action films that Nikkatsu had been producing in the late 1950s and early 1960s. Whereas the action films were ecstatic celebrations of modernity and freedom, ninkyō films were pervaded with a sense of stoic fatalism. In some ways, the genre transplanted the sword-fighting from the *chanbara* genre, which had been set in premodern Japan, to early modern Japan, as most ninkyō films were set in the late Meiji, Taishō, or early Shōwa era (roughly between the mid-1880s and around 1930),[56] but the codes of chivalry that motivated its central characters' actions reach back to a premodern ideal. It is not uncommon for the rival yakuza clan to be a much more modern enterprise: motivated by material greed, refusing to abide by the codes of chivalry, and frequently associated with modernizing construction (or other industrial) projects. There is a heavy and frequent subtext that modern industrial capitalists are just as violent as the old yakuza, only lacking the heavily idealized codes that held the yakuza clans together. Further,

the films differed sharply in form from Nikkatsu Action films, in some ways more obviously than others. While Nikkatsu Action films would frequently feature chic, modern nightclubs, the rough analog setting in Tōei's ninkyō films was the upstairs *bakuchiyado* (gambling den), a much seedier space. Rather than saturating the image in bright neon colors, filmmakers tended toward murkier brown and blue tones. And finally, whereas Nikkatsu Action films tended to deploy wide-angle lenses for shots staged in extreme depth in a compositional aesthetic owing much to American film noir, ninkyō films marked the beginnings of a long-lens aesthetic, which would become even more prominent later in the decade but was already visible in *Theater of Life: Hishakaku*.

Sawashima depicts the film's sense of fatalism, and the characters' barely repressed emotions, through motifs in environmental and seasonal imagery. In the scene in which Hishakaku learns of Otoyo's new relationship with Ninomiya, Hishakaku's own acting is restrained, and he says little more than to tell her new lover to make her happy. But the scene takes place on a beach with relentlessly pounding waves; Hishakaku returns there after learning of the man's death, where he shouts into these waves. More subtly, the film uses gently falling snow in every scene leading into a flashback while Hishakaku is in prison, associating snowfall with reminiscence, and lingers in long shot on wind picking up dust at moments of intense fatalism, either when Hishakaku is pondering all that had to be sacrificed in his romance for the sake of chivalry or in moments when he is being stirred into battle.

Responding to the new dominance of the ninkyō genre, Nikkatsu Action films changed from the early 1960s. The films after the early 1960s became much less youth-oriented; the youngest star, Wada Kōji, retreated to the role of supporting actor, while previously supporting actor Shishido Jō (himself older than any of the Diamond Line actors) began starring in films more regularly. Ishihara and Kobayashi continued on, but playing older and more world-weary characters than previously. Additionally, the studio began making its own ninkyō films, beginning with Matsuo's *The Symbol of a Man* and the series that followed. Suzuki himself directed three films that fit clearly into the ninkyō genre: *Kanto Wanderer*, *The Flower and the Angry Waves*, and *Tattooed Life*. The films *Our Blood Will Not Forgive* and *Tokyo Drifter* also combine elements of the ninkyō genre with those of other genres.[57]

Suzuki's first entry in the genre, *Kanto Wanderer*, is instructive in that the film is actually a remake of an earlier Nikkatsu Action film, *Song of the Underworld* (*Chitei no uta*, 1956), which had been directed by Suzuki's own mentor Noguchi Hiroshi and featured Ishihara Yūjirō in a major role. The gangsters in *Song of the Underworld* are depicted as modern, carefree youths similar to the ones found in *Season of the Sun* and *Crazed Fruit* from the same year, but *Kanto Wanderer*'s yakuza clans operate as if they still exist in the Taishō era, and they would seem antiquated even in those circumstances.

Elements of the film seem to parody the ninkyō genre. Though Suzuki generally applies his own aesthetics, rooted as they are in the tradition of Nikkatsu Action Cinema, in a number of shots he adopts the *michiyuki* shot (a long-lens technique of showing characters running to or from the camera) from ninkyō films. But while in ninkyō films this tends to be reserved for yakuza marching toward a confrontation, in *Kanto Wanderer* Suzuki reserves it for his schoolgirl characters innocently frolicking. Hasumi argues that the film is less a parody of the ninkyō genre than its distillation.[58] Suzuki isolates elements that are present in early ninkyō films and traces them back to abstraction over the course of the film. For example, Suzuki's film abounds with seasonal imagery similar to that which Sawashima uses in *Theater of Life: Hishakaku* and for a lyrical effect. In the earlier film, Sawashima uses these images—snow, dust in the wind—as visual motifs that have a limited relation to their seasonal meanings. At the same time, however, there is no reason to believe that there is anything anomalous about these images in indicating the seasons: though the film does not clearly mark the passage of time or demonstrate a cycle of seasons, it is plausible with the implicit passages in time that the snow and barren wind appear during the correct seasons. As Hasumi notes, however, in *Kanto Wanderer* the motifs in seasonal imagery that occur over the course of the film—winter's snow for reminiscence (although in this case *within* the flashback rather than leading up to it), summer's wind chimes leading to battle, and an autumn bonfire for regret—are all deployed in the film's climax in a single night, as if the film cycles through all seasons over the course of several hours. All that has happened, however, is that Suzuki has completed the divorcing of the seasonal imagery from its meteorological verisimilitude.

Further, Suzuki uses the film's flashback structure to introduce seemingly innocuous stylistic manipulations into the film that later emerge and dominate the film's climax. When Katsuta first encounters Mrs. Iwata in the film, it triggers a flashback to an earlier encounter with her that is characterized by unrealistic lighting and prominent snow. The unrealistic lighting, which isolates Mrs. Iwata in the flashback's first scene and later flashes in and out during a conversation scene between her and Katsuta, can initially be understood as subjectively motivated because the flashback is marked as Katsuta's own memory. These same tendencies, however, reemerge during the film's climax, when the shōji screens of the gambling hall fall back into a solid red cyclorama wall. The film cuts to an apparently closer shot of red, which is actually a red curtain that pulls back to reveal snow resembling that of the earlier scene (fig. 3.1).

These abstractions in the setting, however, are not necessarily as obvious as the examples listed thus far. In "Suzuki Seijun, mata wa kisetsu no fuzai" (Suzuki Seijun or the absence of seasons), Hasumi observes that in the final ten minutes of *Kanto Wanderer* (which, within the film's diegesis, takes place over a single night and day), the season appears to change three times: Suzuki shows

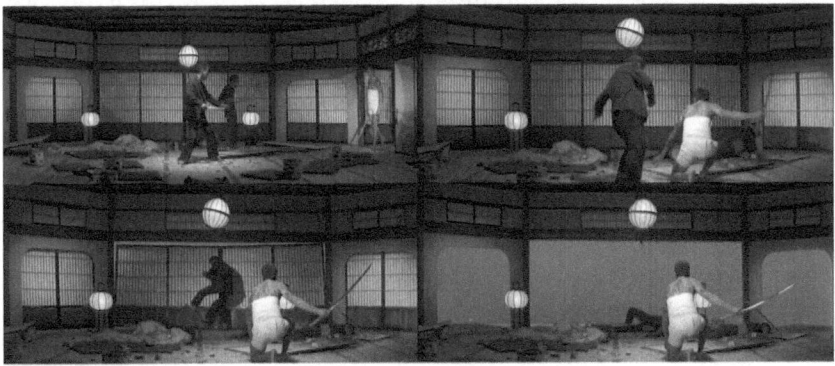

3.1 Abstraction of the set in the climax of *Kanto Wanderer*

snow flurries, wind chimes blowing in the wind, and a bonfire, and Hasumi notes that these three images each have strong seasonal associations in Japan: winter, summer, and autumn, respectively.[59] The cycle of these images in rapid succession, with much greater speed than the actual change of seasons (and in any case, skipping over spring), speaks to Suzuki's tendency to reduce the seasons to imagery and overlook their meteorological conditions. Whereas in *Theater of Life: Hishakaku* and other ninkyō films the environmental meanings of the seasonal imagery help fold it into the diegesis and to naturalize its symbolism, Suzuki's use here distills the symbolism, making it strange and foreign to the film's environment. In its refusal of naturalizing symbolism, the process erodes the distinction between the diegesis and the filmmaker's nondiegetic interventions in the process of narration.

* * *

Looking at the late Nikkatsu films for which Suzuki would retroactively become famous alongside his earlier, less obviously innovative works at the studio makes clear that important aspects of his style (including ones at odds with what Nikkatsu's management wanted) grew out of the Nikkatsu Action Cinema from which the director would ultimately be ejected. This is not to say that Suzuki was merely a product of Nikkatsu Action Cinema, or even that he rehashes the stylistic experiments of his early and mid-period Nikkatsu films in his late Nikkatsu films. Rather, he picked up elements of a kind of house style that can be seen operating in the work of other filmmakers and modified them into the style we now know. The climactic shootout of *Underworld Beauty*, skilled in its use of staging, deep-focus cinematography, and lighting, operates well within the norms of Nikkatsu Action Cinema; one could conceive of such a scene at

the climax of a film by Noguchi Hiroshi or Saitō Buichi as much as one directed by Suzuki. By contrast, the climax of *Tokyo Drifter*'s abrupt and intrusive shifts in lighting and color motivated solely by highlighting dramatic moments without a diegetically realistic pretext may draw on some tendencies toward lighting and color usage that are common throughout Nikkatsu Action Cinema, but their arrangement in the scene is totally unlike what we can observe in other filmmakers working in the same context. Many of these aspects of his style are ones that he would carry into his post-Nikkatsu television, art-house, and genre work. What unites the specifically Seijunesque style—the elements he picked up from his context, those he modified, and those he developed himself—is an inventiveness that constantly pushes against his constraints (generic, technological, and industrial), resulting in a kind of self-reflexivity. At the same time, this self-reflexivity does not overwhelm the narrative or psychological elements of his films but frequently complements them.

CHAPTER 4

THE EMERGENCE OF THE SEIJUNESQUE

When defining the style of a filmmaker, it is common to identify one or more formal traits that the filmmaker uses throughout their career, and to take note of how those techniques are modified either over time or locally within individual films: the dolly and crane movements of Max Ophüls, the sequence shots of Mizoguchi Kenji or Sōmai Shinji, the intercutting of D. W. Griffith, or the competing models of montage by Sergei Eisenstein and Dziga Vertov. In other cases, a style could be defined by a network of elements working in tandem, such as the combination of deadpan acting, isolated framings, and elliptical editing in Robert Bresson, or the combination of stationary, low cameras, frontal character placement, intricate graphic matches, and misleading decoupage in Ozu Yasujirō.

When attempting to define the style of Suzuki Seijun, it quickly becomes apparent that this approach is impossible. Throughout his career, and often within the course of a single film, the formal techniques Suzuki deploys run the gamut of possibilities: deep focus to shallow focus, deep-space staging to flat staging, disjointed juxtapositions through editing to sequence shots, location shooting to impossibly constructed soundstage sets. Suzuki's approach to cinematic form is crucial to understanding his body of work and what defines him as a filmmaker, but it is also a moving target. Rather than rigidly imposing preconceived formal parameters on his films from the outset, Suzuki constantly absorbs and reacts to new developments, both generic-industrial and technological. Ueno Kōshi wrote that the defining Seijunesque trait was not a

sole formal device but rather *zure*, which could loosely be translated as "deviation": the sense of sudden shock and confusion at what we see in front of us.[1]

It is tempting to equate Suzuki's *zure* with a lack of internally consistent logic, and to claim that it merely produces films that favor formal spectacle over narrative integrity. If we look back at Suzuki's sequences in retrospect after the initial, visceral shock, however, what we find is not a lack of logic but a careful set of formal choices to conceal from the audience what is actually taking place in front of them, or to mislead them deliberately, only to have it revealed to them in retrospect. Since there are no overarching formal parameters that govern these sequences in a consistent way across Suzuki's work, even viewers who are thoroughly familiar with his style may still experience the shock of this *zure* when confronted with a new Suzuki film. Though the style that would come to be recognizable as Seijunesque was in part determined by various technological, industrial, and artistic shifts that took place over the course of his career, it is the way that he absorbed them, by exploring their possibilities as new opportunities to startle his audience, that would become characteristically Seijunesque.

Enframing

At the heart of Suzuki's composition style is the inherent contradiction between the flatness of the cinematic image and the appearance of depth it produces. His films often directly juxtapose images staged in depth with ones staged in a flat panorama. At other times, they synthesize flatness and depth with devices such as mirrors or other partitions, with compositing techniques such as rear projection, or by using cyclorama walls that produce an effect of solid color backgrounds that simultaneously appear completely flat and infinitely deep. Suzuki uses these techniques fleetingly within individual films, but a broader pattern of them emerges when looking at his filmography as a whole.

These specific techniques grew out of broader industrial shifts and aesthetic trends in the Japanese film industry, and in Nikkatsu Action Cinema in particular. He entered the industry when the 1.33:1 standard frame dimensions were assumed, and when a deep-space, deep-focus staging style was the norm at Nikkatsu. Over the course of the next decade, Nikkatsu adopted anamorphic lenses and used them for all its films. Nikkatsu films gradually began to incorporate and foreground more stage sets. The coming of 'Scope challenged the assumed aspect ratio and forced filmmakers to consider more consciously the dimensions of the film frame. As Ichikawa Kon articulated, "I had taken for granted how the screen was shaped.... All of a sudden, new windows had appeared to the left and right of that original one, and it was up to me to learn how to connect them."[2] Suzuki's experiments within the initial paradigm, and his responses to the shifts, bear some similarities to other filmmakers

working at the time, but at each stage, Suzuki introduced striking innovations to each of these tendencies. Further, his films are unique for the way that they do not merely follow the technological and stylistic shifts that took place around them but juxtapose them with tendencies from the earlier paradigms.

At the risk of generalizing, the broad tendency of Suzuki's earliest films, as well as those of other filmmakers within his milieu, could be characterized as deep-focus compositions with deep-space staging. Early Nikkatsu Action films tend toward wide-angle lenses, deep focus, and crowded, deep-space staging. For example, Kurahara Koreyoshi's *I Am Waiting* skillfully deploys this kind of focus and staging alternately for emotionally expressive purposes and to set up hierarchies of knowledge within the staging (fig. 4.1). We can see an example of the former tendency in the way that Kurahara expresses Ishihara Yūjirō's and Kitahara Mie's emotional closedness to each other through their physical distance in depth and opposite directions. We see an example of the latter tendency in the frame in which the gangsters roughing up Yūjirō are not yet aware of Kitahara looking on in the distant background.

In the late 1950s the Japanese film industry adopted anamorphic lenses, and the major studios would use the new process for the vast majority of their output into the 1970s.[3] In 1957 Nikkatsu released its first films in NikkatsuScope,[4] and by June 1958 the studio transitioned all its films into the anamorphic process that produced an aspect ratio of approximately 2.35:1.[5] The combination of high-contrast lighting and staging in depth proved difficult to adapt to anamorphic filmmaking when it was first introduced in Hollywood, since anamorphic lenses, particularly early ones, substantially narrowed depth of field, forcing filmmakers to shoot with either more lighting or less depth. This was compounded by the transition to color, which further narrowed depth of field, and the early insistence by 20th Century Fox (CinemaScope's copyright holder in the United States) that all CinemaScope films would be shot in color.[6] However, because anamorphic filmmaking came to Japan several years later, when lenses

4.1 Deep-focus, deep-space staging in Kurahara Koreyoshi's *I Am Waiting*

with deeper focus had been made, and there were never restrictions placed on filming in black-and-white anamorphic in Japan as there initially were in Hollywood, high contrast, deep-focus, black-and-white filmmaking with similar staging practices was able to carry over more seamlessly into Japanese films shot in the anamorphic aspect ratio.[7] Filmmakers continued to use wide-angle lenses, deep focus, and deep-space staging. The additional lateral space also allowed filmmakers to layer the depths without crowding the frame horizontally. Nearly twice as wide as the standard frame, it allowed filmmakers to create multiple points of interest within the same frame with different emphases (what Charles Barr referred to as the "gradation of emphasis").[8] This tendency toward anamorphic deep-space staging, with figures scattered horizontally in different parts of the wider frame and layered at different depths, is visible in early anamorphic Nikkatsu films. The wider screen space also allowed filmmakers to partition the frame laterally to contain what would previously have required two shots. For example, in *Red Pier*, Masuda Toshio combines a close-up of Nakahara Sanae in the extreme foreground, eavesdropping, with a long shot of the gangsters she is listening to in the left background, into a single composition (fig. 4.2). This trend could be elaborated with the use of subframes and reflective surfaces: in the same film, Masuda uses a three-part mirror to glamorize actress Shimizu Mayumi, showing her from multiple angles brushing her hair, while also creating a space in the background of one reflection to show Ishihara Yūjirō in conversation with her (fig. 4.3).

There were, however, two separate influences that pushed Nikkatsu filmmakers broadly toward a flatter aesthetic by the mid-1960s. The more ubiquitous, if less immediately obvious, of these was a broad shift from the deep-focus, deep-space aesthetic of Nikkatsu's noirish thrillers toward a telephoto aesthetic that came with the rise of the ninkyō genre in the early 1960s. Whereas the earlier noir films had used wide-angle lenses to maximize focal depth and emphasize distances along the (simulated) z-axis of the image, ninkyō films began opting for the telephoto lens to narrow focal length in close-ups, turning backgrounds into abstract blurs, as well as flattening the z-axis in longer shots. As Nikkatsu filmmakers began working in the ninkyō genre in the mid-1960s, they began to adopt this aesthetic. By the late 1960s directors who had previously used the deep-focus aesthetic were now using the telephoto aesthetic even in contemporary-set gangster films.

The second push came from the prominence of experiments with what might broadly be called theatricality and theatrical spaces after the adoption of the anamorphic aspect ratio in the 1960s. Because 'Scope's wider aspect ratio is closer to the dimensions of a proscenium stage than the squarer standard frame, its adoption led some filmmakers to embrace a self-consciously theatrical style, with flat staging and backgrounds painted to look like stage sets, as it became ubiquitous. Prestigious filmmakers like Kinoshita Keisuke,

4.2 Laterally partitioned deep-space staging in Masuda Toshio's *Red Pier*

4.3 Mirrors for glamor and recessive staging in Masuda Toshio's *Red Pier*

Uchida Tomu, and Ichikawa Kon embraced this possibility in *The Ballad of Narayama* (*Narayama bushikō*, 1958), *The Mad Fox* (*Koiya koi nasu na koi*, 1962), and *An Actor's Revenge* (*Yukinojō henge*, 1963), respectively. These films adopted relatively flat composition styles, color-filtered lighting, and ostentatiously flat painted backgrounds consistently throughout the film. However, this was not limited to a handful of high-profile experiments. Many films in the comparatively low-brow genre of tanuki musicals, including *The Princess of Badger Palace* (*Ōatari tanuki goten*, Saeki Kōzō, 1959), *Enchanted Princess* (*Hatsuharu tanuki goten*, Kimura Keigo, 1959), and *Vagabonds from Badger Palace* (*Hanakurabe tanuki dōchū*, Tanaka Tokuzō, 1961) also embraced the wider frame as a virtual theatrical stage.

When discussing the use of ostentatiously theatrical techniques in Japanese cinema, particularly in CinemaScope, it is common to invoke Japanese

theatrical practices, particularly in Kabuki, as sources of the techniques. Much has been written on the inherited traits from Kabuki theater in Japanese cinema, and with respect to these films in particular, but we should remember that these filmmakers adapted theatrical techniques to cinema in a more promiscuous way than this might suggest, particularly in the comparatively low-brow tanuki musicals.[9] Though some elements of costuming, set design, choreography, and musical performance were drawn from Kabuki in these films, filmmakers also called on a variety of other theatrical and musical techniques: *The Princess of Badger Palace* even features its tanuki performing a mock-Caribbean dance to a rendition of Harry Belafonte's "Day-O" alongside other musical and dance numbers in both traditional and contemporary styles.

Nikkatsu did not make any of these high-profile experiments with theatricality, nor did it produce any popular genres, such as the tanuki musicals, that worked with these stage spaces in a sustained way over the course of an entire film. Stage spaces *were* important in the context of Nikkatsu Action Cinema, however, most frequently in the form of stages for musical performances at Ginza nightclubs. It is common for brief sequences showing a stage performance in these films to adopt a similar use of the anamorphic frame as re-creating the dimensions of a proscenium stage. In keeping with Nikkatsu's practice of cross-media star making, these were frequently used for musical numbers that could be released as singles alongside the film. The prominence of these stage spaces within Nikkatsu Action films presented numerous opportunities for stylistic experimentation, allowing filmmakers to disguise experimentation with film form as "stage tricks" (even if they were created in ways that would not be possible in a live setting), as well as striking shifts in color and lighting that I will explore in the next section. While Nikkatsu Action filmmakers broadly used many of these tricks, Suzuki is unique for the way that, early in his career, he used the stage as a diegetic pretext for forms of stylistic experimentation that he would later perform after dropping the pretext of the theatrical stage.

Beginning his career when the deep-focus aesthetic was in vogue, Suzuki composed his earliest film shots in extreme depth, placing characters in the foreground, middle ground, and the deepest parts of the background. Like other Nikkatsu Action filmmakers, he varies the ways in which he uses this depth based on the different moods and meanings of the scenes. In *Harbor Toast: Victory Is Ours*, one shot shows a cozy bar scene, grading the depths of its characters between foreground, middle ground, and background; another shows a confrontation, leaving the middle ground empty and separating the two sides (fig. 4.4). Variations on these tendencies are apparent in many of his earliest films, but there is also already a playfulness apparent in his staging. In *An Inn of Floating Weeds*, for example, he plays with the vertical axis in addition to the horizontal and axial axes in a lighthearted romantic scene (fig. 4.5). Though perhaps more subtle than some of his later uses of staging, this more playful staging is exhibited more often than we see in other Nikkatsu films.

4.4 Deep-focus, deep-space staging in *Harbor Toast: Victory Is Ours*

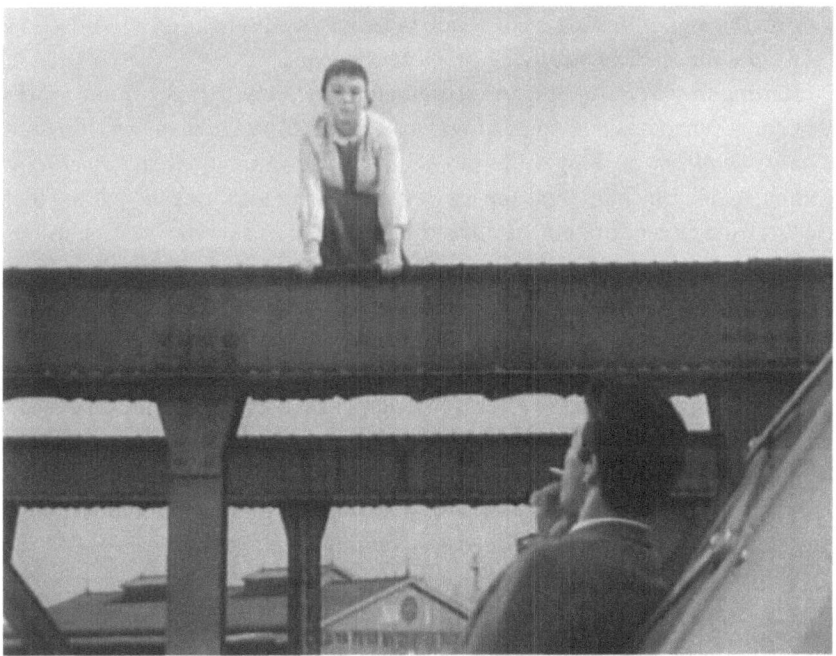

4.5 Deep-space staging along the *x*-, *y*-, and *z*-axes in *An Inn of Floating Weeds*

Suzuki began filming in the anamorphic aspect ratio in 1958, not by choice, but because of Nikkatsu's top-down decision to shoot all its films thenceforth in the new format. This precedes by a few years his own shift toward an exploration of flatness instead of (or alongside) extreme depth. When interviewed about the anamorphic frame later, Suzuki claimed that the transition was his reason for adopting more theatrical techniques, but he did so by expressing a dissatisfaction with the format: "I was working in CinemaScope, and that ratio is very theatrical. When you move a character forward in the frame, it

doesn't have much of an effect, so I would use a spotlight to make the movement more dramatic. I guess I was covering up the weakness of the cinemascope frame with that effect."[10] Suzuki's recollection here is belied by his own initial anamorphic films; the majority, from *Underworld Beauty* in 1958 through *Everything Goes Wrong* in 1960, still adhere much more to the deep-space, deep-focus aesthetic even within the anamorphic frame. His adoption of the flat techniques that he describes as "theatrical" first becomes apparent in short stage sequences in some of these films (including *Love Letter* and *Passport to Darkness*); however, these are confined to relatively short parts of the film. Several of Suzuki's kozō films with Wada Kōji do feature longer stage sequences that allow for formal play understood within these films as stage tricks. In particular, the stage Noh performance at the climax of *Tokyo Knights* and the magical theater performances in *The Wind-of-Youth Group Crosses the Mountain Pass* incorporate more tricks with lighting and mise-en-scène that foreshadow Suzuki's future experiments.

Starting in 1963 Suzuki began incorporating theatrical techniques into spaces that are not marked off as stage spaces. In a flashback sequence midway through *Kanto Wanderer*, he adopts the proscenium-style framing while depicting a gambling hall, which prompts the use of numerous sudden shifts in lighting that lack realistic diegetic origin. The film's climax sequence, discussed in the previous chapter, again adopts the proscenium stage framing, along with a spotlight to trace the protagonist Katsuta's movement as he enters. Suzuki takes this technique to an even further extreme in *Carmen from Kawachi* with an extreme long shot of Tsuyuko's instructor's house in its entirety, literally with a broken fourth wall, and a spotlight on Tsuyuko's movements through the house. It plays with scale, making Tsuyuko look like a doll in a dollhouse, but it also becomes visible as a studio set (fig. 4.6). The sense of the scene taking place on a stage is reinforced by the spotlight that focuses on Tsuyuko as she moves around the set, unmotivated by any light source that can be claimed exists within the diegesis.

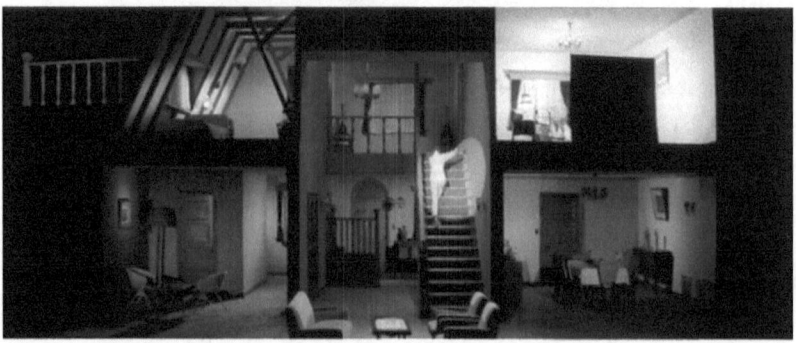

4.6 Soundstage house in *Carmen from Kawachi*

Many of Suzuki's post-Nikkatsu films use a similar kind of flat staging within other aspect ratios, suggesting that even if he developed his practice of flat staging because of the 'Scope frame, he liked it enough to continue the practice elsewhere. Particularly in the Taishō trilogy films, Suzuki frequently uses a staging technique of placing several characters in conversation along the same plane, facing the camera as they ostensibly are speaking to one another (fig. 4.7). Just as frequently, though, he inverts this scheme by placing characters in conversation along the same plane, but with their backs facing the camera for the entirety of a conversation, similarly deploying an artificially flat staging technique but refusing to show their faces (fig. 4.8).

Even if these later films saw Suzuki adopt a flat proscenium style stage aesthetic, and incorporating various types of theatrical techniques such as light cues and set designs lacking a complete foreground or background, it should be stressed that none of these films adopts these techniques for the duration of the film. Other experiments with theatrical staging from the era (whether the prestigious experiments of Kinoshita, Uchida, and Kon or the humble tanuki musicals) tend to operate within a self-contained set of stylistic norms so that the stylistic tendencies of staging and lighting become natural over the course of the film through their consistency. What is distinct about Suzuki's use of these techniques is the fact that they only appear in brief flashes, and in so doing they are more emphatic when they appear, and they prevent a stable set of

4.7 Flat, frontal staging in *Kagero-za*

4.8 Flat, reverse staging in *Spring Cherry Blossoms: Japanesque*

stylistic laws from emerging. Both Suzuki's late Nikkatsu and his post-Nikkatsu work experiment with flat staging in ways that are distinct from his earliest work, but often these same films also contain shots that adopt the wide-angle, deep-space staging aesthetic, sometimes directly juxtaposed with the flat, theatrical staging discussed here.

Like other filmmakers working at the same time, Suzuki began taking advantage of the opportunity to partition the frame almost as soon as he began working in the anamorphic aspect ratio. Mirrors, windows, and doorways, particularly shōji screens and fusuma, lend themselves to creating subframes, and they appear frequently in his work. One unique feature of Suzuki's partitions is that, even from early on, he often uses the partitions to distort parts of the frame. In *The Sleeping Beast Within*, he uses a glass window to break apart a woman's face during a conversation scene in which she is investigating her father's business by interviewing the man (right), which he films entirely from this perspective (fig. 4.9). Rather than presenting a simple two-shot, the glass pane separates the 'Scope frame in half, placing both a shot and a reverse shot in separate frames within the same frame. Seeing the woman broken apart by the frame also has a strange, uneasy effect on the scene, helping establish a suspenseful mood and perhaps suggesting an identity crisis as she discovers her father is involved in a criminal enterprise. This glass panel is one of several types of enframing devices that Suzuki uses to make subcompositions within the greater frame. As with the visual distortion that the glass panel provides, these devices give Suzuki a diegetic pretext to distort the image. Similarly, Suzuki uses mirrors as an opportunity to distort images through the recurring use of shattered mirrors in order to shatter figures within a composition (fig. 4.10). These distortions using the pretext of mirrors form the basis for later experimentation with fragmenting figures even without a distortive surface, seen, for example, in a sequence

4.9 Partitioned framing with distorting glass in *The Sleeping Beast Within*

4.10 Shattered mirror in *Detective Bureau 2-3: Go to Hell, Bastards!*

where the lieutenant is mentally torn into pieces in his later film, *Story of a Prostitute* (fig. 4.11).

Like other Nikkatsu filmmakers discussed earlier, Suzuki also uses mirrors to show characters and objects off-screen behind the camera. In *The Voice Without a Shadow*, he uses this technique to show both a shot and reverse shot (the latter reflected in a mirror) for the duration of a conversation while showing both characters' faces simultaneously (fig. 4.12). He repeats this technique in *Carmen from Kawachi*, showing Tsuyuko's reflection in a mirror as she talks to the man she discovers she has spent the previous evening with (fig. 4.13). Here, though, he uses the mirror for an additional expressive effect: Tsuyuko hits the mirror at one point, setting it spinning around in circles so that it intermittently shows her reflection and the man's reflection, timed almost perfectly to which character is speaking. The spinning mirror gives an intuitive psychological reading: the image of Tsuyuko spinning out of control as a reflection suggests a fraying sense of self. At the same time, however, it replicates the way that the man is framed to the mirror's right between

4.11 Torn figure in *Story of a Prostitute*

4.12 Shot and reflected reverse-shot in *Voice Without a Shadow*

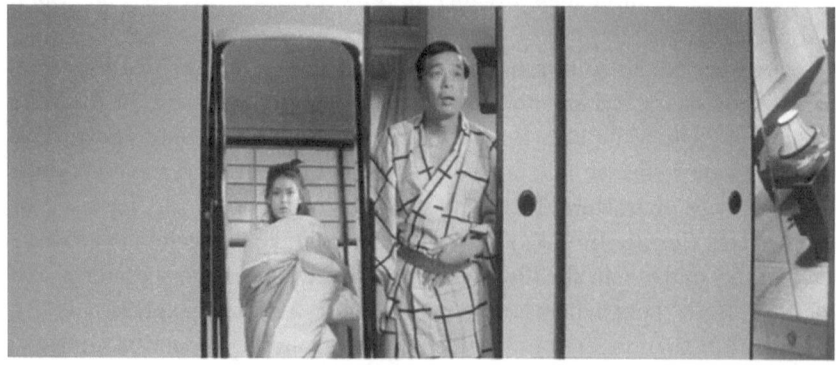

4.13 Spinning mirror in *Carmen from Kawachi*

two fusuma, so that Suzuki simultaneously shows a two shot of two characters facing the camera while looking at each other and isolates each into singles with the subframes.

Returning to the standard-sized aspect ratio in his post-Nikkatsu independent and television work, Suzuki continued to use distortive reflections, but whereas his anamorphic films often self-consciously divided the wide frame into subframes, Suzuki opts not to distinguish between frame and subframe in the squarer films, making it difficult to discern where the reflection begins and ends. For example, in *Kagero-za*, he uses a reflecting pool to create an impossible perspective on a conversation scene, an unusual spatial relationship between the two characters in conversation, and he uses a periodic ripple effect to create further distortion in the reflected figures (fig. 4.14). In "A Family's Choice," a murder investigation unearths a past trauma by revealing that the protagonist had been the sole survivor of a series of rapes and murders several decades ago, and that her son's biological father was actually the rapist-murderer rather than her ex-husband. After this is unearthed in her conversation with a detective that her son overhears, Suzuki ends the sequence with a shot dividing her face in reflection (fig. 4.15). The way the image divides her face in half has a similar effect of fracturing her face that the earlier uses of the broken-mirror motif had, and its function is also

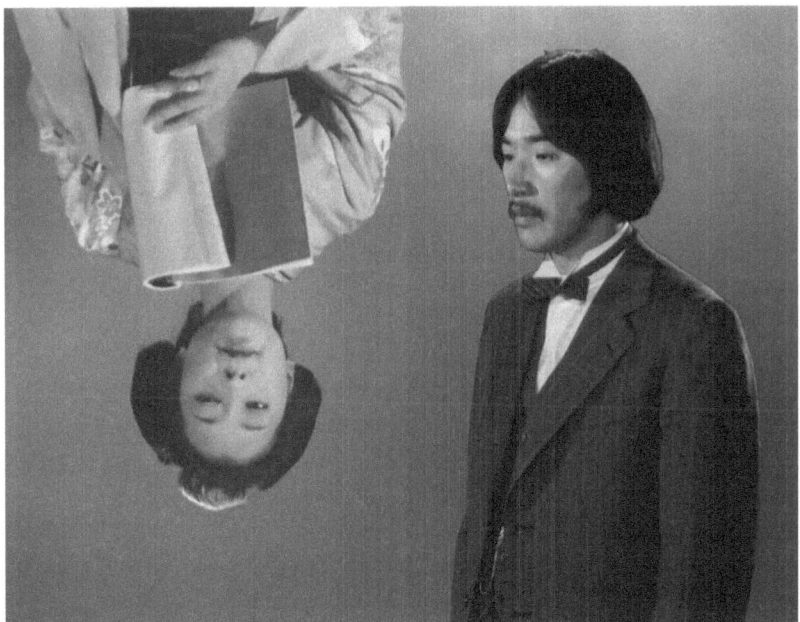

4.14 Reflected conversation in *Kagero-za*

4.15 Face divided in reflection in "A Family's Choice"

similar, visualizing the dissociative effect of her traumatic experience as she is forced to relive it. However, while the broken mirror provides a fractured subframe within the image, this shot blurs the distinction between what is the reflection and what is being reflected.

In addition to partitioning frames visually with subframes, Suzuki also frequently synthesizes multiple perspectives into the same frame with compositing techniques. While rear projection was a common technique in popular Japanese cinema in the 1960s, and other compositing techniques such as "green screening" are common in Japan and elsewhere in contemporary cinema, what is unique about Suzuki's use of these techniques is his commitment to synthesizing perspectives that do not align with one another. In their conventional uses in Nikkatsu Action Cinema and most other commercial narrative cinema, compositing techniques are typically designed to be unnoticeable to the extent possible: filmmakers choose realistic backgrounds (for example, roads for driving sequences) and aim for verisimilitude in perspective between foreground and background, making it look as though the foreground space flows naturally into the background space. This also describes most of Suzuki's uses of rear projection through the early 1960s. Beginning around 1964, however, he frequently aims for discontinuity between foreground and background by using perspectives that do not align with one another.

In *The Flowers and the Angry Waves*, he uses this technique in a flashback when Kenji recalls being given a hit order by his boss. The rear projection separates the boss and Kenji in the foreground from the image of the woman in the background, filmed separately. The images are shot at noticeably different angles: the boss and Kenji are filmed from a slightly low angle, while the picture of the woman is filmed from a high angle. The lighting sources are likewise inconsistent: the overhead light on the picture does not correspond to the key lighting (off-camera right) on the faces in the foreground. Even without

The Emergence of the Seijunesque 105

4.16 Rear projection in flashback in *The Flowers and the Angry Waves*

being able to parse the technical details of the way this was filmed, the very strangeness of this composite image is visible to the naked eye (fig. 4.16). Suzuki uses this technique in a more bizarre way in one scene in *Our Blood Will Not Forgive*, in which Shinji and Ryōta are talking together in a car. Instead of rear projecting a road that the brothers would conceivably be driving on, Suzuki rear projects the ocean with waves crashing in back, and even as he cuts to alternate angles, he continues to use the same shot of the ocean, so that the waves crash in the same direction regardless of the perspective.

In his post-Nikkatsu work, Suzuki frequently foregrounds the artificiality of his use of rear projection and other forms of compositing to create spaces of fantasy. In *Pistol Opera*, the "river of death" is created by projecting a golden body of water behind a dock with a superimposed image of spirits (fig. 4.17). *Princess Raccoon* draws freely from a variety of art forms, including landscape painting, scroll painting, theater, as well as older cinematic techniques like matte-painting and rear projection behind vehicles, creating a world with fluid diegetic laws (fig. 4.18). In each case the impossibly aligned perspectives in the images being composited have the effect of separating the foreground and background images rather than synthesizing them; rather than creating a single, three-dimensional space that flows from foreground to background, these make the audience aware that they are created out of separate flat images, each with their own perspectives designed to simulate depth in separate ways.

These tendencies can all be seen to work in a shot that combines a reflective image, flatness, and depth into a single shot in *Carmen from Kawachi*. When Tsuyuko is auditioning as a model, we see a reflection of her with the headmistress in the foreground and Tsuyuko in the background. The shot, however, is from the headmistress's perspective rather than Tsuyuko's, so when the former lifts her hand and it makes it look as though she is fondling Tsuyuko's breast in the reflection, we see the play of perspective in the mirror but are also consciously aware of the fact that while allowing us access to the headmistress's

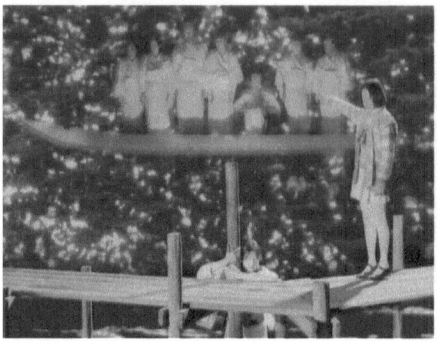

4.17 River of death in *Pistol Opera*

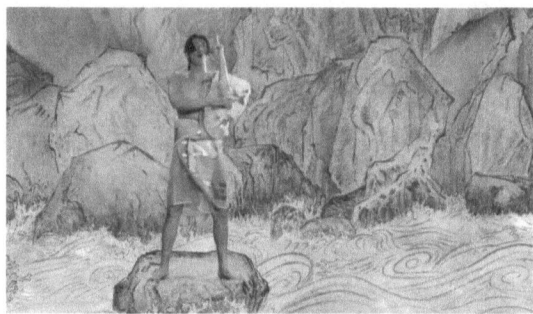

4.18 Staging against abstract backgrounds in *Princess Raccoon*

point-of-view, it foreshadows her later sexual advances on Tsuyuko. Staged near the mirror, the headmistress's perspective is close to our own, whereas Tsuyuko's, standing further back, is not. This means that we and the headmistress can see her hand fondling Tsuyuko's breast in reflection while Tsuyuko cannot. Through the mirror, Suzuki can synthesize both depth and flatness into a single composition (fig. 4.19).

Moving between extreme depth and artificial flatness, Suzuki prevents any one tendency from becoming too familiar and is able to play tricks on the audience's perspective. In incorporating enframing devices into the greater film frame, he introduces visual distortion and produces a kind of visible editing through the juxtaposition of multiple subshots within a single frame. These tendencies push outward to the overarching film frame, which Suzuki, by the end of his Nikkatsu career, would comfortably distort without pretext. At times these techniques are lyrical or subjective nuances in form to the film's narratives that can be felt more viscerally, but at other times they push against the narratives they are ostensibly narrating.

4.19 Synthesizing flatness and depth with a mirror in *Carmen from Kawachi*

Color

Suzuki's bold use of color has come to be regarded as one of the defining aspects of his style in retrospect. When cataloging aspects of the "Seijunesque," Suzuki's use of color is, in fact, the first stylistic trait that Ueno Kōshi observes.[11] From Tetsu's powder-blue jacket in *Tokyo Drifter*, to the brightly colored nightclub backgrounds of *Our Blood Will Not Forgive* and *Tokyo Drifter*, to the color-coded women's dresses in *Gate of Flesh* and the bizarre color shifts that take place at the climaxes of *Kanto Wanderer*, *Tattooed Life*, and *Tokyo Drifter*, Suzuki's use of color is notable for both the intensity of the colors themselves and the sudden, often shocking transformations in color that take place in front of our eyes. Though the majority of his Nikkatsu films were made in black-and-white, the distinct color style has become closely associated with him and has been noted by color cinema scholars such as Richard Misek and Edward Branigan.[12] David Desser offered a more extensive consideration of Suzuki's use of color, but his reference points speak to the limited number of films available when he wrote his essay in 1994. As a result, Desser discusses Suzuki's color in relation to the color films of Ozu and Kurosawa and a handful of watershed films like *Carmen Comes Home* (*Karumen kokyō ni kaeru*, Kinoshita Keisuke, 1951) and *Gate of Hell* (*Jigokumon*, Kinugasa Teinosuke, 1953). However, Suzuki's immediate context of Nikkatsu's popular youth and action films of the 1950s and 1960s bears a more direct relationship to his color design.[13]

Suzuki's use of color derives from a broader color idiom at work in the films of his contemporaries in popular Nikkatsu films but is characterized by a comparative move toward abstraction. I mean abstraction in the sense that the term is used by color theorist Paul Coates, who defines it as "the complete

separation of color and object."[14] This definition of abstraction as a process of isolating a discrete element of film form resonates with some of the claims made by Hasumi as isolating individual properties of the cinematic medium in a way that ultimately reveals their material properties. After experimenting with the possibilities offered by an inherited style in the early 1960s, Suzuki abstracted color design from diegetic objects into a discrete element of film form, and this approach to color would carry over into much of his post-Nikkatsu film, television, and video work.

At Nikkatsu, Suzuki had little control over whether his films would be in black-and-white or color. The studio made the decisions, partly according to how much money it was willing to give to a project, though also according to whether color was thought to suit the subject matter. Under these circumstances, it is perhaps unsurprising that the number of films Suzuki made in color at Nikkatsu traces not only his career arc within the studio hierarchy but also the relative success of the studio and Nikkatsu Action Cinema. He directed his first color film, *Fighting Delinquents*, in 1960, during the height of Nikkatsu Action Cinema's popularity. Between that film and the end of 1964, fourteen of the sixteen films that Suzuki directed were in color. By contrast, only two of the seven features he directed between 1965 and the end of his tenure at Nikkatsu were in color. The studio's decision-making process regarding color could be nebulous and could change very suddenly; on more than one occasion, Suzuki and his cast and crew entered production believing the film they were making was to be in color, only to learn otherwise upon receiving black-and-white film stock.

As with other aspects of Nikkatsu Action Cinema's style, the genre's color idiom has its roots in a group of popular Ishihara Yūjirō starring vehicles from the late 1950s. Specifically, in 1957 Inoue Umetsugu released three Ishihara Yūjirō starring vehicles comprising the earliest color films of Nikkatsu Action Cinema: *The Winner*, *Eagle and Hawk* (*Washi to taka*), and *The Stormy Man*. The films used "Nikkatsu Eastmancolor," the color process in which all subsequent Nikkatsu Action films in color would be made,[15] which, like Nikkatsu-Scope, was simply putting the studio's name on an imported technology. In histories of the Hollywood film industry, Eastmancolor is often cast as the inexpensive and inferior alternative to Technicolor, and not inaccurately: Eastmancolor is a single-strip film process (as opposed to Technicolor's three-strip process), meaning that it requires a third of the film stock as Technicolor and does not rely on special cameras, but the richness of the colors is markedly inferior, and the color fades much more rapidly and unevenly. In the Japanese context, however, Eastmancolor was a marked improvement over Fujicolor and Sakuracolor, the two processes that had been developed locally and were used in the early 1950s.[16] With *The Winner*, Inoue took advantage of Eastmancolor's comparative saturation, particularly in the film's many nightclub sequences,

which heavily draw on the pretext of stage lighting to use brightly colored light filters. Though the association between musical performance and color would appear to replicate the prominence of color design in Hollywood musicals, an important difference quickly emerges. Richard Misek makes a useful distinction between *surface color* (the color of objects as they appear in white light) and *optical color* (color created by lighting). He argues that even within musicals, Hollywood films tended to use white light and to create their more elaborate color schemes with surface color: the props, set designs, and costumes, as spelled out in the guidelines of Hollywood's Society of Motion Picture and Television Engineers.[17] At Nikkatsu, however, Inoue and other filmmakers quickly began using colored light filters in stage spaces, street scenes in the Ginza district (motivated by off-screen neon lights), and even in interior spaces in the Ginza district (motivated by off-screen neon lights coming in through windows). Within a few years Nikkatsu would begin increasingly shooting action films on location outside of Tokyo. In cases where the films were shot in other modern cities, filmmakers would simply use these cities' nightlife districts in a similar way to the Ginza in Tokyo-set films. Films shot on location in rural areas, such as those of the *Rambling Guitarist* series, offered filmmakers fewer pretexts for optical color, and their color design featured less formal play as a result.

The emphasis on optical color had important implications for the color design of Nikkatsu Action films. It gave sequences in the Ginza district (and similar nightlife districts in other parts of Japan) a vibrant color scheme, but one unlike those found in Hollywood musicals. Since color-filtered light would function as the key light for an entire frame, the entire image would appear in subtle variations in hues of that color. As a result, the colorful individual frames in Nikkatsu Action films tend either to be uniform in color design or to divide sections of the image into different colors using multiple colored light sources (what Misek refers to as "chromatic zoning").[18] It also allowed for much more rapid transformations of the color scheme of an individual shot without editing, with shifts in motivating light sources, such as the flickering of a neon sign or the cycling of stage light filters. In Inoue Umetsugu's *The Stormy Man*, for example, Inoue uses multiple colored light filters cycling over Ishihara Yūjirō during his performance so that he and his surroundings quickly change colors.

By 1959 color had become much more widespread, and other filmmakers working at the studio imitated the high-contrast, pastel-filtered lighting. But we can also see a push toward these kinds of bright, filtered lights in the background without the necessary pretext of stage spaces or visible neon lights. Filmmakers also began to play more with quick shifts in optical color without directly showing the light sources causing the shifts, such as a scene in Yamazaki Tokujirō's *The Volcano's Wind* (*Umi o wataru hatoba no kaze*, 1960) in which Shishidō Jo attempts to pick a safe while the main light source cast over him cycles between pink, black, and green.

When Suzuki directed *Fighting Delinquents* at the end of 1960, the Nikkatsu Action color idiom had already been firmly established. Suzuki's earliest color films adopt aspects of it: theatrical and musical performance spaces as a pretext for colored light filters, exterior scenes in nightlife districts with neon lights and key lights from colored light filters implied to be from neon light sources, and the use of colored light filters to facilitate rapid and shocking shifts in an overall color scheme. Even in *Fighting Delinquents*, however, Suzuki begins to experiment with this idiom in unconventional ways, and to push the ostensible pretexts of his colored light cues past diegetic plausibility. He films a conversation scene in a nightclub during a performance, and directly shows the colored light filters it uses. After showing the transition between red and blue light filters, Suzuki cuts to a two-shot of a man and woman bathed in a blue light. The color is uniform across the frame, but it shifts multiple times over the course of the scene: from blue to green, from green to yellow, from yellow to white light, and, finally, to a garish red. Though Suzuki takes the trouble to show the cycling light filter before the conversation, the uniform lighting across the frame, particularly as part of the nightclub that is not close to the stage, seems implausible. Further, even though the color shifts are motivated by the cycling of a light filter, they are timed to turning points in the conversation: the blue-to-green shift takes place at the moment when the man tells the woman that her long-ago-abandoned son has reappeared, and the color shift underscores the change in her facial reaction when she hears the news. Though the technique has both a diegetic pretext and a dramatic function in the scene, it is so overtly manipulative and unrealistic that it turns into a self-reflexive joke about the use of color and light shifts in Nikkatsu Action Cinema.

Suzuki would continue to use similar lighting cycles to create major compositional color shifts over his next several films: in *Tokyo Knights*, in a car scene with a rear-projected background of a Ginza street, using the familiar process of passing lights across the car windows in combination with rear projection to suggest movement, he cycles through a series of color filters so that the villain is bathed sequentially in orange, green, yellow, pink, and blue light. In a performance sequence in *Living by Karate*, he uses spatially discontinuous editing to show three performers suddenly shift to different parts of a nightclub so that they appear suddenly under purple, red, and yellow lights. In *The Wind-of-Youth Group Crosses the Mountain Pass*, three different colored juices splash across Wada Kōji's face, and the lighting shifts each time: red light for the red juice, yellow light for the yellow juice, and green light for the green juice. Though Suzuki maintains a diegetic pretext within each of these sequences, it becomes flimsier with each successive film.

These color cycles in Suzuki's earliest color films contain the seeds of what would become Suzuki's personalized color style in his later films at Nikkatsu. First, the uniformity imposed by the colored light filters would persist even as

Suzuki incorporated surface color in his color design: rather than intricate color patterns, Suzuki's color design at Nikkatsu favored vibrant solid colors in lighting, costume design, and set design. Second, the sudden color shifts would become important for his later action films, in which he often punctuates violent action either by similar sudden shifts in color through lighting, or blocking and staging. Third, Suzuki is typically less interested in an individual color per se than he is with its vibrancy and the visceral shock created by shifting it suddenly. As with the emotional shift he underscores in the conversation scene in *Fighting Delinquents* with a blue-to-green lighting shift, there is no symbolic meaning attributed to the colors blue or green in the scene; the significance is the effect of the sudden transformation of color. In his later Nikkatsu films, the significance of colors will likewise not be found in preexisting "meanings" of individual colors, but rather the way that they either repeat across a film as a motif or shift suddenly in a scene.

In *Gate of Flesh*, Suzuki develops a color scheme that grows directly out of the color cycles in his earliest color films. He assigns a single vibrant, solid color to each of the four central women in the film who work at a cooperative brothel. The bright, solid colors of the women's outfits stand out against their drab surroundings in the bombed-out slums of Tokyo in the immediate postwar, and they distinguish the four central women from the other sex workers in the film, who wear dresses in a neutral main color with patterns or prints on them. By using a consistent color for each of the individual women throughout the film, Suzuki creates a color association with individual characters, and he then uses these colors to provide subjective access to the characters at specific moments.[19] They become what Branigan refers to as "key colors," which "organize our thinking about any aspect of a film—about character motive, theme, action, narration, narrative structure, or important objects" by associations they pick up over the course of the film.[20] As each of the four women delivers an internal monologue in succession, the color of her dress extends to the background set coloration. Though Suzuki develops this technique with surface color in addition to optical color, the emphasis on color uniformity in the costume designs, and particularly in the frames overwhelmed by a uniform solid color, derives from the effect of the colored light filters seen in his earlier films. Using surface color and postproduction color additions, Suzuki modulates the amount of color at different moments in the film. The series of internal monologues is the most extreme example, but at other moments, such as when the three other women are torturing Maya, a gauzy green haze infuses the screen and surrounds her.

The internal monologues in *Gate of Flesh* point to another tendency in Suzuki's late Nikkatsu films, beginning with *Kanto Wanderer*: his tendency to use negative-space backgrounds with abstract color design. As we saw in the previous chapter, in the climax, the protagonist Katsuta slices a man,

sending him through a fusuma in the background. The set collapses around the man, revealing a solid red color.[21] Shot perspectivally, the red in the background appears to have no beginning or end and becomes simply an abstract field of color. In subsequent films, Suzuki continues to use these abstract color backgrounds, particularly in action sequences. In some cases, the color of the background shifts to punctuate action, as in a scene in *Tokyo Drifter* where the background shifts from red to white as Tetsu shoots a gun out of an enemy's hand. The solid, depthless color fields also play into the abstract studio set designs of many of Suzuki's later films discussed in the previous section, such as *Princess Raccoon*.

These abstract color fields are a perfect example of the phenomenon that Hasumi described when he discussed the play between flatness and depth in Suzuki's films. They give the impression that the color wall is not a wall but a vacant mass of color that expands outward indefinitely: it relies on perspectival framing and sets that are built, lit, and filmed to prevent a clear distinction between ground, wall, and ceiling. These bear a relationship to a common production technique in cinema to leave large empty spaces, usually to be filled in during postproduction. These date back to the tendency in early cinema to leave a large, black field of empty space to be filled in later by another superimposed shot, and have a legacy through the use of chroma key effects.[22] Suzuki, however, frequently leaves these spaces empty in postproduction, filled only by bright colors that occasionally transform in response to actions that take place in front of them. In subsequent films he continues to use these primary-color negative spaces in a variety of ways: marking out subjective spaces for characters to deliver internal monologues (*Gate of Flesh*), as backgrounds that shift color, punctuating sword slashes and gunshots (*Kanto Wanderer*, *Tattooed Life*, and *Tokyo Drifter*), or exploiting the negative space for its ambiguity ("The Fang in the Hole").

These fields in a solid color derive in part from the way the emphasis on optical color within Nikkatsu Action Cinema produces uniform coloration over an image. There is, however, another influence that becomes significant for Suzuki in this period that we should consider in looking at this new coloration scheme. *Kanto Wanderer* and *Tattooed Life* are both ninkyō films. Instead of the modern urban nightclubs that characterized Nikkatsu Action films, a more prominent setting for ninkyō films was the *bakuchiyado* (secret gambling den). These incorporated Japanese architecture into their staging: shōji and fusuma could be broken down in combat, or simply opened, to create a sudden, dramatic change in the composition.[23]

While bright, solid colors like the ones we see in *Gate of Flesh* and *Tokyo Drifter* may be the first thing that comes to mind when thinking about color in Suzuki films, we should observe that this does not describe all his films' uses of color. Many of his early color films set in more rural areas, like *The Man with a Shotgun* or *Blood-Red Water in the Channel*, do not feature the same

experimentation with color because of their locations. Even several of the late Nikkatsu films in color use less intense and distinctive color designs: *The Flowers and the Angry Waves* uses a much more subdued blue-gray color palette in costume and set design, as does *Tattooed Life* prior to its climactic fight sequence with colored fusuma screens. Though we might be inclined to shrug these example off as exceptions, perhaps caused by limitations on the projects, some of Suzuki's later independent films also feature fewer vibrant colors, particularly the films of the Taishō trilogy. Given the degree of Suzuki's control over these later projects, it is unlikely that their comparatively subdued color palettes are the result of a lack of control on his part.

Further, though the colors in these films are not generally the vibrant, solid colors we see in his Nikkatsu films, Suzuki still uses color effectively in the films. For one thing, the use of a generally subdued color palette makes individual moments with bright bursts of color stand out more. This is true of *Tattooed Life*, where the color effects of the climax single out the sequence in comparison to the rest of the film. It is also the case in *Zigeunerweisen*, which is dominated by an all-absorbing brown color palette, with only subtle variations in shading through most of the film. Within this broader scheme, several moments are marked as strange by the presence of strong color effects, such as the orange flames in Aochi's dream sequence, or the red of Taeko's kimono, and other elements of composition during her sensuous peach-eating scene. In particular, *Yumeji* features many compositions where a stark color abruptly takes over the screen, with undefined color elements appearing in the foreground or with color painted directly onto the camera lens. The restraint of color for the majority of these films' runtimes gives added effect in the moments when color suddenly becomes richer.

We can also see Suzuki develop color motifs in a less straightforward way than his most obvious Nikkatsu examples. *Kagero-za*'s title sequence over a brook introduces the stony gray-blue color palette that dominates the film and carries over into the first shot. The next shot stays within this dominant color scheme but introduces one faintly incongruous detail: a lavender-and-white kimono with a matching parasol. Though neither a solid color nor as bold a hue as the dresses in *Gate of Flesh*, the color stands out as distinct against its immediate background, and against the broader color palette of the film. A kimono with a similar color palette appears in a fantasy sequence later in the film, in which the lavender-and-white palette extends to the entire abstract landscape. The technique resembles Suzuki's use of the colored dresses in *Gate of Flesh*: a color that appears first as a costume is later extended to an abstract landscape. However, while in *Gate of Flesh* the color-coordinated abstract landscapes were settings for the women's interior monologues, here the connection between the woman in the lavender-and-white kimono at the beginning of the film and the fantasy sequence in which the kimono reappears is somewhat more difficult to discern. It is a different woman wearing the kimono in each shot,

and in the second space the woman is neither alone nor delivering an internal monologue. As a result, the color motif introduces an inexplicable connection that we encounter as a kind of uncanny coincidence.

Suzuki develops other color combination motifs with women's costuming throughout *Kagero-za* that echoes without obvious meaning throughout the film. Early in the film Suzuki introduces a kimono with a pattern including a stark black-and-red with faint hues of cream and green. In the sequence introducing the scheme, he marks off the color combination as significant by echoing it in other parts of the frame: the food arrangements behind the woman in the kimono are made up of the same color combinations. The color combination stands out in contrast to the stony gray-blues that have dominated the film up to this point. However, when the kimono reappears in the underworld at the end of the film, the red, black, and cream color palette comes to dominate the entire setting, with the *yūrei-zu* on the walls and floors. Branigan points out that combinations of color can function as a "key color,"[24] and Suzuki increasingly uses color combination motifs such as these in his Taishō trilogy and other late films. These color motifs are more fluid and nebulous than those from his earlier career and are encountered more as faint, ambiguous echoes than as clearly marked and with overdetermined meanings.

Still, sometimes his use of these more complicated color pattern motifs is less ambiguous in function. Suzuki develops a color motif across *Yumeji* drawing together red, yellow, blue, and white with an opening dream sequence, which begins with bouncing beach balls possessing all those colors. The color motif then transfers to the title character's kimono, which features the same set of colors. The film's opening dream sequence culminates with a jealous husband, whose face is not seen, shooting Yumeji in a composition where both Yumeji's kimono and the beach balls in the background repeat the color motif in the frame. Much later in the film, Wakiya, the husband of one of Yumeji's model/lovers who was long thought dead, appears and can be seen with beach balls featuring the same color pattern as Yumeji's dream. The color association instantly calls back to this opening dream sequence and introduces the possibility that this may be the man who shot Yumeji in his dream. The uncanny echoing of a color pattern blurs the distinction between dream, reality, and the supernatural in the process.

Editing

In discussing editing in Suzuki Seijun's films, it would be easy to fall into the trap of merely pointing out sequences that violate the classical rules of continuity editing. And indeed, there are many such cuts in his filmography that aggressively violate the rules of continuity, through simple jump cuts or overt

differences in the spatial relationships between shots within the same scene. There are also cuts that merely disrupt viewers' sense of continuity by juxtaposing shots in continuity that do not seem like they could be contained within a continuous space. However, this overlooks the fact that the majority of the cuts in the majority of his films *do* largely adhere to the rules of continuity editing; the violations in his films are so jarring because they disrupt the assumed editing laws that govern most of the films. But, additionally, the focus on discontinuity at the expense of recognizing continuity in his films overlooks other tendencies in his editing: notably, his deliberate misleading of audience expectations, often created either within the rules of continuity editing or by the revelation that spaces that seemed continuous turn out to be discontinuous, that spaces that seemed discontinuous turn out to be continuous, or that spaces turn out to be continuous in a different way from what is initially assumed. In short, if there is an overarching principle of what makes editing in Suzuki Seijun's films unique, it is this play between continuity and discontinuity.

The formational films of Nikkatsu Action Cinema are broadly edited according to the rules of Classical Hollywood Continuity.[25] To the extent that there is a distinct editing style for these films, two frequent editing techniques stand out: (1) jarring cuts and (2) economy of editing. Many filmmakers working in the idiom use editing to shock the audience by juxtaposing strikingly different types of shot compositions and action. In *Season of the Sun*, Furukawa cuts from the angst of boxer Tatsuya (Nagato Hiroyuki) taking out his rage on a punching bag to an elegant close-up of his love interest Eiko (Minamida Yōko). To the second point, it is common in Nikkatsu Action films for filmmakers to excise the beginnings and endings of scenes to avoid wasting valuable film stock or screen time on narrative information that the audience can infer without too much difficulty. Characters are rarely shown entering and exiting spaces; filmmakers instead start conversation scenes *in medias res* and simply cut away when the relevant part of the conversation is over. There are many direct cuts from a character in one space to the same character in a totally different space for this reason. A frequent technique for masking these excisions is to open the second scenes with a slight camera movement opening the space so that the filmmakers avoid the effect of a jump cut. For example, in *Song of the Underworld*, Noguchi cuts directly from Diamond Fuyu's (Ishihara Yūjirō) and Hanako's (Kazuki Minako) exchange of glances in shot/reverse shot to a café date the characters have some unspecified amount of time later. The first shot of the café date avoids the jarring effect of a jump cut by masking the two characters' presence in the café, opening with a shot of the door and tracking backward to reveal their conversation, already underway. The cutting economically removes the ending of the scene at the tattoo parlor, their entrance in the café, and whatever arrangements the two characters made to meet, but it does not foreground these excisions. Similarly, in *Farewell to the Southern Tosa*, Saitō cuts from a

street conversation scene between Jōji (Kobayashi Akira) and Asako (Nakahara Sanae) to an office scene showing Jōji signing his work contract. The cut excises the characters leaving the first scene and Jōji's entrance from the latter scene, using the images of boats and the visible port in the background to explain Jōji's new business in place of dialogue. Again, Saitō avoids a direct cut between Jōji in two different locations by using a regressive tracking shot to conceal him briefly at the beginning of the second scene.

Suzuki similarly excises the beginnings and endings of scenes, but he also excises these kinds of camera movements and similar devices used to mask the excisions. He withholds establishing shots, even of the economical variety seen in *Song of the Underworld* or *Farewell to the Southern Tosa*. As a result, his economic editing tends to be more deliberately jarring than that of other directors working within the same idiom. Both *Young Breasts* and *The Wind-of-Youth Group Crosses the Mountain Pass* feature scenes in which a character chases after a moving vehicle that cuts directly to the character standing on the vehicle, midconversation; both the temporal excision and the juxtaposition between movement and stasis have a jarring effect. Even early on, however, he sometimes harnesses this jarring effect for dramatic purposes in more elaborate patterns of elliptical editing. In an early scene in *The Man with a Shotgun*, several minor villains knock down a bridge as Nitani Hideaki crosses it. The editing conceals Nitani's movements, following the villains as they descend the hill instead. As a result, we are surprised, as they are, to find him relaxing on some rocks with his shotgun pointing in their direction, uninjured by the fall. In *Our Blood Will Not Forgive*, Suzuki cuts from a yakuza dropping a knife and a woman recoiling in horror in an elevator to a shot of the two characters on the rooftop. The sudden jump to her curled over the pavement, clutching something, makes it look as if she may have been stabbed. When she rises, we eventually see that she was just laughing

4.20 Misleading editing in *Our Blood Will Not Forgive*

hysterically (fig. 4.20). The quick cut to the middle of the scene, in this case, is not motivated by an effort to excise unnecessary information but by a deliberate attempt to mislead the audience. This kind of sequence, in which shots construct space and action in a misleading way that becomes clear only in retrospect, would become a signature of Suzuki's work.

From an early stage, Suzuki also used common editing techniques like the point-of-view shot sequence to set up expectations before thwarting them. A sequence from *Pure Heart of the Sea* demonstrates an early and relatively simple way that Suzuki does this through editing. Some sailors are drinking and dining together at an *izakaya* during a night off between whaling expeditions, and one of the whalers gets rowdy with a geisha. As he pulls her offscreen, the camera pushes back to a table of other sailors looking on. As she begins to undress, Suzuki cuts shots of her gradually removing her clothes through eyeline matches as the sailors shift between looking at her and looking at the nude statue in the background. The shots of the undressing geisha and nude statue are each framed by eyeline matches and reaction shots, which collectively imply that the sailors expect her to undress completely. The compositions and editing further imply this, or at least make this interpretation possible, by showing only the geisha's kimono fall at her feet, obscuring for several shots what is underneath the kimono. When suddenly we see another shot of her in long shot, however, she is indeed no longer wearing her kimono, but instead of being naked, or at least scantily clad, she is wearing a karate outfit, much to the surprise of the onlooking sailors, and kicks the rowdy customer through the fusuma (fig. 4.21). Suzuki's misleading of the audience aligns us with the three sailors watching the event unfold from the sidelines. He uses the editing to clarify the sailors' expectations and surprises us with the reveal at the same time they realize that she is not stripping but rather preparing for combat.

Suzuki combines his tendencies of elliptical editing and startling juxtapositions with more typical tendencies of continuity editing as a way of constructing seemingly discontinuous or impossible spaces through editing. The opening scene of *Kanto Wanderer* is a useful example. Withholding an establishing shot, Suzuki composes the sequence entirely out of a series of shots from three separate positions, isolating each of three girls against a unique background: Tokiko stands in front of a train, one friend stands in front of the entrance to the station, and the other in front of a busy intersection (fig. 4.22). Adding to the stark contrast in the backgrounds, the ambient sound is distinct in each shot: we can only hear the train in shots of Tokiko, the crowd in shots of her friend in front of the entrance, and the traffic in shots of her friend in front of the road. The background spaces do not add up logically: the train is moving in the wrong direction for where the station is. The space is held together entirely by eyeline matches from the girls, but Suzuki is pushing the limits of what shots eyeline

118 The Emergence of the Seijunesque

4.21 Misleading point-of-view editing sequence in *Pure Heart of the Sea*

4.22 Eyeline matches and seemingly discontinuous backgrounds in *Kanto Wanderer*

matches can hold together to create the sense of a continuous space. Some of Suzuki's cuts within scenes redefine spatial relationships ostentatiously between shots. In *Detective Bureau 2-3: Go to Hell Bastards!*, a woman appears suddenly in a church face-to-face with a fake reverend, but in the following shot, Suzuki shows her at a much greater distance from him (fig. 4.23). The discontinuity is so forceful and flauntingly deliberate that it calls attention the notion of spatial continuity by its absence.

In other cases, Suzuki's withholding of an establishing shot allows for unexpected retroactive construction of space. In *Branded to Kill*, he constructs Misako's second appearance in this way: The scene opens with a long shot of Hanada and his wife arguing, when his wife lets out a sudden shriek about the appearance of another woman, whom we do not see. Hanada begins to talk to the off-screen woman, and the sequence eventually turns into a strange

4.23 Egregious cheating of spatial relationships between shots in *Detective Bureau 2-3: Go to Hell, Bastards!*

shot/reverse shot between Hanada, seen in his apartment, and Misako, in an extremely shallow focus against an entirely blank background, surrounded by falling water but somehow not getting wet. The scene's final shot sets up the spatial relations: Hanada is seen in the apartment and Misako just outside it, while in the left background we see a clouded glass door with water beating down past it, and Hanada's wife appears, clinging to the side of the door. The final shot retroactively explains the spatial relationship: the "rain" was actually water from the shower. Even as the shot gives a practical explanation of spatial relations that initially seemed impossible, the initial impressions offered by the bizarre individual images—Misako unaffected by the "rain" surrounding her, Hanada's wife seemingly imprisoned behind glass—leave a lasting effect, and the sudden retroactive establishing shot foregrounds the construction of the sequence self-consciously (fig. 4.24).

Suzuki's embrace of spatial discontinuity in editing to juxtapose compositions, repeat compositions in succession, or even simply shock viewers with discontinuity in its own right resembles Sergei Eisenstein's writings on montage, as well as Eisenstein's applications of some of those principles in his films. Eisenstein defined *montage* as "an idea that arises from the collision of independent shots—shots even opposite to one another."[26] Since cinema existed in what was created by the juxtaposition of two shots, Eisenstein actively sought to create tensions between shots (spatial, temporal, compositional, and conceptual) that would amplify the effect of the individual edit. Suzuki constructs a sex scene between Shinkichi and Harumi in *Story of a Prostitute* out of three static shots of the two characters with hardly any figure movement in any of the individual shots (fig. 4.25). The shots last nine, twenty-two, and twenty-four seconds, respectively, and contain no camera repositioning and only minor figure movements by performers Nogawa and Kawaji; moreover, the sound and dialogue

4.24 Shot/reverse shot between seemingly irreconcilable spaces in *Branded to Kill*

flow seamlessly from one shot to the next, in spite of the change in character positions between shots. The synthesis of the three still shots implies the act of sex, which itself goes unseen. The movement is created by the striking juxtaposition of the figure placement: centered and upright (first shot), to diagonal downward (second shot), to centered and upright again (third shot). This is an example of how the synthesis of shots can create a meaning that is not itself contained or shown in any of the individual shots. In Eisenstein, this process necessitated didacticism in both the juxtaposition of images, and the selection of images to juxtapose. It also dictated a much faster and more forceful rhythm to the cutting than would allow for three shots of stillness for such a duration as we see here. Suzuki similarly actively seeks to disrupt continuity, and to shock with clashing compositions set immediately next to each other through editing, but his method is not ultimately didactic: his juxtapositions are frequently ambiguous, and sometimes even designed to confound logical meaning.

This tendency reaches its apex late in Suzuki's career, particularly in the films of the Taishō trilogy. We can see one example in a sequence in *Yumeji*, which shows the title character sketching one of his models through a series of

The Emergence of the Seijunesque 121

4.25 Copulation through montage in *Story of a Prostitute*

ambiguous images that are strikingly juxtaposed to one another, both in terms of having conflicting compositions and in using screen directions that disrupt any sense of continuity (fig. 4.26). Like the sequence in *Story of a Prostitute*, the sequence is composed of shots with no camera movement and hardly any movement by the figures within the frame. As the sequence begins, Yumeji and the model are addressing each other in single shots, but not edited according to a conventional shot/reverse shot pattern. Both compositions are unbalanced, but in opposite directions: in the first image, the

4.26 Juxtaposed figures and retroactive establishing shot in *Yumeji*

model occupies the right half of the frame, while in the second image, Yumeji occupies the left half of the frame. The directions that the characters are looking do not allow for an eyeline match: the model is staged frontally, looking off-screen slightly right, while Yumeji is staged on the side, looking off-screen left. The cumulative effect creates a sharp juxtaposition while leaving the spatial relationship of the characters ambiguous. After several more shots showing different fragments of the setting, Suzuki provides an establishing shot of the space in its entirety. Like the shower sequence in *Branded to Kill*, the space in its entirety is shown after the fact, but this "establishing shot" presents spatial relationships that make little sense: all four visible characters carry on a conversation while staged frontally, and the relationship between the foreground characters and the isolated Yumeji and model enframed individually in the background is likewise unclear. This shot lasts for thirty-one seconds, with no camera movement and very little movement of any of the four visible characters.

This sequence exploits the kinds of juxtaposition between compositions and within compositions that Eisenstein would have identified as montage, but Suzuki deliberately refuses to allow the shots to synthesize either spatially or conceptually. Instead, he dwells on striking still compositions that deliberately confuse spatial placement within a broader frame and, particularly in the case of the third shot seen here, do not give us a clear place to look. Combined with the shot's duration, the stillness allows, or even encourages, viewers to scan all over the frame: to observe strange details like the blue

diagonal lines occupying the foreground of each shot. Writing on stillness in Suzuki's films, the photographer Kanemura Osamu argues that still photography is often more dynamic in nature than conventional cinema because stillness encourages viewing the image in its entirety and scanning different aspects of the frame for minute details, while conventional filmmakers tend to encourage a single point of interest within an image. He argues that the way Suzuki uses stillness in some compositions is a way of rediscovering the dynamism of photography within filmmaking.[27] I would suggest that this is compounded by the conflicts created through Suzuki's use of juxtaposition in editing: the visual conflicts between compositions and the conflicts it creates with the sense of space and time necessitate a more dynamic activity of looking at the image. By shocking us with "deviance," Suzuki forces us to look more closely.

Watching both Suzuki's late Nikkatsu and post-Nikkatsu films, it is easy enough to recognize discontinuities in editing: temporal and spatial mismatches or jumps. It may be tempting to conclude that Suzuki is therefore uninterested in continuity or that continuity is irrelevant to his films. It is worth observing, however, that these moments stand out within Suzuki's work precisely because the majority of the films they are in exhibit continuity in their editing. In many cases, Suzuki uses these discontinuities to sharpen the effect of stark juxtapositions. In other instances, he uses common techniques of continuity editing to mislead his audience or to create apparent discontinuities that are explained in retrospect. These do not suggest a simple absence of continuity in editing so much as a sophisticated process of harnessing and subverting its rules in turn to shock his audience in a way that brings conscious awareness to the editing process in cinema.

* * *

As Suzuki worked in a transforming film industry, he experimented with new possibilities given by changes in technology and took up new stylistic trends as they were developed by his colleagues, but he pushed them toward more abstract ends. As a result, Suzuki's style was a constantly shifting target. Neither his late Nikkatsu films nor his post-Nikkatsu films represent a more distilled, personalized version of his style than the others; even as he experimented more boldly in these films than he had in his earliest Nikkatsu films, the fact that he adopts, for example, drastically different color palettes for his late Nikkatsu films from those of his post-Nikkatsu films indicates that neither one nor the other is in itself more Seijunesque. Neither bright nor subdued colors are in themselves Seijunesque, but the way color motifs vacillate between realistically diegetically motivated and abstract within the same film *is* Seijunesque. Neither deep-focus, deep-space staging nor flat, proscenium-style staging is itself Seijunesque, but the startling juxtaposition of the two *is*. Seijunesque

editing cannot be defined as being continuous or discontinuous, as films made throughout his career contain both continuous and discontinuous editing, as well as continuous editing disguised as discontinuous editing and discontinuous editing disguised as continuous editing. Ultimately, the Seijunesque is defined less by a singular trait or tendency than by a push-and-pull, direct juxtaposition, or synthesis between multiple tendencies that would seem to be irreconcilable.

CHAPTER 5

THE AUTHORIAL VOICE OF SUZUKI SEIJUN

Suzuki's social melodrama *Young Breasts* concerns Hiroshi (Kobayashi Akira), the errant son of a wealthy businessman, who is involved in a scheme to blackmail his young stepmother, Yōko (Watanabe Misako), and begins a romantic relationship with Setsuko (Inagaki Mihoko), a young woman with an abusive and exploitive stepfather. Over the course of the film, Yōko becomes a model for a painter (Nitani Hideaki), while Hiroshi's coconspirators in the blackmail plot set up a trap to put Setsuko in a pornographic film without her knowledge. Though ostensibly the star, Kobayashi's character is not the focus of the film so much as he is the connecting thread between two parallel relationships: Yōko with the painter, and Setsuko with the pornographic filmmaker. Though Nitani's painter is high-class in his outward appearance and his art is apparently more respectable, he is ultimately exploiting Yōko's image for his work in the same way the pornographic filmmaker is exploiting Setsuko's; the painter is also eventually identified as the man who raped Yōko many years before, and his paintings as part of a continued fantasy of domination. Both the painter and filmmaker (later revealed to be brothers) have used Yōko's rape for their art: the older brother has made a commemorative painting of the location and uses it to taunt her, while the younger brother had staked out the site and filmed it for his collection.

Young Breasts confronts the weighty subject matter of the capturing and circulation of images of women's bodies and their relationship to sexual violence and trauma. Suzuki articulates this theme throughout the film via a motif of framing images-within-images. On Hiroshi and Setsuko's first date, the young

couple walks off-screen as the camera pushes to a row of posters advertising romance films, showing couples embracing on the posters in place of showing Hiroshi and Setsuko embracing, making a self-reflexive joke of the film's place among popular romantic melodramas and its use of the tropes it draws from them. During the climactic showdown between Yōko and her painter-rapist, the two characters are surrounded by his paintings of her throughout the confrontation, and the scene culminates with Yōko attacking the warehouse painting with a knife, ripping it in half; she can free herself of his domination over her only by destroying the images he has created.

In two sequences, Suzuki plays with this interpolation of subimages in a more remarkable way that blurs the boundaries of filmic narration and confronts more directly the relationship between the issues of sexual violence and trauma. On her first visit to the painter's gallery, Yōko encounters a painting of a warehouse with tall grass in front of it. In a reaction shot, the lights around Yōko dim. She faints to the floor, and the paintings around her collapse from the walls. There is an immediate cut to a series of shots of a young woman running from a man in a warehouse. This series culminates in an extreme long shot of the man pulling the young woman down behind tall grass in front of a warehouse like the one in the painting. There is then a cut back to the warehouse painting, revealing it as a graphic match (fig. 5.1).

This striking sequence appears to be motivated by an attempt to narrate Yōko's subjectivity. It begins with a point-of-view shot sequence from her perspective and follows with a series of implausible environmental shifts, suggesting that the dimming of the lights and the collapsing of the paintings are a visual approximation of Yōko's experience viewing the painting. With the cut to the young woman running in the field by the warehouse, Suzuki cues us to assume that we are watching a subjectively motivated flashback. He reinforces this sense by showing a graphic match between the final image of the sequence and the painting that triggered her memory. In the following scene, Yōko awakens on a couch and explains that she had fainted after the painting triggered a traumatic memory for her, apparently confirming this suggestion.

This same series of shots of the young woman running from a man in front of a warehouse reappears at one other point in the film, and while it similarly

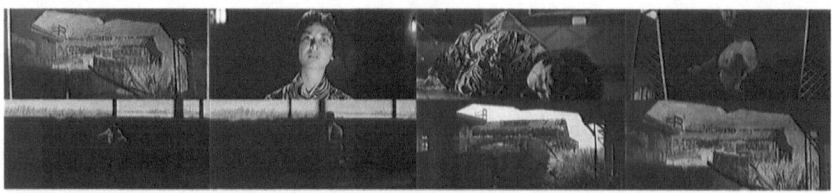

5.1 Flashback sequence brought on by painting in *Young Breasts*

is initiated by an apparent entrance into Yōko's subjectivity, the way that it becomes retroactively placed in the scene by its exit complicates this understanding. Yōko has entered the nightclub owned by the pornographic filmmaker as Hiroshi and Setsuko are in a back room watching a film with several of Hiroshi's other friends. In a separate part of the club, the nightclub owner moves threateningly toward Yōko, and, similarly to the previous sequence, the lights on Yōko begin to dim and narrow so that they illuminate only her eyes. From a low-angle shot of the nightclub owner moving toward Yōko, Suzuki cuts to the footage that we previously saw. From this final shot of the sequence, however, there is a cut to an extreme close-up of a woman's eyes. In context, we might initially be inclined to think that they are Yōko's, but there is a strange flickering light, accompanied by a strange clicking sound effect, that had not been present in the shots leading up to the flashback. From there, Suzuki cuts to a series of shots of teenagers looking in the same direction with a similar flickering light. Eventually, the shot is long enough to see a 16mm projector in the background, projecting a film that the teens are watching, and that Hiroshi and Setsuko are among them. Suddenly, Setsuko stands, partly obstructing the beam of light from the projector, and begs for the film to be shut off (fig. 5.2).

Though this recurrence of the same sequence of shots at the warehouse begins with a series of cues suggesting that it is Yōko's flashback, it ends with reaction shots of teenagers viewing it, reinterpollating it as a film-within-a-film, an object being watched in real time. Further, the flickering light on the decontextualized faces watching the film mimics the subjectively motivated lighting shifts around Yōko's face at the beginning of both sequences. The sequence thus involves a play with the boundaries of narration: between subjective and objective narration, between diegetic and subdiegetic. Eventually, a reason is given for the overlap between Yōko's memory and the film that Hiroshi and Setsuko are watching: the nightclub owner/pornographic filmmaker is the younger brother of Yōko's rapist and had staked out her rape and filmed it for his

5.2 Flashback turns into film-within-film in *Young Breasts*

collection. While this at least partly helps rationalize the overlap (and would also suggest that the filmmaker had a multicamera film crew operating to have filmed all the shots that were used in the sequence in real time), what is more interesting, and most characteristically Seijunesque about the sequence, is the ambiguity of the footage as the sequence unfolds, the state of confusion it leaves viewers in as the sequence unfolds, and the way it ultimately occupies a place as both a subjective flashback and an objective film-within-a-film.

In this pair of sequences in *Young Breasts*, we see Suzuki depicting the serious thematic issue of the violent exploitation of women in the arts. This already challenges the perception of Suzuki as a formally inventive but frivolous and nonsensical filmmaker. That is not to say, however, that *Young Breasts* contrasts with the rest of his filmography as a rare, serious exception. The film, and these sequences in particular, experiments with film form in a self-reflexive way in the invocation of the making and viewing of films. Moreover, the thematic ends are intertwined with the formal experimentation: the acts of filmmaking and viewing that Suzuki invokes are the themes being scrutinized. The temporary state of confusion between subjective and objective narration and of the diegetic boundaries between the film and the film-within-the-film is also a way of articulating the experience of trauma. The sequence thus urges us to reconsider the significant roles of narrative and narration in Suzuki's films.

Narrative vs. Narration

Thinking about Suzuki's relationship to narrative may seem counterintuitive. Suzuki did not control the projects that he was assigned to prior to *Branded to Kill* and, with the sole exception of *The Age of Nudity*, was not credited as screenwriter for any of these films. For the majority of his career, he did not have a regular screenwriting collaborator, as Mizoguchi Kenji had in Yoda Yoshikata, Ozu Yasujirō had in Noda Kōgo, or Kurosawa Akira had in Hashimoto Shinobu and Oguni Hideo. While he would eventually form close collaborations with screenwriters in the latter part of his career, particularly Yamatoya Atsushi and Tanaka Yōzō, both Yamatoya and Tanaka were accomplished as screenwriters (and in Yamatoya's case, as a filmmaker) on their own, and their careers were not defined by their collaborations with Suzuki any more than Suzuki's career was defined by his collaborations with them. Further, thinking about Suzuki's films in terms of narrative runs counter to the terms in which cinephiles like Hasumi and Ueno celebrated his work. Many of the moments we have seen them single out in his work, like the pink dancer behind the mirror in *Youth of the Beast* or the strange perspective lent by the rear-projected waves in *Our Blood Will Not Forgive*, cut against what we might think of as the films' narrative structures.

At the same time, in Suzuki's fifty-year career spanning his work at Nikkatsu, his independent post-Nikkatsu productions, and his television and video work, he worked almost exclusively in narrative filmmaking: his only nonnarrative projects, in fact, are his television commercials. Even Hasumi, in his antinarrative readings of *Youth of the Beast* and *Branded to Kill*, does not ignore the films' narratives so much as he reads them as allegories of their own negation. There is no reason that the celebration of Suzuki's meta-cinematic investigation of the material properties of the moving image must preclude considering his processes of narration. In fact, as a filmmaker working in an industry with an inherited set of practices and codes of narration, Suzuki's exploration of cinema as an institution necessitated delving into these same practices and codes and linked them to questions of cinema's fundamental properties. Laura Lee has argued that Suzuki's experimentation with depicting character subjectivity, starting from his earliest films, frequently led to stylistic choices that challenged ingrained practices of film viewing and invited a rethinking of the fundamental properties of cinematic images and movement. She singles out a sequence in his *Satan's Town* showing a police officer's imagination of a fight with gangsters that Suzuki composes out of still frames. Lee writes that "the *Satan's Town* sequence is legible as a heightened emotional moment in the film, but perhaps most significantly it is also a dramatically elevated visual moment at the cusp of an image revolution." Noting that the film predates the theoretical debates about the place of the cinematic image within the shifting mediascape and the works of the filmmakers making those debates in the early 1960s (the film even predates the work of Francois Truffaut or Jean-Luc Godard), she argues that Suzuki is "experimenting in a more intuitive way here" that nevertheless invites a consideration of the relationship between cinema and still images, and the conflict between cinema's "reality effect" and "the possibility for cinema to register something at odds with that reality, in this case a character's internal perspective or subjectivity."[1] The sequence in *Young Breasts* goes further: by drawing on subjective cues and continuity editing techniques, Suzuki performs an almost psychic transference between Yōko and Setsuko: Yōko's memory becomes the film that traumatizes Setsuko and foreshadows the nightclub owner's plan to trap Setsuko in a similar way later in the film. At the same time, using the cues of subjective narration and continuity editing in such a misleading way, Suzuki throws the techniques he is using into sharper relief. The way that a character's memory can transform into a film-within-a-film underlines the editing techniques used to set it up in one way or the other and draws attention to the way that notions of character subjectivity are constructed cinematically. It can also be read as a commentary on the role of media in shaping subjectivity, as seen in the opening film-within-a-film sequence of *Everything Goes Wrong*, discussed in the first chapter. Though Suzuki did not articulate a theory of the cinematic depiction of character

subjectivity in writing, the intricate processes of editing in the sequences in *Young Breasts*, designed not just to articulate a character's subjectivity but to blur the distinction between subjectivity and objectivity and to mislead his audience, suggest that Suzuki's experimentation may have been more thought-out than the word "intuitive" might suggest.

In the previous chapter, we looked at Ueno's definition of the Seijunesque as *zure*, or "deviance." As we saw, this deviance is not embodied in a single cinematic device but is, rather, a complex process of setting up expectations and upending them; within Suzuki's films, it can take place on the level of a single shot, a single sequence, or the broader structure of the film. As we can see in the example of *Young Breasts*, the institution of cinema that Suzuki worked within to create this effect incorporates not only its physical properties but also the conventions of narration he inherited.

To be clear, this is first and foremost a consideration of the films' processes of narration rather than of the narratives: not a synopsis of character goals and motivations or the development of events but *how* these are relayed to us. At the same time, Suzuki's often devious processes of narration manifest themselves in the films' narratives in ways that we should also identify. In particular, I will argue that Suzuki's use of ambiguous and at times deliberately misleading practices in narration help to explain his proclivity for the supernatural in his later films, as well as an affinity to Taishō-era writers and artists, most fully realized in the three films of his Taishō trilogy.

At the center of narration in cinema is a different set of questions and problems from narration in literature. Whereas in literature the act of narration is telling a story with words, in cinema, narration is not simply telling a story through images. It also entails the act of guiding attention within those images. As Tom Gunning writes, "The primary task of the filmic narrator must be to overcome the initial resistance of the photographic material to telling by creating a hierarchy of narratively important elements within a mass of contingent details."[2] David Bordwell defines narration in cinema as the act "of cuing and channeling the spectator's construction of the film."[3] Bordwell uses a taxonomic approach to film narrative, which provides several useful concepts that I will be drawing on in discussing Suzuki's processes of narration. In particular, Bordwell uses two heuristics, depth and range, to consider the ways that a film aligns its process of narration with a particular character at any given time. In his terminology, depth refers to the extent to which a film's narration inhabits the perspective of a particular character. This includes not only optically inhabiting a character's perspective by way of a point-of-view shot but also entering a subjective register by visually approximating a character's inner thoughts or experience in a scene. It also allows a filmmaker to play more freely with film form, such as in the sequence that Lee highlighted in Suzuki's *Satan's Town*. Its corollary is range, which refers to how much information the

narration relays at any given time, whether that amount of knowledge corresponds to the knowledge of a particular character (restricted), or whether our knowledge exceeds that of any given character (unrestricted).[4] Filmmakers who wish to align their narration completely with a given character might employ restricted narration and make heavy use of subjective techniques, but range and depth are not necessarily so closely related. It is possible, for example, to deploy subjective techniques in a sequence while giving the audience access to more information than the character has. It is also possible to deploy subjective techniques while relaying substantially less narrative information than the character whose subjectivity the narration inhabits, making it difficult to recognize what the subjective techniques are depicting as they first appear. The latter possibility is less common in most narrative filmmaking but is particularly relevant in looking at narration in Suzuki's films.

Registers of Narration

One of the first places where Suzuki played with diegetic boundaries was in the use of sound, particularly the use of music in his earliest kayō films. Diegetic boundaries in narrative film are defined by the distinction between what is understood to be contained within the world of the film and what is understood to be outside of it: put simply, a musical cue that has a source in the world of the film's narrative is diegetic music, and a musical cue without a source in that world is nondiegetic. Claudia Gorbman argues that music in cinema is unusually fluid in its diegetic status by comparison to other stylistic devices: "Its nonverbal and nondenotative status allows it to cross all varieties of 'borders': between levels of narration (diegetic/nondiegetic), between narrating agencies (objective/subjective narrators), between viewing time and psychological time, between points in diegetic space and time (as narrative transition)."[5] The musical genre itself is characterized by fluid diegetic boundaries, as musical numbers often break the diegetic rules that govern the nonmusical portions of the film.[6] As Michael Raine argues, many musicals being made in Japan in the 1950s have a similar self-reflexive play to what we find in some of Suzuki's early films. Specifically, Raine cites an example from *Janken Girls* (*Janken musume*, Sugie Toshio, 1955), a musical in which a young woman writes a song making fun of her teacher. Her teacher overhears it first being sung by the student and then almost immediately on the radio, making a sudden jump between sound sources.[7] Suzuki plays similar games with music and sound sources in *Pure Heart of the Sea*, starring the popular singer Kasuga Hachirō as a sailor on a whaling ship. In an early scene, Hachirō (whose character in the film shares the same name as the actor, further confusing diegetic boundaries) breaks out into his popular song "Hyōtan Boogie" during a whaling expedition, interrupting

the captain's temper tantrum but causing the captain to get even angrier and injure himself in his rage. Hachirō's singing functions as a sound bridge to the following scene of the captain's daughter tending to his wounds at home, where we continue to hear "Hyōtan Boogie" on the soundtrack. When the captain recognizes it in the latter scene, he runs around in and outside his house, shouting at Hachirō to stop singing, only to find that it is Hachirō's voice playing on the portable radio of a woman passing by. Suzuki plays with the frequent ambiguity about the source of music that Gorbman articulated, as well as the ambiguity between the popular singer Hachirō, whose songs could be heard frequently on the radio in 1956, and the sailor Hachirō whom he plays in the film. The film makes similar jokes about sound sources throughout: when the sailors visit an *izakaya*, they hear shamisen music, but the captain is disappointed to find that it is not the geisha playing the instrument but a recording that is quickly replaced by more contemporary music. In the same scene, the geisha all recognize Hachirō (always identifying him only by his given name) and ask him to sing "Otomi-san" for them (one of the singer's biggest hits). Eventually, he does so over an instrumental LP recording that they have obtained for some reason. These jokes repeatedly trick the audience about the film music's source, pointing to the fact that both live music and recorded music in the film are recorded for the soundtrack and become indistinguishable. This play dissolves the boundaries between diegetic and nondiegetic sources of the sound, perhaps the earliest example of a common thread in Suzuki's formal experimentation at Nikkatsu.

Musical numbers feature prominently in many of Suzuki's Nikkatsu films, as they do in many other Nikkatsu Action films. *Passport to Darkness, Love Letter, Fighting Delinquents, Tokyo Knight, Detective Bureau 2–3: Go to Hell, Bastards!, Kanto Wanderer,* and *Carmen from Kawachi* all feature one or more musical numbers, many of which were released as singles alongside the film releases as part of a multimedia stardom strategy. The examples from these films rarely challenge the diegetic boundaries the way that Suzuki's use of musical numbers in *Pure Heart of the Sea* does, but one later film is worth examining for this purpose. Suzuki's repeated use of the "Tokyo Drifter" song in the film of the same name similarly confuses the diegetic boundaries of the film. After its first rendition during the opening credits, Tetsu repeatedly sings the theme song, often in ways that challenge the distinction between diegetic and nondiegetic sound, even in the context of the already challenging diegetic position of musical numbers. In one scene, some rival yakuza are waiting to ambush Tetsu and overhear him singing his theme song in the distance. The song sounds distant and grows gradually louder as he gets closer, as one would expect with diegetic sound, except that his singing is accompanied by a full orchestra that has no visible diegetic source. This orchestral accompaniment is at first distant but grows gradually louder along with Tetsu's singing, making it subject to the

same diegetic rules that govern the volume of Tetsu's voice but without any plausible diegetic source.

Nagato Yōhei has argued that Suzuki uses music (and sound more broadly) to challenge diegetic boundaries in other, less obvious ways. He points out that Suzuki repeatedly uses off-screen music that sounds like a nondiegetic soundtrack, and he shows the music's source after a cut, either immediately off-screen or as a sound bridge to another space. An early example of this is in *Harbor Toast*, where an accordion can be heard for three exterior shots in a harbor before a cut to the interior of a bar, in which a musician is seen playing the accordion. The technique also works in reverse: in *The Age of Nudity*, one of the children begins playing a harmonica on screen in the abandoned airplane hangar; the film then cuts to a series of flashbacks of the children's traumatic home lives that caused them to run away. In the process, the harmonica takes on the effect of nondiegetic music, underscoring the action on the screen. And while Suzuki plays with sound bridges like these to blur the lines between spatial as well as diegetic and nondiegetic boundaries, he also uses deliberate sound *disjunctures* to emphasize cuts: in the opening sequence of *Kanto Wanderer*, there are noticeable differences in the ambient sound over the cuts between close-ups of the three speaking women's faces, even though they are understood to be talking to one another; while background sound is frequently used as a way of preserving continuity over cuts within a single space, here the background sound isolates the three characters into separate spaces. Nagato also notes that Suzuki also frequently breaks off diegetic music that can be seen through a barrier: for example, in the nightclub scene in *Youth of the Beast*, we can initially hear the music from within the nightclub from the basement headquarters, but after a character shuts off the speaker, the music from within the nightclub is suddenly cut off even as we continue to see a dancer dance to the music in the background. Likewise, in *Tokyo Drifter*, as Tetsu escapes through the basement of the Manhole Club, we can see through the floor to the teenagers in the club, dancing to music we have heard in a previous scene, but with the music cut off.[8] Though there is an ostensible diegetic reason for us not to hear the music in both scenes in the form of the glass boundary, the rupture between what we can see and what we can hear serves to separate the sound track from the image, challenging the diegetic effect of synchronizing the two to give the sense that they originate from the same world and emphasizing the fact that they are discretely created formal elements.

Thus Nagato emphasizes that the most interesting uses of sound in Suzuki films often blur the boundary between nondiegetic and diegetic sound, have unidentified off-screen sounds, and continue background sounds over large temporal and spatial jumps to create confusion over the sources of sounds. As a result, Suzuki makes it difficult to place sounds in his film. As Nagato's method shows, however, it can still be useful to define the possibilities that Suzuki is

operating with taxonomically in order to articulate how he is being ambiguous or misleading. His narration may often exist in a liminal state between the different registers listed below, but this effect is created by a careful negation of markers of these categories rather than a formless, anarchic mass. Following Nagato's lead, I have broken down different registers of narration to help articulate the ways that Suzuki's narration can be misleading.

Subjective vs. Objective Registers

A subjective register is one that shows the inner operations of a particular character's mind. Several examples from Suzuki's filmography immediately come to mind. *The Age of Nudity* contains a flashback from Sabu's perspective, detailing a series of instances when he was mistreated by adults (fig. 5.3). The sequence uses a white, ovular iris to surround each of the shots, marking them off as qualitatively different from the rest of the film, and is bookended by shots of Sabu's face, suggesting that what we are seeing is playing out inside his head. More intrusively, in *Branded to Kill*, as Hanada runs through the street, a black masking surrounds his face with cut-out drawings of birds and butterflies (fig. 5.4). Each of these images bears an association with the mysterious Misako, who has been seen dangling a dead bird from her rear-view mirror, and who has a large collection of butterfly specimens in her apartment (which, in turn, also call to mind the butterfly flying in front of Hanada's scope at the moment he missed his hit). The masking effect functions to visualize thoughts playing out in Hanada's head.

In each case, Suzuki maps a character's internal space onto the film frame in its entirety, as we have seen with the colors of the women's outfits in *Gate of Flesh*. There are other moments when exterior spaces are refracted through a

5.3 White iris used for flashback sequences in *Age of Nudity*

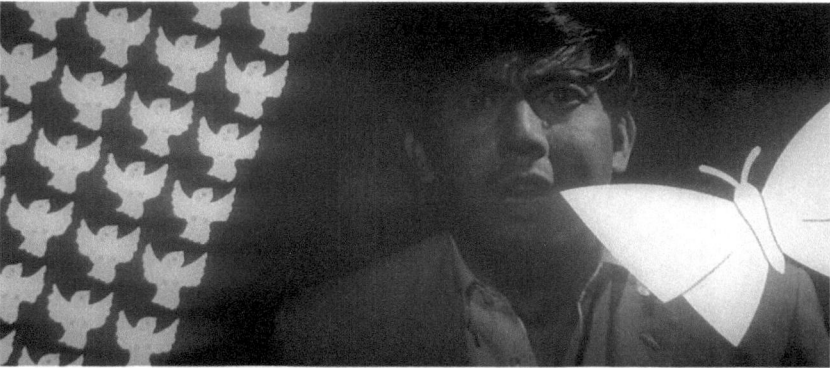

5.4 Bird and butterfly cutouts as subjective device in *Branded to Kill*

character's subjectivity: they are visibly altered so that we see them as a character sees them, or a visual effect evokes some other bodily sensation experienced by the character. In *Eight Hours of Terror*, after the bus has escaped the two bank robbers, the passengers realize that the robbers left the suitcase with their loot in it. One passenger, Tomio, becomes tempted by the loot and looks up at the bag. Suzuki narrates his thought process by superimposing the money inside the bag over the image (fig. 5.5). In *Tokyo Drifter*, Tetsu and Tatsu face off on a railroad track, and Tetsu makes a mental estimation of the distance from which he can reliably shoot Tatsu. Suzuki visualizes this estimation by showing a red wooden railroad plank, distinguishing it from the other planks on the railroad track, which are brown. The red plank is the one that Tetsu must reach in order to be able to shoot at Tatsu accurately; though Tetsu may not see the plank as red, its redness marks it as a point of focus.

An objective register of narration is somewhat more difficult to define. It may be easiest to define it in the negative, as any form of narration that is not subjective, but this would fail to articulate what motivates objective narration or how it functions in Suzuki's work. In some cases, Suzuki's objective narration operates as a straightforward way of creating dramatic irony. In *Teenage Yakuza*, Jirō infiltrates the hideout of the yakuza to try to talk to his former friend Yoshio. Yoshio bears a grudge against Jirō and initially does not want to leave, but the yakuza boss, playing peacemaker, tells him to have a nice heart-to-heart chat somewhere away from the office. While saying these words, he slips a knife into Yoshio's pocket, suggesting that he actually wants Yoshio to kill Jirō. Staged in long shot with Jirō in the far left background, this scene enables Suzuki to create a hierarchy of knowledge showing us the key information of the knife being dropped into Yoshio's pocket while blocking it from Jirō's view: not only do we see it, but we see that Jirō cannot see it (fig. 5.6).

5.5 X-ray vision narrates thought process in *Eight Hours of Terror*

5.6 Hierarchy of knowledge through deep-space staging in *Teenage Yakuza*

In Suzuki's films, there are also many examples of situations where the narration puts us at a significant disadvantage in narrative information in comparison to the characters. In *Capone Weeps with Passion*, a gangster dressed as a cowboy pulls his guns out against an apparently unarmed Gun Tetsu. Without giving advance warning of Gun Tetsu's foresight, a third arm sticks out of his kimono with a gun to shoot the gangster, after which one of the arms in his kimono sleeves falls out, showing itself to be metallic. As we watch the action unfold, we have to piece together that Gun Tetsu entered the space expecting a showdown and stuck the metallic arm in his kimono sleeve in preparation. Suzuki frequently uses a similar narration technique in his yakuza films: the

overarching narrative structure of *Youth of the Beast* forces its audience to piece together Jōji's plan and motivations from fragments of narrative information until a key flashback two-thirds of the way into the film; *Tokyo Drifter* shows Tetsu rescue Chiharu in a car after withholding the fact that he is in the rival yakuza clan's car and how he got there; and the hits that Hanada performs in the early part of *Branded to Kill* are edited in such a way so that we can make sense of his elaborate and convoluted set-ups for the hits and his escape only after he finishes them.

Diegetic vs. Extra-diegetic Registers

Diegetic refers to the self-contained world of the film, while extra-diegetic refers to anything visible or audible that is understood to be exterior to that world. Unlike the subjective register, here the visual and aural alterations are not directly motivated by showing a character's internal thoughts or by approximating a character's experience of a scene, but rather by the intervention of an off-screen presence. To give an example of the difference between the diegetic and extra-diegetic registers, I will discuss two instances where Suzuki uses a similar technique, highlighting a prop with narrative significance using color, in the two registers. In *Tokyo Knights*, Matsubara and his high school friends are spying on a conversation between two crooked real estate developers in a nightclub with a recording device they have planted in a green lamp. The green color of the lamp helpfully distinguishes it from the other lamps in the nightclub, which are red, and allows viewers to trace the movements of the hidden microphone as it moves several times over the course of the scene, in a way that is internally consistent with the film's diegetic laws, so much so that one of the developers eventually looks at the lamp, recognizes its unique color, and becomes suspicious.

In *Youth of the Beast*, Suzuki similarly uses color to direct attention to an important clue in the film's prologue, but he does so in a way that transgresses its diegetic laws. The prologue is in black-and-white apart from a single detail: a camellia flower with a yellow center and red petals. Singling out the camellia in this way highlights its importance and helps viewers to recognize similar flowers that appear later in the film, when the colors of other objects are also visible: in a large tree outside of Takeshita's widow's house, and always accompanying the sex workers of the Nomoto family. Astute viewers can use this to draw a line between Takeshita's widow, the Nomoto clan, and Takeshita's murder before Jōji does. Because the connection is drawn in an extra-diegetic way, however, it remains elusive to both the police officers in the film's prologue and to Jōji in the finale. The color operates according to rules that are not internally

consistent with the diegesis and are not an attempt to approximate a character's experience of the film, making it an extra-diegetic intervention.

Diegetic vs. Nested Diegetic Registers

Suzuki's films often contain nested diegeses. In their simplest form, these nested diegeses are discrete from the film's diegesis. In addition to films-within-films seen in *Young Breasts, Everything Goes Wrong, Youth of the Beast, Our Blood Will Not Forgive, Carmen from Kawachi, Branded to Kill,* "A Family's Choice," and *Marriage*, other works of art that can be thought of as containing their own diegesis include stage performances (*Tokyo Knights, The Wind-of-Youth-Group Crosses the Mountain Pass, Kagero-za*, and *Pistol Opera*), paintings (*Young Breasts* and *Yumeji*), oral storytelling (*Capone Weeps with Passion*), literature ("A Mummy's Love") and even music (*Zigeunerweisen*). "A Mummy's Love" begins as an editor goes to meet a professor of literature in postwar Japan, and the professor then narrates the story "Nise no en" (The tale of a destiny that spanned two lifetimes) from Ueda Akinari's *Harusame monogatari* (Tales of spring rain). The film then enters a visual representation of the story in premodern rural Japan, with the professor's dialogue acting as voice-over. This section of the film forms a diegesis that is subordinate to the film's overarching diegesis.

In *Tokyo Knights*, Matsubara performs a dance in a Noh mask as part of a school production while criminals kidnap his mother and surrogate younger sister in another room. Suzuki intercuts between Matsubara's performance on stage and the kidnapping, alternating between dramatic light shifts over the dance performance and the tense interactions backstage. The technique allows Suzuki to use the dramatic stage effects of the subdiegetic stage space to underscore the conflict in the diegetic space while maintaining a clear distinction between the two spaces.

The Blurring of Registers 1: Films Within Films

Though there are many places where the distinction between subjective and objective, diegetic and extra-diegetic, or diegetic and nested diegetic are relatively straightforward, many of Suzuki's most interesting sequences are the places where these are not straightforward. As we have already seen, one place where he does this regularly is in film-within-film sequences, which are a frequent feature of his films. Beyond those of *Young Breasts* and *Everything Goes Wrong* already considered, there are prominent examples in *Our Blood*

Will Not Forgive, *Carmen from Kawachi*, *Branded to Kill*, "A Family's Choice," and *Marriage*. These four examples can be broken into two groups: films-within-films that are seen as they are watched by characters (in *Our Blood Will Not Forgive*, *Branded to Kill*, and "A Family's Choice"), and those that are seen as they are performed by characters in the diegesis (*Carmen from Kawachi* and *Marriage*). Those in each group reflect on the process of image production and play with the diegetic boundaries between the film and film-within-the-film, and with the way that subjective boundaries overlay these diegetic boundaries, though they differ in that the subjective experience considered in the first group is that of film viewing, while the subjective experience considered in the latter group is that of filmmaking.

The film-within-a-film sequences are impossibly constructed, and often it does not require any great insight or knowledge into the practice of filmmaking to recognize the absurd impossibility of the way they are constructed. The immediate reactions to these sequences may be some combination of confusion at their misleading construction and humor at their absurd impossibility, but these, I argue, are revealing in Suzuki's practice of narration. They require a meticulous construction to mislead or confuse viewers about their diegetic status before they are suddenly revealed as films-within-films. The impossible editing within them is also often woven into editing patterns within the larger scene, which is to say that they create compositions within the film-within-a-film that allows Suzuki to create shot/reverse-shot editing patterns, and other techniques common in continuity editing, between the diegesis and subdiegesis, and to withhold, deny, foreground, or hide significant information: in other words, to function like ordinary narrative films without being burdened by being tied to a single realistically motivated point-of-view in the filmmaking. Suzuki's practice of misleading narration and flagrant disregard for plausibility in the construction of these sequences point to Suzuki's hand as organizer of both the sequences and, by extension, the films themselves. They also ultimately lay bare the processes of editing and framing that go into narrative filmmaking generally, heightening the awareness of the decision-making process that goes into the decoupage of filmmaking.

Discussing the film-within-a-film sequence in *Branded to Kill*, Ryan Cook has argued that the way Hanada views it within the film articulates some of the issues at stake in ongoing discussions of film spectatorship in the 1960s. Cook argues that Hanada functions as the "rube" model of spectatorship referred to in early cinema as "a simpleton film spectator who doesn't know how to separate images on screen from the reality of the theater that surrounds him," as Hanada "becomes entangled in the projector's electric cord while attempting, rube-like, to caress and speak to her projection on the walls as if the image

were not flat and cut off."⁹ Cook's reading treats Hanada as a surrogate viewer and analyzes the film/viewer relationship in terms of how Hanada reacts to the film-within-the-film. My interest in the sequence lies less in Hanada's relationship to the film-within-a-film than it does in the relationship of a spectator to the film, to Hanada, and to the film-within-the-film. In observing that Hanada caresses and speaks to Misako's projection "as if the image were not flat and cut off," we must also remember that Hanada himself is a projection, flat and cut-off from the audience.

It is crucial to remember in discussing these film-within-a-film sequences that there is no ontological difference between the film and the film-within-a-film. In *Branded to Kill* and *Young Breasts* in particular, the film and the film-within-a-film not only are both flat projections but are black-and-white and have the same aspect ratio, making it possible for shots from the film-within-the-film to stand in interchangeably with shots from within the overarching film's diegesis, and difficult to distinguish between the two. Suzuki's formal experimentation within these scenes, and his role in facilitating new spectatorship practices, does not lie solely in the surrogate spectators whose experience he narrates; rather, it lies more in this ambiguity that he creates with these sequences. If Hanada resembles the rube of an early cinema audience member who cannot distinguish between the film and the reality surrounding it, the rubes watching *Branded to Kill* in 1967 and later are audience members who have so thoroughly internalized the processes of continuity editing and the assumptions of a cinematic diegesis that they cannot recognize that both the film-within-the-film and Hanada's "reality" are ontologically the same.

Though the film-within-a-film sequence is marked as such in advance in *Branded to Kill* (the film projector becomes partly visible as Hanada trips over its wiring), throughout the sequence Suzuki can be seen playing between its ontological sameness with the rest of the film and the difference in diegetic status set up by its narrative context. As Cook writes, Hanada does try to touch Misako, only to hit against the flat surface of the screen, but Suzuki also interpolates shots from the sequence into shot/reverse shot patterns, making it look as if the characters are in the same physical space. Even the sequence's final image, in which the film-within-a-film is projected on Hanada's forehead, plays with this tension: Cook reads it as an internalizing of the image, and while it plays on the idea of an image in someone's head and graphically resembles subjective techniques like the masking of Hanada's head with bird and butterfly images, it also uses Hanada's head as a flat surface for the film to project onto, making it at once a rendering of the subjective experience, showing the movie inside Hanada's head, and an objective one, using Hanada's forehead as a flat surface to project the frame onto in place of a wall.

Carmen from Kawachi has a film-within-a-film sequence that takes place at the time of its production, allowing Suzuki to blur the distinction between the subjective experience of the performer in the film with the actions that are taking place in the film. In this case, a young woman named Tsuyuko has a series of jobs that exploit her image—as a bar hostess, a fashion model, and a pornographic actress. The film-within-a-film is a pornographic film that she performs in as it unfolds in real time. She agrees to act in the film to help fund her childhood sweetheart Bon's *onsen* project while keeping the fact that she is working in the pornographic film industry hidden from him. When he discovers that she is, Bon is not angry, jealous, or protective, and he does not even acknowledge to her that he knows—instead, he attempts to blackmail the filmmaker she is working for for additional cash; the filmmaker does not pay him but casts him in one of his films opposite Tsuyuko instead. Tsuyuko does not realize this until she unmasks him during the production.

Suzuki withholds the information that Tsuyuko is set to appear in a pornographic film until the film-within-a-film sequence itself: in a series of meetings with the filmmaker, an older man named Saitō, he asks her to pose nude and walk nude in front of him, and in exchange, he not only pays her a large salary but buys her a fancy new apartment. Initially, she believes that he is asking her to be his mistress, and the moment that explains the job he is asking her to do is elided. The narration suggests only that Saitō is asking her to do something sexually exploitive, and that Bon discovers what it is and blackmails him for it. We are able to make sense of the arrangement only *in medias res*, at the moment that Tsuyuko is discovering that Bon is playing the man in the film. As a result, both Tsuyuko and the audience experience major surprises at the same time, though very different ones. Since the filming is during production rather than viewing, the scene uses shots that overlap with ones that the filmmaker Saitō is using in his film alongside shots that make visible the apparatus involved in filming: the camera itself, the studio lighting and other elements of the studio space, and the crew working with pieces of the set during filming.

The scene itself opens with Saitō giving directions to a kimono-clad Tsuyuko. In the background, there is an empty tatami room giving way to metal supports near the top of the frame. Saitō runs to the back, but Tsuyuko asks him to wait and chases after him. "I don't want to do it!" The lights fade to black, with only a dim spotlight on Tsuyuko at the center. Some stage hands bring out a futon and floor lamps to dress the adjacent room with proscenium-style staging, as a ninja-clad character emerges from a thin, gauze-like sheet that stage hands hang from the ceiling. Tsuyuko turns and tries to run out the door, but she is enclosed by a wall of lights that push inward toward the door frame, blocking her exit path. The ninja runs up from behind her, and there is a cut to a composition showing the lights pressing against her from the left, and the

ninja pressing in on her from the right. With another cut, she is seen through the gauze-like sheet, pushing the ninja away, but the lights push closer to her. Finally, there is a cut to a close-up of her face surrounded by film lights, with some parts of the frame blown out by their intensity. It is at this moment that she recognizes Bon and begins to back away. He pursues her and begins to tear her clothes off. "Why are you doing this?," she asks. The lights and frames are kept on-screen, and even the camera (with Saitō behind it) is visible while she threatens Bon with a sword. At this point, Bon finally explains that Saitō offered to back his *onsen* project in exchange for his appearing in the film with Tsuyuko. As he begs her, she drops her sword, and in another feat of impossible editing, she appears and undresses inside the gauzy sheet, telling Bon that it is their last meeting. It ends with Saitō calling "cut," followed by a series of erotic paintings standing in for Bon and Tsuyuko's sex scene while we hear the corresponding sound.

Throughout the sequence, Tsuyuko's actions take on a double meaning: she tries to escape as part of her role as a victim within the film-within-a-film but also because of her own second thoughts about appearing in the project. Likewise, as her attempts to threaten Bon and to beg him are motivated by her performance in the scene, they also underscore the sense of betrayal she feels at learning that Bon is consciously and willingly exploiting her.

The placement of the cinematic devices—the lights that bear down on Tsuyuko from the sides, the supports above the set, and the camera itself—is realistically motivated and foregrounds the voyeurism of the event, as do the subframes, gauzy cloths, and hanging bamboo sheets. The various devices also function to trap Tsuyuko, and do so literally within the frame. Every attempt to find an escape to off-screen space is thwarted by an element of the cinema: either the lights, the boundaries of the set, or the camera itself. She becomes trapped as an image, and ultimately, the bodily experience of sex with her childhood sweetheart, which she has longed for since the beginning of the film, is replaced by a series of still images standing in for it.

This sequence is the most overtly meta-cinematic in Suzuki's Nikkatsu films, and perhaps his entire oeuvre. The very construction of it all is revealed, trapping Tsuyuko within the boundaries of the frame, as with Jōji in *Youth of the Beast* or Tetsu in *Tokyo Drifter*, but here the entrapment of the film frame is most directly tied to a critique of the exploitation or, more precisely, the imagification of Tsuyuko (which can, in turn, be read as an autocritique of Suzuki's own use of Nogawa Yumiko's image in this film, *Gate of Flesh*, and *Story of a Prostitute*). And as with other sequences, the meta-cinematic quality of the scene is present not just through the visibility of the apparatus, but through the sense of flattening of the screen by, first, the proscenium-style staging and, second, the gauzy white sheet and bamboo sheets through which we see the action taking place, replacing perspectival depth with a flat surface that mediates that depth.

Suzuki was not the only 1960s Japanese filmmaker to play with the use of films-within-films. Ōshima Nagisa features one prominently in *The Man Who Left His Will on Film*, in which a group of student activists discover a film composed primarily of largely empty landscape shots left over by one of their deceased comrades, attempt to make sense of the film, and ultimately try to reshoot it. The student's film-within-a-film is reshown multiple time throughout the film in different contexts, and a variety of interpretations are presented. In the process, the film-within-a-film becomes a kind of blank canvas for the other student activists to project meaning onto. Yuriko Furuhata offers an interpretation of this film-within-a-film as a diagramming of the networks of state power onto the landscape, reinforced by the resistance from the police that the students are met with when they attempt to reshoot the film.[10] Though that is one possible interpretation, I find Furuhata's presentation of it overdetermined: it misses the plethora of interpretations of the film offered by students, and the strange relationships set up by the way that the film is remediated within the film, such as playing behind two students having sexual intercourse, mimicking the practice of rear projection in a meta-cinematic sense.

It is this meta-cinematic aspect of film-within-film-sequences that Suzuki plays with as he uses them. Fernando Canet defines meta-cinema as "the cinematic exercise that allows filmmakers to reflect on their medium of expression through the practice of filmmaking, whereby cinema looks at itself in the mirror in an effort to get to know itself better." He writes that these sequences can be understood as articulating "cinematic reflexivity" ("the processes and mechanisms of film creation and reception") or "filmic reflexivity" (an awareness and invocation of film history).[11] Invariably, Suzuki's film-within-film sequences prioritize "cinematic reflexivity" rather than "filmic reflexivity": they largely eschew direct citations of other films. Though they do at times invoke recognizable genres, what is at stake in them is not the recognizability of generic tropes in itself so much as the way that they investigate the methods, both inherent and conventional, by which both the sense of a diegetic world and meaning (narrative or otherwise) are produced. Beyond this, what distinguishes Suzuki's film-within-film sequences is the way they are frequently woven into the broader diegetic world of Suzuki's own film itself, such that the boundaries between the film-within-a-film and the film's diegesis become unclear. In other words, these films-within-a-film do not refer strictly allegorically to their own production (as many films playing with "cinematic reflexivity," including Ōshima's *The Man Who Left His Will on Film*, do). By confusing and blurring these boundaries, they force viewers to attempt to make sense of what is contained within the diegesis as opposed to the subdiegesis, and the formal techniques at work in creating the film's diegesis are put under as much scrutiny as the film-within-a-film's are.

The Blurring of Registers 2: The Supernatural

Apart from film-within-film sequences, one recurring feature in Suzuki's films that he uses to blur registers of narration is the invocation of the supernatural. Supernatural elements may not be the first thing to come to mind in reference to Suzuki, in part because they are almost entirely absent from the films that first made his reputation in the 1960s. In fact, with the arguable exceptions of *Carmen from Kawachi* and *Branded to Kill*, they are absent from Suzuki's work at Nikkatsu entirely.[12] They are a recurring feature in Suzuki's career, however, from "A Mummy's Love" through *Princess Raccoon*; in other words, as soon as Suzuki became more directly involved in the creative process of his screenplays. This becomes clearer if we consider that a great number of the unrealized screenplays from both his hiatus from filmmaking in the 1968–1977 period and the end of his career also invoke the supernatural to lesser or greater degrees, notably *Red Lion of the Ghost Town*, *Branded to Kill Continued*, *Forging the Swords*, *Hall of Dreams*, *Star Woman*, and *Bitter Honey*.[13] Several of Suzuki's post-Nikkatsu films are explicitly supernatural, prominently featuring spirits, demons, or the underworld as part of their narratives, including "A Mummy's Love," "The Fang in the Hole," *Kagero-za*, *Lupin III & The Legend of Babylon's Gold*, "Yotsuya Kaidan," *Pistol Opera*, and *Princess Raccoon*. Suzuki's two 1980s detective television films, "The Claws of the Divine Beast" and "A Family's Choice," seriously present the supernatural as possible solutions to their mysteries before concluding with nonsupernatural explanations for apparently supernatural phenomena. Several others contain supernatural elements that are eventually discovered to be contained within dreams or subdiegeses, including "A Duel," *A Tale of Youth at Hirosaki High School*, and *Marriage*. Other films contain hints of the supernatural with the strange formal presentation of certain events or characters, and events that go unexplained but defy nonsupernatural explanations, including *Carmen from Kawachi*, *Branded to Kill*, *A Tale of Sorrow and Sadness*, *Zigeunerweisen*, *Spring Cherry Blossoms: Japanesque*, "Musical Variation of Monkey Business," *Capone Weeps with Passion*, and *Yumeji*.

There are any number of reasons that Suzuki and his screenwriting collaborators may have been interested in the supernatural, about which I am not interested in speculating. For the purposes of cinematic narration, however, the introduction of fantasy into the diegesis destabilizes notions of the rules of the film's diegesis. Tsvetan Todorov articulates the problem that the "fantastic" presents to the perception of those encountering it:

> In a world which is indeed our world, the one we know, a world without devils, sylphides, or vampires, there occurs an event which cannot be explained

by the laws of this same familiar world. The person who experiences the event must opt for one of two possible solutions: either he is a victim of an illusion of the senses, of a product of the imagination—and the laws of the world then remain what they are; or else the event has indeed taken place, it is an integral part of reality—but then this reality is controlled by laws unknown to us.[14]

When used in filmmaking, the presence, or even possible presence, of supernatural elements presents the filmmaker with further opportunities to mislead an audience and to blur registers of narration. The presence of supernatural elements, by definition, throws the laws of the film's diegesis into question, and thus when we are presented with something we might be inclined to call unrealistic, we cannot be certain whether we have entered a subjective register, Suzuki is intruding as a narrator from a meta-diegetic register, or something supernatural is occurring within the diegesis itself. This is particularly true of films of the third category, where whether something is supernatural is never fully defined. Suzuki's *Yumeji* begins with the painter Takehisa Yumeji's dream, in which he is challenged to a duel and shot by a jealous husband. As the film continues, he meets a young woman, apparently widowed, whom he takes on as a model and begins an affair with: later her husband appears alive, with a seemingly rational explanation for his apparent death. The twin possibilities that either he is a spirit risen from the dead or there is a rational explanation for his apparent death are both considered but never resolved; further, the specter of the supernatural is still very much present even with the rational explanation, given that Yumeji's dream has predicted encountering the jealous husband, who is identical in real life to the one in his own dream, in spite of the fact that Yumeji had not met either the wife or the husband when he first had the dream. At other times, the suggestion of the supernatural is not woven into the narrative as written in the screenplay but is found in the formal presentation of characters or events. Consider *A Tale of Sorrow and Sadness*: the narrative does not explicitly define any characters as supernatural, but at specific moments, uses a strange formal presentation to hint at it. The first appears when the jealous neighbor, Senbō, is visiting Reiko's house. In a point-of-view shot from her younger brother's perspective, her reflection is bathed in a sinister green light. The change from the neutral white lighting of Senbō's face to the green light from an unseen source illuminating it in reflection presents multiple possibilities: the younger brother could be recognizing an inner demonic nature within Senbō, or he could be hallucinating or imagining it. Suzuki repeats this effect later in the film in a point-of-view shot from Reiko's perspective, panning from Senbō's green reflection to a neutral light source on her face. The repetition of the technique from a different character's perspective might indicate that

Senbō is really demonic after all, rather than that two separate people have had the same hallucination, though this is never definitively resolved.

The ambiguity can also be directed outward, toward the laws of the diegesis itself. "A Mummy's Love" plays with the ambiguity brought about by having a subordinate diegesis in the form of a work of literature. In the section of the film adapting Ueda's *Harusame monogatari* as a professor narrates it, a mummified Buddhist monk returns to life and runs amok in a small village in premodern Japan. This supernatural occurrence is presented unambiguously within the subdiegesis and corresponds neatly to the religious beliefs of the townsfolk. This establishes that returning from the dead is consistent with the laws of this subdiegesis. After the film exits the recounting of the story, however, the professor tells his editor that there have been reports of people seeing her deceased husband in the area, and the editor expresses skepticism about the possibility of the dead resurrecting: it may be possible within the subdiegesis, but not the film's overarching diegesis. When she visits the location, she has an uncanny encounter with someone who may be her resurrected husband, or may be the professor in disguise (who may or may not be already dead as well). While the story in the subdiegesis introduces the possibility of the resurrection of the dead, the apparent distinction between the subdiegesis and diegesis allows this encounter at the end of the film to preserve its element of the fantastic by challenging what were thought to be the film's diegetic laws, but additionally the encounter challenges what seemed to be neat diegetic boundaries in suggesting that the story from *Harusame monogatari* may actually be true, as the professor claims. The possibility presented by a film's subdiegesis can also be misleading: near the end of *Kagero-za*, the playwright Matsuzaki visits a mysterious theater and watches a theatrical performance with a series of lighting cues and stage directions that defy the physical possibilities of the stage. Though we may be inclined to think that this may simply be an instance of the stage possessing its own set of diegetic laws, in fact, the stage *is* a supernatural space, functioning as a portal to the underworld. It should come as no surprise that Suzuki exploits the ambiguities and possibilities that the supernatural presents at every possible opportunity.

Even when it appears unambiguously, the supernatural presents a filmmaker like Suzuki with further opportunities to experiment with film form in depicting things that are "not of this world." Thinking back to Laura Lee's discussion of the tension between cinema's "reality effect" and the urge to show something at odds with that reality, the presence of elements that are by definition at odds with the reality that can be seen by the camera requires a degree of formal ingenuity. In both *Kagero-za* and *Pistol Opera*, the protagonists visit what we are told is the underworld: temporarily in the latter film, permanently in the former film. Suzuki uses different techniques to portray it in each case: *Kagero-za*

depicts the underworld as identical to the real world, with the exception that the characters are boxed in by grotesque, colorful *yūrei-zu* surrounding them on walls where there had previously been an ongoing exterior (fig. 5.7). In *Pistol Opera*, the underworld is approximated by a combination of green screen and superimposition effects overlaying a relatively simple set design.[15] Even in cases like these where the question of whether these are supernatural, subjective, or in some way meta-diegetic is not open to question, Suzuki's invocation of the supernatural draws from a consideration of the nature of the material properties of cinema and the ability, or inability, of live-action filmmaking to evoke something at odds with reality. The golden water created by a green-screen effect in *Pistol Opera* foregrounds the artificiality of its construction, while the use of painting to evoke the underworld and physically block in characters in *Kagero-za* draws on Japan's precinematic (even prephotographic) visual art forms, both tracing the lineage of cinema as a form of visual art and foregrounding its reliance on artificial techniques at odds with its apparent "reality effect."

Writing on fantasy in literature, Rosemary Jackson argues that "a characteristic most frequently associated with literary fantasy has been its obdurate refusal of prevailing definitions of the 'real' or 'possible.'" Jackson argues that the genre has an inherently subversive quality: she writes that it subverts a "unitary vision" of the real: "the fantastic introduces confusion and alternatives."[16] Susan Napier similarly suggests that "the existence of a fantastic genre is itself a comment upon the 'real,' since it exists in contrast to it."[17] It is perhaps more productive, and accurate, to think about the fantastic as a *mode* in Suzuki's case, as many of the films listed slip in and out of apparently supernatural elements, though it should be noted that several of the films would fit neatly into the fantastic genre. Writing on Western literature, the prevailing definition of "real" that

5.7 Background *yūrei-zu* paintings transform the normal world into the underworld in *Kagero-za*

Jackson claims the fantastic genre subverted was "bourgeois ideology upheld through the 'realistic' novel."[18] Napier discusses modern Japanese fantasy literature as it emerged from the beginning of the twentieth century, arguing that what the fantasy genre subverts in Japan is the logic of modernity itself: the fantastic in Japanese literature, she writes, is "the reverse side of the myths of constant progress, economic miracle, and social harmony."[19] I suggest that Suzuki's tendency to throw the logic of the diegesis into question beginning in his Nikkatsu films inevitably brought him to the realm of the fantastic, and that diegetic logic is the primary "reality" in question in his use of fantasy. At the same time, by ending up in the fantastic, Suzuki developed affinities with some of the early modern writers that Napier discusses from the late Meiji and Taishō eras including, notably, Izumi Kyōka, whose work Suzuki adapted in *Kageroza*. Though it began as a playful interrogation of the methods by which films are designed to address their audience, how they produce images, and the processes by which we are led to understand them, it ultimately led to a broader investigation of the processes of perception, and an affinity to literature and art of the Taishō era in particular, where many of these same issues were at stake.

Suzuki's most sustained blurring of registers through the supernatural comes in "The Fang in the Hole." The story follows a police detective (Fujita Makoto) who shoots and kills a suspect (Harada Yoshio, prefiguring his demonic Nakasago in *Zigeunerweisen* the following year) as the latter attacks a bar hostess (Inagawa Junko) in a Ginza bar but is unable to find the bullet. In the process of his search for the bullet, it begins to seem as though the spirit of the dead suspect is haunting him or possessing the bar hostess, or, alternately, that the detective is himself descending into madness. In this film, Suzuki sets up a diegetic space that foregrounds its own construction on a soundstage. Apart from a handful of short scenes shot on location, he constructs the space of the film entirely on a soundstage with a minimalist set design. The space carries off indefinitely into the avocado-green background that surrounds every space in the film. Suzuki uses the consistency in the backgrounds to confuse the space of the scenes deliberately. In one scene, shōji screens behind the detective are surreptitiously pulled back, opening up to total darkness that becomes invaded by the superimposition of the suspect, swooping down as if to attack him. When the detective visits the bar hostess in the hospital, the corpse of the deceased suspect inexplicably slides in next to her on a stretcher: Is this a representation of his taking over the hostess's body, the imagination of the detective, or a function of the abstractness of the space?

Its abstract, minimalist set design allows Suzuki to play with the boundaries between spaces: on more than one occasion, when he cuts between scenes, the visual continuity of the space makes it unclear that we have entered into a new scene. Further, the abstract space allows him to blur completely the boundaries between character subjectivity, the supernatural, and the diegesis. The

abstract space allows Suzuki to leave ambiguous whether the diegesis is pervaded by a sense of the demonic or filtered through a character's subjectivity, and it leaves deliberately unclear whose subjectivity it would be.

The Kyōka Factor: Suzuki and Taishō Romanticism

"Comparing the Meiji, Taishō, and Shōwa eras, Taishō is the best. That is because it is the era I was born in,"[20] Suzuki begins in his written elegy to the Taishō era, in a characteristically facetious manner. He then proceeds to list the supposed virtues of the Taishō emperor, particularly in comparison to his Meiji and Shōwa counterparts. As with much of Suzuki's written work, it can be difficult to distinguish what the author means seriously, what is hyperbolic, and what is written precisely for the sake of absurdity as an end in itself. Nevertheless, Suzuki does have a certain affinity for Japanese culture in the Taishō era. This is most clearly visible in the films of his Taishō trilogy, but Suzuki's depiction of the era dates back to *The Incorrigible* in 1963, his first of three adaptations of a Kon Tōkō novel. Though all three films (*The Incorrigible, Born Under Crossed Stars*, and *Carmen from Kawachi*) were based on novels that Kon had written between 1959 and 1966, Kon had begun his literary career in the 1920s, first gaining prominence as a member of the *shinkankakuha* (sometimes translated to as "Neo-Perceptionist," "New Sensationism"; Yokomitsu Riichi and Kawabata Yasunari were among its best-known members). The first two of Suzuki's Kon adaptations were both set in the Taishō era. *The Incorrigible*'s source novel was semiautobiographical, and many aspects of protagonist Konno Tōgō's characterization replicate (or parody) associations with the *shinkankakuha*, like the protagonist's obsession with August Strindberg's literature and his sweeping, strangely mystical declarations about the unity of body and mind when recounting his experience sleeping with a geisha.[21] Further, Hasumi has argued that Suzuki's artistic temperament makes a strong connection between Suzuki and the Taishō era: "He seems predestined to have been born in an era suspended between development [Meiji] and aggression [early Shōwa], in which he was granted the liberty of fiction."[22]

In a strictly technical sense, the Taishō era refers to the period of the Taishō emperor's reign, 1912–1926. However, social and cultural developments do not map perfectly onto the ruling periods of emperors, and Hasumi's description of the Taishō era as the period of relative peace and tranquility might more accurately be the period 1905–1923, bookended by the end of the Russo-Japanese War at its beginning and the Great Kantō Earthquake at its end. We might observe, additionally, that this is not quite the carefree, apolitical era of Hasumi's description: the imperial project was well underway at the beginning of the era, with Japan's colonization of Taiwan in 1895, and would continue with the

colonization of Korea in 1910, both of which remained colonized by Japan through the end of the Pacific War in 1945. Seiji Lippit has articulated the relationship between the imperial project and Taishō-era culture thus:

> The explicit disavowal of national concerns in Taishō cosmopolitanism in some ways merely masked the assumption of a national subjectivity seen to be equivalent to that of the West, [but] the effects of this consciousness of transnationalism conversely tended to destabilize the borders of national culture.... For certain intellectuals, for example, the influx of mass culture (typically identified as American) signaled the nation's colonization by foreign culture and capital. Yet what was in fact occurring during this period was an expansion of Japanese empire; that is, the wave of accelerated urbanization and industrialization of the period beginning in World War I can be linked to Japan's growing economic extension into Asia.[23]

The possession of an empire and victory over a European power in war were both crucial in creating the Taishō era: they helped to define Japan as a modernized nation and to quell, at least temporarily, anxieties about being colonized by a Western nation, but the colonial violence was largely relegated to the colonies themselves during this period and was kept largely out of sight of Japanese life in Japan itself. This would change very suddenly with the surge of violence against ethnic Koreans after the Great Kantō Earthquake in 1923, the growing militarization of the Japanese government throughout the 1930s with the invasion of Manchuria, the second Sino-Japanese War, and, crucially for the arts, the intensification of censorship laws, particularly toward the end of the 1930s. This has allowed for the Taishō to be looked back on with nostalgia, as if it were an era free of the geopolitical concerns of the Meiji and early Shōwa eras, when in fact they are lurking under the surface. Though Suzuki's Taishō films do not centrally focus on political intrigue, there are noticeable currents that run through the three films, including government officials who show up to question the protagonists about the presence of anarchists, or to inform them that they are under investigation for possible political crimes.[24] The political turmoil, and stricter government censorship, that was to define the early Shōwa era is constantly lurking under the surface.

Within the literature of the late Meiji and Taishō eras, Noriko Mizuta Lippit has identified a strain she calls "aesthetic literature" that indulges in the decadence of the era in its most extreme form, to the point that it reaches the fantastic and the grotesque; she calls this work a "romantic quest for a vision of destructive transcendence." She argues that authors were influenced by Western "dark romantic" authors like Edgar Allen Poe, Charles Baudelaire, and Oscar Wilde, but that "they developed a nostalgic aspiration for the characteristically

erotic and grotesque art and literature of the Edo culture which had developed in the two-and-a-half centuries of Japan's cultural 'isolation.'"25 The most prominent authors she discusses as part of this turn are Tanizaki Jun'ichirō and Akutagawa Ryūnosuke, neither of whom Suzuki adapted. However, the authors whose works Suzuki did adapt—Uchida Hyakken, Izumi Kyōka, and even the painter Takehisa Yumeji—operate in similar ways. Uchida was known for a literary style that "eschewed unified narrative with his fragmentary, brief, simple style,"26 while Kyōka practiced "a brand of romanticism and aestheticism [that followers of the naturalist movement found] an irrelevant vestige of past literary excesses, all style and no substance." His work, critics claimed, lacked "a logically constructed narrative structure, and an intellectual engagement with social issues."27 Between eschewing unity in favor of a fragmentary narrative and the lack of a logical narrative structure and a refusal to engage with social issues in a straightforward way (at least on the surface), it is not difficult to see what Suzuki had in common with these artists. Kyōka in particular had the interest in the "grotesque art and literature of the Edo" period that Lippit mentioned, and its presence is uncanny: it haunts the modern spaces of his work.28 M. Cody Poulton writes that "the meaning of Kyōka's stories is . . . contained not in their deceptive surfaces but rather in the way they constantly shift, transforming images, characters, motifs, and whole genres. . . . This tendency expressed itself in both formal and symbolic terms: in the disquieting ways his stories juxtapose melodrama and fantasy, and in the penchant for his characters to be 'bewitched,' to undergo a metamorphosis into something other than just human."29 This relates closely to the author's interest in the supernatural, as seen in the example of *Kagero-za* (both Kyōka's story and Suzuki's film), in which a kabuki theater is a literal portal to the underworld; the underworld, moreover, is seen in recognizable locations from earlier in the film, distinguished by the presence of *yūrei-zu* (ghost paintings) surrounding the characters.30 The supernatural may not function in so straightforward a way in Uchida's work, but his writing is nevertheless uncanny in the strange encounters, unexplained phenomena, and doubling of characters.

Suzuki and his regular screenwriting collaborator Tanaka Yōzō do not offer a straightforward adaptation of either author's work but rather freely borrow from multiple stories from each to create a fever-dream like vision of the Taishō era that carries across both films, in spite of the fact that they are adaptations of different authors. With *Zigeunerweisen* and *Kagero-za*, Suzuki draws from works of Uchida Hyakken and Izumi Kyōka, respectively, while *Yumeji* takes up the life of the painter Takehisa Yumeji (whom Noriko Mizuta Lippit mentions as a counterpart to this type of literature).31 At the same time, neither *Zigeunerweisen* nor *Kagero-za* is a strict literary adaptation of either author's work. *Zigeunerweisen* brings together elements of Uchida's "Sarasate no ban,"

concerning the exchange of a phonographic record by Sarasate, and the depiction of two Taishō-era intellectuals and authors (supposedly based on Uchida and Akutagawa Ryūnosuke) found in "Yamataka bōshi."[32] *Kagero-za* draws from Kyōka's work of the same name as well as his more famous *Shunchū*.[33] *Yumeji* is not, like the earlier two films, an adaptation of a literary source or author, but rather an ostensible biographical film of Takehisa Yumeji. In this film, however, Suzuki takes up the process of adapting Takehisa's paintings into cinema, at times literally using the camera lens as a canvas and painting directly onto it, and at other times using strange artifacts to create a frame resembling a painting, blurring the boundaries between the diegesis of the film and that of Takehisa's paintings. Throughout the film, Takehisa has a series of relationships with women who act as his model-muses: dressed to resemble the famed *bijin* of Takehisa's paintings, each woman has a distinct kimono pattern that she wears for most of the film until its final scenes, in which the women all unannouncedly swap their kimono designs, blending the distinction between the women. Further, in a sequence near the end of the film, the painter encounters himself at three different stages in his own career, likewise fracturing the character. But *Zigeunerweisen* and *Kagero-za* go further: the central characters, intellectual and playwright, exist as ciphers: their goals, desires, and other defining attributes are not clearly determined, making subjective registers even more difficult to determine and decipher. Rather than fully defined characters, Aochi and Matsuzaki are ciphers who undergo a series of encounters with characters almost emblematically defined by their costumes as types associated with the era, and the films make an often strange recourse to the filmmaking practices of an earlier era, using tableau-like compositions harkening back to cinema's earliest days, while using startling montage-like juxtapositions between them, taking Suzuki's periodic spatial discontinuities in editing to their possible extreme and employing them most regularly. Though the narrative logic of the films is difficult to follow, they operate according to a pastiche of social and artistic associations with the Taishō era (and the Taishō era's own appropriation of elements of premodern Japanese and contemporary European styles), such as *Kagero-za*'s use of the gold-black color designs associated with high-class gold-leaf paintings in the bright colors of a Kabuki performance and *yūrei-zu* as Matsuzaki enters the underworld.

Suzuki's nostalgic embrace of the grotesque of the Taishō era at the end of twentieth century can thus be seen as a repetition of these authors' nostalgia for the grotesque of the Edo period. Likewise, Suzuki and Tanaka perform a practice of double fragmentation, breaking up the already fragmentary literature of Uchida and Kyōka in their process of adaptation. As Rachel DiNitto argues, "Suzuki shows us that nostalgia is in itself a form of doubling ... and that, by extension, history and memory are as elusive as his doppelgangers. The

very notion of originality becomes suspect given the multiple temporalities and the jarring mix of cultures that existed in prewar Japan."[34] DiNitto argues that *Zigeunerweisen* is driven more by a series of associations than a cohesive narrative, a claim that could be equally made about *Kagero-za* and perhaps some of Suzuki's other latter-day films, such as *Capone Weeps with Passion* or even *Pistol Opera*. But a key feature of these associations is the fact that they operate somewhat mysteriously in the different registers of narration: by blurring the distinctions between the subjective and objective, the diegetic and metadiegetic, and the very laws of the diegesis afforded by the specter of the supernatural, Suzuki further confounds attempts to determine a cohesive narrative. The cipher-like nature of the films' protagonists plays an important role in this process, confounding attempts to decipher the meanings of dreams, hallucinations, and other encounters. As a result, Suzuki produces a series of powerful, apocryphal images that are juxtaposed but impossible to decode. By detouring through the fractured, grotesque art and literature of the Taishō era, he furthers his interrogation of the cinematic medium.

✳ ✳ ✳

The charge made by Hori Kyūsaku that Suzuki's films were "incomprehensible," though likely a retroactive rationalization rather than the proximate cause of his firing, is frequently invoked in discussing Suzuki's films, even or perhaps especially in appreciations of his work. As such, looking at the processes of narration in his films may not seem to be productive. We should observe, however, that the vast majority of his films actually *are* comprehensible in a conventional narrative sense, and, further, that even those films that are incomprehensible (or at least difficult to comprehend) are still narrative films: they present characters, flows of events, and settings, though they may be difficult to follow in a causal sense because some elements of their settings are left undefined, such as whether they are supernatural, or are misleadingly presented, as in the weaves in and out of subdiegetic spaces. Further, we should not think that the loose causality is the result of the filmmaker's boredom with conventional material, as his most difficult films to follow in a narrative sense are the ones whose narratives he had a hand in conceiving himself. In many cases the techniques of cinematic narration that Suzuki deploys, like entrances into subjectivity or subdiegetic films-within-films, allow him to draw on film form in a unique, meta-cinematic way, and it may be tempting to conclude that he uses narration as a mere pretense for formal experimentation. While there may be some truth to this, it might be more productive to look at the "incomprehensibility" of some Suzuki sequences or films as a deliberately created sensation. Isolated from an undergirding causal logic, the elements of narration are laid bare, like

the studio sets of the film-within-film sequences in *Carmen from Kawachi* and *Marriage*. It is yet another self-reflexive move, incorporating the hallmarks of narration while isolating them from a logical narrative.

In discussing narrative discourse in early cinema, Tom Gunning has argued that the emergence of narrative creates the specter of a narrator that "embodies the design organizing narrative discourse." He adds that "although it is theoretically separate from the author and processes of production that created the work, it does provide, in the words of Ricoeur, the image of the author within the text."[35] It is perhaps from the consistently devious narrative discourse that our sense of the figure Suzuki Seijun—not the true historical figure Suzuki Seitarō, who directed the films, but the personified motifs and stylistic systems that unify his body of work—emerges.

CODA

At the time Suzuki reemerged as a filmmaker in the 1970s and 1980s, his influence was visible in the work of many of the most interesting filmmakers who were coming on the scene. Perhaps this is most easily recognizable in the films of Ōbayashi Nobuhiko, who had championed Suzuki's work in *Eiga hyōron* while still a young experimental filmmaker, and whose later films exploit different types of trick photography and image compositing to grapple with the often difficult to distinguish boundaries between the natural and the supernatural, false and true memory, and fantasy and reality. Sōmai Shinji, a one-time assistant director to Sone Chūsei working with Suzuki's frequent screenwriting collaborator Tanaka Yōzō, explored this tension in a different way: not through editing or trick photography, but through cinematic compositions that combined temporally and geographically disparate diegetic spaces into the same space without distinguishing where one begins and another ends. By that point, Hasumi Shigehiko, Ueno Kōshi, and Yamane Sadao, the critics whose careers began by championing Suzuki's work in the pages of *Cinema 69*, were arguably the dominant force in Japanese film criticism. In particular, Hasumi was teaching film seminars at Rikkyō University and Tokyo University, where his students included future filmmakers Kurosawa Kiyoshi, Aoyama Shinji, Nakata Hideo, Suo Masayuki, and Shiota Akihiko, among others.

Around this time, Suzuki was also emerging as something of a public figure: he appeared in television commercials and variety shows, won the coveted "Best Dressed" Award from Men's Fashion Unity (*Ippansha dan hōjin Nihon*

menzu fasshon kyōkai) in 1985,[1] and even had a career as an actor in television and movies. As an actor, Suzuki had a range of roles and became perhaps best known for playing friendly, elderly neighbors for television dramas in the 1990s, seemingly having little to do with his persona as a filmmaker.

It is tempting to divide Suzuki Seijun's career neatly into two phases: a Nikkatsu phase, in which he made minor genre films for a major studio whose stylistic experimentation rubbed against their ostensible narratives; and an independent filmmaker phase, after his reemergence into theatrical filmmaking a decade following his firing by Nikkatsu. There is a great deal of debate among Suzuki fans, in Japan and internationally, as to whether the films of his later period, such as the Taishō trilogy, show the full blossoming of his artistry, free of any studio constraints, or whether they are a demonstration that Suzuki needed genre and studio constraints to prevent his artistic instincts from leading to a dull obscurantism.

What this division obscures, however, is that Suzuki's post-Nikkatsu career is not nearly as neat as this debate would suggest. At the same time that he was directing visually rich, artistically ambitious, and narratively impenetrable films, such as *Zigeunerweisen* and *Kagero-za*, Suzuki was continuing to make routine mysteries for television series like *Mystery Masterpiece Theater*, *Ōedo Investigation Network*, and *Tuesday Suspense Theater*. As genre works with relatively straightforward narratives and some formal experimentation around the periphery, these works are closer to earlier Suzuki films like *Passport to Darkness* or *The Sleeping Beast Within* than they are to the Taishō films, or even *Branded to Kill*, for that matter.

This is not to say that there is a neat division within his later career between experimental theatrically released films and routine television ones. His episodes of *Unbalanced Horror Series* and especially *Sunday Horror Series* are among the most fascinating films of his career and were scripted by regular collaborators Tanaka Yōzō and Yamatoya Atsushi. His V-Cinema project, *Spring Cherry Blossoms: Japanesque*, resembles *Zigeunerweisen* and *Kagero-za* in its jarring montage of nearly still compositions and striking imagery. Numerous later films combine the more oblique formal and narrative style of the Taishō films with pastiches of genre clichés, such as *Capone Weeps with Passion* and *Pistol Opera*. It would also be difficult to categorize *A Tale of Sorrow and Sadness*, his segment of the omnibus film *Marriage*, or *Princess Raccoon* neatly in relation to either Suzuki's Nikkatsu films, the Taishō films, or his television work. His work on *Lupin III* presents further difficulties: though he was rarely if ever the central creative force behind episodes of the series during his tenure as supervising director, he hired numerous collaborators for the writing staff and was physically present, if not always conscious, during pitch meetings from writers, along with Yamatoya.

Given that Suzuki's reception in the West has been tied to his late Nikkatsu films for so long, it is perhaps tempting for some scholars to look for the legacy of his influence primarily in yakuza films by subsequent filmmakers. However, this, to my mind, misses the more interesting aspects of his stylistic interventions as a filmmaker. To this point, consider his acting appearance in Aoyama Shinji's *Embalming* (*Enbarumingu EM*, 1999), an unheralded J-horror film from the late 1990s. *Embalming* follows Miyako, a professional embalmer who learns of an illicit, underground trade in which embalmers steal body parts from multiple corpses and stitch them together into new, composite, corpses, either to substitute for the bodies of real people that have gone missing or to invent bodies of people who never existed. The embalmer who tells her of this illicit practice is, naturally, Suzuki Seijun. This is fitting: as we have seen, what is interesting about Suzuki, the threads that carry through his whole career, and, ultimately, the things that make his films celebrated by competing strands of film theorists, was not so much the presence of yakuza, Ginza nightclubs, or other genre markers that his films shared with those of contemporaneous Nikkatsu filmmakers. It is, rather, an approach to the cinema as a mummy reconstructed out of fragments that do not naturally fit together, and marveling at its impossibility: the fact that in spite of the inconsistent scale and the awkward stitching, it still, somehow, moves.

Through *Embalming*, we can see the legacy of Suzuki's self-reflexive filmmaking form, and of Hasumi's celebration of it, in later Japanese films. If a more conventional critic would praise an embalmed, composite corpse by how convincingly it looked like a singular, preserved body, Hasumi is more interested in observing the awkward stitching job between disparate body parts. Hasumi, of course, argued that Suzuki's use of film form, as it grew more abstract, brought viewers closer to the material properties of film itself and, in particular, its limitations. In that respect, Suzuki's films played an important role in bringing Hasumi closer to film's material properties and helped organize his broader thoughts on cinema. This legacy can be seen when a Hasumi student like Aoyama invokes Suzuki by casting him in this way as he works through his own understanding of the essence of filmmaking.

Throughout his career, Suzuki's creative exploration of cinematic form allowed him to reinvent himself stylistically as he adapted to technological shifts in the medium, to broad shifts in the Japanese film industry, to shifts in his own place in that industry, and even to shifts between live action film, television, video, and animation. It also made him an artist well worth stealing by film theorists and filmmakers who wanted to claim him, and the potential that his experimentation unleashed, for their own. This can be seen in the way the New Left and the *Cinema 69* critics took up his cause in the wake of the Suzuki Seijun Incident, in the way that radical *pinku* filmmakers of the Wakamatsu

Production Company became his inner circle of collaborators, or in the way that cinephile filmmakers who studied under Hasumi Shigehiko, such as Aoyama and Kurosawa, could adapt Suzuki's explorations of the cinematic medium to their own purposes. It also makes both Suzuki Seijun himself and his large body of films fluid, with the potential of taking the shape of whatever container they are put into, or enigmatic. We should not mistake this self-effacement, however, to mean that Suzuki was a stylist without substance, or that he lacked anything to say of his own. It might be more accurate to say that he used his voice to articulate its own act of articulation: its properties and limitations.

APPENDIX 1

FILMOGRAPHY

This section was compiled from Ueno Kōshi, "Firumogurafī," in *Suzuki Seijun zen'eiga* (Tokyo: Rippu Shobo, 1986); Taniguchi Kōji, Isoda Tsutomu, and Nobuo Toshirō, "Suzuki Seijun firumogurafī," in *Sei/jun/ei/ga*, ed. Isoda Tsutomu and Todoroki Yukio (Tokyo: Wides, 2006), 412–37; Nikkatsu's official movie database (www.nikkatsu.com; accessed October 2018); and film credits, unless otherwise indicated. Location shooting outside Tokyo has been included where information is available.

Harbor Toast: Victory Is Ours (Minato no kanpai: shōri o wa ga te ni)

 Release date: March 21–27, 1956
 Runtime: 65 minutes
 Aspect ratio: 1.33: 1
 Director: Suzuki Seijun (as Suzuki Seitarō)
 Screenwriters: Urayama Kirio, Nakagawa Norio
 Cinematographer: Fujioka Kumenobu
 Art director: Satani Teruyoshi
 Editor: Kondō Mitsuo
 Assistant director: Kurahara Koreyoshi
 Producer: Asada Kenzō
 Production company: Nikkatsu

Production and release format: 35mm

Cast: Mishima Kō, Minami Sumiko, Amaji Keiko, Maki Shinsuke, Aoki Kōichi

Screened with *Confessions of Love* (*Iro zange*, Abe Yutaka, 92 minutes), romantic drama with Masayuki Mori and Tanaka Kinuyo.

Synopsis: An elder brother returns to shore and reconnects with his younger brother to find that the latter, a jockey, is romantically involved with a woman whom a shady nightclub owner sees as his own property.

Description: Suzuki's directorial debut is a kayō film based on the song "Minato no kanpai" and features singer Aoki Kōichi in a supporting role. In spite of its title, only the beginning and ending of the film are at the harbor. Filmed on location in Yokohama (Kanagawa Prefecture).

Pure Heart of the Sea (*Umi no junjō*)

Release date: June 7–13, 1956
Runtime: 48 minutes
Aspect ratio: 1.33 : 1
Director: Suzuki Seijun (as Suzuki Seitarō)
Screenwriters: Tanabe Chomi, Mayumi Norimasa
Cinematographer: Nagatsuka Kazue
Art director: Yagyū Kazuo
Editor: Suzuki Akira
Assistant director: Takeda Kazunari
Producer: Motegi Ryōji
Production company: Nikkatsu
Production and release format: 35mm

Cast: Kasuga Hachirō, Kō Tomoko, Takada Toshie, Kido Shintarō, Akemi Kyōko

Billed with sumo-themed feature *The Story of Nayoroiwa Shizuo's Fighting Spirit Prize* (*Nayaroiwa Shizuo: Kantō-shō*, Kosugi Isamu, 90 minutes), documentary *Record of a Single Mother* (*Hitori no haha no kiroku*, Kyōgoku Kōei, Iwanami Productions, 40 minutes), and newsreel *Summer Sumo Wrestling: Latter Half-Season* (*Natsu basho ōzumou kōhan sen jikkyō*, Ise Torahiko).

Synopsis: A young whaler is pursued by multiple women, but he remains faithful to his one true love, who happens to be the daughter of his ship captain, with whom he has an antagonistic relationship.

Description: A kayō film starring popular singer Kasuga Hachirō, whose title song was written specifically for the film. Kasuga also sings several other songs that had been previously released. Numerous scenes use the soundtrack to play with diegetic boundaries in a humorous way. The

standout, however, is a misleadingly edited *izakaya* scene suggesting that the sailors are expecting to see a striptease that goes in a very unexpected direction. Suzuki's temperament is well-suited to the musical comedy; under different circumstances, he might have flourished in this genre. Filmed on location in Miura (Kanagawa Prefecture).

Satan's Town (*Akuma no machi*)

Release date: July 12–18, 1956
Runtime: 79 minutes
Aspect ratio: 1.33:1
Director: Suzuki Seijun (as Suzuki Seitarō)
Screenwriter: Shiraishi Gorō
From a story by Shiki Ichirō
Cinematographer: Nagatsuka Kazue
Art director: Satani Sanpei
Editor: Suzuki Akira
Assistant director: Miyano Kō
Producer: Yanagawa Takeo
Production company: Nikkatsu
Production and release format: 35mm
Cast: Kawazu Seizaburō, Yumi Azusa, Shima Keiko, Sugai Ichirō, Nakagawa Haruhiko, Ashida Shinsuke, Matsushita Tatsuo, Kōno Akitake
Billed with *Crazed Fruit* (*Kurutta kajitsu*, Nakahira Kō, 86 minutes) and newsreel *Rikidōzan: Strong-Armed Victory* (*Rikidōzan: Tetsuwan no shōri*, Ise Torahiko).
Synopsis: In this convoluted crime film, a gang boss decides to pull off a heist after getting out of prison, but the team he puts together has multiple competing ambitions and very little loyalty to one another.
Description: Suzuki extends his formal experiments to editing a sequence out of freeze-frames and shooting a scene upside-down in a pool reflection, and his sense of humor shows itself in numerous murder scenes, as well as the film's climax. To viewers who are familiar with only his late Nikkatsu work, *Satan's Town* may be the earliest recognizable Suzuki Seijun film.

An Inn of Floating Weeds (*Ukigusa no yado*)

Release date: January 9–14, 1957
Runtime: 74 minutes

Aspect ratio: 1.33: 1
Director: Suzuki Seijun (as Suzuki Seitarō)
Screenwriter: Yamazaki Iwao (also concept)
Cinematographer: Nakao Toshitarō
Art director: Satani Teruyoshi
Editor: Suzuki Akira
Assistant director: Takeda Kazunari
Producer: Motegi Ryōji
Production company: Nikkatsu
Production and release format: 35mm
Cast: Nitani Hideaki, Kasuga Hachirō, Yamaoka Hisano, Kimuro Ikuko, Ozawa Shōichi, Abe Toru, Takashina Kaku
Screened with *Garden of Sorrow* (*Aishū no sono*, Yoshimura Ren, 80 minutes), romantic drama featuring Minamida Yōko and Ashikawa Izumi.
Synopsis: Shunji skips town by boat after being set up for a murder. He returns several years later to find his fiancée Kozue but learns that she has disappeared and that her younger sister is connected to his enemies from years before. Ultimately, he discovers a smuggling plot between his ship captain and the people who set him up.
Description: Another kayō film starring Kasuga Hachirō, this time in what initially appears to be a supporting role in a crime thriller. Some of Kasuga's musical numbers interrupt the narrative in comical ways. Filmed on location in Yokohama (Kanagawa Prefecture).

Eight Hours of Terror (*Hachijikan no kyōfu*)

Release date: March 6–12, 1957
Runtime: 78 minutes
Aspect ratio: 1.33: 1
Director: Suzuki Seijun (as Suzuki Seitarō)
Screenwriters: Yanagita Gorō, Tsukiji Rokurō
Concept: Saitō Kōichi
Cinematographer: Nagatsuka Kazue
Art director: Satani Teruyoshi
Editor: Suzuki Akira
Assistant director: Takeda Kazunari
Producer: Asada Kenzō
Production and release format: 35mm
Production company: Nikkatsu
Cast: Fukami Taizō, Misuzu Eiko, Shima Keiko, Nakahara Keishichi, Nitani Hideaki, Kazuki Minako, Minami Sumiko, Kondō Hiroshi, Tone Harue, Kaneko Nobuo, Fukuda Fumiko

Screened with *Dangerous Relations* (*Kiken na kankei*, Inoue Umetsugu, 95 minutes), romantic drama with Kitahara Mie and Nagato Hiroyuki.

Synopsis: A group of train passengers have to take a bus through a mountain pass after the train tracks are washed out by a typhoon, and a gang of bank robbers are also thought to be at large in the area. The passengers are a snapshot of various milieus of 1957 Japan: a wealthy businessman, student activists, a sex worker, and a disgraced doctor traumatized by the war, among others.

Description: Recalls John Ford's *Stagecoach* in its plot and character sketches. While the film features less overt formal experimentation than Suzuki's three previous films, it is nevertheless a skillfully made thriller. Filmed on location in Matsuzaki and Izu (Shizuoka Prefecture).

The Naked Woman and the Gun (*Rajo to kenjū*)

Release date: December 7–22, 1957
Runtime: 88 minutes
Aspect ratio: 1.33:1
Director: Suzuki Seijun (as Suzuki Seitarō)
Screenwriters: Tanabe Chomi, Suyama Tetsu
Based on "Chitei no kamigami" by Washio Saburō
Cinematographer: Matsuhashi Umeo
Art director: Chiba Kazuhiko
Editor: Suzuki Akira
Assistant director: Takeda Kazunari
Producer: Asada Kenzō
Production company: Nikkatsu
Production and release format: 35mm
Cast: Mizushima Michitarō, Shiraki Mari, Minami Sumiko, Nitani Hideaki, Ashida Shinsuke, Shizhido Jō, Sugai Ichirō, Abe Toru
Screened with *Female Flower* (*Me-bana*, Abe Yutaka, 91 minutes), romantic drama with Minamida Yōko, December 7–14; and with *Teenage Trap* (*Jūdai no wana*, Noguchi Hiroshi, 86 minutes), crime film starring Nagato Hiroyuki, December 15–22.

Synopsis: A police photographer rescues a dancer from some shady men in pursuit of her one evening and returns to her apartment with her. When he wakes up the next morning, he discovers a dead body and the woman nowhere to be found. He encounters an identical woman and begins to investigate her, uncovering a smuggling plot in the process.

Description: A Hitchcock pastiche that lifts several scenes and situations from *Rear Window* in particular; one would be tempted to say that the film draws heavily on *Vertigo* if not for the fact that the latter film had not

been made yet. The Rube-Goldberg set-up in which the photographer discovers the dead body near the beginning is also a highlight. The film eventually becomes a more conventional crime thriller about smuggling, and its climax resembles other films in the genre, including *An Inn of Floating Weeds*.

Underworld Beauty (*Ankokugai no bijo*)

Release date: March 25–31, 1958
Runtime: 83 minutes
Aspect ratio: 2.35: 1
Director: Suzuki Seijun
Screenplay: Saji Susumu (also concept)
Cinematographer: Nakao Toshitarō
Art director: Sakaguchi Takeharu
Editor: Suzuki Akira
Assistant director: Takeda Kazunari
Producer: Nishioka Takashi
Production company: Nikkatsu
Production and release format: 35mm
Cast: Mizushima Michitarō, Ashida Shinsuke, Shiraki Mari, Nitani Hideaki, Kondō Hiroshi, Fukuda Fumiko, Takashina Kaku
Screened with *One Hundred Views of a Couple* (*Fūfu hyakkei*, Inoue Umetsugu, 99 minutes), romantic comedy with Asaoka Ruriko, and newsreel *Shōwa 33 Spring Season Sumo: In Pursuit of the Championship* (*Shōwa 33 nen'do Ōzumō haru basho: Yūshō o otte*, Ise Torahiko).
Synopsis: A gangster tries to retrieve diamonds that he hid before being sent to prison, but he has to protect them and his deceased friend's younger sister Akiko from their corrupt former boss.
Description: *Underworld Beauty* is Suzuki's first in the anamorphic NikkatsuScope aspect ratio, presenting new possibilities of deep-space staging and subdividing frames. Akiko's boyfriend is a mannequin designer, and the film makes effective use of his creations for playful compositions. It is also the first in which the director adopts the pen name "Seijun."

The Boy Who Came Back (*Fumihazushita haru*)

Release date: June 29–July 5, 1958
Runtime: 99 minutes
Aspect ratio: 2.35: 1

Director: Suzuki Seijun
Screenwriters: Terada Nobuyoshi, Okada Tatsumon
Based on *BBS no onna* by Fujiguchi Tōgo
Cinematographer: Yamazaki Yoshihiro
Art director: Chiba Kazuhiko
Assistant director: Takeda Kazunari
Production company: Nikkatsu
Production and release format: 35mm
Cast: Kobayashi Akira, Asaoka Ruriko, Nitani Hideaki, Shishido Jō, Abe Toru, Fukuda Fumiko, Noro Keisuke, Takashina Kaku
Screened with *That Time It Poured* (*An tokya doshaburi*, Morinaga Kenjirō, 53 minutes), kayō film with Kasuga Hachirō.

Synopsis: Kasahara has just been released from reform school and is given a surrogate "big sister" Keiko to help facilitate his return to society. Keiko quickly falls for Kasahara, however, and some of his old friends (and enemies) are not so eager to let him go.

Description: This social drama marks a significant step up for Suzuki within Nikkatsu, as it was his first film to open as clearly the top half of a double feature, and his first to star Kobayashi Akira. It is also his only film with Asaoka Ruriko, who would soon be one of Nikkatsu's biggest stars. The film's thematic weight and extensive use of elaborate dolly and crane shots are also evidence of its higher prestige, and budget, than his previous films. Filmed on location in Hayama (Kanagawa Prefecture) and Izu (Shizuoka Prefecture).

Aoi chibusa (*Young Breasts*)

Release date: September 8–14, 1958
Runtime: 90 minutes
Aspect ratio: 2.35:1
Director: Suzuki Seijun
Screenwriters: Suzuki Heigo, Tsuji Yoshirō
Based on *Nageki no chibusa* by Ichijō Akira
Cinematographer: Nagatsuka Kazue
Art director: Nakamura Kimihiko
Editor: Suzuki Akira
Assistant director: Takeda Kazunari
Production company: Nikkatsu
Production and release format: 35mm
Cast: Kobayashi Akira, Watanabe Misako, Inagaki Mihoko, Nitani Hideaki, Kō Tomoko, Noro Keisuke, Ozawa Shōichi

Screened with *Don't Let That Woman Escape* (*Sono onna o nigasu na*, Wakasugi Mitsuo, 52 minutes), urban crime film with no major stars.

Synopsis: The ne'er-do-well son of a wealthy family schemes to blackmail his young stepmother without realizing how pernicious his fellow blackmailers are, or the fact that they have their sights on his new girlfriend next. His stepmother, meanwhile, relives a past trauma when she encounters a painting, and she ends up befriending the painter without realizing that he was her assailant.

Description: Following *The Boy Who Came Back*, *Young Breasts* is another social melodrama with Kobayashi Akira in the (ostensible) lead role, but Watanabe Misako as the young stepmother steals the show. Suzuki experiments stylistically much more than in the previous film, particularly in a sequence that blends one character's flashback with a film-within-a-film sequence. Filmed on location in Enoshima (Kanagawa Prefecture).

The Voice Without a Shadow (*Kage naki koe*)

Release date: October 22–28, 1958
Runtime: 92 minutes
Aspect ratio: 2.35: 1
Director: Suzuki Seijun
Screenwriters: Akimoto Ryūta, Saji Susumu
Based on a story by Matsumoto Seichō
Cinematographer: Nagatsuka Kazue
Art director: Sakaguchi Takeharu
Editor: Suzuki Akira
Assistant director: Takeda Kazunari
Production company: Nikkatsu
Production and release format: 35mm
Cast: Nitani Hidaki, Minamida Yōko, Shishido Jō, Kaneko Nobuo, Hatsui Kotoe, Ashida Shinsuke, Takahara Toshio, Kondō Hiroshi, Noro Keisuke, Takashina Kaku
Screened with *The Last Song* (*Zesshō*, Takizawa Eisuke, 109 minutes), romantic drama starring Kobayashi Akira and Asaoka Ruriko.

Synopsis: A telephone operator accidentally overhears a murder that goes unsolved. Several years later, after she has married and left the profession, she meets her husband's business partners and recognizes one as the man whose voice she overheard. After the latter man turns up dead, her husband is suspected as the culprit, so she asks a journalist who covered

the original story to help uncover a broader conspiracy about both murders.

Description: Coming after two social melodramas, *The Voice Without a Shadow* is Suzuki's return to pulpy crime thrillers. The film features extensive play with subjective sound design throughout. The extensive use of broken mirrors at the end of the film are also an early example of subframings and distortions therein that Suzuki would use in his later work.

Love Letter (Rabu Retā)

Release date: January 15–21, 1959
Runtime: 40 minutes
Aspect ratio: 2.35: 1
Director: Suzuki Seijun
Screenwriter: Ishii Kiichi
Concept: Matsu'ura Takeo
Cinematographer: Kakita Isamu
Art director: Yagyū Kazuo
Editor: Suzuki Akira
Assistant director: Takeda Kazunari
Production company: Nikkatsu
Production and release format: 35mm
Cast: Frank Nagai, Tsukuba Hisako, Machida Kyōsuke, Yukioka Keisuke
Doubled billed with *The Stream of Youth* (*Wakai kawa no nagare*, Tasaka Tomotaka, 126 minutes), romantic comedy with Ishihara Yūjirō and Kitahara Mie.

Synopsis: A pianist goes to visit her lover in the wilderness, with whom she has kept up correspondence by mail, but discovers a secret upon her arrival at his address.

Description: This short kayō film stars popular singer Frank Nagai as the pianist's coperformer; he also sings the film's title track. In addition to the unusual genre for the filmmaker, the film's production values seem incongruous with its short running time—a 40-minute kayō film shot on location in rural Tōhoku with elaborate tracking and crane shots on snowy mountains. The landscape shots are gorgeous, and interiors in the log cabin are cozy and inviting. The result is surprisingly effective given how little time there is to develop the narrative. Filmed on location in the Japanese Alps and Yamanouchi (Nagano Prefecture).

Passport to Darkness (*Ankoku no ryoken*)

Release date: May 19–23, 1959
Runtime: 88 minutes
Aspect ratio: 2.35: 1
Director: Suzuki Seijun
Screenwriter: Takaiwa Hajime
Based on *Chitei no ryoken* by Washio Yoshihisa
Cinematographer: Nagatsuka Kazue
Art director: Sakaguchi Takeharu
Editor: Suzuki Akira
Assistant director: Takeda Kazunari
Production company: Nikkatsu
Production and release format: 35mm
Cast: Hayama Ryōji, Sawa Tamaki, Shiraki Mari, Okada Masumi, Kondō Hiroshi, Ashida Shinsuke, Tsukuba Hisako, Noro Keisuke
Screened with *O-yae the Substitute Maid* (*O-yae no migawari jochū*, Sunohara Masahisa, 54 minutes), part of a series of short comedies about a maid "Yae-chan" who speaks in a distinct "zu-zu-ben," and newsreel *Shōwa 34 Summer Season Sumo (Latter Half)* (*Shōwa 34 nen: Ōzumō natsu basho kōhansen*, Ise Torahiko).
Synopsis: A saxophone player's wife is murdered, and he attempts to uncover who did it and why. His investigation leads him to uncover a criminal plot to get young gay men addicted to heroin in order to sell their sexual services to Western tourists, and he realizes a close friend of his is implicated as well.
Description: Suzuki's only film of 1959 longer than sixty minutes, *Passport to Darkness* is an effective crime thriller with a kayō element (its opening number, sung by Sawa Tamaki, was released as a single). The film's elliptical opening sequence, in particular, is precisely framed and edited and maintains an impressive chiaroscuro and graphic clashes between camera angles and elements of the set. While the subject matter may seem surprising for a mainstream studio film of 1959, it is not far off from the premise of to Ishii Teruo's "line" (*chitai*) films at Shin-Tōhō, the first of which, *Secret White Line* (*Shirosen himitsu chitai*), had been released the previous year.

The Age of Nudity (*Supaddaka no nenrei*)

Release date: September 8–12, 1959
Runtime: 54 minutes

Aspect ratio: 2.35: 1
Director: Suzuki Seijun
Screenwriters: Suzuki Seijun, Terada Nobuyoshi
Cinematographer: Fujioka Kumenobu
Art director: Sakaguchi Takeharu
Editor: Suzuki Akira
Assistant director: Takeda Kazunari
Production company: Nikkatsu
Production and release format: 35mm
Cast: Akagi Keiichirō, Hori Kyōko, Hidari Bokuzen, Hatsui Kotoe, Takahara Toshio, Fujimaki Saburō, Hiro'oka Mieko, Hori Uyako, Ozawa Saneko
Screened with *The Doll's Song* (*Ningyō no uta*, Saitō Buichi, 86 minutes), romantic drama with Nakahara Sanae, and newsreel *A Record of Yūjirō's Trip to Europe* (*Yūjirō no ōshū kakearuki*, Kaji Noboru).

Synopsis: A group of youths survive in an abandoned air hangar by petty theft and challenging other youths to motorcycle races, which usually end with a shakedown for cash and their opponents' motorcycles. The eldest, Ken, is the mastermind, while Yōko functions as a surrogate mother for the younger children, most of whom have run away to escape abusive backgrounds (apart from one rich boy who ran away because his parents refused to buy him a pet monkey).

Description: This is Suzuki's only screenwriting credit for a film he also directed, and it was also the first starring role for Akagi Keiichirō. His character's death in a motorcycle accident at the end of this film also uncannily foreshadows the actor's own death in a go-kart accident two years later. The film is a bizarre balance in both technique and tone. Most of the children are played by nonactors, and it seems almost like a neorealist social problem film identifying the underlying causes of their misbehavior and criminal activity. At other times, it indulges in a romantic fantasy about their lives at the airplane hangar, particularly as they interact with a friendly old man against a beautiful sky background, accompanied by a repeated musical cue lifted from "When You Wish Upon a Star." In spite of Akagi's top billing, the focus of the film is on the younger children. The airplane hangar and adjoining field were filmed in Machida.

Take Aim at the Police Van (*"Jūsangō taihisen" yori: Sono gossōsha o nerae*)

Release date: January 27–February 2, 1960
Runtime: 79 minutes

Aspect ratio: 2.35: 1
Director: Suzuki Seijun
Screenwriter: Sekizawa Shinichi
Based on a story by Shimada Kazuo
Cinematographer: Mine Shigeyoshi
Art director: Sakaguchi Takeharu
Editor: Suzuki Akira
Assistant director: Takeda Kazunari
Production company: Nikkatsu
Production and release format: 35mm
Cast: Mizushima Michitarō, Watanabe Misako, Shiraki Mari, Ashida Shinsuke, Noro Keisuke, Ozawa Shōichi, Uchida Ryōhei
Doubled billed with *The Beast That Came from the City* (*Machi ni deta yajū*, Yamauchi Ryōichi, 49 minutes), crime film, January 27–30; and *The Yakuza's Song* (*Yakuza no uta*, Masuda Toshio, 88 minutes), crime film with Kobayashi Akira, January 30–February 2.

Synopsis: After a prison truck is attacked and two of the convicts inside are murdered, the driver is suspended and tries to investigate who instigated the attack.

Description: As with *Passport to Darkness*, *Take Aim at the Police Van* is a noir thriller focused on an investigation. The plot twist, in which a criminal mastermind is discovered to be the father of one of the romantic leads, is one that appears frequently in Nikkatsu Action films, including Masuda Toshio's *The Rusty Knife* and Suzuki's *The Sleeping Beast Within* and *Tokyo Knights*; it is perhaps indicative of the fact that the films were marketed toward a youth audience, and of said audience's distrust of their parents' generation. This was Suzuki's first film to be shot by Mine Shigeyoshi. Filmed on location in Atami and Gotenba (Shizuoka Prefecture).

The Sleeping Beast Within (*Kemono no nemuri*)

Release date: April 9–15, 1960
Runtime: 85 minutes
Aspect ratio: 2.35: 1
Director: Suzuki Seijun
Screenwriter: Ikeda Ichirō
From a story by Kikumura Itaru
Cinematographer: Mine Shigeyoshi
Art director: Nakamura Kimihiko
Editor: Suzuki Akira

Assistant director: Takeda Kazunari
Production company: Nikkatsu
Production and release format: 35mm
Cast: Nagato Hiroyuki, Yoshiyuki Kazuko, Ashida Shinsuke, Noro Keisuke, Ozawa Shōichi, Nishimura Kō, Kusanagi Kōjirō, Yamaoka Hisano, Kusunoki Yūko
Screened with *Blossoms of Love* (*Ajisai no uta*, Takizawa Eisuke, 106 minutes), comedy with Ishihara Yūjirō and Ashikawa Izumi, April 6–12; and with *Detective Stories: The Face Caused by the Sound of a Gun* (*Keiji monogatari: Jūsei ni ukabu kao*, Kosugi Isamu, 53 minutes), part of the "Detective Stories" series of short crime films, April 13–15.
Synopsis: After a businessman returns from an extended international business trip, his daughter begins to suspect something is wrong. She and her reporter fiancé investigate his working and uncover his connections to a religious cult and the illegal drug trade.
Description: Featuring an investigative reporter as protagonist, *The Sleeping Beast Within* even more closely resembles a film from Ishii Teruo's "line" series than its predecessors, *Passport to Darkness* and *Take Aim at the Police Van*. Filmed on location in Yokohama (Kanagawa Prefecture).

Smashing the 0-Line (*Mikkō o-rain*)

Release date: June 25–July 4, 1960
Runtime: 83 minutes
Aspect ratio: 2.35:1
Director: Suzuki Seijun
Screenwriter: Yokoyama Yasurō
Based on *Bōmei no michi* by Sokabe Michita
Cinematographers: Mine Shigeyoshi, Nakao Toshitarō
Art director: Chiba Kazuhiko
Editor: Suzuki Akira
Assistant director: Takeda Kazunari
Production company: Nikkatsu
Production and release format: 35mm
Cast: Nagato Hiroyuki, Odaka Yūji, Shimizu Mayumi, Nakahara Sanae, Ozawa Shōichi, Uchida Ryōhei, Noro Keisuke, Takashina Kaku
Doubled billed with *A Man Overcomes His Fear* (*Otoko no okori o buchimakero*, Matsuo Akinori, 81 minutes), crime film with Akagi Keiichirō and Asaoka Ruriko, June 25–28; with *The Young Woman's Promenade* (*Ojōsan no sanpomichi*, Horiike Kiyoshi, 50 minutes), romantic comedy with Sassamori Reiko, June 29–30; and with *Rambler in the Sunset* (*Akai*

yūhi no wataridori, Saitō Buichi, 80 minutes), an entry in the *wataridori* series starring Kobayashi Akira, July 1–4.

Synopsis: Two reporters with very different work ethics attempt to investigate a human trafficking ring: Nishina is protective of his friends, loved ones, and even sources implicated in the crime, while Katori is willing to sacrifice anyone for the sake of a good scoop.

Description: Though in a similar generic register to *Passport to Darkness*, *Take Aim at the Police Van*, and *The Sleeping Beast Within*, *Smashing the 0-Line* differs in its effective use of dual protagonists, which forms part of a motif of doubling characters that runs through the film and makes effective use of extended tracking sequences with shifting focal points between its dual protagonists and multiple lines of action. Filmed on location in Kamakura (Kanagawa Prefecture) and Kōbe (Hyōgo Prefecture).

Everything Goes Wrong (Subete ga kurutteru)

Release date: October 8–11, 1960
Runtime: 72 minutes
Aspect ratio: 2.35:1
Director: Suzuki Seijun
Screenwriter: Hoshikawa Seiji
Based on *Hai-tīn jōfu* by Ichijō Akira
Cinematographer: Hagiwara Izumi
Art director: Chiba Kazuhiko
Editor: Suzuki Akira
Assistant director: Fujiura Atsushi
Production company: Nikkatsu
Production and release format: 35mm
Cast: Kawaji Tamio, Nezu Yoshiko, Yoshinaga Sayuri, Naraoka Tomoko, Miyagi Chikako, Uenoyama Kōichi, Yanase Shirō, Ashida Shinsuke, Hatsui Kotoe
Screened with *Hero Cadet* (*Eiyū kōhosei*, Ushihara Yōichi, 82 minutes), youth action film starring Wada Kōji filmed in Shikoku.

Synopsis: Follows a group of troublesome youths who hang around a nightclub but focuses on Jiro, whose father died in the war and whose mother is now having an affair with a munitions manufacturer.

Description: In this film that studies the dark underside of the *taiyō-zoku*, Suzuki seems sympathetic to the young generation's contempt for authority even as the film warns against Jirō's nihilism. A significant subplot goes to Noriko, Toshimi's pregnant friend, who attempts to set up

the munitions dealer to blackmail him to pay for an abortion, similar to the central con in Ōshima Nagisa's breakthrough film *Cruel Story of Youth* from earlier the same year. Yoshinaga Sayuri, who would become one of Nikkatsu's biggest stars, also appears in a small role.

Fighting Delinquents (Kutabare gurentai)

Release date: November 23–December 6, 1960
Runtime: 80 minutes
Aspect ratio: 2.35: 1
Director: Suzuki Seijun
Screenwriter: Yamazaki Iwao
Concept: Hara Kenzaburō
Cinematographer: Nagatsuka Kazue
Art director: Satani Teruyoshi
Editor: Suzuki Akira
Assistant director: Nishimura Shōgorō
Production company: Nikkatsu
Production and release format: 35mm
Cast: Wada Kōji, Shimizu Mayumi, Hosokawa Chikako, Sugiyama Hajime, Kondō Hiroshi, Takashina Kaku
Screened with *Rampaging Vagabond* (*Ōabare fūraibō*, Yamazaki Tokujirō, 79 minutes), *mukokuseki* with Kobayashi Akira, November 23–29; later with *Flowers That Blossom in Rain* (*Ame ni saku hana*, Nakajima Yoshitsugu, 54 minutes), a kayō film with Inoue Hiroshi, November 30–December 2; and with *The Man with No Tomorrow* (*Kenjū buraichō: Ashita naki otoko*, Noguchi Hiroshi, 85 minutes) from the *Kenjū buraichō* series with Akagi Keiichirō, December 3–6.
Synopsis: A poor teenager, orphaned at birth, discovers that he is heir to a wealthy family in Kōbe. Upon arriving, he finds that another family member is scheming to get the family's land from him and turn it into an amusement park with the help of a crooked real estate developer. The teen calls his band of orphan friends from Tokyo to thwart the scheme.
Description: Though lighter than *Everything Goes Wrong*, there is also a great deal of overlap with that film: the generational conflict between a gang of bohemian teens and the elder generation (embodied in a mother figure compromised by a sexual relationship). Here, however, the teens' bohemian ways become useful to the traditional family in chasing off villains from stealing the inheritance, which allows for a reconciliation between the sun-tribe and the traditional family against exploitive capitalists. Suzuki's first film in color, and his first kozō film with Wada

Kōji. Suzuki incorporates formal experimentation in color and distorting lenses. Filmed on location in Ōsaka, Sumoto (Awaji Island, Hyōgo Prefecture) and Minami Awaji (Awaji Island, Hyōgo Prefecture).

Tokyo Knights (*Tōkyō naito*)

Release date: February 1–10, 1961
Runtime: 81 minutes
Aspect ratio: 2.35:1
Director: Suzuki Seijun
Screenwriter: Yamazaki Iwao
Concept: Hara Kenzaburō
Cinematographer: Nagatsuka Kazue
Art director: Nakamura Kimihiko
Editor: Suzuki Akira
Assistant director: Takeda Kazunari
Production company: Nikkatsu
Production and release format: 35mm
Cast: Wada Kōji, Shimizu Mayumi, Minamida Yōko, Kaneko Nobuo, Nezu Yoshiko, Ozawa Shōichi, Kondō Hiroshi, Saga Zenpei
Screened with *Pacific Ocean Peddler* (*Taiheiyō no katsugiya*, Matsuo Akinori, 87 minutes), aviation-themed action film with Kobayashi Akira, February 1–7; and with *The Beauty Without a Face* (*Ore wa toppu ya da: Kao no nai bijo*, Ida Motomu, 52 minutes), crime film with Nitani Hideaki, February 8–10.
Synopsis: After his father dies, teenager Matsubara returns home from studying in the United States to be trained to take on his new role as head of the Matsubara Clan, but in so doing he discovers that the man training him arranged his father's death as part of a crooked development scheme.
Description: *Tokyo Knights* recasts elements of *Fighting Delinquents* in a school setting and adds a new plot twist in which Wada's love interest is the daughter of the corrupt businessman villain. As with *Fighting Delinquents*, the film takes advantage of nightclubs and exterior neon lighting to play with bright colors; to this, it adds a school stage performance near its climax for further opportunities to play with color and lighting. Filmed on location in Izu (Shizuoka Prefecture).

Living by Karate (*Muteppō daishō*)

Release date: April 16–22, 1961
Runtime: 82 minutes

Aspect ratio: 2.35: 1
Director: Suzuki Seijun
Screenwriters: Matsu'ura Takeo, Nakanishi Ryūzō
Based on *Tokyo shiratsukagumi* by Ichijō Akira
Cinematographer: Nagatsuka Kazue
Art director: Matsui Toshiyuki
Editor: Suzuki Akira
Assistant director: Takeda Kazunari
Production company: Nikkatsu
Production and release format: 35mm
Cast: Wada Kōji, Shimizu Mayumi, Hayama Ryōji, Ashikawa Izumi, Sugiyama Hajime, Noro Keisuke, Yamaoka Hisano, Sugai Ichirō, Tomita Nakajirō
Screened with *The Drifter Against The Wind* (*Kaze ni sakarau nagaremono*, Yamazaki Tokujirō, 88 minutes), from the *nagaremono* series with Kobayashi Akira and Asaoka Ruriko, April 16–18; and with *Racing Toward Tomorrow* (*Ashita ni mukatte tsuppashire*, Furukawa Takumi, 68 minutes), crime film, April 19–22.

Synopsis: Eiji, a teenage roller-skating instructor, runs a "patrol" of the lower-class business district that he and his friends live in, keeping people from getting pushed around by small-time criminals and yakuza. His arch-nemesis is Shinkai, a yakuza boss who controls most of the businesses in the area, including Eiji's widowed-mother's bar. Eiji learns that Shinkai plans to replace his mother with Eiji's longtime friend Yukiyo and make her his mistress; when Yukiyo refuses the offer, Shinkai kidnaps her father, and Eiji and his patrol have to retrieve him.

Description: Though it rehashes some elements of Suzuki's previous kozō films with Wada Kōji, *Living by Karate* is a darker film than its two predecessors due to the lower-class milieu and Shinkai's shocking cruelty, as well as Sugai Ichirō's performance as the tragic, once-great doctor turned alcoholic that one expects to see in a John Ford or Kurosawa Akira film. It also has an uncomfortable false-happy ending: Eiji's sole rich friend Kyōko pays for a new business for Eiji's mother, but Kyōko never learns that her doting father's apparently respectable company has used Shinkai's services to murder a labor union leader (and he gets off scot-free at the end).

The Man with a Shotgun (*Shottogan no otoko*)

Release date: June 4–11, 1961
Runtime: 84 minutes
Aspect ratio: 2.35: 1

Director: Suzuki Seijun
Screenwriters: Matsu'ura Takeo, Ishii Kiichi
Concept: Tsuyama Tsutomu
Cinematographer: Mine Shigeyoshi
Art director: Satani Teruyoshi
Editor: Suzuki Akira
Assistant director: Higuchi Hiromi
Production company: Nikkatsu
Production and release format: 35mm
Cast: Nitani Hideaki, Ashikawa Izumi, Odaka Yūji, Minamida Yōko, Gō Eiji, Noro Keisuke, Sano Asao, Kōno Hiroshi, Takahara Toshio, Saga Zenpei
Screened with *While We're Young* (*Kono wakasa aru kagiri*, Koreyoshi Kurahara, 76 minutes), youth romance with Yoshinaga Sayuri and Hamada Mitsuo, June 4–10; and later with *Helper Business* (*Suketto kagyō*, Saitō Buichi, 79 minutes), crime film with Shishido Jō and Nagato Hiroyuki, June 11 onward.

Synopsis: A trucker heads into the Tanzawa Mountain range to go game hunting, against the warning of locals. He quickly finds tensions between the people of a rural mountain village and the wealthy owner of a lumber mill, and a gang of ruffians who enjoy humiliating the local, ineffectual sheriff. He also quickly develops a rivalry with another mysterious loner hanging around the local saloon, who may or may not have a past connection with him. Multiple double crossings and plot twists later, he discovers a connection to the heroin trade, as well as the identity of his fiancée's killers.

Description: The clearest example of a Nikkatsu Western in Suzuki's filmography. There are relatively few elements in the film that would immediately distinguish it from the work of most other Nikkatsu Action filmmakers, but Suzuki's use of the locations is effective, particularly during the film's climactic shootouts on a mountaintop and, later, on a volcanic sand beach. There are also some interesting games that he plays with elliptical editing and mirrors in a few sequences that do clearly mark it as Suzuki's work. Filmed on location in Nakatsugawa (Gifu Prefecture) and Tanzawa (Kanagawa Prefecture).

The Wind-of-Youth Group Crosses the Mountain Pass (*Tōge o wataru wakai kaze*)

Release date: August 27–September 1, 1961
Runtime: 85 minutes
Aspect ratio: 2.35:1

Director: Suzuki Seijun
Screenwriters: Ryū Keiichirō, Takahashi Nīsan, Morimoto Yoshihiko
Concept: Himeda Yoshirō
Cinematographer: Isayama Saburō
Art director: Chiba Kazuhiko
Editor: Suzuki Akira
Assistant director: Sakaguchi Kikuo
Production company: Nikkatsu
Production and release format: 35mm
Cast: Wada Kōji, Shimizu Mayumi, Kaneko Nobuo, Hatsui Kotoe, Nihon'yanagi Hiroshi, Hoshi Naomi, Aoki Tomio, Kondō Hiroshi, Fujioka Jūkei
Screened with *Harbor of Evil* (*Kyōaku no hatoba*, Furukawa Takumi, 66 minutes), crime film.
Synopsis: Shintarō is a student traveling in Aomori who runs across a group of traveling performers and joins them at a local festival. One of the festival's organizers has shady ties and harasses them. Pressure begins to mount to get the lead performers' daughter to do a striptease as part of their performance, and Shintarō discovers that one of his traveling companions is actually a yakuza hit man on assignment.
Description: Suzuki's fourth kozō film with Wada Kōji travels across Tōhoku and takes advantage of the many stage settings and local festivals for vibrant colors in lighting, set design, and costuming. Though it contains elements from the earlier films in the kozō cycle, it emphasizes the relations among the members of the traveling performers as they struggle to maintain the integrity of their show, to the point that Shintarō seems incidental to the main interest at times. Filmed on location in Sawara (Chiba Prefecture), Azeta (Chiba Prefecture), and the grounds of Itsukaichi City Shrine (Chiba Prefecture).

Blood-Red Water in the Channel (*Kaikyō, chi ni somete*)

Release date: October 1–10, 1961
Runtime: 84 minutes
Aspect ratio: 2.35: 1
Director: Suzuki Seijun
Screenwriter: Tanada Gorō
Concept: Ōmura Takahiro, Itō Kazuo
Cinematographer: Mine Shigeyoshi
Art director: Nakamura Kimihiko
Editor: Suzuki Akira

Assistant director: Higuchi Hiromi
Production company: Nikkatsu
Production and release format: 35mm
Cast: Wada Kōji, Shimizu Mayumi, Hayama Ryōji, Hanabusa Yuriko, Gō Eiji, Hamada Torahiko, Yamaoka Hisano, Hatsui Kotoe, Hamamura Jun
Screened with *I'm Going to Hell* (*Ore wa jigoku e iku*, Noguchi Hiroshi, 88 minutes), crime film with Shishido Jō, and newsreel *Shōwa 36 Fall Season Sumo (Latter Half)* (*Shōwa 36 nen ōzumō: Aki basho kōhansen*, Ise Torahiko).

Synopsis: A young man tries to succeed as a coast guard officer in his rural seaside hometown, but the other coast guards believe that his college education has made him too soft for the job. Matters get more complicated when the coast guard faces off against a human trafficking ring and the young officer learns that his elder brother is a member.

Description: Though it stars Wada Kōji, *Blood-Red Water in the Channel* is closer to a Nikkatsu Western than to the films of the kozō cycle, as evidenced by the presence of a local saloon on the island and the use of the open sea as the open range. Filmed on location in Shimoda (Shizuoka Prefecture). Made with the cooperation of the Japanese Coast Guard, who supplied the patrol boats.

Million Dollar Smash-and-Grab (*Hyakuman-doru o tatakidase*)

Release date: December 1–9, 1961
Runtime: 90 minutes
Aspect ratio: 2.35: 1
Director: Suzuki Seijun
Screenwriter: Itō Naoya
Concept: Yagi Yasutarō
Cinematographer: Mine Shigeyoshi
Art director: Nakamura Kimihiko
Editor: Suzuki Akira
Assistant director: Higuchi Hiromi
Production company: Nikkatsu
Production and release format: 35mm
Cast: Wada Kōji, Noro Keisuke, Watanabe Misako, Sawa Michiko, Kaneko Nobuo, Hirata Daisaburō, Abe Toru, Hoshi Naomi
Screened with *Gate of Beasts* (*Yajū no mon*, Furukawa Takumi, 81 minutes), crime film with Nitani Hideaki and Matsubara Chieko, December 1–5; with *Fast-Drawing Ruffian: Man of the Great Plains* (*Hayauchi burai: daiheigen no otoko*, Noguchi Hiroshi, 82 minutes), crime film with

Shishido Jō and Matsubara Chieko, and newsreel *Record of Sumo in Kyūshū* (*Ōzumō kyūshū basho jikkyō*, Ise Torahiko), December 6–9.

Synopsis: Kinji and his friend Tokichi leave their home on Hachijo Island so that Tokichi can pursue his dream of boxing. They fall out when Tokichi takes up with yakuza. Kinji opts to learn to box with Haraguchi, an old-fashioned legitimate manager who insists that Kinji adopt right-handed boxing techniques despite being left-handed. As Kinji improves, he develops a rivalry with Iino, a former Haraguchi student. When Kinji enters a boxing competition with high stakes, he must face Tokichi in the ring to advance and must face Iino for the final fight.

Description: Suzuki's final film from 1961 is also the first of two boxing films he would direct with Wada Kōji. As with *Blood-Red Water in the Channel*, there is relatively little to distinguish the film from the work of most of Suzuki's Nikkatsu peers. However, it is effective in some boxing sequences for its use of subjective effectsparticularly in Kinji and Tokichi's fight.

Teenage Yakuza (*Hai-tīn yakuza*)

Release date: June 20–23, 1962
Runtime: 72 minutes
Aspect ratio: 2.35: 1
Director: Suzuki Seijun
Screenwriters: Yoshimura Nozomi, Okusono Mamoru
Cinematographer: Hagiwara Kenji
Art director: Chiba Kazuhiko
Editor: Suzuki Akira
Assistant director: Saitō Wasaburō
Production company: Nikkatsu
Production and release format: 35mm
Cast: Kawaji Tamio, Fuji Tatsuya, Hatsui Kotoe, Tashiro Midori, Sano Asao, Matsumoto Noriko, Sugiyama Keiko, Matsuo Kayo, Takashina Kaku
Screened with *Ginza Tough-Guy Nikaidō Takuya: The Return of the Whirlwind* (*Nikaidō Takuya ginza buraichō: Kaettekita senpūji*, Noguchi Hiroshi, 78 minutes), entry in the "Ginza Tough-Guy" series with Kobayashi Akira and Matsubara Chieko.

Synopsis: Jirō, a rebellious young man, and his group of friends find themselves having to protect local businesses from a group of young yakuza. The charismatic and manipulative yakuza leader attempts to turn one of the friends against Jirō.

Description: *Teenage Yakuza* resembles Suzuki's earlier kozō films, though it has a lower budget (indicated by its shorter running time, its use of a

less famous star, and black-and-white rather than color). Though not as overtly experimental as some of his other work, the film indicates how effective a dramatic filmmaker could be even when working in a more stylistically invisible mode.

Those Who Put Money on Me (*Ore ni kaketa yatsura*)

Release date: December 9–15, 1962
Runtime: 90 minutes
Aspect ratio: 2.35: 1
Director: Suzuki Seijun
Screenwriters: Ogawa Ei, Nakano Akira
Concept: Koyamazaki Kimio
Cinematographer: Mine Shigeyoshi
Art director: Sakaguchi Takeharu
Editor: Suzuki Akira
Assistant director: Higuchi Hiromi
Production company: Nikkatsu
Production and release format: 35mm
Cast: Wada Kōji, Shimizu Mayumi, Minamida Yōko, Hayama Ryōji, Kawaji Tamio, Takashina Kaku, Shiraki Mari
Screened with *Danger Pays* (*Yabai koto nara zeni ni naru*, Nakahira Kō, 82 minutes), action-comedy with Shishido Jō and Asaoka Ruriko, December 9–11; and with *Chase the Killer* (*Satsujinsha o oe*, Maeda Masuo, 71 minutes), detective film, December 12–15.
Synopsis: The last of Suzuki's films to star Wada Kōji, this follows a young boxer who gets a wealthy, middle-aged female patron, causing his longtime girlfriend to be jealous. Meanwhile, his manager's wife is carrying on an affair with his trainer, and the two frame Wada's character when they get caught. Yakuza also try to fix the climactic fight against him, but one yakuza has taken a special interest in him.
Description: Ostensibly a follow-up to *Million Dollar Smash-and-Grab*, *Those Who Put Money on Me* is a more inspired take on the boxing genre. Suzuki achieves a balance between the dramatic concerns of the film and his more experimental tendencies, foreshadowing his work to come.

Detective Bureau 2-3: Go to Hell, Bastards! (*Kutabare akutō-domo: Tantei jimusho 2-3*)

Release date: January 27–February 5, 1963
Runtime: 89 minutes

Aspect ratio: 2.35:1
Director: Suzuki Seijun
Screenwriter: Yamazaki Iwao
Concept: Ōyabu Haruhiko (Based on his Series in *Shinchō Weekly*)
Cinematographer: Mine Shigeyoshi
Art director: Sakaguchi Takeharu
Editor: Suzuki Akira
Assistant director: Higuchi Hiromi
Production company: Nikkatsu
Production and release format: 35mm
Cast: Shishido Jō, Sassamori Reiko, Kawaji Tamio, Hoshi Naomi, Kaneko Nobuo, Sano Asao, Shin Kinzō, Hatsui Kotoe
Screened with *Red-Hot Seat* (*Shakunetsu no isu*, Noguchi Hiroshi, 82 minutes), crime film with Wada Kōji and Matsubara Chieko, January 28–29; and later with *Mobile Investigative Team: The Naked Eye* (*Kidō sōsahan: Hadaka no me*, Kosugi Isamu, 75 minutes), entry in the *Mobile Investigative Unit* series of short crime films January 30–February 2; *Wandering Trumpet* (*Sasurai no toranpetto*, Noguchi Hiroshi, 89 minutes), musically themed Takahashi Hideki and Asaoka Ruriko film, from February 3.

Synopsis: A private detective teams up with the police to infiltrate a group of gun smugglers.

Description: Suzuki's one entry in the subgenre of absurdist action-comedies starring Shishido Jō. Many of the supporting characters are broad caricatures, and much of the action is played as slapstick. The film's goofy humor can be found in Shishido films around this time by other Nikkatsu directors (such as Nakahira Kō's *Danger Pays* and Noguchi Hiroshi's *Murder Unincorporated*). If anything, what distinguishes *Detective Bureau* from other films in this cycle is the dramatic weight that Suzuki gives to some scenes, particularly those involving Sassamori's character. A sequel was released later the same year.

Youth of the Beast (*Yajū no seishun*)

Release date: April 21–27, 1963
Runtime: 92 minutes
Aspect ratio: 2.35:1
Director: Suzuki Seijun
Screenwriters: Ikeda Ichirō, Yamazaki Tadaaki
Concept: Ōyabu Haruhiko, from his story *Hito kari*
Cinematographer: Nagatsuka Kazue
Art director: Yoshinaga Yokō

Editor: Suzuki Akira
Assistant director: Watanabe Noboru
Production company: Nikkatsu
Production and release format: 35mm
Cast: Shishido Jō, Watanabe Misako, Kawaji Tamio, Kazuki Minako, Hirata Daisaburō, Gō Eiji, Uenoyama Kōichi, Kobayashi Akiji, Kiura Yūzō, Hoshi Naomi, Kōno Hiroshi, Esumi Eimei
Screened with *Cowardly Gunfighter* (*Koshinuke ganfaitā*, Noguchi Hiroshi, 75 minutes), dark comedy.
Synopsis: After a double suicide involving police officer Takeshita, a mysterious man with motives not initially explained simultaneously infiltrates two rival yakuza clans. It is eventually revealed that he is a disgraced ex-policeman attempting to avenge Takeshita's death, and he uncovers a scheme involving one of the yakuza clans and the boss's mysterious "sixth mistress."
Description: Suzuki's second film of 1963 based on source material by Ōyabu Haruhiko and starring Shishido Jō, but very different from the first. Where *Detective Bureau 2-3* had been a goofy action comedy, *Youth of the Beast* is utterly deadpan (even, or perhaps especially, in its humor). The film features shocking edits and sound shifts, bright color designs contrasted with black-and-white (with a narrative motivation that only becomes apparent in retrospect), and a frequently jarring juxtaposition between foreground and background action, particularly in its nightclub and movie theater settings. The fact that one of the gangs has a movie-theater hideout with a Nikkatsu advertisement (featuring Shishido's face) suggests that Suzuki may have been more aware that this is what he was doing than he often let on. Filmed on location in Matsudo (Chiba Prefecture).

The Incorrigible (*Akutarō*)

Release date: September 21–28, 1963
Runtime: 95 minutes
Aspect ratio: 2.35 : 1
Director: Suzuki Seijun
Screenwriter: Kasahara Ryōzō
Based on the novel by Kon Tōkō
Cinematographer: Mine Shigeyoshi
Art director: Kimura Takeo
Editor: Suzuki Akira
Assistant director: Endō Saburō

Production company: Nikkatsu
Production and release format: 35mm
Cast: Yamauchi Ken, Izumi Masako, Tashiro Midori, Ashida Shinsuke, Noro Keisuke, Sugiyama Hajime, Kuri Chiharu, Azuma Emiko, Yanase Shirō, Benisawa Yōko, Takamine Mieko
Screened with *Habu Port* (*Habu no minato*, Saitō Buichi, 96 minutes), romance starring Yoshinaga Sayuri, and newsreel *Sumo Report, Fall Season (First Half)* (*Ōzumō aki basho zenhan jikkyō*, Ise Torahiko).
Synopsis: A young man, Konno Togo, is expelled from his school in Kōbe and has to study in a provincial town where he runs afoul of the *fukeibu* (Public Morals Bureau), a band of upperclassmen who allegedly uphold the moral authority. He falls in love with the local doctor's daughter, Emiko, whom *fukeibu* member Tako (Octopus) also had his sights on.
Description: Based on a semiautobiographical novel by Kon Tōkō, this film was among Suzuki's most prestigious projects at Nikkatsu. Many of the supporting cast members return from Suzuki's Wada Kōji kozō cycle in similar roles: Sugiyama Hajime is the cowardly friend, Noro Keisuke is Tako, while the role of the beleaguered mother that had been played by Minamida Yōko in the Wada films is played here by Takamine Mieko. This film was also Suzuki's first collaboration as director with art director Kimura Takeo (Kimura had also been set designer of Yamamura Sō's *Black Tide*, where Suzuki had been assistant director; he had worked on numerous films with cinematographer Mine Shigeyoshi before, including Tanaka Kinuyo's *The Moon Has Risen* [*Tsuki wa noborinu*, 1955] and *Confessions of Love*). It is also Suzuki's first film set during the Taishō era, and the first to make extensive use of parasols. Filmed on location in Toyo'oka (Hyōgo Prefecture), Kyōto, Hikone (Shiga Prefecture), and Nagahama (Shiga Prefecture).

Kanto Wanderer (*Kantō mushuku*)

Release date: November 23–December 7, 1963
Runtime: 93 minutes
Aspect ratio: 2.35 : 1
Director: Suzuki Seijun
Screenwriter: Yagi Yasutarō
Based on *Chitei no uta* by Hirabayashi Taiko
Cinematographer: Shigeyoshi Mine
Art director: Kimura Takeo
Editor: Suzuki Akira
Assistant director: Kuzū Masami

Production company: Nikkatsu
Production and release format: 35mm
Cast: Kobayashi Akira, Matsubara Chieko, Hirata Daisaburō, Itō Hiroko, Nakahara Sanae, Takashina Kaku, Shin Chikako, Esumi Eimei, Noro Keisuke, Kōno Hiroshi
Screened with *The Insect Woman* (*Nippon konchū-ki*, Imamura Shōhei, 123 minutes).
Synopsis: Katsuta, a yakuza of the Izu clan, navigates relations with the rival Yoshida clan and a group of schoolgirls who are infatuated with him. He also encounters a woman who had cheated him in a gambling hall years before.
Description: Suzuki's first *ninkyō* (chivalry) film is ostensibly based on the same source material as Suzuki's mentor Noguchi Hiroshi's *The Song of the Underworld*, featuring Ishihara Yūjirō and scripted by the same screenwriter as the earlier film. Suzuki wholeheartedly embraces the ninkyō genre's use of weather for stylistic flourishes but dispenses with the pretense of realism: the location shooting at the beginning of the film gradually gives way to more abstract set design and lighting effects, and the collapse of the set into abstraction foreshadows the climaxes of the later *Tattooed Life* and *Tokyo Drifter*. Suzuki apparently also planned to include a sequence featuring red snow, which Nikkatsu prevented from being filmed.[1] The film also marks the reunion of Suzuki with Kobayashi for the first time since 1958; by this point, Kobayashi was Nikkatsu's number 2 leading actor, behind only Ishihara. The film was enough of a success that the studio had Suzuki direct two films the following year with Kobayashi opposite Matsubara, and it was also Suzuki's first film to get one vote in the year-end *Kinema junpō* best film poll of Japanese critics.

The Flowers and the Angry Waves (*Hana to dōto*)

Release date: February 8–22, 1964
Runtime: 92 minutes
Aspect ratio: 2.35:1
Director: Suzuki Seijun
Screenwriters: Funahashi Kazuo, Abe Keiichi, Kimura Takeo
Concept: Aoyama Kōji
Cinematographer: Nagatsuka Kazue
Art director: Kimura Takeo
Editor: Suzuki Akira

Assistant director: Kuzū Masami
Production company: Nikkatsu
Production and release format: 35mm
Cast: Kobayashi Akira, Matsubara Chieko, Misaki Chieko, Kawaji Tamio, Tamagawa Isao, Yanase Shirō, Noro Keisuke, Esumi Eimei, Yamanouchi Akira, Takizawa Osamu, Takashina Kaku, Yanase Shirō, Saga Zenpei
Screened with *Beautiful Teenage Years* (*Utsukushii jūdai*, Yoshimura Ren, 79 minutes), kayō film with Mita Akira.
Synopsis: Kikuji had previously been a loyal yakuza but eloped with Yachiyo, the unwilling young fiancée of his boss. The two now live in hiding in Tokyo. Kikuji gets a construction job, but a rival company is mixed up with the yakuza clan trying to kill him, while a detective in love with Yachiyo is looking for a reason to have Kikuji locked up.
Description: Suzuki's second ninkyō film, also starring Kobayashi opposite Matsubara, restrains the oscillating temporality and the stylistic abstractions of the previous film. As a result, the film is perhaps the most conventional of his late Nikkatsu films, though it does feature effective CinemaScope framing, blocking, and editing, particularly during its fight sequences. Perhaps its most remarkable feature is its re-creation of the era in an elaborate set of Tokyo in the era and the costume design of Kawaji Tamio's assassin, hinting at his work with the period in the later Taishō trilogy films. The film was one of Suzuki's more successful films at Nikkatsu and featured prominently in many of the critical defenses of his work from the mid-1960s; now, however, it is one of his most overlooked films from this era.

Gate of Flesh (*Nikutai no mon*)

Release date: May 31–June 17, 1964
Runtime: 90 minutes
Aspect ratio: 2.35: 1
Director: Suzuki Seijun
Screenwriter: Tanada Gorō
Based on the novel by Tamura Taijirō
Cinematographer: Mine Shigeyoshi
Art director: Kimura Takeo
Editor: Suzuki Akira
Assistant director: Kuzū Masami
Production company: Nikkatsu
Production and release format: 35mm

Cast: Nogawa Yumiko, Shishido Jō, Matsuo Kayo, Ishii Tomiko, Kawanishi Kuniko, Tominaga Misako, Chico Roland, Wada Kōji, Esumi Eimei, Noro Keisuke

Screened with *Spy School: Men Without a Country* (*Supai nakano gakkō: Kokuseki no nai otokotachi*, Noguchi Hiroshi, 90 minutes) with Nitani Hideaki, May 31–June 6; and later with *Beach Party* ([*Yamenai de motto*], William Asher, 101 minutes), June 7–17.

Synopsis: Maya, a young woman in a brothel co-op, falls in love with a mysterious veteran on the lam hiding out with the women, throwing their arrangements into disarray.

Description: Suzuki's greatest economic success at Nikkatsu, based on a novel by Tamura Taijirō that had been previously adapted by Makino Masahiro in 1948, and which has been remade at least three times since then. The 1977 version was scripted by Suzuki collaborator Tanaka Yōzō. Many of Suzuki's 1960s fans (including Adachi Masao) regard it as being the first time they began paying attention to his work. This was Nogawa's first film appearance.

Our Blood Will Not Forgive (*Oretachi no chi ga yurusanai*)

Release date: October 3–10, 1964
Runtime: 97 minutes
Aspect ratio: 2.35: 1
Director: Suzuki Seijun
Screenwriters: Takemori Ryōma, Itō Michiko
Concept: Matsu'ura Takeo
Cinematographer: Mine Shigeyoshi
Art director: Kimura Takeo
Editor: Suzuki Akira
Assistant director: Kuzū Masami
Production company: Nikkatsu
Production and release format: 35mm
Cast: Kobayashi Akira, Takahashi Hideki, Matsubara Chieko, Hosakawa Chikako, Hase Yuri, Midorikawa Hiroshi, Takashina Kaku, Inoue Akifumi, Ozawa Eitarō, Hiromatsu Saburō

Screened with *Gazing at Love and Death* (*Ai to shi o mitsumete*, Saitō Buichi, 118 minutes), romance with Yoshinaga Sayuri, and newsreel *Congratulations Nomiya and Hanako!* (*Omedetō Nomiya sama, Hanako sama*), celebrating an imperial family wedding.

Synopsis: The film follows two brothers: the elder, Ryōta runs a nightclub with yakuza ties and is secretly carrying on an affair with his boss's

young girlfriend, while the hotheaded younger brother, Shinji works at an advertising agency with his girlfriend and carries on a series of bizarre escapades before learning of his family's involvement in the yakuza, leading to a climactic showdown by a barn in rural central Japan.

Description: A genre pastiche blending elements of youth-action-comedies, ninkyō, and Nikkatsu Westerns. The film includes the most bizarre use of rear projection in any of Suzuki's Nikkatsu films, where a car appears to be driving in the middle of the Pacific Ocean. It also contains an impossibly constructed film-within-a-film sequence. The film was reportedly unpopular with audiences, and as a result Suzuki did not work with Kobayashi at the studio again.[2] Filmed on location in Asamakōgen (Gunma Prefecture) and Atami (Shizuoka Prefecture).

Story of a Prostitute (Shunpuden)

Release date: February 27–March 3, 1965
Runtime: 96 minutes
Aspect ratio: 2.35: 1
Director: Suzuki Seijun
Screenwriter: Takaiwa Hajime
Based on a novel by Tamura Taijirō
Cinematographer: Nagatsuka Kazue
Art director: Kimura Takeo
Editor: Suzuki Akira
Assistant director: Kuzū Masami
Production company: Nikkatsu
Production and release format: 35mm
Cast: Nogawa Yumiko, Kawaji Tamio, Tamagawa Isao, Ozawa Shōichi, Sugiyama Toshio, Hirata Daisaburō, Ishii Tomiko, Hatsui Kotoe, Imai Kazuko, Takashina Kaku, Esumi Eimei, Matsuo Kayo, Noro Keisuke
Screened with *Intentions of Murder* (*Akai satsui*, Imamura Shōhei, 150 minutes).

Synopsis: Harumi, a comfort woman enslaved to the Japanese military, plots revenge against an adjutant who rapes her by trying to seduce the adjutant's loyal and sexually naïve second, Shinkichi, to turn him against the adjutant. She falls in love with Shinkichi in the process and tries to get him to desert the army with her, but his blind devotion to the Japanese military prevents him from doing so.

Description: Following *Gate of Flesh*, this was Suzuki's second adaptation of a Tamura Taijirō novel (which had also been previously made into a film, *Akatsuki no dasshutsu* [*Desertion at Dawn*, 1950], directed by Taniguchi

Senkichi and scripted by Kurosawa Akira). Contrary to the claim that Suzuki's experimentation came out of boredom with subpar screenplays and subject matter, here the unconventional form enhances an already well-crafted screenplay that grapples more seriously with the consequences of ideological devotion on sex and romance than the novel's earlier adaptation. In the film's original treatment, it was explicit that Harumi was Korean, but Nikkatsu was nervous about the subject matter and removed the direct reference.[3] Listed at #139 in *Kinema junpō*'s "200 Best Japanese Films List" in 2009.

Born Under Crossed Stars (Akutarō'den: Warui hoshi no shita demo)

Release date: August 25–September 3, 1965
Runtime: 98 minutes
Aspect ratio: 2.35: 1
Director: Suzuki Seijun
Screenwriter: Kasahara Ryōzō
Based on a novel by Kon Tōkō
Cinematographer: Nagatsuka Kazue
Art director: Kimura Takeo
Editor: Suzuki Akira
Assistant director: Kuzū Masami
Production company: Nikkatsu
Production and release format: 35mm
Cast: Yamauchi Ken, Nogawa Yumiko, Izumi Masako, Hatsui Kotoe, Fujiyama Ryuichi, Chō Hiroshi, Mishima Chieko, Kasai Kazuhiko, Noro Keisuke, Benisawa Yōko, Hirata Jushirō
Screened with *Murder Unincorporated* (*Dainippon koroshiya'den*, Noguchi Hiroshi, 85 minutes), action comedy with Shishido Jō.
Synopsis: Suzuki Jūkichi, a young student from a poor family, gets by selling milk to pay for school while his ne'er-do-well father secretly gambles his money away, getting him in trouble with local yakuza. Jūkichi also finds himself in a love triangle with Suzuko, the object of his own affections, and Taneko, a sexually forward young woman with designs on him.
Description: Based on a Kon Tōkō novel, *Born Under Crossed Stars* is a far more irreverent film than *The Incorrigible*. However, its raunchy humor effectively depicts the protagonist's discomfort with his newly discovered sexuality, a theme that runs under many male characters of Suzuki's films. Noro Keisuke reprises his lecherous upper-classman role as Ōka.

Filmed on location in Kawagoe (Saitama Prefecture), Kawasaki (Kanagawa Prefecture), and Yao (Ōsaka Prefecture).

Tattooed Life (Irezumi ichidai)

Release date: November 13–22, 1965
Runtime: 87 minutes
Aspect ratio: 2.35: 1
Director: Suzuki Seijun
Screenwriters: Naoi Kinya, Hattori Kei
Cinematographer: Takamura Kuratarō
Art director: Kimura Takeo
Editor: Suzuki Akira
Assistant director: Kuzū Masami
Tattoos: Ōnaka Yutaka
Production company: Nikkatsu
Production and release format: 35mm
Cast: Takahashi Hideki, Izumi Masako, Hananomoto Kotobuki, Kawazu Seizaburō, Itō Hiroko, Matsuo Kayo, Komatsu Hōsei, Takashina Kaku, Yamauchi Akira, Kodaka Yuji, Chiyoda Hiroshi
Screened with *To Rogues There Are No Borders* (*Yarō ni kokkyō wa nai*, Nakahira Kō, 99 minutes), Nikkatsu Western with Kobayashi Akira.
Synopsis: In the early Shōwa era, the boss of a yakuza named Tetsutarō's has set him up, forcing him to flee with his artist younger brother Kenji and attempt to head to Manchuria. After getting swindled at a seaside town, they get a job in construction to raise enough funds to escape. The boss's sister-in-law falls in love with Tetsutarō, arousing the envy of a treacherous manager who decides to sell the brothers out, while Kenji asks the boss's wife to act as a model for his artwork, causing much gossip and commotion.
Description: Suzuki's third and final ninkyō film initially resembles *The Flowers and Angry Waves* more closely than *Kanto Wanderer* in its realistic depiction of period details before giving way to further stylistic abstraction in its climax. For the majority of the film, the subdued color design of earthy browns and stony grays bears a closer resemblance to *Zigeunerweisen* and *Kagero-za* than *Youth of the Beast* and *Tokyo Drifter*; as a result, the film's visual design seems atypical of Suzuki for most of the film. However, it undergoes a sudden and powerful shift in its climax, which packs most of the design elements of a full Suzuki film into a single scene.

Carmen from Kawachi (*Kawachi karumen*)

Release date: February 7–11, 1966
Runtime: 89 minutes
Aspect ratio: 2.35: 1
Director: Suzuki Seijun
Screenwriter: Miki Katsumi
Based on a novel by Kon Tōkō
Cinematographer: Mine Shigeyoshi
Art director: Kimura Takeo
Editor: Suzuki Akira
Assistant director: Kuzū Masami
Production company: Nikkatsu
Production and release format: 35mm
Cast: Nogawa Yumiko, Wada Kōji, Kawaji Tamio, Miyagi Chikako, Itō Ruriko, Matsuo Kayo, Kusunoki Yūko, Noro Keisuke, Chō Hiroshi, Wada Etsuko, Sugiyama Hajime, Saga Zenpei
Screened with with *I Love You, I Love You, I Love You* (*Aishite aishite aishichatta no yo*, Ida Motomu, 76 minutes), youth romance with Hamada Mitsuo.
Synopsis: Tsuyuko, a young woman from rural Kansai, tries to make it in Ōsaka by taking on a series of sexually exploitative jobs (as a bar hostess, a fashion model, maid, and, finally, pornographic actress). She meets her young crush again in adulthood, only to find that he is as sleazy as the other men in her life.
Description: Suzuki's final film to star Nogawa Yumiko and his last film based on a novel by Kon Tōkō. The original screenplay contains a more extensive role for the sexually exploitive monk than appears in the finished film; Nikkatsu stopped the scenes from being filmed for reasons unknown.[4] Filmed on location in Ōsaka, Chiyoda Ward (Tōkyō), and Narita (Chiba Prefecture).

Tokyo Drifter (*Tōkyō nagaremono*)

Release date: April 10–26, 1966
Runtime: 83 minutes
Aspect ratio: 2.35: 1
Director: Suzuki Seijun
Screenwriter: Kawauchi Kōhan
Cinematographer: Mine Shigeyoshi
Art director: Kimura Takeo

Editor: Inoue Shinya
Assistant director: Kuzū Masami
Production company: Nikkatsu
Production and release format: 35mm
Cast: Watari Tetsuya, Matsubara Chieko, Kawaji Tamio, Nitani Hideaki, Tamagawa Isao, Kita Ryūji, Esumi Eimei, Hino Michio, Midorikawa Hiroshi, Chō Hiroshi, Hamakawa Tomoko, Yoshida Tsuyoshi
Screened with *Tales of Japanese Chivalry: Invitation to a Bloodbath* (*Nippon ninkyō'den: Chimatsuri genkajō*, Masuda Toshio, 89 minutes), ninkyō film with Takahashi Hideki, Izumi Masako, and Shishido Jō.
Synopsis: Tetsu is a lieutenant in a yakuza clan that has gone straight but gets roped back into battle when a rival clan tries to edge in on their legitimate business. Though loyal to the core and willing to go to great personal expense for his boss's sake, Tetsu learns the hard way that his loyalty is not reciprocated.
Description: Perhaps Suzuki's best-known film internationally, and boasting an infectious theme song (the popular *enka* that the film is named after, though the lyrics were changed for the version in the film), an iconic powder-blue suit, and a magnificently staged, edited, and lit final gunfight. *Tokyo Drifter* was Watari's only performance in a Suzuki film, and Watari's stoicism acts as a foil for the unrestrained style of the rest of the film. An unwatchably dull sequel was released the same year (as a double bill with Suzuki's *Fighting Elegy*) by a different filmmaker. The coda scene (with Watari against the neon lights) was filmed by Assistant Director Kuzū Masami because Nikkatsu producers disliked Suzuki's original final scene, which apparently involved a green moon. This footage is not thought to be extant.[5] Listed at #70 in *Kinema junpō*'s "200 Best Japanese Films List" in 2009. Filmed on location in Tokamachi (Niigata Prefecture) and Sasebo (Nagasaki Prefecture).

Fighting Elegy (*Kenka erejī*)

Release date: November 9–19, 1966
Runtime: 86 minutes
Aspect ratio: 2.35: 1
Director: Suzuki Seijun
Screenwriters: Shindō Kaneto, Guryū Hachirō (Suzuki Seijun, Yamatoya Atsushi, Tanaka Yōzō, Kimura Takeo, Sone Chūsei, Yamaguchi Seiichirō, Hangai Yasuaki, Okada Yutaka) (uncredited)
Based on a novel by Suzuki Takashi
Cinematographer: Hagiwara Kenji

Art Director: Kimura Takeo
Editor: Taji Mutsuo
Assistant director: Kuzū Masami
Production company: Nikkatsu
Production and release format: 35mm
Cast: Takahashi Hideaki, Asano Junko, Kawazu Yūsuke, Miyagi Chikako, Noro Keisuke, Isao Tamagawa, Sano Asao, Hamamura Jun, Midorikawa Hiroshi
Screened with *Tokyo Drifter Continued: The Sea Bright-Red with Love* (*Zoku'tōkyō nagaremono: Umi wa makka na koi no iro*, Morinaga Kenjirō, 73 minutes).
Synopsis: In the early Shōwa era, Kiroku struggles to uphold the code of his fight club by avoiding women as he falls in love with his landlord's daughter. At the center of the film is a bizarre encounter with an old man who seems to drive the young fight clubs into action, who we later learn is Kita Ikki.
Description: Cleverly disguised as a teen comedy in the vein of Suzuki's films earlier in the decade, the film shows the way that the apparently anarchic violent energies of the young men (and their repressed sexuality) are channeled into the project of fascism, but it only becomes apparent in retrospect, when the process is already too far advanced to be reversed. Noro Keisuke and Sugiyama Hajime reprise versions of their roles from earlier Suzuki teen-action-comedy films. The film is also noteworthy as the first (unofficial) collaboration of the Guryū Hachirō group, who also wrote the unfilmed sequel. Listed at #25 in *Kinema junpō*'s "Best Films of 1966" list (making it the first Suzuki film to make the year-end *Kinema junpō* list), and also listed at #25 in *Kinema junpō*'s "200 Best Japanese Films List" from 2009 (making it the highest-ranked Suzuki film in the latter list as well). Filmed on location in Inawashiro, Bandai, Kitashiobara, Aizuwakamatsu, Kitakata (Fukushima Prefecture), and Ueda (Nagano Prefecture).

Branded to Kill (*Koroshi no rakuin*)

Release date: June 15–27, 1967
Runtime: 91 minutes
Aspect ratio: 2.35: 1
Director: Suzuki Seijun
Screenwriters: Guryū Hachirō (Suzuki Seijun, Yamatoya Atsushi, Tanaka Yōzō, Kimura Takeo, Sone Chūsei, Yamaguchi Seiichirō, Hangai Yasuaki, Okada Yutaka)

Cinematographer: Nagatsuka Kazue
Art director: Kawahara Motozō
Editor: Suzuki Akira
Assistant director: Kuzū Masami
Production company: Nikkatsu
Production and release format: 35mm
Cast: Shishido Jō, Annu Mari, Ogawa Mariko, Nanbara Kōji, Tamagawa Isao, Minami Hiroshi, Yamatoya Atsushi, Midorikawa Hiroshi, Nomura Takashi, Chō Hiroshi
Screened with *The Flower-Eating Insect* (*Hana o kū mushi*, Nishimura Shōgorō, 91 minutes), proto-Roman Poruno.
Synopsis: A hitman fails a hit and becomes a target of the organization that had employed him.
Description: *Branded to Kill* is a watershed, and also an anomaly, in Suzuki's career. It is his only Nikkatsu film that he was not assigned to direct but was conceived with his own collaborators; it is also the only screenplay in his filmography credited to Guryū Hachirō. The project was greenlit because Nikkatsu, then in a disastrous financial state, needed a film to fill their release lineup quickly.[6] The straightforward narrative premise is overwhelmed by its potent imagery, convoluted editing, and loose causality. Listed at #33 in *Kinema junpō*'s "200 Best Japanese Films List" in 2009.

"A Duel" ("Aru kettō"), episode 33 of *Good Evening, Dear Husband* (*Aisai-kun, konbanwa*)

Air date: April 10, 1968
Runtime: 25 minutes
Aspect ratio: 1.33: 1
Director: Suzuki Seijun
Screenwriter: Yamaura Hiroyasu
Cinematographer: Minamida Morio
Art director: Kikugawa Yoshie
Editor: Nishimura Toyoji
Production company: Nikkatsu
Television station: TBS
Production format: 16mm
Broadcast format: Video
Cast: Yamamoto Kōichi, Nagayama Kazuo, Fuji Manami, Ōhira Toru (narrator)
Synopsis: A married couple is visiting the countryside, and the wife feels neglected by her husband, who has immersed himself in his writing.

A hunter stumbles onto their property, welcomes himself into their vacation house, and makes advances on the wife.

Description: This is a strong thematic counterpart to Suzuki's earlier *Love Letter*; like the earlier film, it plays out in a rural landscape and remote cabin and makes extensive use of hunting rifles in its imagery. While the earlier film had been an earnest romance, however, this film explores the unfulfilled sexual desires of an ignored housewife. A series of episodes blur the line between fantasy, dream, and reality, as with many of Suzuki's later films, but here the comically neat resolution packages the ambiguity for easier consumption than most of his other later works.

"There Is a Bird Within a Man" ("Otoko no naka ni wa tori ga iru"), episode 5 of *The Sands of Kurobe* (*Kurobe no taiyō*)

Scheduled air date: August 31, 1969 (pulled before airing)
Runtime: 56 minutes
Director: Suzuki Seijun
Screenwriter: Iwama Yoshiki
From the book by Kimoto Jōji
Production companies: Mingei Productions, MNS Productions
Television station: TBS
Production format: 16mm
Broadcast format: Video (planned)

Description: An episode of the series *The Sands of Kurobe*, which spun off from the popular 1968 film starring Mifune Toshirō and Ishihara Yūjirō. Suzuki's episode follows a character named Hayashida Shōzaburō and his children Fusako and Saburō (none of them characters in the film) in the city of Toyama.[7] The episode was pulled at the request of one of its sponsors.[8] There is a rumor that this was because one of the show's chief sponsors was Nissan, who wanted the episode pulled because it contained a traffic accident. Suzuki claims that he was not informed why the episode was pulled, beyond the fact that it was due to the complaint of a sponsor.[9] It is unclear whether any prints are extant.

"A Mummy's Love" ("Mīra no koi"), episode 1 of *Unbalanced Horror Theater* (*Kyōfu gekijo anbaransu*)

Air date: January 8, 1973
Runtime: 47 minutes

Aspect ratio: 1.33: 1
Director: Suzuki Seijun
Screenwriter: Tanaka Yōzō
Based on *Nisei no enishi-shūi* by Enchi Fumiko (and *Harusame monogatari* by Ueda Akinari)
Cinematographer: Mori Yoshihiro
Art director: Suzuki Yoshio
Editor: Ogawa Nobuo
Assistant director: Shimura Hiroshi
Production company: Tsuburaya Productions
Television station: Fuji Television
Production format: 16mm
Broadcast format: Video
Cast: Watanabe Misako, Hamamura Jun, Yamatoya Atsushi, Kawazu Yusuke

Synopsis: The episode is divided into two halves: the first is based on a story from Ueda Akinari's *Harusame monogatari* and is a comically sacrilegious take on tales of revived mummified Buddhist monks that circulated in the late Edo period, while the second is a story of a literature scholar who uncovers her desire to meet her deceased husband again while encountering the earlier story.

Description: After directing television commercials for five years, Suzuki was given the honor of directing the first episode of *Kyōfu gekijo anbaransu*, a television series in the *kaiki* (horror or ghost story) genre featuring a self-contained story in each episode, bookended by scenes with Aoshima Yukio addressing the audience. Later episodes were directed by Fujita Toshiya, Hasebe Yasuharu, and Kuroki Kazuo (among others). The comedy of the first half gives way to a legitimate sense of the uncanny in the second half, foreshadowing the similar shifts between slapstick and uncanny in *Zigeunerweisen* and *Kagero-za* (also scripted by Tanaka), and also Suzuki's more experimental television film *The Fang in the Hole* later in the decade. Though made for television, it has had at least one public screening in 16mm (its shooting format), at the Kawasaki City Museum Cinematheque in 2000.

A Tale of Sorrow and Sadness (*Hishū monogatari*)

Release date: May 21–June 3, 1977
Runtime: 91 minutes
Aspect ratio: 2.35: 1

Director: Suzuki Seijun
Screenplay: Yamatoya Atsushi
Concept: Kajiwara Ikki
Cinematographer: Mori Masaru
Art director: Kikukawa Yoshie
Editor: Suzuki Akira
Assistant director: Saitō Nobuyuki
Production and release format: 35mm
Production company: Shochiku
Cast: Shiraki Yōko, Harada Yoshio, Okada Masumi, Enami Kyōko, Sano Shūji, Tamagawa Isao, Noro Keisuke, Wada Kōji, Shishido Jō
Screened with *Chance Meeting in the Rain* (*Ame ni meguriai*), Nomura Takashi, 91 minutes.

Synopsis: A clothing company attempts to turn a young golfer into a national star to use her as a marketing model. They succeed, and she is able to move into a fashionable modern suburban neighborhood; however, her fame brings unexpected consequences, including overbearing male suitors and a jealous neighbor who concocts a blackmail scheme against her.

Description: Suzuki's first theatrically released film after the Suzuki Seijun Incident is often overlooked in his filmography, perhaps because it is caught awkwardly between the two stages of his career that are usually emphasized: his renegade studio filmmaker stage at the end of his Nikkatsu career, and his esoteric international art house filmmaker stage inaugurated with *Zigeunerweisen* three years later. Looked at along with his unfilmed screenplays and television work from the intervening years, the distinction between the two stages becomes less clear, and this film fits more naturally into his filmography. Scripted by Yamatoya, the film begins in a relatively straightforward fashion stylistically, but strange flourishes gradually crop up: the jealous neighbor's reflection in green light, a strange park where sakura never seem to stop blossoming, and a house whose walls change color in slow motion. It culminates in a violent, abstract sequence made all the more potent by way it slowly creeps up from the film's stylistically banal opening. The supporting cast is filled with regulars from Suzuki's Nikkatsu career, and some additional mainstays from 1960s Japanese genre cinema also appear (notably Enami Kyōko, star of the *Woman Gambler* series, as the jealous neighbor). A poorly transferred and subtitled English-language copy has circulated for many years, not doing justice to the film's impressive visual design and giving the false impression that its narrative is simply incoherent from start to finish. The film was listed as #18 in *Kinema junpō*'s "Best Films of 1977" list.

Lupin III: Part 2 (*Rupan sansei dai-ni-shirīzu*)

Air dates: October 3, 1977–October 6, 1980
Episode length: 25 minutes (155 episodes)
Aspect ratio: 1.33: 1
Studio: Tokyo Movie Shinsha
Television network: NTV
Based on the manga by Monkey Punch
Supervising director: Suzuki Seijun (October 2, 1978–October 6, 1980; episodes 52–155)
Series organizer: Yamatoya Atsushi (October 9, 1978–October 6, 1980; episodes 53–155)
Literary supervisor: Ioka Junichi (October 9, 1978–October 6, 1980; episodes 53–155)
Writing staff: Takashina Kō, Urasawa Yoshio, Yamatoya Atsushi, Miyazaki Hayao (as Teruki Tsutomu), Ōhara Kiyohide, Suzuki Kōichi (among others)
Directing and animation staff: Yoshida Shigetsugu, Miyazaki Hayao (as Teruki Tsutomu), Ishiguro Noboru, Okuda Seiji, Kodama Kenji, Aoki Yūzō, Mikamoto Yasumi (among others)
Cast: Yamada Yasuo, Kobayashi Kiyoshi, Masuyami Eiko, Naya Gorō, Inoue Makio
Description: The second (of five to date) animated television series following the escapades of master thief Lupin III, referred to as the "red jacket" series because Lupin sports a red blazer in this series (he wore a green blazer in the first series, a pink blazer in the third series, and a blue one in the two most recent series). Suzuki has claimed that his contributions were minor,[10] but given the length of his involvement in the series and the accumulation of regular collaborators on the series writing staff, there is reason to believe that he may have been more involved than he has let on. The account of literary supervisor (*bungei tantō*) Ioka Junichi suggests this as well.

Suzuki was recruited as supervising director by his frequent collaborator Yamatoya Atsushi.[11] Yamatoya had written some episodes of the original series (aired 1971–1972) and *Lupin III: The Mystery of Mamo* (*Rupan sansei*, 1978) but took on a more supervisory role in this series. He wrote two episodes during Suzuki's tenure: episode 99, "Combat Magnum Scattered in the Wasteland" ("Kōya ni chitta konbatto magunamu"), and episode 103, "The Wolf Saw an Angel" ("Ōkami wa tenshi o mita"). Suzuki also recruited two screenwriters to the writing staff he had worked with: Ōhara Kiyohide (*Spring Cherry Blossoms: Japanesque*), and Suzuki Kōichi (*Capone Weeps with Passion*),[12] and he formed relationships with

two others: director Yoshida Shigetsugu (codirector of *Lupin III & the Legend of Babylon's Gold*) and screenwriter Urasawa Yoshio (*Babylon's Gold*, *Marriage*, and *Princess Raccoon*).

Writers would meet with Suzuki and Yamatoya when they were pitching ideas, and the head director of episodes would later meet with the two once storyboards had been drawn. Suzuki took special interest in certain episodes, such as the two-part "The Mysterious Cherry Blossom Gang" ("Hanafubuki: nazo no goninshū," episodes 55–56, written by Takashina Kō and directed by Ishihara Taizō), but on other occasions, he would seem to be asleep for meetings in their entirety. At other times, he would wait until the end of a meeting to say something to the effect of "I don't understand" or "It doesn't have enough action," which staff took as a coded instruction to scrap the idea and start over. Ioka recounts a particularly contentious pitch meeting for episode 145, "Albatross: The Wings of Death" ("Shi no tsubasa: Arubatorosu"), when Suzuki said something to this effect, but the writer refused to scrap the idea, at which point one of Suzuki's assistants began shouting at the writer.[13] It must be observed that some of these anecdotes seem to place him in the role of meddlesome producer rather than beleaguered artist.

The series is also notable for two episodes written and directed by Miyazaki Hayao (under the pen name Teruki Tsutomu). Miyazaki had also contributed to the first series (also under a pen name) and directed *Lupin III: The Castle of Cagliostro* (*Rupan sansei: Kariosutoro no shiro*, 1979). His episodes are both quite different from other episodes, and in retrospect we can see elements of what would become Miyazaki's style, from the obsession with flying devices to the portrayal of Fujiko as heroine rather than femme fatale. One of Miyazaki's episodes even discards Lupin as a protagonist in favor of an adolescent girl and her flying robot, which resembles the robots from his later *Castle in the Sky* (*Tenkū no shiro: Rapyuta*, 1986). Miyazaki's episodes are "Albatross: The Wings of Death" and episode 155, "Farewell to My Beloved Lupin" ("Saraba toshiki rupan yo," the series finale).

"The Fang in the Hole" ("Ana no kiba"), season 2, episode 10, of *Sunday Horror Series* (*Nichiyō kyōfu shirīzu*)

Air date: September 23, 1979
Runtime: 45 minutes
Aspect ratio: 1.33: 1
Director: Suzuki Seijun

Screenwriter: Yamatoya Atsushi
Based on the novel by Tsuchiya Takao
Cinematographer: Fujii Hideo
Art director: Hosoishi Terumi
Editor: Taniguchi Toshio
Production company: Daiei
Television station: Fuji Television
Production format: 16mm
Broadcast format: Video
Cast: Fujita Makoto, Inagawa Junko, Harada Yoshio
Synopsis: Police Detective Togura kills a fugitive yakuza hitman in a standoff in a bar in an unnamed Japanese city, and the hitman's blood splashes over a woman, Miyuki. After a series of strange dreams and encounters, Togura begins to suspect that the hitman's ghost is possessing Miyuki.
Description: *Nichiyō kyōfu shirīzu* was another *kaiki* television series that had weekly self-contained episodes and recruited established filmmakers to direct individual episodes (episodes were also directed by *kaiki eiga* master Nakagawa Nobuo and Nikkatsu Action alums Hasebe Yasuharu and Akinori Matsuo). Filming almost entirely on Daiei's Kyōto soundstage,[14] Suzuki uses a minimalist set design with backgrounds consistently in a strange avocado green color. Some of the backgrounds are designed as walls within the film's diegesis, with clear boundaries and props on them, but many are cyclorama walls that create an ambiguous green void that carries off indefinitely, as if the footage had been shot for green-screen but without any postproduction effects added. Suzuki uses this process as part of a broader strategy to blur the lines between the supernatural, Togura's imagination, and reality, and also between spaces. The handful of location shots in and around Kyoto only make the studio shot sets more unsettling. Though originally broadcast on television, there has been at least one public screening of the film in 16mm (its original shooting format) at the Shin-Bungeiza in Tokyo in 2017.

Zigeunerweisen (*Tsigoeneruwaizen*)

Release date: April 1, 1980–June 1980
Runtime: 145 minutes
Aspect ratio: 1.33: 1
Director: Suzuki Seijun
Screenwriter: Tanaka Yōzō
Cinematographer: Nagatsuka Kazue
Art director: Kimura Takeo

Editor: Kamiya Nobutake
Assistant director: Yamada Junsei
Producer: Arata Genjirō
Production company: Cinema Placet
Production and release format: 35mm
Cast: Fujita Toshiya, Harada Yoshio, Ōtani Naoko, Yasuda Michiyo, Makishi Kisako, Maro Akaji, Kirin Kiki, Sasaki Sumie, Yamaya Hatsuo, Tamagawa Isao

Synopsis: In the Taishō era, Aoichi, a professor of German, encounters his old friend Nakasago on the road, accused of murdering a woman, and vouches for his character. The two reconnect and spend the night with a geisha named Koine. They reconnect again later, and Aochi finds that Nakasago has married a woman identical to Koine. The lives of the two characters intersect periodically over the following years in a series of real or imagined affairs, and a phonographic recording of a Zigeunerweisen by Sarasate.

Description: Though Suzuki had made *A Tale of Sorrow and Sadness* three years earlier, it was the success of *Zigeunerweisen* that cemented his return to theatrical filmmaking. Initially, the film was released only in a makeshift movie theater in an inflatable dome in Tokyo.[15] After media attention and critical success, the film was eventually released more widely; it also won awards at the Berlin International Film Festival and the Japanese Academy Awards, was voted the best Japanese film of 1980 by *Kinema junpō*, and later was named the best Japanese film of the decade by a group of Japanese film critics. *Zigeunerweisen* was thus both Suzuki's most celebrated film in its initial released and his introduction to the international art-house circuit. Suzuki's attention to certain aspects of period detail, such as costuming and setting, is striking but also fragmentary and wedded to a fanciful imagery and a narrative that moves seamlessly between dreams and reality. The effect is a stunning re-creation of Taishō Japan that also gives the sense that the era is a fantasy of Suzuki's and Tanaka's own invention. Though the screenplay does not list a source novel, early drafts of it have the title "Sarasate no ban" (A Sarasate phonographic record), named for an Uchida Hyakken story. The film's narrative weaves together elements of "Sarasate no ban" as well as numerous other Uchida stories. The character Aochi resembles the author, who was a professor of German in the same period. Suzuki pitched the idea of making an adaptation of Uchida's story to Tanaka as early as 1968.[16] Listed at #35 in *Kinema Junpō*'s "200 Best Japanese Films List" in 2009. Filmed on location in Kamakura (Kanagawa Prefecture).

"Chin Shun-shin's 'The Claws of the Divine Beast'" ("Chin Shun-shin no shinjū no tsume"), episode 13 of *Mystery Masterpiece Theater* (*Kessaku suiri gekijō*)

Air date: December 25, 1980
Runtime: 45 minutes
Aspect ratio: 1.33: 1
Director: Suzuki Seijun
Screenwriter: Sakurai Yasuhiro
Based on a story by Chin Shun-shin
Cinematographer: Saitō Takao
Art director: Kimura Mitsuno
Editor: Kamiya Nobuo
Production company: Mifune Productions
Television station: Asahi Television
Production format: 16mm
Broadcast format: Video
Cast: Ōtani Naoko, Sekiguchi Hiroshi, Nagato Isamu, Kondō Hiroshi, Kimura Yūki, Nishimura Kō, Uchida Asao
Synopsis: A wealthy Yokohama man is murdered with mysterious claw marks across his face. The police first suspect a man from his old army regiment whom he had been seen arguing with before the killing, but they uncover a larger conspiracy involving an old Tang dynasty artifact and unpunished war crimes from the Japanese invasion of China.
Description: The first of three television projects that Suzuki directed in the 1980s for Mifune Productions (Mifune Toshirō's Production Company) was this final episode of *Mystery Masterpiece Theater*, based on a story by Taiwanese-Japanese author Chin Shun-shin. Without the collaboration of Tanaka Yōzō or Yamatoya Atsushi as screenwriters, the project is more workmanlike than either "A Mummy's Love" or "Fang in the Hole." The episode does culminate, however, in an elaborate flashback/dream/theater sequence during its climax set in Yokohama's Chinatown.

"Storm of Falling Petals: The Banner of a Fireman in the Flames" ("Hanafubuki: honō ni mau ichiban matoi"), episode 66 of *Ōedo Investigation Network* (*Ōedo sōsa-mō*), series 5

Air date: January 10, 1981
Runtime: 45 minutes
Aspect ratio: 1.33: 1

Director: Suzuki Seijun
Screenwriter: Yamazaki Iwao
Cinematographer: Yamada Ichio
Art director: Touma Fumio
Editor: Inoue Shinya
Production company: Mifune Productions
Television station: Tokyo Channel 12
Production format: 16mm
Broadcast format: Video
Cast: Matsukata Hiroki, Sagawa Tetsurō, Tsuchida Sanae, Katase Rino, Araki Yumiko, Hamada Akira, Izawa Ichirō, Kitahara Yoshirō, Uenoyama Kōichi, Shimotsuka Makoto
Synopsis: Set in the Edo era, a group of four secret agents investigate mysterious fires that are burning down stores at night. They quickly identify their first suspect, but there may be a deeper conspiracy at work than is at first apparent.
Description: An episode of a long-lived period television series about a clandestine group of detectives working under the shogun's order (its original run was from 1970 to 1984, but it has been rebooted in the 1990s and 2010s). Other episodes were directed by such filmmakers as Hasebe Yasuharu, Sone Chūsei, and Ikehiro Kazuo. The work is of interest primarily as Suzuki's only foray as a director into the period genre. It also makes for an unlikely reunion between Suzuki and screenwriter Yamazaki Iwao, who had written the screenplays for numerous early Suzuki films at Nikkatsu. Yamazaki was a regular writer for the series.

Kagerō-za

Release date: August 29, 1981
Runtime: 139 minutes
Aspect ratio: 1.33:1
Director: Suzuki Seijun
Screenwriter: Tanaka Yōzō
Concept: Izumi Kyōka
Cinematographer: Nagatsuka Kazue
Art director: Ikeya Noriyoshi
Editor: Suzuki Akira
Assistant director: Shiraishi Kōichi
Producer: Arata Genjirō
Production company: Cinema Placet
Production and release format: 35mm

Cast: Matsuda Yūsaku, Yasuda Michiyo, Kaga Mariko, Nakamura Katsuo, Harada Yoshio, Sano Asao, Itō Hiroko

Synopsis: A playwright named Matsuzaki runs through a series of strange encounters with a patron and two women, one of whom may or may not be the patron's wife, and the other of whom is said to be a European woman disguised as Japanese, with her blonde hair and blue eyes visible only in the moonlight. The film culminates in a mysterious stage performance by child actors that blends the distinctions between theater and cinema, dream and reality, natural and supernatural, and the underworld.

Description: The second film in Suzuki's Taishō trilogy is an even more disjointed, fever-dream like film than its predecessor, but it benefited from the critical and financial success of *Zigeunerweisen* such that it did not have the same initial difficulties reaching audiences in conventional movie theaters. As with the earlier film, the period details are closely observed, but even more perversely twisted. It draws heavily on color schemes and artistic designs from premodern Japan that were resurfacing in the Taishō era, particularly in the film's depiction of the underworld and the use of *yūrei-zu* as part of the film's set design in the final sequences. Tanaka initially suggested adapting Kyōka's novel in 1968.[17] Listed as #3 in *Kinema junpō*'s "Best Films of 1983" list.

Spring Cherry Blossoms: Japanesque (Haru sakura: japanesuku)

Release date: 1983
Runtime: 79 minutes
Aspect ratio: 1.33:1
Director: Suzuki Seijun
Screenwriter: Ōhara Kiyohide
Cinematographer: Itō Yoshihiro
Art director: Tada Kajin
Editor: Tsukamoto Kaoru
Producer: Arata Genjirō, Katsuta Shōzō
Production company: Dentsu, Geneon
Format: Video
Cast: Kazefu Jun, Ibu Masatō

Synopsis: A series of increasingly bizarre episodes revolve around the custom of *hanami*, or cherry-blossom viewing. It begins when a blind woman hitchhikes with a truck driver with the words "Women Forbidden" pasted on his vehicle. When he asks where she is going, she responds "to see the cherry blossoms." Little does she realize that the man is

carrying a special cherry blossom tree in the back of the truck, whose blossoming petals offer to extend their life if he stays with the woman.

Description: Produced by Arata Genjirō (producer of the Taishō Trilogy films), this was Suzuki's first project shot directly to video, and while that places obvious limitations on image quality, his eye for composition and striking edits is very much in evidence. It is unfortunate that Hasumi does not write about the film in his discussion of Suzuki's (mis)use of Japanese seasonal imagery in his films, as this seems like an extended meditation on that undercurrent in Suzuki's filmography. It was made as part of a direct-to-video series with the subtitle "Japanesque" that Dentsu released in the early days of V-Cinema.[18] Filmed on location in Kobuchizawa (Gunma Prefecture), Kawaguchi Lake (Yamanashi Prefecture), and Gotenba (Shizuoka Prefecture).[19]

"A Family's Choice" ("Kazoku no sentaku"), episode of *Tuesday Suspense Theater* (*Kayō sasupense gekijo*)

Air date: November 8, 1983
Runtime: 95 minutes
Aspect ratio: 1.33:1
Director: Suzuki Seijun
Screenwriter: Tagami Yū
From the story *Shikashi satsujin wa . . .* by Sano Yō
Cinematographer: Shīzuka Akira
Art director: Kitagawa Hiromu
Editor: Araki Yoshihiro
Production company: Mifune Productions
Television station: Nihon Television
Production format: 16mm
Broadcast format: Video
Cast: Fujimura Shiho, Satō Makoto, Obata Kuniko, Kawaji Tamio

Synopsis: A divorced mother who works as a nurse is struggling to get enough money to pay for her son's schooling, and her ex-husband refuses to help. A wealthy lawyer with a terminal illness in her care offers to kill her husband psychically as he dies so that she can collect life insurance, but there may be more going on than is first apparent.

Description: *Tuesday Suspense Theater* was a series of self-contained suspense stories that aired between 1981 and 2005, often focusing on ordinary people who become implicated in murders. Other episodes were directed by Ishii Teruo, Ikehiro Kazuo, Hasebe Yasuharu, Sai Yōichi, Urayama Kirio, Ōbayashi Nobuhiko, Nakajima Sadao, Kudō Eiichi, and

Morisaki Azuma. Suzuki crafts a suspenseful thriller grounded by a curiously developed relationship between the central mother and son, making "A Family's Choice" the most satisfying of Suzuki's three television projects for Mifune Productions. Several sources incorrectly list another episode of *Tuesday Suspense Theater* ("The Demon of the Sleepless Night" ["Nemurenu yoru no akuma"] from 1986) as directed by Suzuki Seijun; he appears in it, but Nomura Takashi directed it.

"Musical Variation of Monkey Business" ("Warunori hensōkyoku"), episode 13 of *Lupin III: Part 3* (*Rupan sansei dai-san-shirīzu*)

Air date: October 20, 1984
Runtime: 25 minutes
Aspect ratio: 1.33: 1
Director: Yoshida Shigetsugu
Screenwriter: Suzuki Seijun
Based on the manga by Monkey Punch
Television station: Yomiuri Television
Cast: Yamada Yasuo, Kobayashi Kiyoshi, Masuyami Eiko, Naya Gorō, Inoue Makio

Synopsis: Mine Fujiko tricks Lupin into attending a party at a mysterious castle that turns into an elaborate set-up, but things begin to go haywire when the castle turns into a spaceship and drops him in a country where he is sentenced to crucifixion, only to be rescued by a murder of crows who attack the site. Things get weirder from there.

Description: Suzuki's sole contribution to the "pink jacket" television series of *Lupin III*. According to Ioka Junichi, the episode's director, Yoshida Shigetsugu, attempted to translate Suzuki's visual style into animation in the episode, but it is not entirely clear what this could mean.[20]

Capone Weeps with Passion (*Kapone ōi ni naku*)

Release date: February 16–March 20, 1985
Runtime: 129 minutes
Aspect ratio: 1.85: 1
Director: Suzuki Seijun
Screenwriters: Yamatoya Atsushi, Kimura Takeo, Suzuki Kōichi
From the novel by Kajiyama Sueyuki
Cinematographer: Fujisawa Junichi

Art director: Kimura Takeo
Editor: Suzuki Akira
Assistant director: Takahashi Shōji
Production company: K Enterprise, C.C.J
Distributor: Shochiku
Production and release format: 35mm
Cast: Hagiwara Kenichi, Tanaka Yūko, Chuck Wilson, Laurie Belisle, Emoto Akira, Hirata Mitsuru, Kiki Kirin, Katō Haruko, Maki Shinji, Umemiya Tatsuo, Sawada Kenji

Synopsis: A *naniwa-bushi* singer named Kaiemon flees Japan with a yakuza's mistress to the United States in the 1920s and gets pulled into the gangster underworld. He becomes involved in a gang war between the Japanese American gangsters of San Francisco and their rival, Frank Capone (Al's brother), when he attempts to perform *naniwa-bushi* in front of Al Capone, mistaking the latter for the president of the United States. Kaiemon tries to stay true to his craft and navigates changes in American society from the Prohibition era to the rise of xenophobia and racism as the United States and Japan go to war.

Description: This film was one of the many projects that Suzuki's Guryū Hachirō collaborators wrote during his exile from theatrical filmmaking; screenplay drafts (initially titled "Tōchūken Umiemon: Amerika kidan") date back to at least 1976. The portrayal of period in the film is achieved through an accumulation of references that look to have been picked up from popular culture more than thoroughly researched, never more so than in the film's *naniwa-bushi* performances, when pastiches of perceived American life in the 1920s glide by in the background. The pastiche of American culture is frequently comic but occasionally insidious. Filmed primarily in an abandoned amusement park in Japan, which places obvious limitations on the production. Suzuki makes no effort to hide this fact, however, and it adds to the festive and bizarre conception of American life in the 1920s. Listed as #20 in *Kinema junpō*'s "Best Films of 1985" list.

Lupin III: The Legend of the Gold of Babylon (*Rupan sansei: Babiron no ōgon densetsu*)

Release date: July 19, 1985
Runtime: 100 minutes
Aspect ratio: 1.85 : 1
Directors: Suzuki Seijun, Yoshida Shigetsugu
Screenwriters: Yamatoya Atsushi, Urasawa Yoshio

Based on the manga by Monkey Punch
Animation directors: Aoki Yūzō, Ryūno Tatsuo, Owashi Hidetoshi
Production companies: Tōhō, Nihon Television, Yomiuri Television, Tokyo Movie Company
Production and release format: 35mm
Cast: Yamada Yasuo, Kobayashi Kiyoshi, Masuyami Eiko, Naya Gorō, Inoue Makio, Shiozawa Toki, Carousel Maki, Ōtsuka Chikao, Oban, Koban, Hirano Fumi

Synopsis: After several attempts on his life by gangsters and a showdown with Inspector Zenigata at a Manhattan billboard, Lupin heads out to find the legendary gold of Babylon, based on clues from a song sung by a drunken old lady named Rosetta. Meanwhile, the ICPO, frustrated with Zenigata's continued failures to catch Lupin, tries to distract the inspector by making him host an ICPO beauty contest. There may also be more to the legend of the gold of Babylon than it seems at first.

Description: Suzuki's codirected Lupin III feature film does not compare favorably to either of the feature-length animated Lupin films that preceded it, or however we may imagine Oshii Mamoru's Lupin film (abandoned just before production on *Gold of Babylon* began) might have been. Suzuki claimed in interviews to have limited involvement in the production, adding that he could not draw; though not contradicting Suzuki on the latter point, his codirector, Yoshida Shigetsugu, claims that Suzuki did play an active role at times, including giving elaborate descriptions of how certain scenes in the screenplay should appear, including the motorcycle chase early in the film.[21] This is the final Suzuki film to have been scripted by Yamatoya Atsushi and the first to have been scripted by Urasawa Yoshio (excluding episodes of *Lupin III: Part 2* that Urasawa had written while Suzuki was supervising director). Urasawa would later script *Marriage* and *Princess Raccoon*.

"Yotsuya Kaidan" (segment of variety show hosted by "Kosakin")

Air date: Circa 1987
Runtime: 8 minutes
Aspect ratio: 1.85: 1
Director: Suzuki Seijun
Based on the Kabuki play *Tōkaidō yotsuya kaidan* by Tsuruya Nanboku IV
Cast: Kosakai Kazuki, Sekine Tsutomu, Torigoe Mari

Description: A very short adaptation of the oft-filmed Kabuki play for a variety show in the late 1980s. Suzuki's segment begins with a short montage of him filming it on a soundstage before entering into the main

story and is followed by an interview with hosts Kosakai Kazuki and Sekine Tsutomu (the comedy team known as "Kosakin"), who also appear in the film. Though brief, this has all the stylistic flourishes of a Suzuki film: filtered light cues, flat staging directly juxtaposed with deep-space staging, and choreographed parasols, and it culminates in a tap dance number between Kosakai and Sekine, anticipating *Princess Raccoon*'s blend of theater and musical types nearly two decades later.

Yumeji

Release date: April 13, 1991
Runtime: 129 minutes
Aspect ratio: 1.66:1
Director: Suzuki Seijun
Screenwriter: Tanaka Yōzō
Cinematographer: Fujisawa Junichi
Art director: Ikeya Noriyoshi
Editor: Suzuki Akira
Assistant director: Saishu Yasushi
Producer: Arata Genjirō
Production company: Arato Genjirō Pictures
Production and release format: 35mm
Cast: Sawada Kenji, Mariya Tomoko, Miyazaki Masumi, Bandō Tamasaburō, Harada Yoshio, Hasegawa Kazuhiko, Hirota Leona, Miyagi Chikako
Synopsis: A fanciful biography of the painter Takehisa Yumeji.
Description: Released ten years after its Taishō trilogy predecessors, *Yumeji* resembles them in its interweaving of dreams, art, and reality. As with the previous two films, it circulated on the international art-house circuit, playing at the Cannes Film Festival in 1991, and was accompanied by an extensive career retrospective at the Rotterdam Film Festival the same year. In fact, *Yumeji* is perhaps the most conventional art-house film in Suzuki's filmography, though that is not meant to denigrate it: its invocation of painting through its own imagery is inventive, eccentric, and evocative all at once and occasionally pushes toward a more interesting self-reflexive investigation of the boundaries between cinema and painting in its attempts to make its images look like Yumeji paintings. That Suzuki can accomplish this alongside the more conventional tasks of tracing a painter's creative struggles, sexual escapades, and insecurities is evidence of great versatility. The score by Umebayashi Shigeru is so exceptional that Wong Kar-wai used different parts of it in two films. This is also the last of Suzuki's films to be scripted by Tanaka, or any member

of Guryū Hachirō. Listed as #11 in *Kinema junpō*'s "Best Films of 1991" list.

A Tale of Youth at Hirosaki High School (*Hirokō seishun monogatari*)

Release date: 1992
Runtime: 56 minutes
Aspect ratio: 1.33: 1
Director: Suzuki Seijun
Screenwriter: Hirosaki Senior High School Alumni Association
Cinematographer: Yanai Jun
Art director: Ikeya Noriyoshi
Production company: Hirosaki Senior High School Alumni Association
Cast: Matsushita Kazuya, Kim Weom-bae, Kikuchi Yōko, Tamagawa Isao, Nogawa Yumiko
Format: Video
Synopsis: Kiyonori is a senior high school student who has just transferred to Hirosaki from Tokyo. The film focuses on his experience of the local culture, high school fight clubs, and simply growing up in the area.
Description: This short video project, which Suzuki made for Hirosaki Senior High School (now Hirosaki University), features a narrative sketch about life at the university in the late Taishō or early Shōwa era alongside landmarks associated with the school and city. Viewers may observe that the film bears a resemblance to Suzuki's earlier *The Incorrigible* and *Fighting Elegy*; however, it also relates to Suzuki's own life, as he transferred to the school from Tokyo as a young man. The protagonist's name, "Kiyonori," is also an alternate reading of the characters in "Seijun." Whether this means that *The Incorrigible* and *Fighting Elegy* were more autobiographical than previously recognized, or that Suzuki interpolated his films into his recollection of his own youth, is not clear. Frequent Suzuki performers Nogawa Yumiko and Tamagawa Isao also appear in small roles. Filmed on location in Hirosaki (Aomori Prefecture).

Suzuki Seijun's Mystery Theater (*Suzuki Seijun no misuterī gekijo*)

Air date: August 10, 1992
Runtime: 39 minutes (2 episodes)
Director: Suzuki Seijun
Cinematographer: Ishida Kōichirō

Art director: Ikeya Noriyoshi
Television station: Asahi Television
Production and broadcast format: Video
Cast: Suzuki Seijun, Mikami Kan, Saitō Haruko, Miyaji Masako, Miura Ōsuke, Akinō Haruko, Nihei Kōichi, Miyamoto Masae
Episode 1: "The Night of the Long-Nosed Goblins" ("Tengu no yobai") (18 minutes)
Episode 2: "The Outcome of Jealousy" ("Shitto no yukue") (21 minutes)
Description: A two-episode special of Asahi Television's late-night *Prestage* (*Puristēji*) Series. Both are filmed on location in rural Japan and focus on local *yōkai* traditions, highlighting local festivals around the *yōkai* and showing brief, comic stories about encounters with them. Suzuki's sense of humor is in evidence, but these shorts do not feature as much formal play as his short "Yotsuya Kaidan" adaptation from a few years earlier.

"The Lives of Extras" ("Ekisutora jinsei"), episode of *Human Documentary Theater* (*Dokyumentarī ningen gekijo*)

Air date: 1993 (exact date unknown)
Runtime: 45 minutes
Aspect ratio: 1.33:1
Director: Suzuki Seijun
Organizer: Nemoto Masayoshi
Cinematographer: Manabe Enjirō
Editor: Ōhashi Tomiyo
Television station: Tokyo Television
Production and broadcast Format: Video
Cast: Yatome Kenji, Matsushita Shōji, Suzuki Seijun, Sai Yōichi
Description: A short television documentary about the role of extras in filmmaking and their lives. Suzuki interviews director Sai Yōichi and two extras from one of his films (Yatome Kenji and Matsushita Shōji) about their work and sketches out details of the latter two's lives. Some aspects seem to be dramatic reenactments, though the boundaries between documentary and fiction are not entirely clear. Near the end of the episode, Suzuki films Yatome and Matsushita acting as "extras" in a scene with no lead performances to draw more attention to their craft. Though a minor work by any measure, this is a playful and charming entry in Suzuki's filmography and suggests that it might have been interesting to think of what Suzuki would have done with the documentary form had he worked in it more extensively.

Marriage (Kekkon) (segment: "Jinnai-Harada Families")

Release date: April 24, 1993
Runtime: 147 minutes (Suzuki Seijun's segment: 53 minutes)
Aspect ratio: 1.85 : 1
Director: Suzuki Seijun (one segment of an omnibus film—other segments by Nagao Jōji and Onchi Hideo)
Screenwriter: Urasawa Yoshio
Cinematographer: Fujisawa Junichi
Art director: Ikeya Noriyoshi
Editor: Uraoka Keiichi
Production companies: Seshiru, Shochiku
Distributor: Shochiku
Production and release format: 35mm
Cast: Jinnai Takanori, Harada Tomoyo, Harada Kiwako, Bengaru, Ōkōchi Hiroshi, Hidari Tokie, Minegishi Tōru, Harada Yoshio
Synopsis: A low-level TV actor tries to woo a famous actress in hopes that it will help his career, while she sees the marriage as an opportunity to deflect from her scandalous love affair with a married man.
Description: Suzuki directed one segment of this three-part omnibus film about three separate marriages; each segment had its own cast, crew, and production, and the stories were unrelated. The name "Jinnai-Harada" refers to the names of the lead performers rather than their characters. Suzuki filmed his segment at Shochiku's Ofuna Studio, his first time to return there since working as an assistant director for the studio in the early 1950s.[22] The film's caricatured set designs and play with television studio spaces have their antecedents in Suzuki's earlier films, but the film also makes extensive use of crane and dolly movements that perform unexpected visual transformations and glide across spatial discontiguities recalling the most eccentric films of Sōmai Shinji. The red snow in the film's car crash scene is based on an idea that Suzuki had planned to use in *Kanto Wanderer* thirty years earlier. In its home video release, Suzuki's 53-minute segment was released independently of Nagao's and Onchi's segments.

The Way of Karate (Karatedō)

Release date: 1997
Runtime: 84 minutes
Aspect ratio: 1.33 : 1
Director: Suzuki Seijun

Producer: Kurata Masaru
Narrator: Harada Yoshio
Format: Video
Cast: Asai Tetsuhiko, Ishimine Minoru, Richard Amos, Yamaguchi Takashi
Description: A two-part instructional video with karate master Asai Tetsuhiko. The videos mainly comprise Asai demonstrating karate techniques, though Suzuki interviews Asai as well. Over the end credits, Suzuki plays with perspective and depth when Asai and his acolytes perform karate techniques in silhouette against a red curtain.

Pistol Opera (*Pisutoru opera*)

Release date: September 19, 2001
Runtime: 112 minutes
Aspect ratio: 1.33:1
Director: Suzuki Seijun
Screenwriter: Itō Kazunori
Cinematographer: Maeda Yonezō
Art director: Kimura Takeo
Editor: Suzuki Akira
Production companies: Victor (Japan), Shochiku, Eisei Gekijo, Tokyo Channel 12, Dentsū, Ogura Jimusho
Distributor: Shōchiku
Production and release format: 35mm
Cast: Esumi Makiko, Yamaguchi Sayoko, Kan Hanae, Sawada Kenji, Kiki Kirin, Hira Mikijirō, Nagase Masatoshi, Katō Haruko
Synopsis: Miyuki, known as "Stray Cat," is ranked number three in an Assassin's Guild and attempts to rise in the ranks by fending off the other assassins.
Description: *Pistol Opera* draws several elements from *Branded to Kill*, including its mysterious guild with ranked assassins and a character named Hanada Gorō (with Hira Mikijirō taking Shishido Jō's place in the role). Suzuki works with some of the techniques he had developed at Nikkatsu, including colored cyclorama backgrounds, and makes interesting use of shadow play against shōji screens; to these, he adds strange digital postproduction effects. The screenplay is mostly unrelated to Guryū Hachirō's unfilmed screenplay for *Zoku'koroshi no rakuin* from 1967; however, one prominent detail that comes from the earlier project is the killer whose victims always have a smile on their face. Listed as #14 in *Kinema junpō*'s "Best Films of 2001" list.

Princess Raccoon (*Operetta tanuki goten*)

Release date: May 28, 2005
Runtime: 111 minutes
Aspect ratio: 1.85: 1
Director: Suzuki Seijun
Screenwriter: Urasawa Yoshio
Concept: Kimura Keigo
Production designer: Kimura Takeo
Cinematographer: Maeda Yonezō
Art director: Arata Norifumi
Editor: Itō Nobuyuki
Production company: Geneon, Shochiku, Nippon Herald, Ogura Jimusho, Dentsū, Eisei Gekijo
Distributors: Nippon Herald, Shochiku
Production and release format: 35mm
Cast: Zhang Ziyi, Odagiri Jō, Yakushimaru Hiroko, Yuki Saori, Misora Hibari (digital appearance), Hira Mikijirō, Takahashi Gentarō, Yamamoto Tarō, Sasai Eisuke, Ichikawa Miwako, Papaya Suzuki
Synopsis: A prince who has been cast out by his jealous father meets and falls in love with a tanuki princess while she is disguised as a human.
Description: Suzuki's final film is an abstract musical that draws from Japanese folklore, particularly as it was realized in a series of tanuki-themed musicals of the 1950s. It features multiple musical styles, from Kabuki to hip hop to Misora Hibari musicals (the late Misora appears in a digital projection in Suzuki's film as the spirit of the prince's mother). The theatrical connection is emphasized by the frequent use of proscenium-style staging, but Suzuki plays with space and perspective in ways that are purely cinematic, using abstract digital backgrounds and strange movements around them to enhance the film's sense of fantasy. *Princess Raccoon* features the most elaborate dance choreography in any Suzuki film and makes one wonder why he did not direct more musicals. At once a quaint throwback to an antiquated genre and an exciting, bold, and original formal experiment, *Princess Racoon* is fitting swan song to Suzuki's career. Listed as #12 in *Kinema junpō*'s "Best Films of 2005" list.

APPENDIX 2

UNFILMED PROJECTS

This is a list of projects that Suzuki was involved with that were never filmed. In some cases, synopses and even complete screenplays have been published in film journals or books, though they did not reach the production stage.

Fighting Elegy Continued (*Zoku-kenka erejī*)

Written: Circa 1968
Published: July 1, 1968 (*Eiga hyōron* 7: 106–40)
Screenwriters: Guryū Hachirō; mainly Sone Chūsei and Hangai Yasuaki[1]
Synopsis: Follows Kiroku from Suzuki's earlier *Fighting Elegy* to his entrance into the Japanese military, in which he takes part in the invasion of China. According to the screenplay, the sequel's opening scene begins with a solitary figure entering Waseda University's campus in winter and discovering a bulletin board detailing various school events and groups. The screenplay notes that it includes a picture of Kihira Tadayoshi, one of the infamous intellectuals of the Kyoto School who provided the ideological backbone of Japanese fascism in the early 1940s. Though Kihira never appears in the film, the opening directly recalls the closing of the earlier film, with the implied visual trajectory of the figure wandering on narrow, dark paths through the snow resembling the marching soldiers at the end of the first film. The image on the bulletin board with Kihira's face in place of Kita's demonstrates the social transformation of Japan in

the intervening years: Kita's seditious ideology is now Kihira's nationally endorsed one. The sequel continues to work out Kiroku's repressed sexuality as a function of his absorption into the fascist and imperialist project of early Shōwa Japan. Early in the screenplay, Kiroku tells Kaneda that he is still "pure," and when Kaneda takes it upon himself to make sure that Kiroku loses his virginity before entering the military by taking him to a brothel, Kiroku sheepishly sneaks away. Kiroku loses his virginity in a brothel in Hankou only when Ine-chan begins commanding him with military orders that function as sexual innuendos, suggesting that Kiroku's sexuality has been commandeered by militarism.

Red Lion of the Ghost Town (*Gōsuto-taun no akai shishi*)

Written: Circa 1966[2]
Published: July 1, 1968 (*Eiga hyōron* 7: 141–73)
Screenwriters: Guryū Hachirō; mainly Yamatoya Atsushi
Synopsis: A group of criminals on the run find themselves in an abandoned town where strange things begin happening after sundown: a mysterious villain, it is discovered, plans to use them as a sacrifice for a strange demonic ritual. Allegedly, the project originated because Suzuki wanted to film a scene with a large body of water dyed red (suggesting that the film would have been in color), and that the film branched out from there.[3] Though all the members of Guryū Hachirō pitched ideas, the screenplay was primarily written by Yamatoya, who drew inspiration from Sergio Leone's *A Fistfull of Dollars* and Ōe Kenzaburō's short story "Seinen no omei" (The young man's stigma) to create what has been described as a Spaghetti-Western-horror film.[4] The central set-piece would have been a massacre scene performed for the villain's ritual designed to create the image of the dyed-red body of water that Suzuki sought to create. The cast was to include Kobayashi Akira, Shishido Jō, Watanabe Misako, and Peter ("Pītā," the stage name of singer Ikehata Shinnosuke, who later appeared in Matsumoto Toshio's *Funeral Parade of Roses* and Kurosawa Akira's *Ran*).[5]

Untitled

Conceived: 1967
Published: Referenced in Yamatoya Atsushi, "Don Kihōte yo, eien ni: Suzuki Seijun mi-eigaka shinario o meguru danshō," in *Akuma ni yudaneyo* (Tokyo: Wides shuppan, 1994), 378–85.

Screenwriters: Unknown

Synopsis: Late in his Nikkatsu career, Yamatoya Atsushi writes that there was a Watari Tetsuya–Yoshinaga Sayuri romance vehicle that Suzuki was supposed to have directed. The loosely described plot was about an aging yakuza played by Ashida Shinsuke who decides to help Yoshinaga, a ballerina dancer, advance in her career, in hopes of making her his mistress. However, Yoshinaga's character meets Watari, a boxer also backed by Ashida's yakuza character, and the two fall in love, leading them into conflict with Ashida. The narrative seems quite similar to Inoue Umetsugu's *The Winner* from a decade earlier, starring Ishihara Yūjirō and Kitahara Mie, although rougher: the caretaker/would-be lover figure in the earlier film was a mere nightclub owner rather than a gangster, and this film was to end with a more violent confrontation. Nikkatsu had remade Inoue's *The Stormy Man* with Watari in the Ishihara role a year earlier. This project seems like it was meant, in the studio's eyes, to have been another (quasi-)remake of an Ishihara film, with Watari taking his place.

Branded to Kill Continued (*Zoku'koroshi no rakuin*)

Written: 1967

Published: (Synopsis only) *Style to Kill—Koroshi no rakuin VISUAL DIRECTORY* (Tokyo: Puchi Gura Paburisshingu, 2001), B27–B32

Screenwriters: Guryū Hachirō

Synopsis: This loose sequel to *Branded to Kill* would have followed a new protagonist, Noda, a skilled contract killer that has not been ranked by the mysterious "guild" of the first film but wants to be. He believes that he gets an opportunity when a woman named Ruiko asks him to kill her husband (himself a formerly ranked, now disgraced, killer), but Noda discovers an uncanny resemblance between his own killing methods and those of the man he is supposed to kill: the bodies of the victims of both killers have an eerie grin on their faces. The film was to have ended with a strange shootout against a computer on an abandoned island. Yamatoya has written that their intention was to "crank up" the weirdness of *Branded to Kill* and give meaning to the word *rakuin* ("brand" or "mark") in the title, with the strange grin on the victim's faces acting as Noda's mark or band. The project was begun before the release of the first *Branded to Kill* but was given up before a screenplay was completed after the first film was poorly received in a test screening. Shishido Jō was intended for the role of Noda.[6] The practice of having

quasi-sequels without direct continuity between films was common at Nikkatsu at the time.

Assassination Counting-Song (*Hitokiri kazoeuta*)

Written: 1968[7]
Published: 1970 (synopsis only), *Fighting Elegy* (*Kenka erejī*) (Tōkyō: Nihon Tōsho sentā, 2003), 157–77
Screenwriters: Guryū Hachirō
Synopsis: The stated intention was to create a "wandering gambler" film in the vein of to Katō Tai's *Long-Sought Mother* (*Mabuta no haha*, 1962) with a protagonist named Shinjirō, who sings a new fragment of a song every time he kills someone new. There was even hope of creating a "*hitokiri*" series following Shinjirō.[8] No full screenplay was written, as the project was abandoned in the wake of the Suzuki Seijun Incident; this was the last project that Suzuki worked on at Nikkatsu before his firing.[9]

Forging the Swords (*Chūken*)

Written: 1969
Published: 1970, in Suzuki Seijun, *Fighting Elegy*, 179–287
Screenwriters: Tanaka Yōzō, Yamatoya Atsushi, Ōhara Kiyohide, Suzuki Kōichi, Sone Chūsei, Suzuki Seijun; based on a story by Lu Xun
Synopsis: An adaptation of Chinese author and essayist Lu Xun's story "Forging the Swords" from his *Old Tales Retold*. The original Chinese story tells the story of a debauched king in Zhou dynasty China who asks a swordsmith to make a master sword; the latter makes the sword, but his wife hides it and gives the king a fake, thinking that such a powerful weapon should not be in the hands of a bad ruler. The king finds out and kills the swordsmith, but the swordsmith's wife and son escape with the help of a soldier. Many years later, the swordsmith's son seeks revenge against the king with the soldier's help. Lu Xun's version is an irreverent adaptation and adds some fanciful details, including a talking mouse and a swordfight with three dismembered heads. While it is not difficult to see why Yamatoya, Tanaka, and the others thought the material would be ideally suited to Suzuki, one wonders how some of the imagery would have been realized had it been filmed. According to Sone, they hoped to cast Takakura Ken in the lead role and to film on location in Afghanistan.[10] This was written *after* Suzuki's firing; Suzuki and his collaborators

may or may not have had a specific figure in mind as a model for the corrupt king who unjustifiably kills his skilled craftsman.

Wolf of Hell (Ōdo no ōkami)

Written: 1971
Published: Unknown (a copy of the screenplay exists at Tsubouchi Memorial Library, publication date unlisted)
Screenwriters: Yamatoya Atsushi, Tanaka Yōzō, Sone Chūsei; based on a novel by Itō Keiichi (1965)
Synopsis: Set during Japan's invasion of mainland China, the film was written as a tragic romance about a Japanese man and Chinese woman who fall in love on the night of the Manchuria Incident and are immediately separated. They meet again four years later, when he has become a Japanese soldier and she has become a spy for China's Eighth Route Army. Though a less fanciful project than most of the planned works by the members of Guryū Hachirō, the project does resemble Suzuki's *Story of a Prostitute* as well as the unfilmed sequel to *Fighting Elegy*. Suzuki and the screenwriters hoped to cast Asaoka Ruriko in the role of the female spy and Takahashi Hideki in the role of the soldier.[11]

Hall of Dreams (Yumedono)

Written: 1972
Published: 1977, *Eiga geijutsu* (October): 45–60
Screenwriters: Yamatoya Atsushi, Tanaka Yōzō, Maeda Katsuhirō
Synopsis: A romantic fantasy set in the Asuka period (538–710 CE). The film's narrative includes several real historical figures in major and minor roles, including Prince Yamashiro, Soga no iruka, Nakatomi no Kamatari, and the ghost of Prince Shōtoku. The "Hall of Dreams" referenced in the title is an actual building at Horyū-ji Temple in Nara (then the capital) that was constructed around the time the film was to be set. The film begins with a vagabond named Jirō who encounters a strange old man in the desert asking to be killed. The old man drops a necklace that looks like a shrine, and he tells Jirō that it is a replica of the Hall of Dreams (*Yumedono*), and that if he finds the hall, Jirō will find the most beautiful woman in the world. Jirō heads to the capital as it is in disarray because of a succession struggle between Prince Shōtoku's two sons (Prince Yamashiro and Soga no iruka) and religious tensions between Shintoism and Buddhism. Jirō gets caught in the political intrigue because of his physical resemblance to

Prince Shōtoku, and he falls in love with Prince Yamashiro's daughter, Princess Kaguya. The narrative becomes increasingly convoluted, with dream sequences and magic performed by Nakatami no Kamatari, but culminates in Jirō's journey to a mystical five-story pagoda with a magical, hidden top floor that appears to be a completely vacant, white space when Jirō enters but transforms, either through magic or illusion. The role of Jirō is thought to have been intended for Harada Yoshio.[12]

A Ballad Dedicated to Mother (*Haha ni sasageru barādo*)

Written: 1973–1976
Published: 1977 (description only), Yamatoya Atsushi, "Nagareta kikaku mo ikiteiru: Seijun to mita jūnen no yume," *Eiga geijūtsu*, no. 317 (June–July 1977): 35
Screenwriters: Sasaki Mamoru, Naitō Makoto
Synopsis: In the mid-1970s, Suzuki was in talks to direct a film for Tōei named after the 1973 hit song by Kaientai. The film's two screenwriters had not worked with Suzuki before, but Naitō was a genre director and screenwriter at Tōei, while Sasaki was an accomplished screenwriter who had worked regularly with Ōshima Nagisa. During the development process, Suzuki and the screenwriters played around with different potential mother-son ages and relationships before settling on a relationship between a former yakuza son and a mother who had been sold into the sex trade in the postwar era, with the son keeping his mother alive so that she could see the fireworks she remembered from her youth once again. A full screenplay was written for the project but has never been made available. The screenplay was reworked into *Daughter of Time* (*Toki no musume*, 1980), which was ultimately directed by Naitō, and which was the second film released by Cinema Placet after *Zigeunerweisen*. Suzuki was given a credit for the original concept of the finished film, and it resembles the outline reported by Suzuki and Yamatoya in some details,[13] but without the original screenplay available it is difficult to say how much changed in the intervening years. However, the song from which the project originated is absent from the finished film.

Tahrir Al-Suez (*Tahariru aru-suez*)

Written: 1976[14]
Published: Unknown (a copy of the screenplay exists at Tsubouchi Memorial Library, publication date unlisted)

Screenwriters: Yamatoya Atsushi, Tanaka Yōzō
Concept by Yoshimura Sakuji
Synopsis: Set during the fourth Arab-Israeli War (a.k.a. the Yom Kippur War), the narrative follows Kaitō Takeshi, a Japanese tourist visiting dance halls and ancient sites in Egypt when the war breaks out. He becomes infatuated with a young dancer named Rosa and learns that she is a member of the PLO. To get closer to Rosa, Takeshi pretends to be a Japanese man known only by the alias "Mustapha," a legendary member of the PFLP who had formerly been a member of the Japanese Red Army.[15] Yoshimura Sakuji, who is credited with the concept, is a prominent Japanese Egyptologist, currently director of the Institute of Egyptology at Waseda University. "Mustapha" may be modeled after Adachi Masao, who was also a onetime member of the Japanese Red Army who joined the PFLP; Adachi had documented this with Wakamatsu Kōji in their earlier film *Red Army/PFLP: Declaration of World War* (*Sekigun--P.F.L.P: Sekai sensō sengen*, 1971).

Star Woman (*Hoshijorō*)

Written: 1976
Published: 1994, in Takahashi Hiroshi, Shiota Akihiko, and Ikawa Kōichirō, eds., *Kōya no dacchi waifu: Yamatoya Atsushi dainamaito kessakusen* (Tokyo: Firumu Ātosha, 1994), 325–61
Screenwriter: Yamatoya Atsushi; based on the ghost story by Izumi Kyōka (1908)
Synopsis: A group of students see a strange woman floating in the stars one night on the road. This was the first project pitched when Shōchiku hired Suzuki to direct a feature film in the late 1970s after his ten-year absence from filmmaking. The studio passed on the project as it was apparently not what it had in mind when it asked for a Suzuki film. Following this, Yamatoya wrote *A Tale of Sorrow and Sadness*, which became the project that Suzuki filmed for Shōchiku in place of *Star Woman*.[16]

The Typhoon's Festering Madness (*Gufū kyōran*)

Written: 2001
Published: 2006, in Isoda Tsutomu and Todoroki Yukio, eds., *Sei/jun/ei/ga* (Tokyo: Wides Shuppan, 2006), 438–93
Screenwriter: Ōhara Kiyohide

Synopsis: Set in the twelfth year of the Taishō era (1923), the story follows a group of anarchists from the Guillotine Society in the aftermath of the Great Kantō Earthquake. Two of their members are assigned to assassinate an important political figure, but they discover that someone has beaten them to the job, and they set out to solve the mystery of who killed their target first. The screenplay incorporates several musical numbers, which were meant to have been performed in the style of Asakusa Opera (a Taishō-era entertainment style era that combined elements of musical theater, opera, and vaudeville). Ōhara wrote it at Suzuki's request.[17]

Bitter Honey (Mitsu no aware)

Written: Circa 2006[18]

Published: 2018, in Honda Akiko and Yahata Kaoru, eds., *Sonna koto wa mō wasureta yo: Suzuki Seijun Kanwashū* (Tokyo: Space Shower, 2018), 186–201

Screenwriter: Suzuki Seijun; based on the novel by Murō Saisei

Synopsis: An aging writer with ambitions of greatness grooms a young woman to be his new muse and lover, but the ghost of one of his former lover/muses begins to haunt the young woman, wreaking havoc on his plans. Suzuki wrote the screenplay shortly after the opening of *Princess Raccoon* but gave up the project before filming due to poor health.[19] It is difficult not to read an autobiographical element into this project: he had just married his second wife Takako, an actress, in 2004, after his first wife of forty-seven years had died in 1997.[20] Ishii Sogo directed an adaptation of the same novel in 2014, which was unrelated to Suzuki's screenplay.

APPENDIX 3

GURYŪ HACHIRŌ EXTENDED FILMOGRAPHY

As seen in the filmography in appendix 1, most of Suzuki's significant film and television work post-Nikkatsu involved other members of Guryū Hachirō. Listed below are additional films in which two or more members of Guryū Hachirō collaborated. This list is based on a film series titled *Guryū Hachirō no sekai* (The world of Guryū Hachirō), held at the Kawasaki City Film Museum Cinematheque in 2000, curated by Suzuki Seijun, Kimura Takeo, Okada Yutaka, and Ueno Kōshi; I have excluded the films already listed in Suzuki's filmography and supplemented the list with additional films with contributions from multiple Guryū Hachirō members.

Resume of Love Affairs (*Jōji no rirekisho*, 1965)

Director: Wakamatsu Kōji
Screenwriters: Ōtani Yoshiaki (Yamatoya Atsushi, Sone Chūsei, Hangai Yasuaki, and Yamaguchi Seiichirō), Wakamatsu Kōji

Season of Treachery (*Uragiri no kisetsu*, 1966)

Director: Yamatoya Atsushi
Assistant director: Tanaka Yōzō
Screenwriters: Ōtani Yoshiaki (Yamatoya Atsushi and Tanaka Yōzō)

Song Rambling on a Busy Street: Shinjuku Woman

Director: Takeda Kazunari
Assistant director: Okada Yutaka
Screenwriters: Yamamura Eiji, Kurusu Saburō (Tanaka Yōzō, Hangai Yasuaki, and Okada Yutaka)

Neon Police Officer: Jack's Tattoo (*Neon keisatsu: Jakku no irezumi*, 1970)

Director: Takeda Kazunari
Screenwriters: Yamatoya Atsushi, Sone Chūsei

Juvenile Delinquent: A Young Man's Stronghold (*Hikōshōnen: wakasha no toride*, 1970)

Director: Fujita Toshiya
Screenwriters: Kuru Saburō (Okada Yutaka, Tanaka Yōzō, and Hangai Yasuaki), Fujita Toshiya

Foreigner's Mistress Oman: The Equinox Flowers Scatter (*Rashamen Oman: Higanbana wa chitta*, 1972)

Director: Sone Chūsei
Screenwriter: Yamatoya Atsushi
Producer: Okada Yutaka

The Scent of Eros in August (*Hachigatsu wa Erosu no nioi*, 1972)

Director: Fujita Toshiya
Screenwriters: Fujita Toshiya, Yamatoya Atsushi
Producer: Okada Yutaka

Naked Rashomon (*Shōwa onnamichi: rashōmon*, 1973)

Director: Sone Chūsei
Screenwriter: Yamatoya Atsushi

Producer: Okada Yūtaka

Trapped in Lust (*Aiyoku no wana*, 1973)

Director: Yamatoya Atsushi
Screenwriter: Tanaka Yōzō
Producer: Arata Genjirō
A quasi-remake of *Branded to Kill*

A Sigh (*Tameiki*, 1973)

Director: Sone Chūsei
Screenwriter: Tanaka Yōzō

The True Story of Shirakawa Kazuko: Naked Personal History (*Jitsuroku Shirakawa Kazuko: Hadaka no rirekisho*, 1973)

Director: Sone Chūsei
Screenwriter: Tanaka Yōzō

Adult Toy: Sex-Doll Report (*Otona no omocha: Dacchi-waifu no repōto*, 1975)

Director: Sone Chūsei
Screenwriter: Yamatoya Atsushi

Flower Cheerleading Squad (*Aa! Hana no ōendan*, 1976)

Director: Sone Chūsei
Screenwriter: Tanaka Yōzō

Unrelated Murder Cases (*Furenzoku satsujin jiken*, 1977)

Director: Sone Chūsei
Screenwriters: Yamatoya Atsushi, Tanaka Yōzō, Sone Chūsei, Arai Haruhiko

Dogura magura (1988)

Director: Matsumoto Toshio
Art directors: Kimura Takeo, Saitō Iwao
Screenwriters: Matsumoto Toshio, Yamatoya Atsushi

Matoqin Nocturne (Batōkin yasōkyoku, 2007)

Screenwriter and director: Kimura Takeo
Cast: Yamaguchi Sayoko, Suzuki Seijun

APPENDIX 4

SUZUKI SEIJUN AS ASSISTANT DIRECTOR

At Shōchiku Ofuna Studio

Traces of Rouge (*Beni imada kiezu*, Shibuya Minoru, 1949)
Shimizu Kin'ichi's Travels as an Irregular Ninja (*Shimikin no ninjutsu ōtotsu dōchū*, Iwasawa Tsunenori, 1949)
The Dancing Palace of the Dragon King (*Odoru ryūjūgō*, Sasaki Yasushi, 1949)
A Passionate Girl Derailed (*Dassen jōnetsu musume*, Ōba Hideo, 1949)
Spring Tide: Part One (*Haru no ushio: Zenpen*, Nakamura Noboru, 1950)
Spring Tide: Part Two (*Haru no ushio: Kōhen*, Nakamura Noboru, 1950)
The Appearance of a Flower (*Hana no omokage*, Ieki Miyoji, 1950)
Passionate Rhumba (*Jōnetsu no rumuba*, Sasaki Yasushi, 1950)
A Man's Sorrows (*Otoko no aishū*, Iwama Tsuruo, 1951)
Motherly Lovesickness (*Bokoigusa*, Iwama Tsuruo, 1951)
South Wind (*Nanfū*, Iwama Tsuruo, 1951)
Vow of Youth (*Wakōdo no chikai*, Iwama Tsuruo 1952)
Enka Master of Izu (*Izu no enkashi*, Nishikawa Katsumi, 1952)
Don't Kill Him (*Kare o korosuna*, Iwama Tsuruo, 1952)
The Young Wife's Greatest Victory (*Waka okusama ichiban shōri*, Mizuho Shunkai, 1952)
Siblings (*Kyōdai*, Iwama Tsuruo, 1953)
Beauty and Sin (*Bibō to tsumi*, Iwama Tsuruo, 1953)
Okinawa Band of Youths (*Okinawa Kenji-tai*, Iwama Tsuruo, 1953)

At Nikkatsu Studio

Chuji Kunisada (*Kunisada Chūji*, Takizawa Eisuke, 1954)
Black Tide (*Kuroi shio*, Yamamura Sō, 1954)
Trifoliate Orange Flower (*Karatachi no hana*, Saeki Kiyoshi, 1954)
My Pistol Is Quick (*Ore no kenjū wa subbayai*, Noguchi Hiroshi, 1954)
Baby-Faced Reporter (*Bottchan kasha*, Noguchi Hiroshi, 1955)
The Final Duel (*Rakujitsu no kettō*, Noguchi Hiroshi, 1955); also screenwriter
Kiss of Hell (*Jigoku no seppun*, Noguchi Hiroshi, 1955)
Ōka Politics (Chapter One): The Skin of a Bat (*Ōka seidan daiichiwa: Hitohada kōmori*, Noguchi Hiroshi, 1955)
Passion and Rifle Bullets (*Aiyoku to jūdan*, Noguchi Hiroshi, 1955); also screenwriter
Reward for Evil (*Aku no hōshū*, Noguchi Hiroshi, 1956)
I'm Not a Criminal (*Ore wa hannin ja nai*, Noguchi Hiroshi, 1956)

APPENDIX 5

COMMERCIALS DIRECTED BY SUZUKI SEIJUN

Renown Piccolo (Diapers)—"The Chair and the Baby" ("Isu to akachan"), 1969

Renown Johnbull (Clothing)—"Duel" ("Kettou"), 1969 (assistant director: Sone Chūsei)

Seiko (Watches)—"Red Lace" ("Akai himo"), 1969

Sapporo Beer—"Summer Gift" ("Ochūgen"), 1971 (featuring Mifune Toshirō)

Sapporo Beer—"Salamander" ("Saramandā"), 1971 (featuring Mifune Toshirō)

Sapporo Beer—"Ranch" ("Bokushō"), 1971 (featuring Mifune Toshirō)

Yamaichi Securities—"Untitled," 1972 (featuring Kino Hiroko)

Maruichi Jitensha (Bicycles)—"Big Fight" ("Daikakutou"), 1972

Yamasa Furēbu—"Untitled," 1972

Mitsubishi Caterpillar—"Untitled," 1972

Shōchikubai (Sake)—"Untitled," 1972 (featuring Ishihara Yūjirō)

Kikkoman—"Year-End Gift" ("Oseibo"), 1972 (featuring Nishina Akiko and Hara Kensaku)

Kirin Beer—"Untitled," 1972 (featuring Sano Asao)

Nomura Securities—"Untitled," 1975 (featuring Mizusawa Aki and Tamagawa Isao)

Kirin Stout—"Untitled," 1977 (featuring Takahashi Etsushi and Izawa Ichirō)

Kirin Light—"Untitled," 1980 (featuring Matsuda Yūsaku, Harada Yoshio, and Uzaki Ryūdō)
Shiseidō Men's Cosmetics—"Untitled," 1980 (featuring the Meikyūkai)
Yamazaki Biscuits—"Untitled," 1985 (featuring Kitaōji Kinya)
Ichikoshi—"Untitled," 1991

APPENDIX 6

BOOKS WRITTEN BY SUZUKI SEIJUN

Fighting Elegy (Kenka erejī)—1970
Flower Hell (Hana jigoku)—1972
Leaving the Town in Search of Violence (Bōryoku sagashi ni machi e deru)—1973
Dreams and Medicine Man (Yume to kitōshi)—1974
Lonely Contemplation (Koshū)—1980
City Planning (Machizukushi)—1982
A Cineaste Speaks, Volume One: Suzuki Seijun—1990
The Life View of a Toppled-Over Hermit (Sukkorobi sennin no jinseiron)—1995
Sei/jun/ei/ga—2006
Suzuki Seijun Essay Collection (Suzuki Seijun essei korekushon)—2010, edited by Yomota Inuhiko, who also wrote the afterword
"I've Already Forgotten About That": A Collection of Conversations with Suzuki Seijun (Sonna koto wa mō wasureta yo: Suzuki Seijun Kanwashū)—2018

NOTES

Introduction

1. Karatani Kōjin, *Origins of Modern Japanese Literature*, trans. Brett de Bary (Durham, N.C.: Duke University Press, 1993), 137.
2. This was a frequent claim of "apparatus theory" in the 1970s, perhaps most succinctly articulated by Jean-Louis Baudry: "Fabricated on the model of the *camera obscura*, it [the camera lens] permits the construction of an image analogous to the perspective projections developed during the Italian renaissance." (Baudry, "Ideological Effects of the Basic Cinematographic Apparatus," trans. Alan Williams, *Film Quarterly* 28, no. 2 [Winter 1974–1975]: 41.) Jean-Louis Comolli had previously made the claim in the essays "Machines of the Visible" and "Technique, and Ideology: Camera, Perspective, Depth of Field" (1971), and many others echoed it afterward. More recently, Thomas Lamarre has discussed this as the basis of the term *cinematism*, which he borrows and develops from Paul Virilio in *The Anime Machine*. See Comolli, "Machines of the Visible," in *The Cinematic Apparatus*, ed. Teresa de Lauretis and Stephen Heath (London: Macmillan, 1980), 121–42; Comolli, "Technique and Ideology: Camera, Perspective, Depth of Field," in *Cahiers du Cinéma*, vol. 3: *1969–1972 The Politics of Representation*, ed. Nick Browne (New York: Routledge, 1996), 213–47; Thomas Lamarre, *The Anime Machine* (Minneapolis: University of Minnesota Press, 2009), 4–5; and Paul Virilio and Sylvere Lotringer, *Pure War: Twenty-Five Years Later*, trans. Mark Polizzotti (Cambridge, Mass.: MIT Press, 2008), 97.
3. A compilation of their debates was published in Karatani Kōjin and Hasumi Shigehiko, *Karatani Kōjin Hasumi Shigehiko zentaiwa* (Tokyo: Kōdansha, 2013).
4. Hasumi Shigehiko, "Suzuki Seijun: soshite sono chinmoku no naritachi," *Shinema 69* 2 (1969): 49–57. See the section "*Yajū no seishun*, mata wa fukusa no nai fukusa" [*Youth of the Beast*, or depths without depth], 50–53.

5. Hasumi Shigehiko, "Suzuki Seijun, mata wa kisetsu no fuzai," *Yurīka* 4 (1991): 54.
6. Many scholars of Japanese cinema tend to overlook the circulation of Japanese films in other parts of Asia and somewhat carelessly write that certain films or filmmakers were only seen or known in Japan until they were seen at film festivals in Europe or North America, as when Kurosawa Akira's *Rashomon* is called the film that first made Japanese cinema recognized outside Japan, when in fact Japanese films had been circulating and influential in other parts of Asia (including but not limited to places that Japan had colonized) for decades. In this specific case, Nikkatsu's popular films circulated in Hong Kong throughout the 1960s, with some former Nikkatsu filmmakers, like Inoue Umetsugu and Nakahira Kō, even working in the Hong Kong film industry for a time. Though Suzuki did not himself work in Hong Kong, his films played there. For more on this subject, see Yomota Inuhiko, *Ajia no naka no Nihon eiga* (Tokyo: Iwanami Shōten, 2001), particularly the section "Hon kon eiga to Nikkatsu" [Hong Kong cinema and Nikkatsu], 29–40.
7. DVD interview with Suzuki Seijun (New York: Criterion Collection, 2011).
8. For a more detailed discussion of Suzuki's contributions to *Lupin III*, see the entries on the series and film in appendix 1.
9. As of this writing, Aaron Gerow, Abé Mark Nornes, and Iwamoto Kenji have just published an edited volume of prewar Japanese film theory in Japanese: Gerow, Iwamoto, and Nornes, eds., *Nihon senzen eiga ronshū: Eiga riron no saihakken* (Tokyo: Yumani Shobō, 2018). A second volume, covering postwar Japanese film theory, and English translations are reportedly in the works.
10. See Ōshima Nagisa, *Cinema, Censorship, and the State*, trans. Dawn Lawson (Cambridge, Mass.: MIT Press, 1993); Yoshida Kijū, "My Theory of Film: The Logic of Self-Negation," trans. Patrick Noonan, *Review of Japanese Culture and Society* 22 (December 2010): 104–9; and Matsumoto Toshio, "A Theory of Avant-Garde Documentary," trans. Michael Raine, *Cinema Journal* 51, no. 4 (Summer 2012): 144–54.
11. See Christian Keathley, *Cinephilia and History, or the Wind in the Trees* (Bloomington: Indiana University Press, 2005); and Rashna Wadia Richards, *Cinematic Flashes: Cinephilia and Classical Hollywood* (Bloomington: Indiana University Press, 2013).
12. See Girish Shambu, "For a New Cinephilia," *Film Quarterly* 72, no. 3 (Spring 2019): 32–34.
13. Alex Zahlten, *The End of Japanese Cinema: Industrial Genres, National Times, & Media Ecologies* (Durham, N.C.: Duke University Press, 2017).
14. Ueno Kōshi, "Furidashi ni modoru kantoku" [A director returns to the drawing board], in *Suzuki Seijun zen'eiga* (Tokyo: Rippū Shobō, 1986), 8.

1. 1968 and the Suzuki Seijun Incident

1. In an interview with Ueno Koshi, Suzuki explained his entrance into Shōchiku in the following way: "I had failed the entrance exam of the University of Tokyo so I was toying with the idea of enrolling in another preparatory year. A high school friend had also failed the entrance exam, and we had a lot of fun together but we didn't get very much done. So when we learned that the Kamakura academy was starting a film course that year, we decided to have a look. . . . There were also some directors from Shōchiku's Ofuna studio. . . . The most important was probably the director Toyoda Shiro. And then there was the scriptwriter Noda Kogo [co-scriptwriter on a great number of Ozu films]." Ueno Koshi, "Mr. Seijun Is Not Like That," in *Suzuki Seijun: The Desert Under*

the Cherry Blossoms, Rotterdam International Film Festival, trans. Rogier Busser, Patricia van Vugt, and Frank van Herk (Rotterdam: Film Festival Rotterdam, NFM/IAF, VPRO, Uitgeverij Uniepers Abcoude, 1991), 67.
2. Nikkatsu, formed in 1912, was Japan's oldest film studio, but it had closed in 1941 when the government attempted to consolidate film production during the war. Joseph L. Anderson and Donald Richie, *The Japanese Film: Art and Industry* (New York: Grove Press, 1960), 142.
3. See appendix 1 for a complete filmography of the films that Suzuki wrote and directed, with transliterated Japanese titles, plot descriptions, release dates, major cast and crews, and the films they were screened with in their original release.
4. Tayama Rikiya, "Fumihazushita haru," *Eiga hyōron* 15, no. 8 (August 1958): 100–101.
5. See, for example, Hasumi Shigehiko, "Suzuki Seijun soshite sono chinmoku no naritachi," *Shinema 69* 2 (1969): 49–57. This is also often repeated in English-language fan literature on Suzuki, such as Tony Rayns and Simon Field, *Branded to Thrill: The Delirious Cinema of Suzuki Seijun* (London: British Film Institute, 1995).
6. Suzuki Seijun, "Seijun on Seijun," in Rayns and Field, *Branded to Thrill*, 25.
7. David Desser discusses the decline in theater attendance, which he attributes to television, in *Eros Plus Massacre*: "Despite the turn to wide-screen productions, the motion picture audience began to drop off in numbers in the late '50s; the increasing encroachment of television was the major factor in this decline. In 1960, television had begun to make its presence felt in a significant manner; by 1965, it had penetrated approximately 60 percent of all Japanese homes; by 1970, 95 percent of all Japanese homes had television. Attendance at movies peaked in 1958 at 1.127 billion; in 1960, the figure was down to a still massive 1.014 billion. By 1963, however, attendance had been cut almost in half to 511 million; in 1965, it dropped off to 373 million, and by 1970, the depressing statistic was a mere 253 million moviegoers per year. . . . As attendance fell and theaters closed, film production declined from 547 films in 1960 to 423 films in 1970; by 1978, this number stabilized at 340, the bulk of which were 'pink movies, *romanporuno*, and other marginal sex exploitation pictures.'" David Desser, *Eros Plus Massacre* (Bloomington: Indiana University Press, 1988), 8–9.
8. The others were Shōchiku, Daiei, Tōei, Tōhō, and Shin-Tōhō. Why a group of six studios is referred to as the "five-studio system" remains a mystery.
9. One of the main initiators of the Art Theater Guild, and its primary backer, was Toho, which was one of the major studios. Roland Domenig, "The Anticipation of Freedom: Art Theater Guild and Japanese Independent Cinema," *Midnight Eye*, June 28, 2004, http://www.midnighteye.com/features/the-anticipation-of-freedom-art-theatre-guild-and-japanese-independent-cinema/.
10. Ryan Cook attributes the lack of scholarly attention to Cine-Clubs to "the difficulty of obtaining documents, which in many cases seem to have disappeared with the groups themselves." (Ryan Cook, "Through the Looking Glass: Flirtations with Nonsense in 1960s Japanese Film Culture," Ph.D. diss., 2013, ProQuest Dissertation Publishing, UMI 3572013, 34.) The main exception, which Cook studies in detail, is the Suginami Cine-Club; unfortunately Suginami was not founded until 1967, which is after Suzuki had already developed a following among some independent filmmakers and college-age cinephiles.
11. Suzuki Seijun, Kimura Takeo, Ishigami Mitsutoshi, and Satō Shigechika, "Zadankai: Jumon ni miirarete: Suzuki Seijun no reihō," in *Sōtokushū Suzuki Seijun*, ed. Motomura Shūji (Tokyo: Kawade, 2001), 151.

12. Interview: Mori Takuya and Ishigami Mitsutoshi, "Puroguramu pikucha ga atta! Seijun fan ga ita!!," in Motomura Shūji, *Sōtokushū Suzuki Seijun*, 103. Ishigami's original *OFF* pamphlet, featuring his own essay under the name Imamura Shō, as well as short writings by both Suzuki Seijun and Kimura Takeo, is also reprinted in *Sōtokushū Suzuki Seijun*, 114–19. Ishigami would later be instrumental in helping Suzuki transition to commercial work in the late 1960s, as well as a collaborator with Ōbayashi Nobuhiko.
13. Matsuda Masao, "'Seijun kyōtai' o megutte," in Motomura Shūji, *Sōtokushū Suzuki Seijun*, ed. 62–63. Matsuda was a leftist critic and activist who would be instrumental in founding the Suzuki Seijun Joint Struggle Committee. Yuriko Furuhata writes extensively about Matsuda's contributions to politically inflected film criticism and theory in the 1960s; see Yuriko Furuhata, *Cinema of Actuality: Japanese Avant-garde Filmmaking in the Season of Image Politics* (Durham, N.C.: Duke University Press, 2013).
14. Adachi Masao, *Eiga/kakumei* (Tokyo: Kawade shobō, 2003), 240, 168.
15. Kajiwara Ryūji, "Suzuki Seijun no bi," *Eiga hyōron* 21, no. 7 (July 1964): 69–71. In the essay Kajiwara claims to have only seen *Youth of the Beast*, *Kanto Wanderer*, and *The Flowers and the Angry Waves*. Though the essay was published a month after the release of *Gate of Flesh*, it was likely written before the film's release.
16. Kazuki Ryōsuke, "Suzuki Seijun yo, ongaku ni motto aijō o: Sono bi no sekai o kansei suru tame ni," *Eiga hyōron* 21, no. 11 (November 1964): 85. Ōbayashi's review is not entirely complimentary—he is quite critical of the film's score and suggests that a lack of musical interest is holding back the power of Suzuki's images. At this time, Ōbayashi was an independent 8mm and 16mm filmmaker and a cosignatory of the "Film Andependan [Independents] Manifesto," stating that "independent films have so far been subordinate to industrial filmmaking, where commercial and political ideologies have burdened their shoulders day and night. . . . Cinema must disassociate itself from such commercial and political strategies in order to obtain the true meaning of freedom." (Takahiko Iimura, Koichiro Ishizaki, Nobuhiko Obayashi, Jyushin Sato, and Donald Richie, "Film Andependan [Independents] Manifesto," trans. Julian Ross, in *Film Manifestos and Global Cinema Cultures: A Critical Anthology*, ed. Scott MacKenzie [Berkeley: University of California Press, 2014], 71). In an interview, Ōbayashi confirms he wrote the article under the Kazuki Ryōsuke pen name. Ōbayashi Nobuhiko and Ishigami Mitsutoshi, "Tosshutsu firumu no motsu seimeikan ga, soko ni wa atta: Nikkatsu eiga no naka no Seijun eiga," in Motomura Shūji, *Sōtokushū Suzuki Seijun*, 171).
17. Shirai Yoshio and Iijima Tetsuo, "Suzuki Seijun/Katō Tai: Nihon eiga ranse no itanji," *Kinema junpō* 440 (June 1967): 40, 43, 46, 49. The authors describe a specific discussion panel event with Katō Tai and quote him regarding the tension between cine-club members, but they imply that this is similar to the questions and answers given at other discussion panel events between cine-clubs and these two filmmakers.
18. Kimura Takeo, "Guryū Hachirō ni tsui te," *Mita bungaku* No. 3 79 (61): 92.
19. Sone Chūsei, *Sone Chūsei Jiden: Hito wa nanomi no tsumi no fukasa yo* (Tokyo: Bunyūsha, 2014), 92.
20. Jasper Sharp, *Historical Dictionary of Japanese Cinema* (Lanham, Md.: Scarecrow Press, 2011), 127, 126.
21. Kawarabata Yasushi, "Shiki: Suzuki Seijun mondai no ichi saikuru," in *Genzo to seiji no aida*, vol. 5 of *Gendai Nihon eigaron taikei*, ed. Ogawa Tōru et al. (Tokyo: Tōjusha, 1971), 463.

22. Suzuki explains his relationship with Emori thus: "I suspect that the reason I wasn't given the pink slip had something to do with the following. Emori Seijirō, the managing director, had ssured the head of the studio and other people at the top that I was talented. Emori was my most devoted fan, and after *Nikutai no mon* (1964) was finished, he was the first to approach me and express his unqualified admiration. . . . Emori preceded me in being fired by Nikkatsu. That meant I had lost my guardian angel." Suzuki Seijun, "The Days of *Kantō Mushuku*," in Rotterdam International Film Festival, *Suzuki Seijun: The Desert Under the Cherry Blossoms*, 34–35.
23. Quoted in Kawarabata, "Shiki,"465.
24. Kawarabata, 465, 466.
25. Quoted in Ueno Kōshi, "Suzuki Seijun tatakau: Nikkatsu kaiko•sakuhin fusaken o furikaeru," in *Suzuki Seijun zen'eiga* (Tokyo: Rippū Shobō, 1986), 217.
26. Ueno, 221.
27. Cook, "Through the Looking Glass," 45
28. Notably, Ōshima broke with Shōchiku after the latter pulled his film *Night and Fog in Japan* (*Nihon no yoru to kiri*, 1960) from theaters after four days, and Yoshida Kijū broke with the same studio after it reedited his film *Escape from Japan* (*Nihon dasshutsu*, 1964) without his consent. Apparently one of the reasons for pulling *Night and Fog* given by Shōchiku to Ōshima (by his own account) was that "no one understands it" (Ōshima Nagisa, "In Protest Against the Massacre of *Night and Fog in Japan*," in *Cinema, Censorship, and the State: The Writings of Nagisa Oshima*, trans. Dawn Larson [Cambridge, Mass.: MIT Press, 1992], 56), which Hori's claim that Suzuki made "incomprehensible" films would echo. Allegedly, Hori had even made this comparison himself, declaring that "these incomprehensible Ōshima-Nagisa-like-films are a problem." Quoted in Kawarabata Yasushi, "Suzuki Seijun jiken repōto: Sakka ni osareta 'Koroshi no rakuin,'" *Eiga hyōron* 25, no. 7 (July 1967): 19. Kawarabata notes that Hori said this *prior* to firing Suzuki and was referring not only to Suzuki's films but to several by directors Kurahara Koreyoshi and Nakahira Kō as well.
29. Quoted in Ueno, "Suzuki Seijun tatakau," 218.
30. Kawarabata, "Shiki," 468, 469.
31. Kawarabata, 469.
32. Within English-language scholarship, Matsuda is perhaps best known as a proponent of what Yuriko Furuhata calls "landscape theory" (*fukeiron*). See Furuhata, *Cinema of Actuality*, 134–36.
33. Kawarabata, "Shiki," 469.
34. Quoted in Ueno, "Suzuki Seijun tatakau," 222–23.
35. "Japanese cinema as it is is failing to answer the young people who appreciate cinema. This trend has progressed rapidly over the last few years, and it is not possible for young people who appreciate movies to enter Japanese cinema at all. The young people who have not lost the will to make movies have decided to do so from outside the industry by their own means. . . . However, I am not trying to say that young people empathize with or have sympathy with Suzuki Seijun. They have taken up this movement as an opportunity to show their ambitions about movies." Ōshima Nagisa, quoted in Kawarabata, "Shiki," 470.
36. Matsumoto Toshio, "Ōshima Nagisa, Kimi wa machigatteiru," in *Eiga no henkaku: Geijutsuteki rajikarizumu to wa nani ka* (Tokyo: San'ichi shobō, 1972), 37. Originally published in *Eiga hyōron* 25, no. 10 (October 1968).
37. Quoted in Watano Tetsuro, "Suzuki Seijun mondai to wa nani ka," *Shinema 69* 2 (1969): 74.

38. Matsuda Masao, "Higōri no dokyumentarisuto: Suzuki Seijun, sakka to sakuhin," in *Bara to mumeisha: Matsuda Masao eiga ronshū* (Tokyo: Haga shoten, 1970), 137–39.
39. Hasumi Shigehiko, "Suzuki Seijun, mata wa kisetsu no fuzai," *Yurīka* (April 1991): 50, 51. Hasumi's analysis here overlooks the fact that Suzuki himself was one of the eight members of Guryū Hachirō.
40. Hasumi, "Suzuki Seijun, mata wa kisetsu no fuzai," 50.
41. When Ueno Kōshi once asked about his use of color in *The Wind-of-Youth Group Crosses the Mountain Pass*, Suzuki responded that "we didn't plan everything in advance. We weren't as calculating as Kurosawa or Ozu." When Ueno presses him about his systematic use of color in *Gate of Flesh*, in which each of the main female characters is dressed in a single pastel color that corresponds to each of her props, as well as entrances into her subjectivity, he only answers, "I thought that was aesthetically the right thing." Ueno, "Mr. Seijun Is Not Like That," 69.
42. Suzuki Seijun, "Cinema, Film Directors, and Ōshima," in Rotterdam International Film Festival, *Suzuki Seijun: The Desert Under the Cherry Blossoms*, 47.
43. Suzuki, "Cinema, Film Directors, and Ōshima," 49.
44. Eric Hobsbawm, *Primitive Rebels* (Manchester, UK: University of Manchester Press, 1959), 2.
45. The moment is not in the screenplay, meaning it was likely improvised while filming. See Kasahara Ryōzō and Kon Tōkō, "Akutarō" [The Incorrigible], original screenplay (Tokyo: Nikkatsu, 1963).
46. Michihiro Matsunami, "Origins of *Zengakuren*," in *Zengakuren: Japan's Revolutionary Students*, ed. Stuart Dowsey (Berkeley, Calif.: Ishi Press, 2012), 48, 56.
47. Hisato Harada, "The Anti-*Anpo* Struggle," in Dowsey, *Zengakuren: Japan's Revolutionary Students*, 85.
48. Lawrence Olson, *Ambivalent Moderns* (Lanham, Md.: Rowman & Littlefield, 1992), 92.
49. See Yoshimoto Takaaki, "Tenkō-ron," *Showa bungaku zenshū*, no. 27 (February 1989): 642–54.
50. William Marotti, "Japan 1968: The Performance of Violence and the Theater of Protest," *American Historical Review* (February 2009): 98.
51. For a discussion of the source novel by Tamura Taijirō and the censorship thereof, see H. Eleanor Kerkham, "Pleading for the Body: Tamura Taijirō's 1947 Korean Comfort Woman Story, Biography of a Prostitute," in *War, Occupation, and Creativity: Japan and East Asia, 1920–1960*, ed. Marlene J. Mayo and J. Thomas Rimer with H. Eleanor Kerkham (Honolulu: University of Hawai'i Press, 2001), 310–59.
52. Desser, *Eros Plus Massacre*, 4.
53. Furuhata, *Cinema of Actuality*, 51–52.
54. Furuhata, 3–4.
55. Furuhata, 39.
56. Matsumoto Toshio, "Jiko kyūsai no gishiki," in *Hyōgen no sekai: Geijutsu zen'eitachi to sono shisō* (Tokyo: San'ichi shobō, 1967), 144. Originally published in *Haiyū shōgekijō*, April 1966.
57. Ōshima, *Cinema, Censorship, and the State*, 31.
58. Like Ōshima, Yoshida also wrote extensively about both the importance of fictional cinema and the need to reinvent it as a way of dealing with politics. Patrick Noonan has written the following on Yoshida: "Responding to a question about how he treated the protests against the 1960 resigning of the U.S.-Japan Security Treaty in his first film, *Good For Nothing*, he stated that he was not concerned with the details of the treaty itself or the dynamics of the protests. Rather, he said that he wanted to capture 'the

buried energy of Japan's younger generation and how those on the inside responded to and coped [with the protests].' That is, he aimed to use fictional filmmaking to show the normally concealed forces at work within society, politics, and culture. This required that subjectivities collide with the external world." (Patrick Noonan, "The Alterity of Cinema: Subjectivity, Self-Negation, and Self-Realization in Yoshida Kijū's Film Criticism," *Review of Japanese Culture and Society* 22 [2010]: 118.) As Yoshida himself described this process, "Making a film is an act that transcends me, that pushes me forward, closer to the unknown. The audience that receives the film also transcends the 'film they are made to watch,' insofar as they themselves create it. Within this new relationship—in which, that is to say, film is not already offered as a fixed entity—the creator and the viewer enter into a free dialogue with one another, which begets film as a potential exchange, as a relational concept." (Yoshida Kijū, "My Theory of Film: The Logic of Self-Negation," trans. Patrick Noonan, *Review of Japanese Culture and Society* 22 [2010]: 105.) Yoshida's discussion of subjectivity and surrendering oneself (as a filmmaker) to the process is quite different from Ōshima's, and it is difficult to draw a parallel between his style and Ōshima's, much less Suzuki's. We can see, however, that Yoshida was working through some of these same problems.
59. For a discussion of how Ōshima does this in *Cruel Story* specifically, see Mitsuhiro Yoshimoto, "Questions of the New: Ōshima Nagisa's *Cruel Story of Youth* (1960)," in *Japanese Cinema: Texts and Contexts*, ed. Alastair Phillips and Julian Stringer (New York: Routledge, 2007), 168–79.
60. Yoshimoto, 175, reads these as metonymous for the contemporaneous student protests in Japan.
61. According to Annette Michelson, the name "was originally proposed by an editor of the *Weekly Yomiuri*, which published feature articles on *Cruel Story of Youth* (1960)." Note from Ōshima, *Cinema, Censorship, and the State*, 56.
62. Seijun's *Kantō Wanderer* was the B picture assigned to follow Imamura's *The Insect Woman* (*Nippon konchuki*, 1963), and *The Story of a Prostitute* was assigned to follow Imamura's *Intentions of Murder* (*Akai satsui*, 1964). Hasumi, "Suzuki Seijun, mata wa kisetsu no fuzai," 41.
63. Yoshimoto, "Questions of the New," 172.
64. Yoshimoto, 172.

2. Suzuki Seijun and the Impossibility of Cinema

1. "Top Ten: 250 Verdicts," *Sight and Sound* 8 (December 1992): 30.
2. David Bordwell discusses this tendency in some depth in *Ozu and the Poetics of Cinema*. To pick one of his examples in which the movie poster appears to comment on the actions of the film, the boys in *Ohayō* (*Good Morning*, 1959) has a poster of Stanley Kramer's *The Defiant Ones* on one of their walls as they decide to stage a speaking strike to force their father to buy them a television. See Bordwell, *Ozu and the Poetics of Cinema* (Princeton, N.J.: Princeton University Press, 1988), 72.
3. Ueno Kōshi, "Furidashi ni modoru kantoku," in *Suzuki Seijun zen'eiga* (Tokyo: Rippū Shobō, 1986), 12–13.
4. See, for example, Robin Wood, *Hitchcock's Films Revisited*, rev. ed. (New York: Columbia University Press, 2002); Robin Wood, *Howard Hawks*, new. ed (Detroit, Mich.: Wayne State University Press, 2006); Andrew Sarris, "Notes on the Auteur Theory in 1962," in *Film Theory and Criticism: Introductory Readings*, ed. Leo Braudy and

Marshall Cohen (Oxford: Oxford University Press, 1999), 515–18; Andrew Sarris, *The American Cinema: Directors and Directions 1929–1968* (Boston: Da Capo Press, 1996); and V. F. Perkins, *Film As Film: Understanding and Judging Movies* (New York: Penguin Books, 1972).
5. Ryan Cook, "Through the Looking Glass: Flirtations with Nonsense in 1960s Japanese Film Culture," Ph.D. diss., Yale University, 2013, 211.
6. John Edward Gibbs, *Mise-en-scène: Film Style and Interpretation* (New York: Wallflower Press, 2002), 62.
7. Alexandre Astruc, "The Birth of a New Avant-Garde: *La Camera-Stylo*," in *The French New Wave: Critical Landmarks*, ed. Peter Graham with Ginette Vincendeau (London: BFI, 2009), 34.
8. Fereydoun Hoveyda, "Nicholas Ray's Reply: *Party Girl*," in *Cahiers du Cinéma 1960–1968: New Wave, New Cinema, Reevaluating Hollywood* (Cambridge, Mass.: Harvard University Press, 1986), 127.
9. Perhaps the most extreme version of this argument was offered by Michel Mourlet, whom Godard quotes in the opening of *Contempt* (deliberately misattributing the quotation to André Bazin): "The cinema substitutes for our gaze a world more at harmony with our desires." Mourlet, "Sur un art ignoré," *Cahiers du cinéma*, no. 10 (August 1959): 23–37.
10. Hoveyda, "Nicholas Ray's Reply," 126–27.
11. "Auteur analysis does not consist of retracing a film to its origins, to its creative source. It consists of tracing a structure (not a message) within the work, which can then *post factum* be assigned to an individual, the director, on imperical grounds.... Fuller or Hawks or Hitchcock, the directors, are quite separate from 'Fuller' or 'Hawks' or 'Hitchcock,' the structures named after them" (Peter Wollen, *Signs and Meanings in the Cinema: Expanded Edition* [London: BFI, 1998], 115). Wollen's application of structuralism to auteurism did receive criticism from fellow auteurists, most notably Robin Wood, for its tendency to overlook or dismiss small details that do not fit neatly into the single overarching structure that defines an auteur: "The resulting richness cannot be adequately represented by means of a single schematic structure" (Robin Wood, "Hawks De-Wollenized," in *Personal Views: Explorations in Film*, rev. ed. [Detroit: Wayne State University Press, 2006], 248.) However controversial the word *structure* may be here, Wollen nevertheless correctly identifies that it is repeated deployment of similar visual strategies within a filmmaker's body of work rather than the identity of the filmmaker that identifies an auteur to an auteurist.
12. This is the central theme of several *Cinema 69* writings, including Yamane Sadao, "Nihon eiga hihyō no genzai chiten," *Shinema 70* 4 (1970): 45–48; Hasumi Shigehiko, "Hihyō to firumu taiken," *Shinema 71* 8 (1971): 2–14; and Ueno Kōshi, "Kotoba no ketsuraku ni: hihyō no kidō suru ichi," *Shinema 71* 8 (1971): 15–23. It is also the central theme of Hasumi's later essay "Eiga to hihyō," one of the two essays that Cook is primarily analyzing in "An Impaired Eye." See Hasumi Shigehiko, "Eiga to hihyō," in *Eiga yūwaku no ekurichuru* (Tokyo: Chikuma shobō, 1990), 353–59.
13. Ryan Cook, "An Impaired Eye: Hasumi Shigehiko on Cinema and Stupidity," *Review of Japanese Culture and Society* 22 (December 2010): 131.
14. Adrian Martin, "Given to See: A Tribute to Shigehiko Hasumi," *LOLA*, no. 7 (November 2016), http://www.lolajournal.com/7/index.html.
15. Richard I. Suchenski, "On Hasumi," *LOLA*, no. 7 (November 2016), http://www.lolajournal.com/7/hasumi_suchenski.html.

16. Nakamura Hideyuki, "Ozu, or On the Gesture," trans. Kendall Heitzman, *Review of Japanese Culture and Society* 22 (2010): 145–46, 148.
17. A brief excerpt has also been translated into English in David Desser, ed., *Ozu's Tokyo Story* (Cambridge: Cambridge University Press, 2003). More recently, other vintage Hasumi writings have been translated into French, including his first essay on Suzuki from 1969, which was translated by Mathieu Capel and published in *Trafic* in 2018.
18. Alexander Jacoby, *A Critical Handbook of Japanese Film Directors* (Berkeley, Calif.: Stone Bridge Press, 2008), 281.
19. An excerpt from Satō's reading of the film, as quoted in Hasumi's book: "Because of losing the war, all Japanese have lost the purity of their souls, or have perhaps even become the same as prostitutes. But even if they have become prostitutes, aren't they at least retaining the simplicity of eating a lunchbox in the open field?" Hasumi Shigehiko, *Kantoku Ozu Yasujirō* (Tokyo: Chikuma Shobō, 2012), 54.
20. Jonathan Rosenbaum. "Building from Ground Zero: *A Hen in the Wind*," jonathanrosenbaum.net, September 21, 2016, https://www.jonathanrosenbaum.net/2016/09/building-fron-ground-zero-a-hen-in-the-wind-tk/.
21. Hasumi, *Kantoku Ozu Yasujirō*, 56.
22. Ueno Kōshi, "Yakuza eiga: hana to okite o jōnen no hiyū toshite," *Shinema 69* 1 (1969): 65–66.
23. Ueno Kōshi, "Eiga no omoshirosa to iu koto," *Shinema 71* 7 (1971): 3.
24. Aaron Gerow is one scholar who has made this criticism of Hasumi's writings: "Spectators were not divided by different historical circumstances, so Hasumi's frequent use of the pronoun 'we' (*wareware*) ended up creating a unitary, exclusive group privileged in its access to the ineffable qualities of cinema." Gerow, "Critical Reception: Historical Conceptions of Japanese Film Criticsm," in *The Oxford Handbook of Japanese Cinema*, ed. Daisuke Miyao (Oxford: Oxford University Press, 2014), 74.
25. Ueno, "Yakuza eiga: hana to okite," 65.
26. Yamane Sadao, "Shūdatsusha-Suzuki Seijun: tsubaki no hana wa naze akai no ka," *Shinema 69* 2 (1969): 65.
27. Ueno Kōshi, "Furidashi ni modoru kantoku," 1, 3.
28. Interview: Ueno Koshi and Hasumi Shigehiko, "1968 nen wa nan da/nan deatta?," in *1968*, ed. Suga Hidemi (Tokyo: Sakuhinsha, 2005), 40.
29. Cook, "An Impaired Eye," 139.
30. Cook, 140, 132. The simplest example that Hasumi uses (and Cook describes) is the "eyeline match" in classical Hollywood filmmaking. Eyeline matches are an editing technique in which a shot of one set of eyes looking off-screen is followed by a shot of another set of eyes, looking off-screen in the opposite direction, with the implication that the two pairs of eyes are looking at each other. This is "a systemic effect in that it forgets the impossibility of filming two sets of eyes looking at each other" (Cook, 133), but for this "forgetting" to work the eyeline match must be repeated in the same way, in fact limiting the possibilities of the cinema while seeming to expand them. Only when a director breaks the systematicity, as Ozu does with his "false eyeline matches," do we remember them.
31. Cook, 137.
32. Fukasawa Tetsuya, "*Yaju no seishun*," *Kinema junpō* 342 (June 1963): 86.
33. Hasumi Shigehiko, "Suzuki Seijun: soshite sono chinmoku no naritachi," *Cinema 69* 2 (1969): 50. Translated by Phil Kaffen.

34. Hasumi, 49.
35. Formalism is generally referred to as *keishiki shugi* (形式主義) in Japanese, where *keishiki* is the word used for form. In this essay, however, Hasumi uses the word "form," transliterated from English into Japanese as *forumu* (フォルム).
36. Hasumi, "Suzuki Seijun: shoshite sono chinmoku no naritachi," 52.
37. Both essays can be found in Takahashi Murakami, *Superflat* (Tokyo: Dainippon, 2001).
38. Hiroki Azuma, *Otaku: Japan's Database Animals*, trans. Jonathan E. Abel and Shion Kono (Minneapolis: University of Minnesota Press, 2009), 103–4. Arguably, the move to favor the part over the whole, and in particular isolated, highly specific details, can be seen as related to *moé*, which would be a commodified form of these that are picked up and circulated in isolation of narrative. Azuma argues (25–95) that the investment in these aspects over traditional narrative is part of what distinguishes the way otaku engage with media, and how they relate to postmodernism.
39. Hasumi, "Suzuki Seijun: soshite sono chinmoku no naritachi," 53.
40. Hasumi, 56.
41. Hasumi, 55.
42. Hasumi, "Suzuki Seijun, mata wa kisetsu no fuzai," 21.
43. "The apparent movement of protagonists meeting and leaving as undulating turn out to be nothing more than movements along parallel lines; in *Tokyo Drifter*, the protagonist leaves Tokyo and comes back across a flat surface, while in *Branded to Kill* he moves up and then back down along a vertical axis.... The former protagonist traverse the country from north to south under his boss's orders, while the latter, driven by both the desire to achieve the number one killer status and the fear of falling down the ranks, just ends up suspended in the middle. The reason that the horizontal wipes and sideways character movements are so effective in *Tokyo Drifter* is that they make prominent the movements along a horizontal plane that the character makes." Hasumi, "Suzuki Seijun, mata wa kisetsu no fuzai," 21–22.
44. Hasumi, 23. Hasumi puts Suzuki alongside Jean-Luc Godard for their mutual concern with "the tangibility of cinema."
45. Hasumi, 24.
46. Jacques Rancière, *Disagreement: Politics and Philosophy*, trans. Julie Rose (Minneapolis: University of Minnesota Press, 1999), 29–30.

3. Postwar Japanese Genre Filmmaking and the Nikkatsu Action Stylistic Idiom

1. Kōno Marie, scholar of Japanese melodrama, has argued that Suzuki's experience as assistant director of Shōchiku Ōfuna melodramas was formative, and has traced stylistic tendencies typically associated with melodrama in Suzuki's Nikkatsu work. See Kōno Marie, "Katarazaru danpen no shibire: Merodoama toshite mita Seijun eiga," *Yurīka* 49-8, no. 701 (May 2017): 97–103.
2. Jasper Sharp, *Historical Dictionary of Japanese Cinema* (Lanham, Md.: Scarecrow Press, 2011), 181–82.
3. Isoda Tsutomu and Todoroki Yukio, eds., *Sei/jun/ei/ga* (Tokyo: Wides Shuppan, 2006), 433.
4. Kamijima Haruhiko, "Noguchi Hiroshi-gumi Suzuki Seitarō to iu shifuku: Shoki Nikkatsu akushon eiga ni okeru futari," *Yurīka* 49-8, no. 701 (May 2017): 82. Kamijima

notes that two of Suzuki's future collaborators, editor Suzuki Akira and art director Kimura Takeo, also worked on this film.
5. Kamijima, 82. In some later films, Noguchi Hiroshi is credited as Noguchi Haruyasu, such as *Murder Unincorporated* (1964).
6. Kamijima, 82. "Director Noguchi and Assistant Director Seitarō" is a phrase that Kamijima uses in quotation marks but does not attribute to anyone in particular.
7. Kamijima, 82–83.
8. Several of Suzuki's assistant directors would become full-fledged Nikkatsu directors as well, including Kurahara Koreyoshi (Suzuki's assistant director on his first film), Takeda Kazunari (Suzuki's most regular first assistant director at Nikkatsu), and Sone Chūsei (a lower-ranked assistant director who became a prolific Nikkatsu director in the *roman poruno* era).
9. DVD interview with Suzuki Seijun, *Tokyo Drifter* (New York: Criterion Collection, 2011).
10. Suzuki Seijun, "The Days of *Kantō Mushuku*," in *Suzuki Seijun: The Desert Under the Cherry Blossoms*, trans. Geert van Bremen, Naoko Shashiki, and Frank van Herk (Rotterdam: Film Festival Rotterdam, NFM/IAF, VPRO, Uitgeverij Uniepers Abcoude, 1991), 34.
11. As a minor fact of trivia, Suzuki did have the opportunity to direct Ishihara in a television commercial for Shōchikubai (a sake brand) in 1978. Isoda and Todoroki, *Sei/jun/ei/ga*, 432.
12. "Pinch-hitters" is Watanabe Takenobu's phrase. See Watanabe Takenobu, *Nikkatsu akushon no karei na sekai* (Tokyo: Mirai-sha, 2004), 24–25.
13. Many of these collaborators apparently devoted themselves to Suzuki's more unique aesthetic, which is perhaps why they continued to collaborate with him after he left the studio. Suzuki Akira would be Suzuki's editor for *Kagero-za*, *Capone Weeps with Passion*, *Yumeji*, and *Pistol Opera*, while Nagatsuka would later be Suzuki's director of photography for *Zigeunerweisen* and *Kagero-za*.
14. Alexander Zahlten, *The End of Japanese Cinema: Industrial Genres, National Times, & Media Ecologies* (Durham, N.C.: Duke University Press, 2017), 3.
15. Zahlten discusses how certain films are made to be received in different ways in multiple exhibition contexts, allowing them to shift genres as they move. Imaoka Shinji's *Lunch Box*, for example, though produced as a pink film, was also made to be received at art house theaters like Eurospace in Tokyo (Zahlten, 204). Suzuki's Nikkatsu films were not specifically produced to be received belatedly in an international art house context, but the fact that his cinematic form gets more experimental the moment he is embraced by alternative exhibition practices like cine-clubs (and just as these alternative exhibition practices were becoming more influential in the Japanese film industry) suggests that Suzuki may have made the films with more than one place of reception in mind, even though he never mentioned that in interviews or writings.
16. Brian Taves, "The B-Film: Hollywood's Other Half," in *Grand Design: Hollywood as a Modern Business Enterprise 1930–1939*, ed. Tino Balio (Berkeley: University of California Press, 1995), 314.
17. Taves, 314.
18. See appendix 1 for a complete list of the films that Suzuki's Nikkatsu films were screened with in their initial release.
19. Ryan Cook, "Casablanca Karaoke: The Program Picture as Marginal Art in 1960s Japan," in *The Japanese Cinema Book*, ed. Hideaki Fujiki and Alastair Phillips (London: BFI, 2020), 1158.

20. Sone Chūsei, *Sone Chūsei jiden: Hito wa nanomi no tsumi no fukasa yo* (Tokyo: Bunyasha, 2014), 97.
21. The footage of Suzuki's original ending is no longer extant. In place of the scene showing Tetsu singing the film's theme song on a staircase in Tokyo at night and walking into the distance, there was a strange scene featuring a green moon. Blu-ray interview with Suzuki Seijun and Kuzū Masami (New York: Criterion Collection, 2011).
22. See appendix 2 for more information about this project.
23. DVD interview with Suzuki Seijun, *Tokyo Drifter* (New York: Criterion Collection, 2011).
24. Unlike Hollywood screenplays, Japanese screenplays that were sold by the studio or printed in film journals were not composed after the fact to reflect the finished film but were, instead, the final draft written by the screenwriter before production. Lauri Kitsnik discusses this practice in the context of a broader discussion of screenwriting in Japanese cinema, in "Scenario Writers and Scenario Readers in the Golden Age of Japanese Cinema," *Journal of Screenwriting* 7, no. 2 (2016): 293–94.
25. Michael Raine, "Ishihara Yūjirō: Youth, Celebrity, and the Male Body in Late-1950s Japan," in *Word and Image in Japanese Cinema* (Cambridge: Cambridge University Press, 2001), 214.
26. Mark Schilling, *No Borders, No Limits: Nikkatsu Action Cinema* (Godalming, UK: FAB Press, 2007), 6.
27. Watanabe, *Nikkatsu akushon*, 24.
28. One exception to this trend is Noguchi Hiroshi, who was born in the mid-1910s and had begun making films in the early 1940s.
29. Watanabe, *Nikkatsu akushon*, 24.
30. Watanabe, 24.
31. Secondary sources sometimes include Shishido and Nitani in the Diamond Line, and while they did periodically star in films from this time, Watanabe maintains that they were considered "pinch-hitters." Watanabe, 24–25.
32. Raine, "Ishihara Yūjirō," 177–78.
33. "He arrived with a nice body and a bad attitude: both together made up his impersonation of a new kind of modern young masculinity associated with the *taiyōzoku*. But with the attacks on the *taiyōzoku*, he lost the attitude and kept the body. Yūjirō's interviews and Nikkatsu studio publicity during the remainder of 1956 and throughout 1957 worked to dissociate him from the excesses of the *taiyōzoku*." Raine, 213.
34. Watanabe, *Nikkatsu akushon*, 211.
35. Watanabe, 25.
36. Watanabe, 25–28.
37. One exception to this is *I Look Up As I Walk* (*Ue o muite arukō*, Masuda Toshio, 1962).
38. Michael John Raine, "Youth, Body, and Subjectivity in the Japanese Cinema, 1955–60," Ph.D. diss., University of Iowa, 2002, ProQuest Dissertation Publishing UMI 3052454, 112–13.
39. Raine, 112–13. Raine points out that the idea of the American musical that these films were held up against frequently did not live up to this standard either.
40. One of Suzuki's unfilmed projects from the 1970s, *A Ballad Dedicated to Mother*, was intended to be a *kayō* film; when the film was ultimately made (directed by Naitō Makoto) as *Daughter of Time*, the narrative and some of Suzuki's designs were used, but the initial song the project was named for was replaced by several new songs. For more information on this project, see the *Ballad Dedicated to Mother* entry in appendix 2.

41. Michael Raine discusses the role of music in cultivating Yūjirō's stardom and in the popularity of some of his early films, such as *I Am Waiting* and *The Man Who Called Up A Storm*. See Raine, "Ishihara Yūjirō," 211–16.
42. The song "Rokusannen no dandī" (Dandy of 1963) was released as a duet between Shishido and Hoshi Naomi, who has a minor role in the film. The song is perhaps an indication of why Shishido was not able to reach the star status of Ishihara Yūjirō or Kobayashi Akira in a period when Nikkatsu expected its stars to sing: Hoshi sings all but one verse of the song, and Shishido struggles to croon through his single verse.
43. See, for example, James Naremore's writing on Japanese postwar noir in *More Than Night*, in which he identifies Suzuki as "one of the most flamboyant auteurs in this field" and compares him to Samuel Fuller. (James Naremore, *More Than Night: Film Noir in Its Contexts* [Berkeley: University of California Press, 1998], 227). The comparison between Suzuki and Fuller has been made by others, notably Stephen Teo, "Suzuki Seijun: Authority in Minority," *Senses of Cinema*, no. 8 (July 2000). To my knowledge, the category of "Nikkatsu Noir" was invented by the Criterion Collection in 2009 for a boxset of Nikkatsu Action films.
44. David Desser, "The Gunman and the Gun: Japanese Film Noir Since the Late 1950s," in *International Noir*, ed. R. Barton Palmer and Homer B. Pettey (Edinburgh: Edinburgh University Press, 2014), 113.
45. Homer B. Pettey puts forth Ozu Yasujirō's *Dragnet Girl* (*Hijōsen no onna*, 1933) as a prototypical film of the genre and argues that its aesthetic combines the influences of earlier avant-garde Japanese films like Kinugasa Teinosuke's *Crossroads* (*Jūjiro*, 1928) with those of American crime films of the 1920s and 1930s. See Pettey, "Early Japanese Noir," in Palmer and Pettey, *International Noir*, 91. Naremore's gloss of Japanese noir identifies it as a postwar phenomenon, but this may be because prewar Japanese *ankokugai* films were not as widely available in 1998, particularly to non-Japanese speakers, as they had become by 2014.
46. Daisuke Miyao, "Dark Visions of Japanese Film Noir: Suzuki Seijun's *Branded to Kill* (1967)," in *Japanese Cinema: Texts and Contexts*, ed. Alistair Phillips and Julian Stringer (New York: Routledge, 2007).
47. See Dennis Broe, "Occupy the *Zaibatsu*: Post-War Japanese Film Noir from Democracy to the (Re)Appearance of the (Old) New Order," in *Class, Crime, and International Film Noir: Globalizing America's Dark Art* (New York: Palgrave Macmillan, 2014), 146–75.
48. Kōno, "Katarazaru danpen no shibire," 97.
49. Hasumi Shigehiko, "Suzuki Seijun, mata wa kisetsu no fuzai," *Yurīka* 4 (1991): 47.
50. Hasumi Shigehiko, "Akutarō-san," *Yurīka* 49-8, no. 701 (May 2017): 42–46.
51. Hiroshi Kitamura, "Frontiers of Nostalgia: The Japanese Western and the Postwar Era," in *The Japanese Cinema Book*, ed. Hideaki Fujiki and Alastair Phillips (London: BFI, 2020), 1083.
52. Kitamura suggests a slightly different formulation, in which "these local settings usually involved tensions between two social groups. One was the innocent townspeople, a group to which the pure-hearted heroine usually belonged. The other was a group of gangsters or ruffians, who were exploiting the local population to monopolise wealth and power" (1083). I have found that the gangsters and ruffians themselves are usually not the main villains in these films but are hired hands doing the dirty work of a land developer or industrialist looking to kick the local people off the land in the vein of *Shane* (George Stevens, 1953). It also means that in this formulation, the forces of

modernization are the villain rather than a sign of progress or a tragic necessity, as they frequently are in American Westerns.

53. Watanabe, *Nikkatsu akushon*, 118–31.
54. Many years later, Suzuki would put the film on his Sight & Sound Ten Best list; additionally, Kitamura cites *Stagecoach*'s popular success when it was released during the U.S. Occupation period as a key point in the development of Westerns in postwar Japanese cinema (Kitamura, "Frontiers of Nostalgia," 1080–81). It may also be worth recalling that *Stagecoach* was indirectly based on Guy de Maupassant's short story "Boule de Suif," which Mizoguchi Kenji had adapted into film as *Oyuki the Virgin* (*Maria no Oyuki*, 1935) four years earlier than Ford.
55. Watanabe Takenobu, "Ninkyō eiga sōmokuroku: 1961–1969," in *Ninkyō eiga no sekai*, ed. Kusumoto Kenkichi (Tokyo: Arechi, 1969), 212.
56. An exception should be made for "wandering gambler" films, which are often put under the broader heading of ninkyō films, but many of which were still set in the premodern era, including Katō Tai's *Long-Sought Mother* (1962) and Daiei's *Zatoichi* series. However, Suzuki's one planned but unfilmed wandering gambler film, *Assassination Counting Song*, was to have been set in the early modern era (see appendix 2).
57. In what could be taken as evidence of the fluidity of these genres, Watanabe's list of ninkyō films in *Ninkyō eiga no sekai* includes *Tokyo Drifter* but omits *Our Blood Will Not Forgive*, while Hasumi's breakdown of Suzuki's genres in his late Nikkatsu films in "Suzuki Seijun, mata wa kisetsu no fuzai" lists *Our Blood Will Not Forgive* with Suzuki's other ninkyō films, while listing *Tokyo Drifter* along with *Yajū no seishun* and *Koroshi no rakuin* as a "hard-boiled gangster" film. (Both authors count *Kanto Wanderer*, *The Flower and the Angry Waves*, and *Tattooed Life* among Suzuki's *ninkyō* films).
58. Hasumi Shigehiko "Suzuki Seijun mata wa kisetsu no fuzai," 46.
59. Hasumi, 41.

4. The Emergence of the Seijunesque

1. Ueno Kōshi, *Suzuki Seijun zen'eiga* (Tokyo: Rippū Shobō, 1986), 8.
2. Ichikawa Kon, "CinemaScope and Me," in *Kon Ichikawa*, ed. James Quandt (Toronto: Cinematheque Ontario, 2001), 303.
3. Namhee Han, "Technologies of Anamorphic Vision: Widescreen Cinema and Postwar Modernity in Japan and South Korea," Ph.D. diss., University of Chicago, 2014, ProQuest Dissertation Publishing UMI 3615650, 47.
4. The first anamorphic Nikkatsu film was Fuyushima Taizō's *A Young Samurai in the Moonlight* (*Gekka no wakamusha*), released July 9, 1957. Jasper Sharp, "Japanese Widescreen Cinema: Commerce, Technology and Aesthetics," Ph.D. diss., University of Sheffield, 2013, 179.
5. Watanabe Takenobu, *Nikkatsu akushon no karei na sekai* (Tokyo: Miraiya Shoten, 2004), 24.
6. David Bordwell discusses this topic further in "CinemaScope: The Modern Miracle You Can See Without Glasses," in *Poetics of Cinema* (New York: Routledge, 2008), 290–307.
7. In "Japanese Widescreen Cinema," 173–74, Jasper Sharp points out that Japanese studios adapted an anamorphic system from Franscope designed by Ernst Abbe, which

was different from the one that 20th Century Fox used. This meant that they did not need to license the use of anamorphic lenses from Fox or follow Fox's guidelines. Fox would eventually concede that CinemaScope could be used in some black-and-white films, and there were a handful of important Hollywood features in black-and-white CinemaScope in the late 1950s, but black-and-white anamorphic films were more prominent in Japan through the end of the 1960s than they ever were in Hollywood. For more on black-and-white CinemaScope in Hollywood, see Lisa Dombrowski, "Cheap but Wide: The Stylistic Exploitation of CinemaScope in Black-and-White, Low-Budget American Films," in *Widescreen Worldwide*, ed. John Belton, Sheldon Hall, and Steve Neale (Bloomington: Indiana University Press, 2010), 63–70.

8. Charles Barr, "CinemaScope: Before and After," *Film Quarterly* 16, no. 4 (Summer 1963): 19. David Bordwell expands this notion in *Figures Traced in Light: On Cinematic Staging* (Berkeley: University of California Press, 2005). His methods have influenced the way I analyze deep-space staging here.
9. For a discussion of this topic, see Sharp, "Japanese Widescreen Cinema," 246–51.
10. DVD interview with Suzuki Seijun, *Tokyo Drifter* (New York: Criterion Collection, 2011).
11. "One thing that we can recall instantly is his use of color. There is the way that the colors change with lighting, as well as the colors the things themselves have. In any case, be it the scene in *Kanto Wanderer* where the color seems to emerge from the swipes of Kobayashi Akira's sword, the colors in the club in *Tokyo Drifter*, the colors revealed by the opaque doors in the residence of *Tatooed Life*, the color of the heroine's room in *A Tale of Sorrow and Sadness*, the colors of the four women's outfits in *Gate of Flesh*, the colors of the flowers in *Youth of the Beast*, when we see colors functioning in this way, we know instantly that we are within the Seijunesque." Ueno, *Suzuki Seijun zen'eiga*, 6–7.
12. Richard Misek, *Chromatic Cinema: A History of Screen Color* (Hoboken, N.J.: Wiley-Blackwell, 2010), 50, 100; Edward Branigan, *Tracking Color in Cinema and Art: Philosophy and Aesthetics* (New York: Routledge, 2018), 21.
13. David Desser, "Gate of Flesh(-tones): Color in the Japanese Cinema," in *Cinematic Landscapes: Observations on the Visual Arts and Cinema of China and Japan*, ed. Linda C. Erlich and David Desser (Austin: University of Texas Press, 1994), 299–317.
14. Paul Coates, *Cinema and Colour: The Saturated Image* (London: BFI, 2010), 30.
15. Desser, "Gate of Flesh(-tones)," 310.
16. Joseph L. Anderson and Donald Richie, *The Japanese Film: Art and Industry*, exp. ed. (New York: Grove Press, 1960), 233–34.
17. Misek, *Chromatic Cinema*, 6, 128.
18. Misek, 143.
19. Desser gives a symbolic reading of the colors based on an interview in which Suzuki reads several symbolic interpretations of the film's colors by critics, though Suzuki has subsequently said that he supplied these readings only to mock them, and that his sole intention was to pick colors that stood out from the background and were consistent across the film. Desser acknowledges that Suzuki's supplied readings do not map meaningfully onto the characters, but he offers alternative symbolic readings ("red = leadership") that are arbitrary at best. Desser, "Gate of Flesh(-tones)," 315; "Interview with Suzuki Seijun," *Eiga hyōron* (January 1966): 20; "From the Ruins: Making *Gate of Flesh*," in *Gate of Flesh* (New York: Criterion Collection, 2005).

248 4. The Emergence of the Seijunesque

20. Branigan, *Tracking Color in Cinema and Art*, 131.
21. Screenshots for this sequence can be found in fig. 3.1.
22. Trond Lundemo, "The Colors of Haptic Space: Black, Blue, and White in Moving Images," in *Color, the Film Reader*, ed. Angela Dalle Vacche and Brian Price (New York: Routledge, 2006), 88–101.
23. Shōji and fusuma are both rectangular screens and function as both doors and walls; however, shōji are translucent while fusuma are opaque. As Noël Burch observes, this use of Japanese architecture in fight choreography has been common since at least the *chanbara* (sword-fighting) films of the 1920s set in the premodern era; ninkyō films adapt this practice to their early modern setting. See Noël Burch, *To the Distant Observer* (Berkeley: University of California Press, 1979), 118.
24. Branigan, *Tracking Color in Cinema and Art*, 132.
25. David Bordwell describes this editing paradigm in *Classical Hollywood Cinema*, particularly the chapters "Time in the Classical Film" and "Space in the Classical Film." See David Bordwell, Janet Staiger, and Kristin Thompson, *The Classical Hollywood Cinema: Film Style & Mode of Production to 1960* (London: Routledge, 1985), 42–60.
26. Sergei Eisenstein, "A Dialectic Approach to Film Form," in *Film Form: Essays in Film Theory*, ed. and trans. Jay Leyda (New York: Meridian Books, 1957), 49.
27. Kanemura Osamu, "Kokoro no nai Suzuki Seijun no eiga," *Yurīka* 49-8, no. 701 (May 2017): 78, 79.

5. The Authorial Voice of Suzuki Seijun

1. Laura Lee, *Japanese Cinema Between Frames* (New York: Palgrave Macmillan, 2017), 55–56.
2. Tom Gunning, "Narrative Discourse and the Narrator System," in *Film Theory and Criticism*, ed. Leo Braudy and Marshall Cohen (Oxford: Oxford University Press, 2009), 394.
3. David Bordwell, *Narration in the Fiction Film* (Madison: University of Wisconsin Press, 1985), 53.
4. Bordwell, 58, 57.
5. Claudia Gorbman, *Unheard Melodies: Narrative Film Music* (Bloomington: Indiana University Press, 1987), 30.
6. For a discussion of the problems that musicals present us with regard to diegetic versus nondiegetic sound sources, see Rick Altman, *The American Film Musical* (Bloomington: Indiana University Press, 1987), 63–74.
7. Michael Raine, "Youth, Body, and Subjectivity in the Japanese Cinema, 1955–1960," Ph.D. diss., University of Iowa, 2002, Proquest Dissertation Publishing UMI 3052454, 113–14.
8. Nagato Yōhei, "Eiga no shijima," *Yurīka* 49-8, no. 701 (May 2017): 114–21.
9. Ryan Cook, "Through the Looking Glass: Flirtations with Nonsense in 1960s Japanese Film Culture," Ph.D. diss., Yale University, 2013, ProQuest Dissertation Publishing UMI 3572013, 74.
10. Yuriko Furuhata, *Cinema of Actuality: Japanese Avant-garde Filmmaking in the Season of Image Politics* (Durham, N.C.: Duke University Press, 2013), 144–48.
11. Fernando Canet, "Metacinema as Cinematic Practice: A Proposal for Clarification," trans. Paula Saiz Hontangas, *L'Atalante* (July–December 2014): 18.

12. Takahashi Hiroshi (a screenwriter, director, and essayist best known internationally for writing the screenplay for *Ringu*) has identified Suzuki as a filmmaker who "made 'ghost story films' sometimes with humans that looked ghostly, but sometimes [they] really were ghosts." He does not provide specific examples of "humans that looked ghostly," but the monk in *Carmen from Kawachi*, Misako in *Branded to Kill*, and Kayo in *A Tale of Sorrow and Sadness* all spring to mind. Takahashi Hiroshi, "Yūrei eiga ni tsuite," *Eiga no ma* (Tokyo: Seidosha, 2004), 27.
13. Descriptions and sources for these unrealized projects can be found in appendix 2.
14. Tsvetan Todorov, *The Fantastic: A Structural Approach to a Literary Genre*, trans. Richard Howard (Ithaca, N.Y.: Cornell University Press, 1975), 25.
15. An image of this space can be found in figure 4.17.
16. Rosemary Jackson, *Fantasy: The Literature of Subversion* (London: Routledge, 1981; digital printing 2003), 13, 19.
17. Susan Napier, *The Fantastic in Modern Japanese Literature: The Subversion of Modernity* (New York: Routledge, 1996), 8.
18. Jackson, *Fantasy*, 19.
19. Napier, *The Fantastic in Modern Japanese Literature*, 12.
20. Suzuki Seijun, "Taishō erejī," *Yume to kitōshi* (Tokyo: Isseidō, 1991), 149–53.
21. Irena Hayter has discussed Kon Tōkō's call for a unity of "Western" materialism and "Japanese" spiritualism in the first moments of the *shinkankakuha* as part of the school's attempts to create a new secular mysticism uniting spirituality with science in the modern era. See Hayter, "Figures of the Visual: Japanese Modernism, Technology, Vitalism," in *positions* 25, no. 2 (2017): 302–5.
22. Hasumi Shigehiko, "Suzuki Seijun, mata wa kisetsu no fuzai," *Yurīka* 4 (April 1991): 57.
23. Seiji M. Lippit, *Topographies of Japanese Modernism* (New York: Columbia University Press, 2002), 20.
24. Suzuki intended to direct a musical (in Asakusa Opera style) about Taishō-era anarchists, and Ōhara Kiyohide wrote a complete screenplay for this project circa 2001, though it was never made into a film. For more information about this project, see appendix 2.
25. Noriko Mizuta Lippit, *Reality and Fiction in Modern Japanese Literature* (White Plains, N.Y.: M. E. Sharpe, 1980), 71, 74.
26. Rachel DiNitto, *Uchida Hyakken: A Critique of Modernity and Militarism in Prewar Japan* (Cambridge, Mass.: Harvard University Press, 2008), 6.
27. M. Cody Poulton, *Spirits of Another Sort: The Plays of Izumi Kyōka* (Ann Arbor: University of Michigan Press, 2001), 3.
28. See Chiyoko Kawakami, "The Metropolitan Uncanny in the Works of Izumi Kyōka: A Counter-Discourse on Japanese Modernization," *Harvard Journal of Asiatic Studies* 59, no. 2 (December 1999): 559–83.
29. Poulton, *Spirits of Another Sort*, 60.
30. *Yūrei-zu* is a genre of painting depicting supernatural occurrences that was popularized in the nineteenth century.
31. Lippit, *Reality and Fiction in Modern Japanese Literature*, 72.
32. Rachel DiNitto, "Translating Prewar Culture into Film: The Double Vision of Suzuki Seijun's *Zigeunerweisen*," *Journal of Japanese Studies* 30, no. 1 (Winter 2004): 56.
33. Poulton, *Spirits of Another Sort*, 312.
34. DiNitto, *Uchida Hyakken*, 208–9.
35. Gunning, "Narrative Discourse and the Narrator System," 401.

Coda

1. Isoda Tsutomu and Todoroki Yukio, eds., *Sei/jun/ei/ga* (Tokyo: Wides Shuppan, 2006), 437.

Appendix 1. Filmography

1. Shirai Yoshio and Iijima Tetsuo, "Suzuki Seijun/Katō Tai: Nihon eiga ranse no itanji," *Kinema junpō* 440 (June 1967): 43.
2. Sone Chūsei, *Sone Chūsei jiden: Hito wa nanomi no tsumi no fukasa yo* (Tokyo: Bunyasha, 2014), 97.
3. Sone, 103.
4. Sone, 97, 105–6.
5. Blu-ray interview with Suzuki Seijun and Kuzū Masami (New York: Criterion Collection, 2011).
6. Takahashi Hiroshi, "*Koroshi no rakuin*," in *Kōya no dacchi waifu: Yamatoya Atsushi dainamaito kessakusen*, ed. Takahashi Hiroshi, Shiota Akihiko, and Ikawa Kōichirō (Tokyo: Firumu Ātosha, 1994), 90.
7. This summary synopsizes the screenplay available at Waseda University's *Empaku* library: Iwama Yoshiki, *Kurobe no taiyō (Daisanwa): Otoko no naka ni wa tori ga iru* (N.p.: Junbikō, n.d.).
8. Ueno, *Suzuki Seijun Zen'eiga*, 365.
9. Isoda Tsutomu and Todoroki Yukio, eds., *Sei/jun/ei/ga* (Tokyo: Wides Shuppan, 2006), 341.
10. See, for example, *Sei/jun/ei/ga*, 368–69; and Suzuki Seijun and Yoshida Shigetsugu, "Staff and Cast Interview," in *Lupan sansei: babiron no ōgon densetsu* (promotional booklet) (Tokyo: Tōhō, 1985).
11. Ioka Junichi, *Watashi no "Rupan sansei" funtōki: Anime kyakuhon monogatari* (Tokyo: Kawade, 2015), 54.
12. Ioka, 63.
13. Ioka, 59, 61, 58–59, 88–89.
14. Isoda and Todoroki, *Sei/jun/ei/ga*, 378–79.
15. Rachel DiNitto, "Translating Prewar Culture into Film: The Double Vision of Suzuki Seijun's *Zigeunerweisen*," *Journal of Japanese Studies* 30, no. 1 (Winter 2004): 37.
16. Takahashi Hiroshi et al., "Yamatoya Atsushi shūsei," in *Kōya no dacchi waifu: Yamatoya Atsushi dainamaito kessakusen*, ed. Takahashi Hiroshi, Shiota Akihiko, and Ikawa Kōichirō (Tokyo: Firumu Ātosha, 1994), 390.
17. Takahashi et al., 390.
18. Isoda and Todoroki, *Sei/jun/ei/ga*, 381.
19. Yasauki Wada, *Hurec Afterhours*, book and cinema review blog, http://hurec.bz/mt/archives/2013/11/2051_198406.html.
20. Ioka, *Watashi no "Rupan sansei" funtōki*, 110.
21. Suzuki Seijun and Yoshida Shigetsugu, "Staff and Cast Interview," in *Lupan sansei: babiron no ōgon densetsu* (promotional booklet) (Tokyo: Tōhō, 1985).
22. Isoda and Todoroki, *Sei/jun/ei/ga*, 375.

Appendix 2. Unfilmed Projects

1. Yamatoya Atsushi, "Don Kihōte yo, eien ni: Suzuki Seijun mi-eigaka shinario o meguru danshō," in *Akuma ni yudaneyo* (Tokyo: Wides shuppan, 1994), 379. Originally published in *Image Forum*, April 1985.
2. Ikawa Kōichirō, "*Gōsuto taun no akai shishi*: Mi-eigaka sakuhin," in *Kōya no dacchi waifu: Yamatoya Atsushi dainamaito kessakusen*, ed. Takahashi Hiroshi, Shiota Akihiko, and Ikawa Kōichirō (Tokyo: Firumu Ātosha, 1994), 50.
3. Ikawa, 50.
4. Ikawa, 50.
5. Yamatoya, "Don Kihōte yo," 381.
6. Yamatoya, 380–1.
7. Takahashi Hiroshi et al., "Yamatoya Atsushi shūsei," in *Kōya no dacchi waifu: Yamatoya Atsushi dainamaito kessakusen*, ed. Takahashi Hiroshi, Shiota Akihiko, and Ikawa Kōichirō (Tokyo: Firumu Ātosha, 1994), 372.
8. Suzuki Seijun, *Kenka erejī* (Tokyo: Nihon Tōsho sentā, 2003), 158.
9. Takahashi et al., "Yamatoya Atsushi shūsei," 372.
10. Sone Chūsei, *Sone Chūsei jiden: Hito wa nanomi no tsumi no fukasa yo* (Tokyo: Bunyasha, 2014), 120.
11. Yamatoya Atsushi, "Nagareta kikaku mo ikiteiru: Seijun to mita jūnen no yume," *Eiga geijūtsu*, no. 317 (June–July 1977): 33–34.
12. Takahashi et al., "Yamatoya Atsushi shūsei," 388–89.
13. Yamatoya, "Nagareta kikaku mo ikiteiru," 35.
14. Some sources refer to this project as *Egypt* (*Ejiputo*); I am using the title of the available screenplay, which is also used in "Yamatoya Atsushi shūsei" by Takahashi Hiroshi et al. The title *Egypt* is used in Yamatoya, "Nagareta kikaku mo ikiteiru," 35.
15. Synopsis adapted from Takahashi, "Yamatoya Atsushi shūsei," 395.
16. Yamatoya Atsushi, "Hoshijorō," in *Kōya no dacchi waifu: Yamatoya Atsushi dainamaito kessakusen* (Tokyo: Firumu Ātosha, 1994), 326.
17. Ōhara Kiyohide, "Gufū kyōran," in *Sei/jun/ei/ga*, ed. Isoda Tsutomu and Todoroki Yukio (Tokyo: Wides Shuppan, 2006), 439.
18. "Suzuki Seijun kantoku ga shikyo: dokutoku eizō-bi no 'Seijun bigaku'" *Nikkan Spōtsu* (written February 23, 2017, accessed December 6, 2018, https://www.nikkansports.com/entertainment/news/1782752.html).
19. "Suzuki Seijun kantoku ga shikyo."
20. "88 sai Suzuki Seijun kantoku ga saikon: aite wa 48-sai toshishita," *Sponichi Annex* (written June 27, 2011, accessed December 7, 2018, https://www.sponichi.co.jp/entertainment/news/ 2011/06/27/kiji/K20110627001097490.html).

BIBLIOGRAPHY

Abé Mark Nornes. *Forest of Pressure*. Minneapolis: University of Minnesota Press, 2007.
——. *Japanese Documentary Film: The Meiji Era Through Hiroshima*. Minneapolis: University of Minnesota Press, 2003.
Adachi Masao. *Eiga/kakumei* [Film/rebellion]. Tokyo: Kawade shobō, 2003.
Altman, Rick. *The American Film Musical*. Bloomington: Indiana University Press, 1987.
Anderson, Joseph L., and Donald Richie. *The Japanese Film: Art and Industry*. Exp. ed. New York: Grove Press, 1960.
Art Theater Guild. *Zigeunerweisen* (*Tsigoeneruwaizen*). Art Theater Guild, no. 144, 1980.
Azuma, Hiroki. *Otaku: Japan's Database Animals*, trans. Jonathan E. Abel and Shion Kono. Minneapolis: University of Minnesota Press, 2009.
Barr, Charles. "CinemaScope: Before and After." *Film Quarterly* 16, no. 4 (Summer 1963): 4–24.
Barthes, Roland. "The Death of the Author." In *The Rustle of Language*, trans. Richard Howard, 49–55. Berkeley: University of California Press, 1989.
——. *S/Z*, trans. Richard Miller. New York: Hill and Wang, 1974.
Baudry, Jean-Louis. "Ideological Effects of the Basic Cinematographic Apparatus," trans. Alan Williams. *Film Quarterly* 28, no. 2 (Winter 1974–1975): 39–47.
Bordwell, David. "A Cinema of Flourishes: Decorative Style in 1920s and 1930s Japanese Film." In *Reframing Japanese Cinema*, ed. David Desser and Arthur Noletti, 327–45. Bloomington: Indiana University Press, 1992.
——. "CinemaScope: The Modern Miracle You Can See Without Glasses." In *Poetics of Cinema*, 281–325. New York: Routledge, 2008.
——. *Figures Traced in Light: On Cinematic Staging*. Berkeley: University of California Press, 2005.
——. *Narration in the Fiction Film*. Madison: University of Wisconsin Press, 1985.
——. *Ozu and the Poetics of Cinema*. Princeton, N.J.: Princeton University Press, 1988.

Branigan, Edward. *Tracking Color in Cinema and Art: Philosophy and Aesthetics*. New York: Routledge, 2018.
Broe, Dennis. "Occupy the *Zaibatsu*: Post-War Japanese Film Noir from Democracy to the (Re)Appearance of the (Old) New Order." In *Class, Crime, and International Film Noir: Globalizing America's Dark Art*, 146–75. New York: Palgrave Macmillan, 2014.
Browne, Nick, ed. *Cahiers du Cinéma*. Vol. 3: *1969–1972 The Politics of Representation*. New York: Routledge, 1996.
Burch, Noël. *To the Distant Observer*. Berkeley: University of California Press, 1979.
Canet, Fernando. "Metacinema as Cinematic Practice: A Proposal for Clarification," trans. Paula Saiz Hontangas. *L'Atalante* (July–December 2014): 17–26.
Cavanaugh, Carole. "Eroticism in Two Dimensions: Shinoda Masahiro's *Double Suicide*." In *Japanese Cinema: Texts and Contexts*, ed. Alistair Phillips and Julian Stringer. London: Routledge, 2007.
Coates, Paul. *Cinema and Colour: The Saturated Image*. London: BFI, 2010.
Comolli, Jean-Louis. "Machines of the Visible." In *The Cinematic Apparatus*, ed. Teresa de Lauretis and Stephen Heath, 121–42. London: Macmillan, 1980.
Cook, Ryan. "An Impaired Eye: Hasumi Shigehiko on Cinema and Stupidity." *Review of Japanese Culture and Society* 22 (December 2010): 130–43.
———. "Through the Looking Glass: Flirtations with Nonsense in 1960s Japanese Film Culture." Ph.D. diss., Yale University, 2013, ProQuest Dissertation Publishing UMI 3572013.
Cossar, Harper. *Letterboxed: The Evolution of Widescreen Cinema*. Lexington: University Press of Kentucky, 2011.
Crosby, Eric. "Widescreen Composition and Transnational Influence: Early Anamorphic Filmmaking in Japan." In *Widescreen Worldwide*, ed. John Belton, Sheldon Hall, and Steve Neale, 175–98. Bloomington: Indiana University Press, 2010.
Desjardins, Chris. *Outlaw Masters of Japanese Film*. London: I. B. Tauris, 2005.
Desser, David. *Eros Plus Massacre*. Bloomington: Indiana University Press, 1988.
———. "Gate of Flesh(-tones): Color in the Japanese Cinema." In *Cinematic Landscapes: Observations on the Visual Arts and Cinema of China and Japan*, ed. Linda C. Erlich and David Desser, 299–317. Austin: University of Texas Press, 1994.
———. "The Gunman and the Gun: Japanese Film Noir Since the Late 1950s." In *International Noir*, ed. R. Barton Palmer and Homer B. Pettey. Edinburgh: Edinburgh University Press, 2014.
———, ed. *Ozu's Tokyo Story*. Cambridge: Cambridge University Press, 2003.
DiNitto, Rachel. "Translating Prewar Culture Into Film: The Double Vision of Suzuki Seijun's *Zigeunerweisen*." *Journal of Japanese Studies* 30, no. 1 (Winter 2004): 35–63.
———. *Uchida Hyakken: A Critique of Modernity and Militarism in Prewar Japan*. Cambridge, Mass.: Harvard University Press, 2008.
Dombrowski, Lisa. "Cheap but Wide: The Stylistic Exploitation of CinemaScope in Black-and-White, Low-Budget American Films." In *Widescreen Worldwide*, ed. John Belton, Sheldon Hall, and Steve Neale, 63–70. Bloomington: Indiana University Press, 2010.
Domenig, Roland. "The Anticipation of Freedom: Art Theater Guild and Japanese Independent Cinema." *Midnight Eye*, June, 28, 2004. http://www.midnighteye.com/features/the-anticipation-of-freedom-art-theatre-guild-and-japanese-independent-cinema/.
Dowsey, Stuart, ed. *Zengakuren: Japan's Revolutionary Students*. Berkeley. Calif.: Ishi Press, 2012.
Eisenstein, Sergei. *Film Form: Essays in Film Theory*, ed. and trans. Jay Leyda. New York: Meridian Books, 1957.
"From the Ruins: Making *Gate of Flesh*." *Gate of Flesh*. New York: Criterion Collection, 2005.

Fujiwara, Chris. "The Critical Event of *Director Ozu Yasujiro*." *LOLA*, no. 7 (November 2016). http://www.lolajournal.com/7/hasumi_fujiwara.html.
Fukasawa, Tetsuya. "*Yaju no seishun*" [*Youth of the Beast* review], *Kinema junpō*, no. 342 (June 1963): 86.
Fukiji, Hideaki, and Alastair Phillips, eds. *The Japanese Cinema Book*. London: BFI, 2020.
Furuhata, Yuriko. *Cinema of Actuality: Japanese Avant-garde Filmmaking in the Season of Image Politics*. Durham, N.C.: Duke University Press, 2013.
Gerow, Aaron. "Critical Reception: Historical Conceptions of Japanese Film Criticism." In *The Oxford Handbook of Japanese Cinema*, ed. Daisuke Miyao, 61–78. Oxford: Oxford University Press, 2014.
———. "Introduction: The Theory Complex." *Review of Japanese Culture and Society* 22 (December 2010): 1–13.
———. *Visions of Japanese Modernity: Articulations of Cinema, Nation, and Spectatorship, 1895–1925*. Berkeley: University of California Press, 2010.
Gerow, Aaron, Iwamoto Kenji, and Abé Mark Nornes, eds. *Nihon senzen eiga ronshū: Eiga riron no saihakken* [Collected prewar Japanese film theory: Rediscovering film theory]. Tokyo: Yumani shobō, 2018.
Gondō Susumu. "Suzuki Seijun to Kita Ikki: Shiroi yuki ni nijinda akai kanashimi" [Suzuki Seijun and Kita Ikki: Red sorrow blurred in the white snow]. *Shinema 69* 2 (1969): 57–63.
Gorbman, Claudia. *Unheard Melodies: Narrative Film Music*. Bloomington: Indiana University Press, 1987.
Graham, Peter, ed. *The French New Wave: Critical Landmarks (2009 Edition)*. London: BFI, 2009.
Gunning, Tom. "Narrative Discourse and the Narrator System." In *Film Theory and Criticism*, ed. Leo Braudy and Marshall Cohen, 390–401. Oxford: Oxford University Press, 2009.
———. "Phantom Images and Modern Manifestations: Spirit Photography, Magic Theater, Trick Films, and Photography's Uncanny." In *Cinematic Ghosts: Haunting and Spectrality from Silent Cinema to the Digital Era*, ed. Murray Leeder, 17–38. New York: Bloomsbury, 2015.
Guryū Hachirō. "Zoku Kenka ereji" [Fighting Elegy continued]. *Eiga hyōron* 7 (July 1968): 106–40.
———. "Gōsuto-taun no akai shishi" [Red lion of the ghost town]. *Eiga hyōron* 7 (July 1968): 141–73.
Han, Namhee. "Technologies of Anamorphic Vision: Widescreen Cinema and Postwar Modernity in Japan and South Korea." Ph.D. diss., University of Chicago, 2014, ProQuest Dissertation Publishing UMI 3615650.
Hasumi Shigehiko. "Akutarō-san" [In praise of *Akutarō*]. *Yurīka* 49-8, no. 701 (May 2017): 42–46.
———. "Aran Rene: Arui wa kagami wo okoreru narushisu" [Alain Resnais: or Narcissus frightened by his own reflection]. *Shinema 69* 1 (1969): 32–41.
———. *Eiga kyojin, kataru* [Madman of cinema speaks]. Tokyo: Aoki shoten, 2001.
———. *Eiga yūwaku no ekurichuru* [Writings on the allurement of cinema]. Tokyo: Chikuma shobō, 1997.
———. *Eizo no shigaku* [Poetics of cinema]. Tokyo: Chikuma shobō, 2012.
———. "Hihyō to firumu taiken" [Criticism and the physical experience of film]. *Shinema 71* 8 (1971): 2–14.
———. *Hyōsō hihyō no sengen* [Proclamation for surface criticism]. Tokyo: Chikuma shobō, 1979.

———. "Miburi o kaita temaneki: *Hishu Monogatari*" [Beckoning without a gesture: *A Tale of Sorrow and Sadness*]. *Eiga geijutsu* (August 1977): 110–12.

———. "Suzuki Seijun, mata ha kisetsu no fuzai" [Suzuki Seijun, or the absence of seasons]. *Yurīka* 4 (April 1991).

———. "Suzuki Seijun: soshite sono chinmoku no naritachi" [Suzuki Seijun and the structure of his silence]. *Shinema 69* 2 (1969): 49–56.

Hayashi, Sharon. "Marquis de Sade Goes to Tokyo: The Gynaecological-political Allegories of Wakamatsu Koji and Adachi Masao." In *The Pink Book: The Japanese Eroduction and Its Contexts*, ed. Abé Mark Nornes, 265–93. Ann Arbor, Mich.: Kinema Club, 2014.

Hayter, Irena. "Figures of the Visual: Japanese Modernism, Technology, Vitalism." *positions* 25, no. 2 (2017): 293–322.

Heath, Stephen. "Narrative Space." *Screen* 17, no. 3 (1976).

Heckman, Heather. "We've Got Bigger Problems: Preservation During Eastmancolor's Innovation and Early Diffusion." *Moving Image* 15, no. 1 (Spring 2015): 44–61.

Hillier, Jim, ed. *Cahiers du Cinéma: The 1950s*. Cambridge, Mass.: Harvard University Press, 1985.

———. *Cahiers du Cinéma: The 1960s*. Cambridge. Mass.: Harvard University Press, 1986.

Hirano, Kyoko. *Mr. Smith Goes to Tokyo*. Washington, D.C.: Smithsonian Institute, 1992.

Hobsbawm, Eric. *Primitive Rebels*. Manchester: University of Manchester Press, 1959.

Honda Akiko and Yahata Kaoru, eds. "*Sonna koto wa mō wasureta yo*": *Suzuki Seijun Kanwashū* ["I've already forgotten about that": A collection of conversations with Suzuki Seijun]. Tokyo: Space Shower, 2018.

Ichikawa Kon. "CinemaScope and Me." In *Kon Ichikawa*, ed. James Quandt, 303–6. Toronto: Cinematheque Ontario, 2001.

Interview with Suzuki Seijun. *Tokyo Drifter*. Blu-ray. New York: Criterion Collection, 2011.

Interview with Suzuki Seijun and Kuzū Masami. *Tokyo Drifter*. Blu-ray. New York: Criterion Collection, 2011.

Ioka Junichi. *Watashi no "Rupan sansei" funtōki: Anime kyakuhon monogatari* [The record of my strenuous efforts on "Lupin the Third": A story of anime screenwriting]. Tokyo: Kawade, 2015.

Ishigami Mitsutoshi. "Jūmon ni miirarete: Suzuki Seijun no reihō" [Possessed by the charm: The sacred mountain of Suzuki Seijun]. Interview with Suzuki Seijun and Kimura Takeo. *Eiga hyōron* 23, no. 11 (November 1966): 19–36.

Isoda Tsutomu and Todoroki Yukio, eds. *Sei/jun/ei/ga*. Tokyo: Wides Shuppan, 2006.

Itō Akihiko. "Suzuki Seijun eiga o idotta joyu: Nogawa Yumiko intabyū" [The actresses who adorned Suzuki Seijun films: Nogawa Yumiko interview]. *Kinema junpō*, no. 1744 (April 2017) 2: 28–30.

Iwabuchi, Koichi. *Recentering Globalization: Popular Culture and Japanese Transnationalism*. Durham, N.C.: Duke University Press, 2002.

Iwama Yoshiki. *Kurobe no taiyō (Daisanwa): Otoko no naka ni wa tori ga iru* [Screenplay]. N.p., Junbikō, n.d.

Jackson, Rosemary. *Fantasy: The Literature of Subversion*. London: Routledge, 1981; digital printing 2003.

Jacoby, Alexander. *A Critical Handbook of Japanese Film Directors*. Berkeley, Calif.: Stone Bridge Press, 2008.

Kaffen, Philip James. "Image Romanticism and the Responsibility of Cinema: The Indexical Imagination in Japanese Film." PhD Diss., 2011, ProQuest Dissertation Publishing (UMI Number: 3482895)

Kajiwara Ryūji. "Suzuki Seijun no bi" [The aesthetics of Suzuki Seijun]. *Eiga hyōron* 21, no. 7 (July 1964): 69–71.
Kamijima Haruhiko. "Noguchi Hiroshi-gumi Suzuki Seitarō to iu shifuku: Shoki Nikkatsu akushon eiga ni okeru futari" [The supreme beauty of Suzuki Seitarō from the Noguchi Hiroshi Group: Two people at the start of Nikkatsu Action Cinema]. *Yurīka* 49-8, no. 701 (May 2017): 82–87.
Kanemura Osamu. "Kokoro no nai Suzuki Seijun no eiga" [The heartless films of Suzuki Seijun]. *Yurīka* 49-8, no. 701 (May 2017): 78–81.
Karatani Kōjin. *Origins of Modern Japanese Literature*, trans. Brett de Bary. Durham, N.C.: Duke University Press, 1993.
Karatani Kōjin and Hasumi Shigehiko. *Karatani Kōjin Hasumi Shigehiko zentaiwa* [The collected dialogues of Karatani Kōjin and Hasumi Shigehiko]. Tokyo: Kōdansha, 2013.
Kasahara Ryōzō and Kon Tōkō. "Akutarō" [The incorrigible]. Original screenplay. Tokyo: Nikkatsu, 1963.
———. "Warui hoshi no shita demo" [Born under crossed stars]. Original screenplay. Tokyo: Nikkatsu, 1965.
Kawakami, Chiyoko. "The Metropolitan Uncanny in the Works of Izumi Kyōka: A Counter-Discourse on Japanese Modernization." *Harvard Journal of Asiatic Studies* 59, no. 2 (December 1999): 559–83.
Kawarabata Yasushi. "Shiki: Suzuki Seijun mondai no ichi saikuru" [One cycle of the Suzuki Seijun movement: My diary]. In *Genzo to seiji no aida* [Between politics and illusion]. Vol. 5 of *Gendai Nihon eigaron taikei* [System of modern Japanese film theory], ed. Ogawa Tōru, Watano Tetsuro, Ījima Tetsuo, and Yamane Sadao. Tokyo: Tōjusha, 1971.
———. "Suzuki Seijun jiken repōto: Sakka ni osareta 'Koroshi no rakuin'" [Suzuki Seijun incident report: *Branded to Kill* pushed by author]. *Eiga hyōron* 25, no. 7 (July 1968).
———. "Suzuki Seijun jiken repōto 2: 'Oretachi no chi ga yurusanai'" [Suzuki Seijun Incident report 2: "Our blood will not forgive"]. *Eiga hyōron* 25, no. 8 (August 1968), 63–67.
———. "Suzuki Seijun jiken repōto 3: Kyōto kaigi de eiga kakushin" [Suzuki Seijun Incident report 3: Toward film reform at the Joint Struggle Committee]. *Eiga hyōron* 25, no. 9 (September 1968): 64–69.
———. "Suzuki Seijun jiken repōto 4: Nikkatsu ga hayaku mo tōbensho teishutsu" [Suzuki Seijun Incident report 4: Nikkatsu has already presented its legal documents]. *Eiga hyōron* 25, no. 10 (October 1968): 61–64.
———. "Suzuki Seijun jiken repōto 5: Baberu no tō kara" [Suzuki Seijun Incident report 5: From the Tower of Babel]. *Eiga hyōron* 25, no. 12 (December 1968): 44–47.
Kazuki Ryōsuke. "Suzuki Seijun yo, ongaku ni motto aijō o: Sono bi no sekai o kansei suru tame ni" [Suzuki Seijun, love music more!: To perfect your aesthetic world]. *Eiga hyōron* 21, no. 11 (November 1964): 85–86.
Keathley, Christian. *Cinephilia and History, or the Wind in the Trees*. Bloomington: Indiana University Press, 2005.
Kerkham, H. Eleanor. "Pleading for the Body: Tamura Taijirō's 1947 Korean Comfort Woman Story, Biography of a Prostitute." In *War, Occupation, and Creativity: Japan and East Asia, 1920–1960*, ed. Marlene J. Mayo and J. Thomas Rimer with H. Eleanor Kerkham, 310–59. Honolulu: University of Hawai'i Press, 2001.
Kimura Takeo. "Guryū Hachirō ni tsui te" [About Guryū Hachirō]. *Mita bungaku* 79, no. 3 (61): 91–93.
———. "Kotoshi koso Suzuki Seijun kantoku ni eiga o tottemorau tame ni!" [To help director Suzuki Seijun finally return to filmmaking this year!]. *Kinema junpō* 1, no. 654 (April 1975): 118–20.

Kinoshita, Chika. "The Mummy Complex: Kurosawa Kiyoshi's *Loft* and J-Horror." *Horror to the Extreme: Changing Boundaries in Asian Cinema*, ed. Jinhee Choi and Mitsuyo Wada-Marciano, 103–22. Hong Kong: Hong Kong University Press, 2009.

Kitsnik, Lauri. "Scenario Writers and Scenario Readers in the Golden Age of Japanese Cinema." *Journal of Screenwriting* 7, no. 2 (2016): 285–97.

Komatsu, Hiroshi. "From Natural Color to the Pure Motion Picture Drama." *Film History* 7 (1995): 69–86.

Kōno Marie. "Katarazaru danpen no shibire: Merodoama toshite mita Seijun eiga" [The mesmerizing nature of fragments that do not speak: Watching Suzuki Seijun films as melodramas"] *Yurīka* 49-8, no. 701 (May 2017): 97–103.

Kovacs, Andras Balint. *Screening Modernism: European Art Cinema, 1950–1980*. Chicago: University of Chicago Press, 2007.

Kuramoto Tetsu. *Shineasuto wa kataru—1: Suzuki Seijun*. [*Cineastes Speak—1: Suzuki Seijun*] Nagoya: Nagoya Cinematheque, 1990.

Kusumoto Kenkichi, ed. *Ninkyō eiga no sekai* [The world of the ninkyō film]. Tokyo: Arechi, 1969.

Lamarre, Thomas. *The Anime Machine*. Minneapolis: University of Minnesota Press, 2009.

Lee, Laura. *Japanese Cinema Between Frames*. New York: Palgrave Macmillan, 2017.

Lippit, Noriko Mizuta. "Western Dark Romanticism and Japan's Aesthetic Literature." In *Reality and Fiction in Modern Japanese Literature*, 70–81. White Plains, N.Y.: M. E. Sharpe, 1980.

Lippit, Seiji M. *Topographies of Japanese Modernism*. New York: Columbia University Press, 2002.

Lundemo, Trond. "The Colors of Haptic Space: Black, Blue, and White in Moving Images." In *Color, the Film Reader*, ed. Angela Dalle Vacche and Brian Price, 88–101. New York: Routledge, 2006.

MacKenzie, Scott, ed. *Film Manifestos and Global Cinema Cultures: A Critical Anthology*. Berkeley: University of California Press, 2014.

Marotti, William. "Japan 1968: The Performance of Violence and the Theater of Protest." *American Historical Review* (February 2009): 97–135.

——. *Money, Trains, and Guillotines: Art and Revolution in 1960s Japan*. Durham, N.C.: Duke University Press, 2013.

Martin, Adrian. "Cinephilia as War Machine." *Framework: The Journal of Cinema and Media* 50, no. 1 & 2 (2009): 221–25.

——. "Given to See: A Tribute to Shigehiko Hasumi." *LOLA*, no. 7 (November 2016). http://www.lolajournal.com/7/hasumi_martin.html.

Matsuda Masao. *Bara to mumeisha: Matsuda Masao eiga ronshū* [Roses and anonymous people: The collected film writings of Matsuda Masao]. Tokyo: Haga shoten, 1970.

Matsumoto Toshio. *Eiga no henkaku: Geijutsuteki rajikarizumu to wa nani ka* [Revolution of cinema: What is formal radicalism?]. Tokyo: San'ichi shobō, 1972.

——. *Hyōgen no sekai: Geijutsu zen'eitachi to sono shisō*. [*The world of expression: Avant-garde form and its ideology*] Tokyo: San'ichi shobō, 1967.

——. "A Theory of Avant-Garde Documentary," trans. Michael Raine. *Cinema Journal* 51, no. 4 (Summer 2012): 148–54.

Misek, Richard. *Chromatic Cinema: A History of Screen Color*. Hoboken, N.J.: Wiley-Blackwell, 2010.

Miyao, Daisuke. *The Aesthetics of Shadow: Lighting in Japanese Cinema*. Durham, N.C.: Duke University Press, 2013.

———. "Dark Visions of Japanese Film Noir: Suzuki Seijun's *Branded to Kill*." In *Japanese Cinema: Texts and Context*, ed. Alistair Phillips and Julian Stringer. New York: Routledge, 2007.
———. "Out of the Past: Film Noir, Whiteness, and the End of the Monochrome Era." In *East Asian Film Noir: Transnational Encounters and Intercultural Dialogue*, ed. Chi-yun Shin and Mark Gallagher, 21–36. New York: Bloomsbury, 2015.
Motomura Shuji, ed. *Sōtokushū Suzuki Seijun* [Suzuki Seijun complete special edition]. Tokyo: Kawade, 2001.
Mourlet, Michel. "Sur un art ignoré." *Cahiers du cinéma*, no. 10 (August 1959): 23–37.
Murakami Tadahisa. *Nihon eiga sakkaron*. Tokyo: Kinema junpō-sha, 1937.
Murakami, Takashi. *Superflat*. Tokyo: Dainippon, 2001.
Nakamura Hideyuki. "Ozu, or On the Gesture," trans. Kendall Heitzman. *Review of Japanese Culture and Society* 22 (2010): 145–46.
Napier, Susan. *The Fantastic in Modern Japanese Literature: The Subversion of Modernity*. New York: Routledge, 1996.
Nagato Yōhei. "Eiga no shijima" [The silence of the movie]. *Yurīka* 49-8, no. 701 (May 2017): 114–21.
Naremore, James. *More than Night: Film Noir in Its Contexts*. Berkeley: University of California Press, 1998.
Noonan, Patrick. "The Alterity of Cinema: Subjectivity, Self-Negation, and Self-Realization in Yoshida Kijū's Film Criticism." *Review of Japanese Culture and Society* 22 (December 2010): 110–29.
Nornes, Abé Mark, and Aaron Gerow. *Research Guide to Japanese Film Studies*. Ann Arbor: Center for Japanese Studies, University of Michigan, 2009.
Okajima Hisashi. "Color Film Restoration in Japan: Some Examples," trans. Akiko Mizoguchi. *Journal of Film Preservation* 66 (October 2003): 32–36.
Olson, Lawrence. *Ambivalent Moderns*. Lanham, Md.: Rowman & Littlefield, 1992.
Ōshima, Nagisa. *Cinema, Censorship, and the State: The Writings of Nagisa Oshima*, trans. Dawn Lawson. Cambridge, Mass.: MIT Press, 1992.
Perkins, V. F. *Film as Film: Understanding and Judging Movies*. New York: Penguin, 1986.
Pettey, Homer B. "Early Japanese Noir." In *International Noir*, ed. R. Barton Palmer and Homer B. Pettey, 85–111. Edinburgh: Edinburgh University Press, 2014.
Poulton, M. Cody. *Spirits of Another Sort: The Plays of Izumi Kyōka*. Ann Arbor: University of Michigan Press, 2001.
Raine, Michael. "Introduction to Matsumoto Toshio: A Theory of Avant-Garde Documentary." *Cinema Journal* 51, no. 4 (Summer 2012): 144–47.
———. "Ishihara Yūjirō: Youth, Celebrity, and the Male Body in Late-1950s Japan." In *Word and Image in Japanese Cinema*, 211–16. Cambridge: Cambridge University Press, 2001.
———. "Youth, Body, and Subjectivity in the Japanese Cinema, 1955–1960." Ph.D. diss., University of Iowa, 2002, Proquest Dissertation Publishing UMI 3052454.
Rancière, Jacques. *Disagreement: Politics and Philosophy*, trans. Julie Rose. Minneapolis: University of Minnesota Press, 1999.
Rayns, Tony, and Simon Field. *Branded to Thrill: The Delirious Cinema of Suzuki Seijun*. London: BFI, 1995.
Richards, Rashna Wadia. *Cinematic Flashes: Cinephilia and Classical Hollywood*. Bloomington: Indiana University Press, 2013.
Rodowick, D. N. *The Crisis of Political Modernism: Criticism and Ideology in Contemporary Film Theory*. Berkeley: University of California Press, 1995.

Rosenbaum, Jonathan. "Building from Ground Zero: *A Hen in the Wind*." jonathanrosenbaum.net, September 21, 2016. https://www.jonathanrosenbaum.net/2016/09/building-from-ground-zero-a-hen-in-the-wind-tk/.
Rosenbaum, Jonathan, and Adrian Martin. *Movie Mutations: The Changing Face of World Cinephilia*. London: BFI, 2003.
Rotterdam International Film Festival. *Suzuki Seijun: The Desert Under the Cherry Blossoms*. Rotterdam: Film Festival Rotterdam, NFM/IAF, VPRO, Uitgeverij Uniepers Abcoude, 1991.
Saiga Akira. "Tōkyō naito" [Tokyo knights]. Original screenplay. Tokyo: Nikkatsu, 1967.
Saito, Ayako. "Occupation and Memory: The Representation of Woman's Body in Postwar Japanese Cinema." In *The Oxford Handbook of Japanese Cinema*, ed. Daisuke Miyao. Oxford: Oxford University Press, 2014.
Sarris, Andrew. *The American Cinema: Directors and Directions 1929–1968*. Boston: Da Capo Press, 1996.
———. "Notes on the Auteur Theory in 1962." In *Film Theory and Criticism: Introductory Readings*, ed. Leo Braudy and Marshall Cohen, 515–18. Oxford: Oxford University Press, 1999.
Satō, Tadao. *Currents in Japanese Cinema*, trans. Gregory Barrett. New York: Kodansha International/USA, 1982.
Schilling, Mark. *No Borders, No Limits: Nikkatsu Action Cinema*. Godalming, UK: FAB Press, 2007.
———. *The Yakuza Movie Book*. Berkeley: Stone Bridge Press, 2003.
Shambu, Girish. "For a New Cinephilia." *Film Quarterly* 72, no. 3 (Spring 2019): 32–34.
———. *The New Cinephilia (Kino-Agora Book 8)*. Montreal: caboose, 2014.
Sharp, Jasper. *Historical Dictionary of Japanese Cinema*. Lanham, Md.: Scarecrow Press, 2011.
———. "Japanese Widescreen Cinema: Commerce, Technology and Aesthetics." Ph.D. diss., University of Sheffield, 2013.
Shinematēku bibō sōchi. "'Hanafubuki mau! Haru no Suzuki Seijun maboroshi no sakuhin Matsuri'~Guryū Hachirō to 10-nen: Dotō hen." ['Storm of falling petals! Festival of the lost works of Suzuki Seijun'—ten years of Guryū Hachirō]. http://callmesnake1997.hatenablog.com/entry/seijun_guru2.
Shirai Yoshio and Iijima Tetsuo. "Suzuki Seijun/Katō Tai: Nihon eiga ranse no itanji" ["Suzuki Seijun/Katō Tai: *Enfant terribles* of Japanese cinema's turbulent era"]. *Kinema junpō* 440 (June 1967): 40–49.
Shklovsky, Viktor. "Art as Device." In *Theory of Prose*, trans. Benjamin Sher, 1–14. Elmwood Park, Ill.: Dalkey Archive Press, 1990.
Silverberg, Miriam. *Erotic Grotesque Nonsense: The Mass Culture of Japanese Modern Times*. Berkeley: University of California Press, 2009.
Sone Chūsei. *Sone Chūsei jiden: Hito wa nanomi no tsumi no fukasa yo* [Autobiography of Sone Chūsei]. Tokyo: Bunya-sha, 2014.
———. "Suzuki Seijun ron: utae odore" [On Suzuski Seijun: Sing, dance]. *Eiga geijutsu* 16 12 255 (July 1968): 52–54.
Style to Kill—Koroshi no rakuin VISUAL DIRECTORY. Tokyo: Puchi Gura Paburisshingu, 2001.
Suchenski, Richard I. "On Hasumi." *LOLA*, no. 7 (November 2016). http://www.lolajournal.com/7/hasumi_suchenski.html.
Suzuki Seijun. *Bōryoku sagashi ni machi e deru* [Leaving the town in search of violence]. Tokyo: Hokutō shobō, 1973.

———. *Hana jigoku* [Flower hell]. Tokyo: Hokutō shobō, 1972.
———. *Kenka erejī* [Fighting elegy]. Tokyo: Nihon Tōsho sentā, 1970.
———. *Koshū* [Lonely contemplation]. Tokyo: Hokutō shobō, 1980.
———. *Machizukushi* [City planning]. Tokyo: Hokutō shobō, 1990.
———. *Sukkorobi sennin no jinseiron* [The life view of a toppled-over hermit]. Tokyo: Kōdansha, 1995.
———. *Yume to kitōshi* [Dreams and medicine man]. Tokyo: Isseidō, 1991.
Suzuki Seijun interview, "Dōmo kensetsu wa kirai de ne . . .: Suzuki Seijun wa kataru" [I hate the Establishment . . . : Suzuki Seijun speaks] (Hasumi Shigehiko, Ueno Kōshi, Editors). *Shinema 69*, no. 2 (April 1969): 30–43.
Suzuki Seijun mondai kyōtō kaigi. *Nihon eiga no genjo to hihan: Suzuki Seijun mondai Kyoto kaigi* [The present state of Japanese cinema and criticism: The Suzuki Seijun Joint Struggle Committee] (September and December 1968).
Suzuki Seijun, Paul Willeman, and Satō Tadao, eds. *The Films of Suzuki Seijun*. Edinburgh: Edinburgh Film Festival, 1988.
Suzuki Seijun and Yoshida Shigetsugu. "Staff and Cast Interview." In *Lupan sansei: babiron no ōgon densetsu* (promotional booklet). Tokyo: Tōhō, 1985.
Takahashi Hiroshi. *Eiga no ma* [The dark magic of cinema]. Tokyo: Seidosha, 2004.
Takahashi Hiroshi, Shiota Akihiko, and Ikawa Kōichirō, eds. *Kōya no dacchi waifu: Yamatoya Atsushi dainamaito kessakusen* [Inflatable sex doll of the wastelands: A selection of Yamatoya Atsushi's dynamite masterpieces]. Tokyo: Firumu Ātosha, 1994.
Tanabe Asami and Mayumi Norimasa. "Umi no junjō" [Pure heart of the sea]. Screenplay. Tokyo: Nikkatsu, 1956.
Tanaka, Yōzō. *Tanaka Yōzō chosakushū: Jingaimakyōhen* [Tanaka Yōzō collected writings: Compiled from an ominous place beyond the human world]. Tokyo: Kabushiki kaisha bunyū-sha, 2017.
Taves, Brian. "The B-Film: Hollywood's Other Half." In *Grand Design: Hollywood as a Modern Business Enterprise 1930–1939*, ed. Tino Balio, 313–50. Berkeley: University of California Press, 1995,
Tayama Rikiya. "Fumihazushita haru." [*The Boy Who Came Back* review] *Eiga hyōron* 15, no. 8 (August 1958): 100–101.
Teo, Stephen. "Seijun Suzuki: Authority in Minority." *Senses of Cinema*, no. 8 (July 2000). http://sensesofcinema.com/2000/festival-reports/Suzuki/.
Terada Nobuyoshi and Suzuki Seijun. "Suppadaka no nenrei" [Age of nudity]. Original screenplay. Tokyo: Nikkatsu, 1959.
Theweleit, Klaus. *Male Fantasies*. Vol. 2: *Male Bodies: Psychoanalyzing the White Terror*, trans. Erica Carter and Chris Turner. Minneapolis: University of Minnesota Press, 1989.
Todorov, Tsvetan. *The Fantastic: A Structural Approach to a Literary Genre*, trans. Richard Howard. Ithaca, N.Y.: Cornell University Press, 1975.
Tsivian, Yuri. "Two 'Stylists' of the Teens: Franz Hofer and Yevgenii Bauer." In *A Second Life: German Cinema's First Decades*, ed. Thomas Elsaesser, 264–76. Amsterdam: Amsterdam University Press, 1996.
Tsutomu Isoda, ed. *Seijun sutairu* [Seijun style]. Tokyo: Wides shuppan, 2001.
Tweedie, James. "Interlude 3: Neon." In *Cinema at the City's Edge: Film and Urban Networks in East Asia*, ed. Yomi Braester and James Tweedie, 89–92. Hong Kong: Hong Kong University Press, 2010.
Ueno Koshi. *Eiga: Han Eiyutachi no yume* [Film: The dream of antiheroes]. Tokyo: Hanashi no Tokushu, 1983.

———. "Eiga no omoshirosa to iu koto" [What is called a film's omoshirosa]. *Shinema 71* 7 (1971): 2–10.
———. "Kotoba no ikishini no ketsuraku" [The lack of life and death in words]. *Shinema 70* 6 (1970): 2–7.
———. "Kotoba no ketsuraku ni: hihyō no kidō suru ichi" [What words cannot express: The starting point of film criticism]. *Shinema 71* 8 (1971): 15–23.
———. "Pen to hashi o nigiru onaji te" [The same hand that holds the pen and chopsticks]. *Shinema 70* 4 (1970): 2–5.
———. *Suzuki Seijun zen'eiga* [The complete filmography of Suzuki Seijun]. Tokyo: Rippū shobō, 1986.
———. "Yakuza eiga: hana to okite o jōnen no hiyū toshite" [Yakuza films: Flowers and codes as metonymy for sentiment]. *Shinema 69* 1 (1969): 65–69.
———. "Yakuza eiga: Mujun o onore no nikutai ni" [Yakuza films: The contradictions to our bodies]. *Shinema 69* 2 (1969): 78–85.
———. "Yakuza eiga wa doko e iku ka?" [Where are yakuza films going?]. *Shinema 69* 3 (1969): 86–95.
Ueno Koshi and Hasumi Shigehiko. "1968 nen wa nan da/nan deatta?" [What is/was 1968?]. In *1968*, ed. Suga Hidemi, 20–55. Tokyo: Sakuhinsha, 2005.
Vick, Tom. *Time and Place Are Nonsense: The Films of Seijun Suzuki*. Seattle: University of Washington Press, 2015.
Vincent, J. Keith. *Two-Timing Modernity: Homosocial Narrative in Modern Japanese Fiction*. Cambridge, Mass.: Harvard University Press, 2012.
Watanabe Takenobu. *Nikkatsu akushon no karei na sekai* [The wonderful world of Nikkatsu Action]. Tokyo: Miraiya shoten, 2004.
Watano Tetsurō. "Suzuki Seijun mondai to wa nani ka" [What is the Suzuki Seijun Incident?]. *Shinema 69* 2 (1969).
Wilson, George Macklin. *Radical Nationalist in Japan: Kita Ikki, 1883–1937*. Cambridge, Mass.: Harvard University Press, 1969.
Wollen, Peter. "The Auteur Theory." *Signs and Meanings in the Cinema: Expanded Edition*, 50–78. London: BFI, 1998.
Wood, Robin. *Hitchcock's Films Revisited*. Rev. ed. New York: Columbia University Press, 2002.
———. *Howard Hawks*. New ed. Detroit, Mich.: Wayne State University Press, 2006.
———. *Personal Views: Explorations in Film*. Rev. ed. Detroit, Mich.: Wayne State University Press, 2006.
Yamane Sadao. "Nihon eiga hihyō no genzai chiten" [The current state of Japanese film criticism]. *Shinema 70* 4 (1970): 45–48.
———. "Shūdatsusha Suzuki Seijun: tsubaki no hana wa naze akai no ka" [Suzuki Seijun the exploiter: Why are the camelia flowers red?]. *Shinema 69* 2 (1969): 64–70.
Yamane Sadao and Hasumi Shigehiko, eds. *Midnight Surprise: Katō Tai*. CineFiles, Berkeley Art Museum and Pacific Film Archive, University of California. https://cinefiles.bampfa.berkeley.edu/catalog/27042.
Yamane Sadao, Ueno Kōshi, Fujii Jinshi, and Arai Haruhiko. "Suzuki Seijun o megutte" [Looking at Suzuki Seijun]. *Eiga geijutsu*, no. 459 (Spring 2017): 80–87.
Yamatoya Atsushi. *Akuma ni yudaneyo*. Tokyo: Wides shuppan, 1994.
———. "Ana no kiba" [The fang in the hole]. Screenplay. Osaka: KTV, n.d.
———. "Nagareta kikaku mo ikiteiru: Seijun to mita jūnen no yume." [The lapsed plans still live: The dreams I saw with Suzuki Seijun for ten years]. *Eiga geijūtsu*, no. 317 (June–July 1977): 31–36.

Yamatoya Atsushi, Tanaka Yōzo, and Maeda Katsuhirō. "Yumedono." Screenplay. *Eiga geijutsu*, no. 319 (October 1977): 45–60.
Yamazaki, Iwao. "Ukikusa no yado" [An inn of floating weeds]. Screenplay. Tokyo: Nikkatsu, 1956.
Yomota Inuhiko. *Ajia no naka no nihon eiga* [Japanese cinema in Asia]. Tokyo: Iwanami shoten, 2001.
——. *Nihon eiga no radikaru na ishi* [The radical consciousness of Japanese cinema]. Tokyo: Iwanami shoten, 1999.
——, ed. *Suzuki Seijun essei korekushon* [Suzuki Seijun essay collection]. Tokyo: Chikuma shobō, 2010.
Yoshida Kijū. "My Theory of Film: The Logic of Self-Negation," trans. Patrick Noonan. *Review of Japanese Culture and Society* 22 (December 2010).
Yoshimoto, Mitsuhiro. *Kurosawa: Film Studies and Japanese Cinema*. Durham, N.C.: Duke University Press, 2000.
——. "Questions of the New: Ōshima Nagisa's *Cruel Story of Youth* (1960)." In *Japanese Cinema: Texts and Contexts*, ed. Alastair Phillips and Julian Stringer. New York: Routledge, 2007.
Yoshimoto Takaaki. "Tenkō-ron" [On ideological conversion]. *Showa bungaku zenshū*, no. 27 (February 1989): 642–54.
Zahlten, Alex. *The End of Japanese Cinema: Industrial Genres, National Times, & Media Ecologies*. Durham, N.C.: Duke University Press, 2017.

INDEX

Italicized page numbers refer to figures

Abbe, Ernst, 246n7
Abe Keiichi, 184
Abe Toru, 162–63, 165, 178
Abe Yutaka, 68, 160, 163
À Bout de Souffle [*Breathless*] (Godard, 1960), 40
Actor's Revenge, An [*Yukinojō henge*] (Ichikawa, 1963), 95
Adachi Masao, 17, 18, 22, 186, 251n14
Adult Toy [*Otona no omocha*] (Sone, 1975), 225
Age of Nudity, The [*Supaddaka no nenrei*] (Suzuki, 1959), 71, 74–75, 128, 168–69; flashback sequences, 133, *134*; as melodrama, 80; nondiegetic music in, 133
Aisai-kun, konbanwa [*Good Evening, Dear Husband*] (television series), 76
Akagi Keiichirō, 65, 75, 169, 171, 173; as "Diamond Line" actor, 74; in *Kenjū buraicho* (*Fast-Draw Ryū*) series, 83–84
Akemi Kyōko, 160
Akimoto Ryūta, 166
Akinō Haruko, 210
Akinori Matsuo, 199

Akutagawa Ryūnosuke, 151–52
Amaji Keiko, 160
Amos, Richard, 212
ankokugai (underworld) films, 79, 245n45
Annu Mari, 193
Anpo security treaty, leftist opposition to, 23, 27, 33, 238n58
Aoki Kōichi, 76, 160
Aoki Tomio, 177
Aoki Yūzō, 197, 207
Aoshima Yukio, 195
Aoyama Kōji, 184
Aoyama Shinji, 38–39, 155, 157
"apparatus theory," 233n2
Appearance of a Flower, The [*Hana no omokage*] (Ieki, 1950), 227
Arai Haruhiko, 225
Araki Yumiko, 202
Arata Genjirō, 200, 202–4, 208, 225
Arata Norifumi, 213
Arrow Video box sets, 10
Arsenic and Old Lace (Capra, 1944), 39
Art Theater Guild (ATG), 16, 19, 235n9
"*Aru kettō*" ["A Duel"] (Suzuki, TV episode, 1968), 76

Asada Kenzō, 159, 162–63
Asai Tetsuhiko, 212
Asakusa Opera, 222, 249n24
Asano Junko, 192
Asaoka Ruriko, 69, 74, 83–84, 164, 166, 171, 175, 180–81, 219; in *The Boy Who Came Back*, 14, 165
Asher, William, 186
Ashida Shinsuke, 163–64, 166, 168, 170–72, 183, 217
Ashikawa Izumi, 162, 171, 175–76
aspect ratio: anamorphic [NikkatsuScope] (2.35:1), 35, 67, 93, 94, 97, 164; standard [academy ratio] (1.33:1), 35, 67, 92, 103
Assassination-Counting Song [*Hitokiri uta*] (Suzuki, unfilmed, written 1968), 19, 218
Astruc, Alexandre, 43–44
audiences, 31, 32; attack on complacency of, 33; cinephile, 9; at disadvantage in narrative information, 136–37; expectations of, 4; misleading of, 12, 123; *nonpori* ("nonpolitical"), 30; *omoshirosa* as cultivation of audience interest, 48–52; restricted narration and, 131
auteurism, 9, 43, 45, 60, 240n11
authorship, 54
Azuma, Hiroki, 57, 242n43
Azuma Emiko, 183

Baby-Faced Reporter [*Bottchan kasha*] (Noguchi, 1955), 228
Ballad Dedicated to Mother, A [*Haha ni sasageru barādo*] (Suzuki, unfilmed, written 1973–76), 220, 244n40
Ballad of Narayama [*Narayama bushikō*] (Kinoshita, 1958), 17, 95
Band of Ninja [*Ninja bugeichō*] (Ōshima, 1967), 32
Bandō Tamasaburō, 208
Barr, Charles, 94
Barthes, Roland, 45
Bastard, The. See *Incorrigible, The* [*Akutarō*]
Baudelaire, Charles, 150
Baudry, Jean-Louis, 233n2
Bazin, André, 34, 240n9
BBS no onna (Fujiguchi), 165
Beach Party [*Yamenai de motto*] (Asher, 1963), 186

Beast That Came from the City, The [*Machi ni deta yajū*] (Yamauchi, 1960), 170
Beautiful Teenage Years (Yoshimura, 1964), 69, 185
Beauty and Sin [*Bibō ti tsumi*] (Iwama, 1953), 227
Beauty Without a Face, The [*Ore wa toppu ya da: Kao no nai bijo*] (Ida, 1961), 174
Belisle, Laurie, 206
Belmondo, Jean-Paul, 40
Bengaru, 211
Benisawa Yōko, 183, 188
Bitter Honey [*Mitsu no aware*] (Suzuki, unfilmed, written ca. 2006), 144, 222
Black Tide [*Kuroi shio*] (Yamamura), 64, 79, 183, 228
Blood of Revenge [*Meiji kyōkyakuden: Sandaime shumei*] (Katō, 1965), 51, 86
Blood-Red Water in the Channel [*Kaikyō, chi ni somete*] (Suzuki, 1961), 75, 82, 84, 112–13, 177–79
Bloody Territories [*Kōiki bōryoku: Ryūsetsu no shima*] (Masuda, 1969), 76
Blossoms of Love [*Ajisai no uta*] (Takizawa, 1960), 69, 171
Blue Angel, The (Von Sternberg, 1930), 39
B movies, 13, 68–69, 76
Bogart, Humphrey, 40
Bōmei no michi (Sokabe), 171
Boorman, John, 2
Bordwell, David, 130, 239n2, 247n8
Born Under Crossed Stars [*Akutarō'den: Warui hoshi no shita demo*] (Suzuki, 1965), 3, 71–72, 75, 188–89; as Taishō-set film, 149–50; *kozō* films and, 85
Boy Who Came Back, The [*Fumihazushita haru*] (Suzuki, 1958), 14–15, 68–69, 70, 74, 164–66
Branded to Kill [*Koroshi no rakuin*] (Suzuki, 1967), 10, 12, 16, 19, 23–24, 31, 65, 71, 75, 128–29, 137, 192–93, 225; editing in, 118–19, 120, 122, 246n57; film-within-a-film in, 138–40; flatness in, 56; as ghost story film, 144, 249n12; subjective register of narration in, 134, 135; verticality in, 57–59, 61, 242n43
Branded to Kill Continued [*Zoku'koroshi no rakuin*] (Suzuki, unfilmed, written 1967), 144, 212, 217–18

Branigan, Edward, 107, 114
Bresson, Robert, 91
Burch, Noël, 248n23
By a Man's Face Shall You Know Him [*Otoko no kao no rirekisho*] (Katō), 18

Cahiers du cinéma (film journal), 34, 42–44, 60–61
cameras/camera movements, 43, 115, 121; anamorphic lenses, 92–94, 246n4; dollies and cranes, 69, 80, 91
Canet, Fernando, 143
Cannes Film Festival, 6, 208
capitalism, 24
Capone Weeps with Passion [*Kapone ōi ni naku*] (Suzuki, 1985), 16, 136, 156, 197, 205–6, 243n13; driven by series of associations, 153; supernatural elements in, 144
Capra, Frank, 39
Carmen from Kawachi [*Kawachi karumen*] (Suzuki, 1966), 17, 27, 75, 107, 149, 190; film-within-a-film in, 139–43, 154; as ghost story film, 144, 249n12; mirrors as enframing devices in, 101, *102*, 105–6, *107*; songs in, 78, 132; theatrical staging in, *98*
Carousel Maki, 207
Castle in the Sky [*Tenkū no shiro Rapyuta*] (Miyazaki, 1986), 198
chanbara (swordfighting) genre, 39, 64, 86, 248n23
Chance Meeting in the Rain [*Ame ni meguriai*] (Nomura, 1977), 196
Charell, Erik, 39
Chase the Killer [*Satsujinsha o oe*] (Maeda, 1962), 180
Chiba Kazuhiko, 163, 165, 171–72, 177, 179
Chiba Yasuki, 64
China, Japanese invasion of, 219
Chin Shun-shin, 201
"Chin Shun-shin's 'Claws of the Divine Beast, The'" ["Chin Shun-shin no shinjū no tsume"] (Suzuki, episode of TV show *Mystery Masterpiece Theater*, 1980), 144, 201
Chitei no ryoken (Washio), 168
Chitei no uta (Hirabayashi), 183
Chiyoda Hiroshi, 189

Chō Hiroshi, 188, 190–91, 193
Chuji Kunisada [*Kunisada Chūji*] (Takizawa, 1954), 64, 228
Chūji's Travel Diary (Itō, 1927), 64
Cineaste Speaks, Volume One, A (Suzuki, 1990), 231
cine-clubs, college, 16, 18–19, 68, 235n10, 243n15
Cine-Club Study Group (Shine-kurabu kenkyūkai), 19–22
Cinema 69 [*Shinema 69*] (film journal), 3, 8, 9, 11, 155, 157; cinephilic turn in film theory and, 68; influential critics associated with, 10; Japanese cinephilia in global context and, 42–43, 45–46; *omoshirosa* (interestingness) concept and, 41, 48, 50–52
"Cinema and Criticism" (Hasumi), 53
"Cinema as a System" (Hasumi), 53
cinema of actuality, 33
Cinema of Actuality (Furuhata), 9, 11
"cinema of quality," in France, 43, 60
CinemaScope, 36, 62, 73, 185; in black-and-white, 247n7; in color, 93; theatrical staging and, 95. *See also* NikkatsuScope
cinephilia, 5, 8, 10, 12, 14, 16, 24, 38–42, 61; Anglophone, 37, 42, 46; "cinephiliac moments," 9; college students, 17–18, 235n10; Japanese cinephilia in global context, 42–48; "Seijun Group," 17
City Planning [*Machizukushi*] (Suzuki, 1982), 231
Coates, Paul, 107–8
color, 66, 73–75, 106–14, 123, 238n41; abrupt shifts in, 52, 90, 96, 110; black-and-white substituted in budget cuts, 71; CinemaScope films in, 93; "key color," 111, 114; narration and, 134, 137; negative-space background with abstract color, 111–12; surface and optical, 109
Comolli, Jean-Louis, 233n2
compositing techniques, 104
Confessions of Love [*Iro zange*] (Yutaka), 68, 160, 183
Congratulations Nomiya and Hanako! [*Omedetō Nomiya sama, Hanako sama*] (imperial wedding celebration), 186
Congress Dances (Charell, 1931), 39

Contempt (Godard, 1963), 240n9
Cook, Ryan, 10, 42, 45, 53, 60, 139–40, 235n10, 241n30
Cowardly Gunfighter [*Koshinuke ganfaitā*] (Noguchi, 1963), 182
Crazed Fruit [*Kurutta kajitsu*] (Nakahira, 1956), 33, 68, 72, 87; development of Nikkatsu Action Cinema and, 73–74; *Satan's Town* billed with, 161
Criterion Collection, 67
Critical Handbook of Japanese Film Directors, A (Jacoby, 2008), 47
Crossroads [*Jūjirō*] (Kinugasa, 1928), 245n45
Crossroads of Death [*Shi no jūjirō*] (Inoue, 1956), 79
Cruel Gun Story [*Kenjū zankoku monogatari*] (Furukawa, 1964), 75
Cruel Story of Youth, A [*Seishun zangoku monogatari*] (Ōshima, 1960), 11, 33–35, 173, 239n61
cyclorama walls, 88, 92, 199, 212

Daibotsu Tōge (Inagaki, 1935–36), 39
Daiei film studio, 64, 235n8, 246n56
Daisuke Miyao, 79
Dancing Palace of the Dragon King, The [*Odoru ryūjūgō*] (Sasaki, 1949), 227
Dangerous Relations [*Kiken na kankei*] (Inoue, 1957), 163
Danger Pays [*Yabai koto nara zeni ni naru*] (Nakahira, 1962), 75, 180–81
Daughter of Time [*Toki no musume*] (Naitō, 1980), 220, 244n40
Death by Hanging [*Kōshikei*] (Ōshima, 1968), 32
deep-focus aesthetic, 89, 91, 94, 96, 98
Defiant Ones, The (Kramer), 239n2
Deleuze, Gilles, 53
Delon, Alain, 1–2
Desertion at Dawn [*Akatsuki no dassō*] (Taniguchi, 1950), 30–31, 187–88
Desser, David, 31, 34, 79, 107, 235n7, 247n19
Detective Bureau 2-3: Go to Hell, Bastards! [*Kutabare akutō-domo: Tantei jimusho 2–3*] (Suzuki, 1963), 75, 78, 180–82; editing in, 118, *119*; songs in, 132; mirror in, *101*

Detective Stories: The Face Caused by the Sound of the Gun [*Keiji monogatari: Jūsei ni ukabu kao*] (Kosugi, 1960), 69, 171
Diary of a Yunbogi Boy [*Yunbogi no ikki*] (Ōshima, 1965), 32
DiNitto, Rachel, 152–53
Director's Guild of Japan (Nihon eiga kantoku kyōkai), 13, 21
Dogura magura (Matsumoto, 1988), 226
Doll's Song, The [*Ningyō no uta*] (Saitō, 1959), 169
Donen, Stanley, 39
Don't Kill Him [*Kare o korosuna*] (Iwama, 1952), 227
Don't Let That Woman Escape [*Sono onna o nigasu na*] (Wakasugi, 1958), 166
dōtai shiryoku (skill of seeing movement), 11, 42, 47, 52–60
Dragnet Girl [*Hijosen no onna*] (Ozu, 1933), 245n45
Dreams and Medicine Men [*Yume to kitōshi*] (Suzuki, 1974), 231
Drifter Against the Wind, The [*Kaze ni sakarau nagaremono*] (Yamazaki, 1961), 175
Drunken Angel [*Yoidore tenshi*] (Kurosawa, 1948), 79
"Duel, A" ["Aru kettō"] (Suzuki, episode of TV show *Good Evening, Dear Husband*, 1968), 144, 193–94
Duvivier, Julien, 39
DVD releases, 10

Eagle and Hawk [*Washi to taka*] (Inoue, 1957), 108
Eastmancolor, 108
editing, 72, 91, 114–23, 214; classical continuity editing, 114–15, 117, 123, 129, 139; "cutting with the camera," 65; elliptical, 91, 116–17, 176; establishing shots, 116–19, *122*; "eyeline match" technique, 117, *118*, 241n30; jump cuts, 114–15; montage, 91, 119, *121*, *122*; point-of-view shots, 15, 106, 117, *118*; reaction shots, 15, 83, 117, 126–27; shot/reverse shot, 25, 28, 40, 119, *120*, 121
Eiga hihyō (film journal), 22
Eiga hyōron (film journal), 14, 15, 17, 155

"Eiga no omoshirosa to iu koto" [What is called a film's *omoshirosa*] (Ueno), 41–42, 49
Eight Hours of Terror [*Hachijikan no kyōfu*] (Suzuki, 1957), 40, 62, 74, 82, 162–63; subjective register of narration in, *135*
Eisenstein, Sergei, 91, 120, 122
eizō discourse, 32, 33
Eizō no shigaku [*Poetics of cinema*] (Hasumi, 2012), 42
Embalming [*Enbarumingu EM*] (Aoyama, 1999), 157
Emblem of a Man [*Otoko no monshō*] (Matsuo, 1963), 75
Emori Seijirō, 19, 237n22
Emoto Akira, 206
Enami Kyōko, 196
Enchanted Princess [*Hatsuharu tanuki goten*] (Kimura, 1959), 95
Enchi Fumiko, 195
Endō Saburō, 182
Enka Master of Izu [*Izu no enkashi*] (Nishikawa, 1952), 227
Eros Plus Massacre (Desser, 1988), 31, 235n7
Escape from Japan [*Nihon dasshutsu*] (Yoshida, 1964), 237n28
establishing shots: retroactive, 119, 122, *122*; withholding of, 116–18
Esumi Eimei, 1, 182, 184–87, 191
Esumi Makiko, 212
Everything Goes Wrong [*Subete ga kurutteru*] (Suzuki, 1960), 34–36, 70, 75, 98, 172–73; film-within-a-film in, 138

"Family's Choice, A" ["Kazoku no sentaku"] (Suzuki, episode of TV show *Tuesday Suspense Theater*, 1983), 103, *104*, 138–39, 144, 204–5
"Fang in the Hole, The" ["Ana no kiba"] (Suzuki, episode of TV show *Sunday Horror Series*, 1979), 144, 148, 195, 198–99, 201
fantastic genre, in literature, 147
Farewell to the Southern Tōsa [*Nangoku Tōsa o ato ni shite*] (Saitō, 1959), 74, 81, 82, 115–16
fascism, 23, 25, 28–29, 215–16
Fast-Drawing Ruffian [*Hayauchi burai*] (Noguchi, 1961), 178–79

Female Flower [*Me-bana*] (Abe, 1957), 163
Fighting Delinquents [*Kutabare gurentai*] (Suzuki, 1960), 17, 69, 173–74; color in, 75, 108, 110–11, 173; songs in, 78, 132; *taiyō-zoku* genre and, 34; as kozō film, 84
Fighting Elegy [*Kenka erejī*] (Suzuki, book, 1970), 231
Fighting Elegy [*Kenka erejī*] (Suzuki, film, 1966), 16, 19, 23, 27–28, 31, 75, 191–92, 209; college cinephiles and, 17–18; student movement of 1968 and, 25–26; kozō films and, 85
Fighting Elegy Continued [*Zoku-kenka erejī*] (Suzuki, unfilmed, written ca. 1968), 215–16
Figures Traced in Light (Bordwell, 2005), 247n8
film festivals, international, 67, 200
film industry, Japanese, 6, 18, 158; circulation of films in Asia, 4, 234n6; evolution of Suzuki's filmmaking practice and, 12
film theory/criticism: cinephilic turn in, 47–48, 51, 60, 68; *eizō* discourse, 32–33; interplay of theory and practice, 7–12; Japanese cinephilia in global context and, 42–48; *omoshirosa* (interestingness) concept and, 11, 41–42, 47–52. See also *Cinema 69* [*Shinema 69*]
film-within-a-film (*geki chū geki*), 32, 40, 154; blurring of narration registers and, 138–43; in *Branded to Kill*, 138–39; in *Carmen from Kawachi*, 138–39; in *Everything Goes Wrong*, 35–36, 129, 138; in "A Family's Choice," 138; in *Our Blood Will Not Forgive*, 138–39; in *Young Breasts*, 127–29, 138; in *Youth of the Beast*, 40, 41, 138
Final Duel, The [*Rakujitsu no kettō*] (Noguchi, 1955), 65, 73, 81, 228
Fistful of Dollars, A (Leone, 1964), 216
"five-studio system," 16, 19, 235n8
flashbacks: in *The Age of Nudity*, 133–34; in *Everything Goes Wrong*, 36; in *The Flowers and the Angry Waves*, 104, *105*; in *The Incorrigible*, 72; in *Kanto Wanderer*, 88, 98; in *Theater of Life* (Sawashima), 87; in *Young Breasts*, 126, 127–28

flatness, of cinematic image, 4, 55–56; appearance of depth and, 92, 106, *107*; flat staging, 99, 100; in *Tokyo Drifter*, 2; in *Youth of the Beast*, 3, *57*, 61

Flower Cheerleading Squad [*Aa! Hana no ōendan*] (Sone, 1976), 225

Flower-Eating Insect, The [*Hana o kū mushi*] (Nishimura, 1967), 193

Flower Hell [*Hana jigoku*] (Suzuki, 1972), 231

Flowers and the Angry Waves, The [*Hana to dōto*] (Suzuki, 1964), 16–17, 70, 75, 184–85, 189; color in, 113; as *ninkyō* film, 87, 246n57; rear projection in, *105*; as Taishō-set film, 69; theme song, 78

Flowers of Shanghai, The (Hou, 1998), 46

Flowers That Blossom in Rain [*Ame ni saku hana*] (Nakajima, 1960), 173

Ford, John, 39, 42, 60, 82, 163

Foreigner's Mistress Oman [*Rashamen Oman*] (Sone, 1972), 224

Forging the Swords [*Chūken*] (Suzuki, unfilmed, written 1969), 144, 218–19

formalism, 43, 54–55, 242n35

Foucault, Michel, 53

French New Wave, 34, 42

Fujicolor, 108

Fujiguchi Tōgo, 165

Fujii Hideo, 199

Fujimaki Saburō, 169

Fuji Manami, 193

Fujimura Shiho, 204

Fujioka Jūkei, 177

Fujioka Kumenobu, 159, 169

Fujisawa Junichi, 205, 208, 211

Fujita Makoto, 148, 199

Fujita Toshiya, 22, 76, 195, 200, 224

Fuji Tatsuya, 179

Fujiura Atsushi, 172

Fujiyama Ryuichi, 188

Fukami Taizō, 162

Fukasaku Kinji, 42, 61

Fukasawa Tetsuya, 54

Fukuda Fumiko, 162, 164–65

Fuller, Samuel, 240n11, 245n43

Funahashi Kazuo, 184

Funeral Parade of Roses [*Bara no sōretsu*] (Matsumoto, 1969), 32, 216

Furuhata, Yuriko, 7, 9, 11, 32, 143, 236n13, 237n32

Furukawa Takumi, 75, 175, 177–78

fusuma screens, 100, 103, 112–13, 117, 248n23

Fuyushima Taizō, 246n4

Gakushuin University, 18

Garden of Sorrow [*Aishū no sono*] (Yoshimura, 1956), 162

Gate of Beasts [*Yajū no mon*] (Furukawa, 1961), 178

Gate of Flesh [*Nikutai no mon*] (Suzuki, 1964), 16–17, 27, 70, 71, 75, 142, 185–86, 237n22, 238n41; color in, 104–5, 107, 111–14, 247n11; internal monologues in, 111–12; subjective register of narration in, 134

Gazing at Love and Death [*Ai to shi o mitsumete*] (Saitō, 1964), 186

Genet, Jean, 32

Gerow, Aaron, 7, 10, 234n9, 241n24

Gibbs, John Edward, 43

Ginza Love Story [*Ginza no koi no monogatari*] (Kurahara, 1962), 75

Ginza Tough-Guy Nikaidō Takuya [*Nikaidō Takuya ginza buraichō*] (Noguchi, 1962), 179

Godard, Jean-Luc, 34, 38–39, 42, 129, 240n9

Gō Eiji, 176, 178, 182

Gondō Susumu, 42

Gone with the Wind (Fleming/Cukor/Wood, 1939), 47

Good for Nothing (Yoshida), 238n58

Gorbman, Claudia, 131–32

Gosho Heinosuke, 13, 21, 63

Greater Japan Motion Picture Production Company (Dai Nihon eiga seisaku kabkishikigaisha). *See* Daiei film studio

Great Kantō Earthquake (1923), 149–50, 222

"green screening," 104

Griffith, D. W., 91

Gunning, Tom, 130, 154

Guryū Hachirō ("Group of Eight"), 18–19, 25, 27, 30, 66, 71, 191–93, 209, 215–17, 223–26, 238n39

Habu Port [*Habu no minato*] (Saitō, 1963), 183

Hagiwara Izumi, 172

Hagiwara Kenichi, 206
Hagiwara Kenji, 179, 191
Hai-tīn jōfu (Ichijō), 172
Hall of Dreams [Yumedono] (Suzuki, unfilmed, written 1972), 144, 219–20
Hamada Akira, 202
Hamada Mitsuo, 176, 190
Hamada Torahiko, 178
Hamakawa Tomoko, 191
Hamamura Jun, 178, 192, 195
Hanabusa Yuriko, 178
Hananomoto Kotobki, 189
Hangai Yasuaki, 18, 191–92, 215, 223–24. *See also* Guryū Hachirō ("Group of Eight")
Hani Susumu, 23, 34
Harada Kiwako, 211
Harada Tomoyo, 211
Harada Yoshio, 148, 196, 199–200, 203, 208, 211–12, 219, 230
Hara Kensaku, 229
Hara Kenzaburō, 173–74
Harbor of Evil [Kyōaku no hatoba] (Furukawa, 1961), 177
Harbor Toast: Victory Is Ours [Minato no kanpai: shōri o wa ga te ni] (Suzuki, 1956), 14, 73, 77, 159–60; deep-focus staging in, 96, 97; as kayō film, 68, 76; songs in, 67; as crime film, 79
Harusame monogatari [Tales of spring rain] (Ueda), 138, 146, 195
Hasebe Yasuharu, 76, 195, 199, 202, 204
Hasegawa Kazuhiko, 208
Hase Yuri, 186
Hashimoto Shinobu, 128
Hasumi Shigehiko, 3, 9, 10, 45, 54–55, 59, 63, 128, 242n43; Anglophone cinephilia and, 46; auteurism of, 60; on *Branded to Kill*, 56–57; *Cinema 69* and, 11, 42; essay on Suzuki, 24–25, 31; on "eyeline match" technique, 241n30; on flatness and depth in Suzuki's films, 112; flatness of image as preoccupation of, 56–57; French cinephile influence on, 42–43, 45; future filmmakers among students of, 155, 157–58; on *The Incorrigible*, 80–81; on kineticism, 52–53; poststructural auteurist method of, 46; on Suzuki and the Taishō era, 149; translated into English, 46–47, 241n17;

writings on Suzuki, 12, 42, 53–59; on *Youth of the Beast*, 54–55
Hatsui Kotoe, 166, 169, 172, 177–79, 181, 187–88
Hattori Kei, 189
Hawks, Howard, 42, 60, 240n11
Hayama Ryōji, 168, 175, 178, 180
Hayter, Irena, 249n21
Hell Squad: Charge! [Jigoku butai totsugekiseyo] (Katō), 18
Helper Business [Suketto kagyō] (Saitō, 1961), 176
Hen in the Wind, A (Ozu), 47, 241n19
Hero Cadet [Eiyū kōhosei] (Ushihara, 1960), 172
Hibari Misora, 64
Hidari Bokuzen, 169
Hidari Sachiko, 14
Hidari Tokie, 211
High Noon (Zinneman, 1952), 65, 81
Higuchi Hiromi, 176, 178, 180–81
Himeda Yoshirō, 177
Hino Michio, 191
Hirabayashi Taiko, 183
Hira Mikijirō, 212–13
Hirano Fumi, 207
Hirata Daisaburō, 178, 182, 184, 187
Hirata Jushirō, 188
Hirata Mitsuru, 206
Hiromatsu Saburō, 186
Hiro'oka Mieko, 169
Hirota Leona, 208
Histoire(s) du cinéma (Godard), 39–40
Hitchcock, Alfred, 39, 40, 60, 163, 239n2, 240n11
Hito kari (Ōyabu), 181
Hobsbawm, Eric, 27
Hollywood, 42, 47; anamorphic filmmaking in, 94; B movies, 68; classical Hollywood continuity editing, 115; color schemes of, 109; "eyeline match" editing technique, 241n30; film noir, 78–79; Japanese studio system compared with, 69–70; screenplays, 244n24
Honda Akiko, 222
Horiike Kiyoshi, 171
Hori Kyōko, 169
Hori Kyūsaku, 4–5, 19–21, 64, 70, 153, 237n28. *See also* Suzuki Seijun Incident

Hori Uyako, 169
Hosakawa Chikako, 186
Hoshikawa Seiji, 172
Hoshi Naomi, 177–78, 181–82, 245n42
Hosoishi Terumi, 199
Hosokawa Chikako, 173
Hou Hsiao-hsien, 46
Hoveyda, Fereydoun, 44

I Am Waiting [*Ore wa matteru ze*] (Kurahara, 1957), 72–73, 93, 245n41
Ibu Masatō, 203
Ichijō Akira, 165, 172, 175
Ichikawa Kon, 92, 95, 99
Ichikawa Miwako, 213
Ida Motomu, 174, 190
Ieki Miyoji, 63, 80, 227
"Ikarechatta" (song), 78
Ikawa Kōichi, 221
Ikeda Ichirō, 170, 181
Ikehata Shinnosuke ("Pītā"), 216
Ikehiro Kazuo, 202
Ikeya Noriyoshi, 202, 208–11
I Look Up As I Walk [*Ue no muite arukō*] (Masuda, 1962), 244n37
I Love, I Love You, I Love You [*Aishite aishite aishichatta no yo*] (Ida, 1966), 190
Imai Kazuko, 187
Imai Tadashi, 29–30
Imamura Shōhei, 23, 34, 66, 70, 76, 184, 187, 239n62
Imaoka Shinji, 243n15
I'm Going to Hell [*Ore wa jigoku e iku*] (Noguchi, 1961), 178
I'm Not a Criminal [*Ore wa hannin ja nai*] (Noguchi, 1956), 228
imperialism, 28, 216
Inagaki Hiroshi, 39, 44
Inagaki Mihoko, 165
Inagawa Junko, 148, 199
Incorrigible, The [*Akutarō*] (Suzuki, 1963), 15, 27–28, 31, 62, 70, 71–72, 75, 182–83, 188, 209; as melodrama, 80–81; as Taishō-set film, 149; kozō films and, 85
independent filmmakers, 13, 16, 23, 235n10
"industrial genres," 12
Inn of Floating Weeds, An [*Ukigusa no yado*] (Suzuki, 1957), 74, 161–62, 164; deep-space staging in, 96, 97; as kayō film, 76–78
Inoue Akifumi, 186
Inoue Hiroshi, 78
Inoue Makio, 197, 205, 207
Inoue Shinya, 191
Inoue Umetsugu, 66, 70–73, 79, 163–64, 217; color film and, 108–9
Insect Woman, The [*Nippon konchuki*] (Imamura, 1963), 69, 184, 239n62
Intentions of Murder [*Akai satsui*] (Imamura, 1964), 187, 239n62
internal monologues, 111–14
In the Realm of the Senses [*Ai no korida*] (Ōshima, 1976), 18
Ioka Junichi, 197–98, 205
Isayama Saburō, 177
Ise Torahiko, 160–61, 164, 168, 178–79, 183
Ishida Kōichirō, 209
Ishigami Mitsutoshi, 16–17, 236n12
Ishiguro Noboru, 197
Ishihara Yūjirō, 65, 68–69, 115, 167, 171, 184, 194, 217, 229, 243n11; development of Nikkatsu Action Cinema and, 73, 108–9, 244n33; "Diamond Line" of stars in wake of, 74; in *I Am Waiting*, 93; ninkyō (chivalry) genre and, 87; singing career of, 72, 78, 245n41
Ishii Kiichi, 167, 176
Ishii Sogo, 222
Ishii Teruo, 79, 168, 171, 204
Ishii Tomiko, 186–87
Ishimine Minoru, 212
Isoda Tsutomu, 221
Itō Daisuke, 44, 64
Itō Hiroko, 184, 189, 203
Itō Kazunori, 212
Itō Kazuo, 177
Itō Keiichi, 219
Itō Michiko, 186
Itō Naoya, 178
Itō Nobuyuki, 213
Itō Ruriko, 190
Itō Yoshihiro, 203
"I've Already Forgotten That": A Collection of Conversations with Suzuki Seijun [*Sonna koto wa mō wasureta yo: Suzuki Seijun Kanwashū*] (2008), 231
Iwama Tsuruo, 4, 64, 65, 227

Iwama Yoshiki, 194
Iwamoto Kenji, 234n9
Iwasawa Tsunemori, 227
Izawa Ichirō, 202, 229
Izumi Kyōka, 147, 151–52, 202, 221
Izumi Masako, 183, 188–89, 191

Jackson, Rosemary, 147
Jacoby, Alexander, 47
Janken Girls [*Janken musume*] (Sugie, 1955), 131
Japanese New Wave, 31, 34
Japanese Red Army, 221
Japan Film Library Council, 19
Jarmusch, Jim, 39
JCP (Japan Communist Party), 28–30
Jinnai Takanori, 211
jump cuts, 114
Juvenile Delinquent [*Hikōshōnen*] (Fujita, 1970), 224

Kabuki theater, 96, 151–52, 207, 213
Kaffen, Phil, 10, 241n33
Kaga Mariko, 203
Kagerō-za (Suzuki, 1981), 156, 189, 195, 202–3, 243n13; color in, 113–14; distortive reflections in, 103; flat, frontal staging in, 99; supernatural elements in, 144, 146, *147*; Taishō-era romanticism and, 151–53. *See also* Taishō trilogy films
Kaji Noboru, 169
Kajiwara Ikki, 196
Kajiwara Ryūji, 17
Kajiyama Sueyuki, 205
Kakita Isamu, 167
Kamakura Academy, 14, 19, 63, 234n1
Kamiya Nobuo, 201
Kamiya Nobutake, 200
Kaneko Nobuo, 83, 162, 166, 174, 177–78, 181
Kanemura Osamu, 123
Kan Hanae, 212
Kantoku Ozu Yasujirō [*The director Ozu Yasujirō*] (Hasumi), 46–47
Kanto Wanderer [*Kantō mushuku*] (Suzuki, 1963), 17, 40, 60, 69, 75, 183–84, 211, 239n62; abstraction of the set in, 88, 89; color in, 107, 111, 247n11, 247n19; editing in, 117, *118*; songs in, 78, 132; as

ninkyō film, 87–89, 112, 246n57; sound in, 133
Karatani Kōjin, 2–3, 233n3
Kasahara Ryōzō, 182, 188
Kasai Kazuhiko, 188
Kasuga Hachirō, 76–78, 131–32, 160, 162, 165
Katase Rino, 202
Katō Haruko, 206, 212
Katō Tai, 17–18, 42, 51, 61, 236n17; *ninkyō* (chivalry) genre and, 86; "wandering gambler" films and, 218, 246n56
Katsuta Shōzō, 203
Kawabata Yasunari, 149
Kawahara Motozō, 193
Kawaji Tamio, 1, 172, 179–82, 185, 187, 191, 204
Kawakita Kazuko, 19, 21
Kawanishi Kuniko, 186
Kawarabata Yasushi, 21–22, 237n28
Kawashima Yūzō, 80
Kawauchi Kōhan, 190
Kawazu Seizaburō, 161, 189
Kawazu Yūsuke, 66, 192, 195
kayō (ballad) films, 10, 12–13, 68, 76–78, 131
Kazefu Jun, 203
Kazuki Minako, 115, 162, 182
Keathley, Christian, 9, 50–51
Keio Universitiy, 17–18
Kelly, Gene, 39
Kenjū buraicho (*Fast-Draw Ryū*) series (Noguchi), 83–85, 173
Kido Shintarō, 160
Kihira Tadayoshi, 215, 216
Kikuchi Yōko, 209
Kikugawa Yoshie, 193
Kikukawa Yoshie, 196
Kikumura Itaru, 170
Kimoto Jōji, 194
Kimura Keigo, 95, 213
Kimura Mitsuno, 201
Kimura Takeo, 15–16, 18, 42, 66, 182–85, 187–88, 190, 199, 205–6, 212–13, 223, 226, 236n12, 243n4. *See also* Guryū Hachirō ("Group of Eight")
Kimura Yūki, 201
Kimuro Ikuko, 162
Kim Weom-bae, 209
Kinema junpō (film journal), 14, 192, 193, 196, 200; annual "ten-best" list, 17; *Youth of the Beast* reviewed in, 54

kineticism. See *dōtai shiryoku*
Kino Hiroko, 229
Kinoshita Keisuke, 17, 29, 33, 63; melodrama and, 80, 85; theatrical staging and, 94–95, 99
Kinugasa Teinosuke, 245n45
Kirin Kiki, 200, 206, 212
Kishi Matsuo, 44
Kiss of Hell [*Jigoku no seppun*] (Noguchi, 1955), 79, 228
Kitagawa Hiromu, 204
Kitahara Mie, 68, 93, 163, 167, 217
Kitahara Yoshirō, 202
Kitamura Hiroshi, 81, 245n52, 246n54
Kitaōji Kinya, 230
Kita Ryūji, 191
Kitsnik, Lauri, 244n24
Kiura Yūzō, 182
Koban, 207
Kobayashi Akiji, 182
Kobayashi Akira, 14, 65, 68–69, 72–75, 116, 125, 165–66, 170, 173–75, 184–86, 189, 216, 247n11; as "Diamond Line" actor, 74; theme songs sung by, 78; in *Wataridori (Rambling Guitarist)* series, 83, 172
Kobayashi Kiyoshi, 197, 205, 207
Kobayashi Tetsuo, 20
Kodaka Yuji, 189
Kodama Kenji, 197
Komatsu Hōsei, 189
Kondō Hiroshi, 162, 164, 166, 168, 173–74, 177, 201
Kondō Mitsuno, 159
Kōno Akitake, 161
Kōno Hiroshi, 176, 182, 184
Kōno Marie, 12, 80, 242n1
Kon Tōkō, 149, 182, 188, 190, 249n21
Korea, colonization of, 150
Korean War, 29
Kosakai Kazuki, 207–8
Kosugi Isamu, 160, 171, 181
Kō Tomoko, 160, 165
Koyamazaki Kimio, 180
kozō films, 82–85, 98, 177, 179
Kudō Eiichi, 204
Kurahara Koreyoshi, 66, 70, 72–73, 75, 93, 159, 176, 243n8
Kurata Masaru, 212
Kuri Chiharu, 183

Kuroki Kazuo, 195
Kurosawa Akira, 6, 79, 82, 107, 128, 188, 216, 234n6, 238n41
Kurosawa Kiyoshi, 38–39, 155, 158
Kurusu Saburō, 224
Kusanagi Kōjirō, 171
Kusunoki Yūko, 171, 190
Kuzū Masami, 183, 185–93

Lamarre, Thomas, 233n2
Langlois Affair, 37
Last Song, The [*Zesshō*] (Takizawa, 1958), 69, 166
Leaving the Town in Search of Violence [*Bōryoku sagashi ni machi e deru*] (Suzuki, 1973), 231
Lee, Laura, 129, 130
Leone, Sergio, 216
Life View of a Toppled-Over Hermit, The [*Sukkorobi sennin no jinseiron*] (Suzuki, 1995), 231
lighting, 89, 98; abrupt shifts in, 90, 96; color-filtered, 95; in film noir, 79; inconsistent sources of, 104; light cues, 99; optical color and, 109; sudden shifts in, 52
Lippit, Noriko Mizuta, 150
Lippit, Seiji, 150–51
"Lives of Extras, The" ["Ekisutora jinsei"] (Suzuki, episode of TV show *Human Documentary Theater*, 1993), 210
Living by Karate [*Muteppō daishō*] (Suzuki, 1961), 62, 75, 84, 110, 174–75
LOLA (online cinephile journal), 9, 10, 46
Lonely Contemplation [*Koshū*] (Suzuki, 1980), 231
Lonely Yakuza, The [*Yūkyō ippiki*] (Katō), 18
Long-Sought Mother (Katō, 1962), 218, 246n56
Love Letter [*Rabu Retā*] (Suzuki, 1959), 10, 74–75, 77, 167; as kayō film, 68, 76, 78, 80; musical numbers in, 132
Lunch Box (Imaoka), 243n15
Lupin III: The Castle of Cagliostro [*Rupan sansei: Kariosuturo no shiro*] (Miyazaki, 1979), 198
Lupin III: Part 2 [*Rupan sansei dai-ni-shirīzu*] (Suzuki, 1980), 6, 197–98

Lupin III: Part 3 [Rupan sansei:dai-san-shirīzu] (Yoshida, 1984), 6
Lupin III: The Legend of the Gold of Babylon [Rupan sansei: Babiron no ōgon densetsu] (Suzuki and Yoshida, 1985), 6, 144, 198, 206–7
Lupin III: The Mystery of Mamo [Rupan Sansei] (Yoshikawa, 1978), 197
Lu Xun, 218

Machida Kyōsuke, 167
"Machines of the Visible" (Comolli, 1971), 233n2
Mad Fox, The [Koiya koi nasu na koi] (Ichikawa, 1962), 95
Maeda Katsuhirō, 219
Maeda Masuo, 180
Maeda Yonezō, 212–13
Makino Masahiro, 42, 61, 73
Makishi Kisako, 200
Maki Shinji, 206
Maki Shinsuke, 160
Manchuria, Japanese invasion of, 150
Man Oversomes His Fear, A [Otoko no okori o buchimakero] (Matsuo, 1960), 171
Man's Sorrows, A [Otoko no aishū] (Iwama, 1951), 227
Man Who Left His Will on Film, The [Tōkyō sensō sengo hiwa] (Ōshima, 1970), 32, 143
Man with a Shotgun, The [Shottogan no otoko] (Suzuki, 1961), 75, 82, 112, 116, 175–76
Man with No Tomorrow, The [Kenjū buraichō: Ashita naki otoko] (Noguchi, 1960), 173
Mariya Tomoko, 208
Maro Akaji, 200
Marotti, William, 30
Marriage [Kekkon] (Suzuki, segment of "Jinnai-Harada Families," 1993), 138–39, 144, 154, 156, 211
Martin, Adrian, 9, 46
Marvin, Lee, 2
Masayuki Mori, 68, 160
Masters of Cinema, 67
Masuda Toshio, 66, 70, 73, 75–76, 94, 95, 170, 191

Masukomi shimin [Mass communication citizenry] (journal), 23, 27
Masumura Yasuzō, 33
Masuyami Eiko, 197, 205, 207
Matoqin Nocturne [Batōkin yasōkyoku] (Kimura, 2007), 226
Matsubara Chieko, 71, 178–79, 181, 184–86, 191
Matsuda Masao, 17, 24, 63, 236n13
Matsuda Yūsaku, 203, 230
Matsuhashi Umeo, 163
Matsui Toshiyuki, 175
Matsukata Hiroki, 202
Matsumoto Noriko, 179
Matsumoto Seichō, 166
Matsumoto Toshio, 8, 9, 22–23, 32, 216, 226, 237n32
Matsuo Akinori, 75, 171, 174
Matsuo Kayo, 179, 186–87, 189, 190
Matsushita Kazuya, 209
Matsushita Shōji, 210
Matsushita Tatsuo, 161
Matsu'ura Takeo, 167, 175–76, 186
Mayumi Norimasa, 160
Meiji period, 75, 86, 147–49
melodrama, 12–13, 68–69; Shōchiku Ōfuna studio and, 64, 242n1; in Suzuki's early filmography, 80–81
Melville, Jean-Pierre, 2
meta-cinema, 36, 41, 129, 142–43, 153; as "cinematic reflexivity," 143; New Left and, 12
Michelson, Annette, 239n61
michiyuki shot (long-lens technique), 88
Midorikawa Hiroshi, 186, 191–93
Mifune Toshirō, 194, 201, 229
Mikami Kan, 210
Mikamoto Yasumi, 197
Miki Satsumi, 190
Million Dollar Smash-and-Grab [Hyakuman-doru o tatakidase] (Suzuki, 1961), 17, 75, 84, 178–79, 180
Minamida Morio, 193
Minamida Yōko, 69, 115, 162–63; in The Man with a Shotgun, 176; in Those Who Put Money on Me, 180; in Tokyo Knights, 174; in The Voice Without a Shadow, 166
Minami Hiroshi, 193

Minami Sumiko, 162–63
Minegishi Tōru, 211
Mine Shigeyoshi, 66, 176–78, 181–83, 185–86, 190
mirrors, 80; flatness and depth synthesized with, 92; recessive staging and, 95; shattered, *101*; spinning, 101, *102*
mise-en-scène, 43–44, 98
Misek, Richard, 107, 109
Mishima Chieko, 188
Mishima Kō, 160
Misora Hibari, 131, 213
Misuzu Eiko, 162
Mita Akira, 185
Miura Ōsuke, 210
Miyagi Chikako, 66, 172, 190, 192, 208
Miyaji Masako, 210
Miyamoto Masae, 210
Miyano Kō, 161
Miyazaki Hayao, 197–98
Miyazaki Masumi, 208
Mizoguchi Kenji, 79, 128, 246n54
Mizuho Shunkai, 227
Mizusawa Aki, 229
Mizushima Michitarō, 163, 164, 170
Mobile Investigative Team [*Kidō sōsahan*] (Kosugi, 1963), 181
montage, 91, 119, *121*, 122, 156
"mood" action subgenre, 75
Moon Has Risen, The [*Tsuki wa noborinu*] (Tanaka, 1955), 183
More Than Night (Naremore, 1998), 245n43
Mori Masaru, 196
Morimoto Yoshihiko, 177
Morinaga Kenjirō, 165, 192
Morisaki Azuma, 205
Mori Yoshihiro, 195
Motegi Ryōji, 160, 162
Motherly Lovesickness [*Bokoigusa*] (Iwama, 1951), 227
Mourlet, Michel, 240n9
Movie (UK-based film journal), 43
Movie Mutations (Rosenbaum and Martin, 2003), 9, 46
"Mummy's Love, A" ["Mīra no koi"] (Suzuki, episode of TV show *Unbalanced Horror Theater*, 1973), 138, 144–46, 194–95, 201
Murakami, Takahashi, 57

Murakami Tadahisa, 44–45
Murder Unincorporated [*Dainippon koroshiya den*] (Nakahira, 1965), 181, 188
Murō Saisei, 222
music, diegetic boundaries and, 131–33
musicals: American, 244n39; Japanese, 131
"Musical Vairation of Monkey Business" ["Warunori hensōkyoku"] (Yoshida, episode of *Lupin III: Part 3*, of 1984), 144, 205
My Gun Is Quick [*Ore no kenjū wa subayai*] series (Noguchi, 1954–56), 65, 79, 228
Mystery Masterpiece Theater (television series), 156

Nagai, Frank, 76, 167
Nagao Jōji, 211
Nagase Masatoshi, 212
Nagato Hiroyuki, 69, 115, 163, 171, 176
Nagato Isamu, 201
Nagato Yōhei, 12, 132–34
Nagatsuka Kazue, 66, 160–62, 165–66, 173–75, 181, 184, 187–88, 193, 199, 202, 243n13
Nagayama Kazuo, 193
Nageki no chibusa (Ichijō), 165
Naitō Makoto, 220, 244n40
Nakagaqa Norio, 159
Nakagawa Haruhiko, 161
Nakagawa Nobuo, 199
Nakahara Keishichi, 162
Nakahara Sanae, 94, 116, 169, 171, 184
Nakahira Kō, 33, 68, 73, 75, 181, 189, 234n6
Nakajima Sadao, 18, 204
Nakajima Yoshitsugu, 173
Nakamura Hideyuki, 46
Nakamura Katsuo, 203
Nakamura Kimihiko, 165, 170, 174, 177–78
Nakamura Noboru, 63, 227
Nakanishi Ryūzō, 175
Nakano Akira, 180
Nakao Toshitarō, 162, 164, 171
Nakata Hideo, 155
Nakatami no Kamatari, 219
Naked Rashomon [*Shōwa onnamichi: rashōmon*] (Sone, 1973), 224–25
Naked Woman and the Gun, The [*Rajo to kenjū*] (Suzuki, 1957), 40, 74, 163–64
Nanbara Kōji, 193

naniwa-bushi (musical storytelling), 138, 206
Naoi Kinya, 189
Napier, Susan, 147
Naraoka Tomoko, 172
Naremore, James, 245n43, 245n45
Narita Airport protests, 23, 27
narration, 12, 153–54; diegesis and nondiegetic interventions in, 89; elliptical, 72; misleading, 139; narrative versus, 128–31
narration, registers of, 131–34; diegetic versus extra-diegetic, 137; diegetic versus nested diegetic, 137–38; films within films as blurring of, 138–43; subjective versus objective, 134–37, *134–36*; supernatural as blurring of, 143–46, *147*, 148
narrative, 12, 46, 66, 242n43; compositing techniques and, 106; discarded by film theory, 60; emergence in early cinema, 154; experimentation with narrative structure, 32; formulaic, 48; narration versus, 128–31; rejection of narrative hierarchy, 57; taxonomic approach to, 130
Naruse Mikio, 80, 85
Naya Gorō, 197, 205, 207
Nemoto Masayoshi, 210
Neon Police Officer: Jack's Tattoo [*Neon keisatsu: Jakku no irezumi*] (Takeda, 1970), 224
nested diegesis. *See* film-within-a-film (*geki chū geki*)
"New Action" films, 76
New Left, 5, 9, 12–13, 27, 157; on cinema's relation to actuality and emerging media, 36; cinephilic turn in film theory and, 59; critique of the Old Left, 11, 47, 60; film in 1960s Japan and, 31–37; intellectual history of, 28–31; Suzuki Seijun Incident and, 7, 8, 11; Suzuki's formal experimentation admired by, 10
Nezu Yoshiko, 84, 172, 174
Night and Fog in Japan [*Nihon no yoru to kiri*] (Ōshima, 1960), 237n28
Night Women [*Nihiki no mesu inu*] (Watanabe, 1964), 50–51
Nihei Kōichi, 210
Nihon eiga sakka ron [Book of Japanese film authors] (Murakami, 1937), 45

Nihon University Cinema Club, 17
Nihon'yanagi Hiroshi, 177
Nikkatsu Action Cinema, 40, 63, 66–67, 89; Classical Hollywood Continuity editing and, 115; color in, 108, 112; compositing techniques in, 104; deep-focus staging in, 93; film noir and, 78–79; integration of popular music into, 78; lighting and color use in, 90; musical numbers in, 132; *ninkyō* (chivalry) genre and, 87–88; rise and fall of, 68–76; stage spaces in, 96; subgenres of, 82–85
Nikkatsu film studio, 4, 12–13, 54, 59, 65–66, 159, 235n2; apprentice system of, 65; budget cuts on Suzuki films, 70–71; color and budgeting for films, 108; "Diamond Line" of stars, 65–66, 72, 74–75, 78, 87, 244n31; Hong Kong market and, 234n6; *kayō* (ballad) films, 76–77; lawsuit against, 21; *ninkyō* (chivalry) films, 85–89; *roman poruno* line, 5; Suzuki as assistant director at, 228; Suzuki fired by, 4–5, 19–21, 237n22; Suzuki's late films at, 10, 19, 20, 27, 40, 62–63, 156; film noir, 78–80; Westerns, 81–82, 178. *See also* Suzuki Seijun Incident
NikkatsuScope, 67, 93
ninkyō (chivalry) genre, 40, 67, 75, 85–89, 191, 246n57; telephoto aesthetic in, 94; "wandering gambler" films, 218, 246n56
Nisei no enishi-shūi (Enchi), 195
Nishi Ginza Station [*Nishi ginza eki*] (Imamura, 1958), 76–77
Nishikawa Katsumi, 227
Nishimura Kō, 171, 201
Nishimura Shōgorō, 173, 193
Nishimura Toyoji, 193
Nishina Akikol, 229
Nishioka Takashi, 164
Nitani Hideaki, 66, 69, 73, 77–78, 116, 162–63, 165–66, 174, 176, 178, 186, 191, 244n31
Noda Kogo, 128, 234n1
Nogawa Yumiko, 66, 78, 142, 185, 187–88, 190, 209
Noguchi Hiroshi, 69, 79, 83–84, 90, 163, 173, 178, 181, 186, 228, 244n28; Suzuki as assistant director to, 4, 64–65, 73, 87

Noh theater, 98
noir and noirish films, 64, 78, 94
Nomura Takashi, 196, 205
Noonan, Patrick, 234n10, 238n58
No Regrets for Our Youth [*Waga seishun ni kuinashi*] (Kurosawa, 1946), 29
Nornes, Abé Mark, 7, 234n9
Noro Keisuke, 66, 84–85, 165–66, 168, 170–71, 175–76, 178, 183–85, 187–88, 190, 192
Nothing but Bones [*Hone made shaburu*] (Katō), 18

Ōba Hideo, 63, 227
Oban, 207
Obata Kuniko, 204
Ōbayashi Nobuhiko, 17, 155, 204, 236n12, 236n16
Odagiri Jō, 213
Odaka Yūji, 171, 176
Ōe, Kenzaburō, 216
Ōedo Investigation Network (television series), 156
OFF (college cinephile pamphlet), 17, 236n12
Ogawa Ei, 180
Ogawa Mariko, 193
Ogawa Nobuo, 195
Oguni Hideo, 128
Ōhara Kiyohide, 197, 203, 218, 221–22, 249n24
Ōhashi Tomiyo, 210
Ohayō [*Good Morning*] (Ozu, 1959), 239n2
Ōhira Toru, 193
Okada Hiroshi, 65
Okada Masumi, 66, 168, 196
Okada Tatsumon, 165
Okada Yutaka, 18, 191–92, 223. See also Guryū Hachirō ("Group of Eight")
Ōka Politics (Chapter One): The Skin of a Bat [*Ōka seidan daiichiwa: Hitohada kōmori*] (Nigochi, 1955), 228
Okinawa Band of Youths [*Okinawa Kenji-tai*] (Iwama, 1953), 227
Ōkōchi Hiroshi, 211
Okuda Seiji, 197
Okusono Mamoru, 179
Old Tales Retold (Lu Xun), 218
Olson, Lawrence, 30
omoshirosa (interestingness), 11, 41–42, 47–52

Ōmura Takahiro, 177
"On a Certain Tendency in French Cinema" (Truffaut), 43
Ōnaka Yutaka, 189
Onchi Hideo, 211
One Hundred Views of a Couple [*Fūfu hyakkei*] (Inoue, 1958), 164
Ophüls, Max, 91
Oshii Mamoru, 207
Ōshima Nagisa, 6, 8, 9, 11, 16, 21–23, 26, 29–30, 32–34, 37, 143, 220, 237n28, 237n35
Ōtani Naoko, 200, 201
Ōtani Yoshiaki, 223
"Otoko no ereji" [Elegy for a man] (song), 78
Ōtsuka Chikao, 207
Our Blood Will Not Forgive [*Oretachi no chi ga yurusanai*] (Suzuki, 1964), 70, 71, 75, 128, 186–87; color in, 107; editing in, 116–17; film-within-a-film in, 138; ninkyō (chivalry) genre and, 87, 246n57; rear projection in, 105
Outlaw: Gangster V.I.P. [*Burai yori daikanbu*] (Masuda, 1968), 76
Owashi Hidetoshi, 207
Ōyabu Haruhiko, 181, 182
O-yae the Substitute Maid [*O-yae no migawari jochū*] (Sunohara, 1959), 69, 168
Oyuki the Virgin [*Maria no Oyuki*] (Mizoguchi, 1935), 246n54
Ozawa Eitarō, 186
Ozawa Saneko, 169
Ozawa Shōichi, 162, 165, 170–71, 174, 187
Ozu and the Poetics of Cinema (Bordwell), 239n2
Ozu Yasujiro, 13, 38, 46–47, 60, 63, 85, 91, 107, 128, 238n41, 245n45

Pacific Ocean Peddler [*Taiheiyō no katsugiya*] (Matsuo, 1961), 174
Pacific War, 150
Passion and Rifle Bullets [*Aiyoku to jūdan*] (Noguchi, 1955), 228
Passionate Girl Derailed, A [*Dassen jōnetsu musume*] (Ōba, 1949), 227
Passionate Rhuma [*Jōnetsu no rumumba*] (Sasaki, 1950), 227
Passport to Darkness [*Ankoku no ryoken*] (Suzuki, 1959), 62, 69, 75, 156, 168, 172; musical number in, 132; as crime film, 79
Pépé le Moko (Duvivier, 1937), 39

Perkins, Victor, 42, 43, 45
perspective, linear, 2–3, 233n2
photogénie (French critical term), 43
photography, 32, 123
pinku ("pink") films, 6, 18, 157–58, 235n7, 243n15
Pistol Opera [*Pisutoru opera*] (Suzuki, 2001), 10, 153, 156, 212, 243n13; compositing techniques in, 105, *106*; supernatural elements in, 144, 146–47
Poe, Edgar Allan, 150
Point Blank (Boorman, 1967), 2
point-of-view shots: in *The Boy Who Came Back*, 15; in *Carmen from Kawachi*, 105–6; character subjectivity and, 130; in *Pure Heart of the Sea*, 117, *118*; in *A Tale of Sorrow and Sadness*, 145; in *Young Breasts*, 126
pornography, 4, 18, 19, 67, 141
Port of Flowers [*Hana saku minato*] (Kinoshita, 1943), 80
postmodernism, 242n43
poststructural theory, 2–3, 45, 53
Powell, Michael, 39
Pressburger, Emeric, 39
Primitve Rebels (Hobsbawm), 27
Princess of Badger Palace, The [*Ōatari tanuki goten*] (Saeki, 1959), 95–96
Princess Raccoon [*Operetta tanuki goten*] (Suzuki, 2005), 6, 10, 156, 208, 213, 222; abstract set designs in, 105, *106*, 112; supernatural elements in, 144
Pure Heart of the Sea [*Umi no junjō*] (Suzuki, 1956), 10, 73, 77, 160–61; editing in, 117–18; as kayō film, 76; sound and diegetic boundaries in, 131–32; popular songs in, 67

Racing Toward Tomorrow [*Ashita ni mukatte tsuppashire*] (Furukawa, 1961), 175
Raine, Michael, 10, 74, 77, 131, 245n41
Rambler in the Sunset [*Akai yūhi no wataridori*] (Saitō, 1960), 171–72
Rambling Guitarist, The [*Gitaa o motta wataridori*] (Saitō, 1959), 74, 81
Rampaging Vagabond [*Ōabare fūraibō*] (Yamazaki, 1960), 69, 173
Ran (Kurosawa, 1985), 216
Rancière, Jacques, 59

Rashomon (Kurosawa), 234n6
Ray, Nicholas, 60
rear projection, 92, 104–5, *105*, 128, 143
Rear Window (Hitchcock, 1956), 39, 40, 163
Record of a Single Mother [*Hitori no haha no kiroku*] (Kyōgoku, 1956), 160
Record of a Woman Doctor [*Joi no kiroku*] (Shimizu, 1942), 80
Record of Sumo in Kyūshū [*Ōzumō kyūushū basho jikkyō*] (Ise, 1961), 179
Record of Yūjirō's Trip to Europe [*Yūjirō no ōshū kakearuki*] (Kaji, 1959), 169
Red Army/PFLP: Declaration of World War [*Sekigun—P.F.L.P.: Sekai sensō sengen*] (Adachi/Wakamatsu, 1971), 221
Red Handkerchief [*Akai hankachi*] (Masuda, 1964), 75
Red-Hot Seat [*Shakunetsu no isu*] (Noguchi, 1963), 181
Red Lion of the Ghost Town [*Gosuto Taun no akai shishi*] (Suzuki, unfilmed, written 1966), 19, 144, 216
Red Peony Gambler [*Hibotan bakuto*] (Yamashita, 1968), 86
Red Pier [*Akai hatoba*] (Masuda, 1958), 73, 94, 95
Red Shoes, The (Powell and Pressburger, 1948), 39
Reed, Carol, 39
Renoir, Jean, 42
Resnais, Alain, 42
Resume of Love Affairs [*Jōji no rirekisho*] (Wakamatsu, 1965), 18, 223
Retaliation [*Shima wa moratta*] (Hasebe, 1968), 76
Reward for Evil [*Aku no hōshū*] (Noguchi, 1956), 65, 79, 228
Richards, Rashna Wadia, 9, 50–51
Ricouer, Paul, 154
Rikidōzan: Strong-Armed Victory [*Rikidōzan: Tetsuwan no shōri*] (Ise, 1956), 161
Rivette, Jacques, 38, 39
"Rokusannen no dandi" [Dandy of 1963] (song), 245n42
Roland, Chico, 186
roman poruno films, 5, 6, 235n7
Rosenbaum, Jonathan, 9, 46, 47
Rouge (online cinephile journal), 9, 46

Russo-Japanese War, 149
Rusty Knife, The [*Sabita naifu*] (Ishihara, 1958), 73, 170
Ryū Keiichirō, 177
Ryūno Tatsuo, 207

Saeki Kiyoshi, 64, 228
Saeki Kōzō, 95
Sagawa Tetsurō, 202
Saga Zenpei, 174, 176, 185, 190
Saishu Yasushi, 208
Saitō Buichi, 73–74, 83, 90, 115–16, 169, 172, 176, 183, 186
Saitō Haruko, 210
Saitō Iwao, 226
Saitō Kōichi, 162
Saitō Nobuyuki, 196
Saitō Takao, 201
Saitō Wasaburō, 179
Sai Yōichi, 204, 210
Saji Susumu, 164, 166
Sakaguchi Takeharu, 164, 166, 168–70, 180–81
Sakuma Yoshiko, 86
Sakuracolor, 108
Sakurai Yasuhiro, 201
Samouraï, Le (Melville, 1967), 2
Sano Asao, 176, 179, 181, 192, 203, 229
Sano Shūji, 196
San Yō, 204
"Sarasate no ban" (Uchida), 151
Sarris, Andrew, 42–43
Sartre, Jean-Paul, 53
Sasai Eisuke, 213
Sasaki Mamoru, 220
Sasaki Sumie, 200
Sasaki Yasushi, 63, 227
Sassamori Reiko, 84, *101*, 171, 181
Satamo Teruyoshi, 159
Satani Sanpei, 161
Satani Teruyoshi, 162, 173, 176
Satan's Town [*Akuma no machi*] (Suzuki, 1956), 62, 68, 73, 161; character subjectivity in, 129, 130; as crime film, 79
Satō Makoto, 204
Satō Tadao, 47, 241n19
Sawada Kenji, 206, 208, 212
Sawa Michiko, 178
Sawashima Tadashi, 86, 87

Sawa Tamaki, 168
Scent of Eros in August, The [*Hachigatsu wa Erosu no nioi*] (Fujita, 1972), 224
Schilling, Mark, 10, 79
Season of the Sun [*Taiyō no kisetsu*] (Furukawa, 1956), 72–73, 87, 115
Season of Treachery [*Uragiri no kisetsu*] (Yamatoya, 1966), 18, 223
Secret White Line [*Shirosen himitsu chitai*] (Ishii, 1958), 79, 168
Sei/jun/ei/ga (Suzuki, 2006), 231
Seijunesque style, 12, 52, 63, 89–90, 103, 153–54, 214; color and, 106–14; deep-focus/deep-space aesthetic, 93–100; definition of, 91–92, 130; editing and, 114–24; enframing, 92–106, *93*, *95*, *97–106*; flat staging, 99, 100; melodrama and, 80; mirrors and distortive reflections, 92, 100–107; narrative versus narration, 128–31; rear projection, 104–5
Seijun-gumi ("Seijun Group"), 66
"Seinen no omei" [The young man's stigma] (Ōe), 216
Sekiguchi Hiraoshi, 201
Sekine Tsutomu, 207, 208
Sekizawa Shinichi, 170
Seven Samurai, The (Kurosawa, 1954), 82
Shambu, Girish, 9
Shane (Stevens, 1953), 82, 245n52
Sharp, Jasper, 10, 246n7
Shibata Shun, 19
Shibuya Minoru, 63, 227
Shikashi satsujin wa, (Sano), 204
Shiki Ichirō, 161
Shimada Kazuo, 170
Shima Keiko, 161
Shimakura Chiyoko, 78
Shimizu Hiroshi, 44, 80
Shimizu Kin'ichi ("Shimikin"), 64, 227
Shimizu Kin'ichi's Travels as an Irregular Ninja [*Shimikin no ninjutsu ōtotsu dōchū*] (Iwasawa, 1949), 227
Shimizu Mayumi, 94, *95*, 171, 173–75, 177–78, 180
Shimotsuka Makoto, 202
Shimura Hiroshi, 195
Shin Chikako, 184
Shindō Kaneto, 191

shinkankakuha (Neo-Perceptionist, New Sensationism), 149, 249n21
Shin Kinzō, 181
Shinoda Masahiro, 22–23, 33
Shin-Tōhō film studio: "five-studio system" and, 235n8; "line" (*chitai*) films at, 79, 168, 171
Shiota Akihiko, 155, 221
Shiozawa Toki, 207
Shiraishi Gorō, 161
Shiraishi Kōichi, 202
Shiraki Mari, 163–64, 168, 170, 180
Shiraki Yōko, 196
Shishido Jō, 66, 73, 75, 78, 83, 87, 109, 165–66, 176, 178–82, 186, 188, 191, 193, 196, 216–17, 244n31, 245n42
Shisō no kagaku (Science of Thought) group, 52
Shizhido Jō, 163
Shīzuka Akira, 204
Shklovsky, Viktor, 55
Shōchiku film studio, 4, 5, 23; apprentice system of, 65; "five-studio system" and, 235n8; "New Wave" as marketing strategy, 34; Ōfuna studio, 63–64, 227, 234n1, 242n1; radical filmmakers' exit from, 21; Suzuki's entrance into, 14, 234n1
shōji screens: in fight choreography, 112, 248n23; as frame partition, 100; supernatural elements and, 148
shot/reverse shot, 121, 139; in *À Bout de souffle*, 40; in *Branded to Kill*, 119, 120, 140; in *Fighting Elegy*, 25, 28
Shōwa 33 Spring Season Season Sumo [*Shōwa 33 nen'do Ōzumō haru basho*] (Ise, 1958), 164
Shōwa 34 Summer Season Sumo (Latter Half) [*Shōwa 34 nen: Ōzumō natsu basho kōhansen*] (Ise, 1959), 168
Shōwa 36 Fall Season Sumo (Latter Half) [*Shōwa 36 nen ōzumō: Aki basho kōhansen*] (Ise, 1961), 178
Shōwa period, 23, 75, 86, 149–50
Shunchū (Kyōka), 152
Siblings [*Kyōdai*] (Iwama, 1953), 227
Sigh, A [*Tameiki*] (Sone, 1973), 225
Sight and Sound (film journal), 39
Singin' in the Rain (Donen and Kelly, 1952), 39
Sino-Japanese War, second, 150

Sleeping Beast Within, The [*Kemono no nemuri*] (Suzuki, 1960), 69, 75, 156, 170–72; enframing devices in, 100, *101*; as crime film, 80
Smashing the o-Line [*Mikkō o-rain*] (Suzuki, 1960), 80, 171–72
Sokabe Michita, 171
"Solitary Cedar of Parting, The" ["Wakare no ipponsugi"] (song), 78
Sōmai Shinji, 155, 211
Sone Chūsei, 18, 66, 70, 155, 191–92, 202, 215, 218–19, 223–25, 243n8. *See also* Guryū Hachirō ("Group of Eight")
Song of Stone [*Ishi no uta*] (Matsumoto, 1963), 32
Song of the Underworld [*Chitei no uta*] (Noguchi, 1956), 87, 115–16, 184
Song Rambling on a Busy Street: Sinjuku Woman (Takeda), 224
songs, on soundtracks, 67, 76, 78. *See also kayō* (ballad) films
South Wind [*Nanfū*] (Iwama, 1951), 227
Spring Cherry Blossoms: Japanesque [*Haru sakura: Japanesuku*] (Suzuki, 1983), 100, 144, 156, 197, 203–4
Spring Tide: Part One [*Haru no ushio: Zenpen*] (Nakamura, 1950), 227
Spring Tide: Part Two [*Haru no ushio: Kōhen*] (Nakamura, 1950), 227
Spy School [*Supai nakano gakkō*] (Noguchi, 1964), 186
Stagecoach (Ford, 1939), 39, 40, 82, 163, 246n54
staging, 55; deep-focus/deep-space, 91–92, 93, 123, 164; flat, 91, 94; proscenium-style, 98, 123, 141–42, 213; theatrical, 17, 94–95; verticality and, 56
Star Woman [*Hoshikjorō*] (Suzuki, unfilmed, written 1976), 144, 221
Stepbrothers [*Ibo kyōdai*] (Ieki, 1957), 80
Stevens, George, 82
"Storm of Falling Petals" ["Hanafubuki"] (Suzuki, episdoe of TV show *Ōedo Investigation Network*, 1981), 201–2
Stormy Man, The [*Arashi o yobu otoko*] (Inoue, 1957), 72–74, 108–9, 217, 245n41
Story of a Prostitute [*Shunpuden*] (Suzuki, 1965), 11, 27, 30–31, 71, 75, 142, 187–88, 219, 239n62; editing in, 119, 121; mirror as enframing device in, 101, *102*

Story of Nayoroiwa Shizuo's Fighting Spirit Prize, The [*Nayaroiwa Shizuo: Kantō-shō*] (Kosugi, 1956), 160
Stray Cat Rock [*Nora neko rokku*] series (Fujita), 76
Stray Dog [*Nora inu*] (Kurosawa, 1949), 79
Stream of Youth, The [*Wakai kawa no nagare*] (Tasaka, 1959), 68, 167
Street of Shame [*Akasen chitai*] (Mizoguchi, 1956), 79
Strindberg, August, 149
structuralism, 60, 240n11
studio system, Japanese, 4, 15, 18–19, 23, 34, 42, 59, 63; comparison with Hollywood, 69–70
subjectivity, 53, 126–27, 148–49, 153; blurred subjective–objective distinction, 130; cinematic construction of, 129; subjective versus objective registers of narration, 134–37
Suchenski, Richard I., 46
Sugai Ichirō, 84, 161, 163, 175
Suginami Cine-Club, 235n10
Sugiyama Hajime, 84, 85, 173, 175, 183, 190
Sugiyama Keiko, 179
Sugiyama Toshio, 78, 187
Summer Sumo Wrestling: Latter Half-Season [*Natsu basho ōzumou kōhan sen jikkyō*] (Ise, 1956), 160
Sumo Report, Fall Season (First Half) [*Ōzumō aki basho zenhan jikkyō*] (Ise, 1963), 183
Sunday Horror Series (television series), 156
Sunohara Masahisa, 168
Sun's Burial, The [*Taiyō no hakaba*] (Ōshima, 1960), 33
Suo Masayuki, 155
"Superflat Manifesto" (Murakami), 57
supernatural, the, 144–49, 249n12
Suyama Tetsu, 163
Suzaki Paradise: Red Light [*Suzaki Paradaisu: Akai shingō*] (Kawashima, 1956), 80
Suzuki Akira, 66, 160–61, 163, 166–68, 170–71, 175–84, 186–90, 193, 196, 206, 208, 212, 243n4, 243n13
Suzuki Heigo, 165
Suzuki Kōichi, 197, 205, 218
Suzuki Papaya, 213
"Suzuki Seijun, or the Absence of Seasons" [*Suzuki Seijun, mata wa kisetsu no fuzai*] (Hasumi, 1991), 24–26, 88

Suzuki Seijun, style of. *See* Seijunesque style
Suzuki Seijun Essay Collection [*Suzuki Seijun essei korekushon*] (Yomota, ed., 2010), 231
Suzuki Seijun Incident, 5, 13–14, 53–54, 158, 218; film theory and, 7–8, 11, 41–42; history of, 14–24; "season of politics" in 1968 and, 24–28, 37
Suzuki Seijun Joint Struggle Committee (Suzuki Seijun mondai kyōto kaigi), 13–14, 22–23, 236n13
Suzuki Seijun's Mystery Theater [*Suzuki Seijun no misuterī gekijo*] (Suzuki, 1992), 209–10
Suzuki Seijun zen'eiga (Ueno, 1986), 52
Suzuki Yoshio, 195
Symbol of a Man, The [*Otoko no monshō*] (Matsuo, 1963), 86–87
S/Z (Barthes, 1974), 45

Tada Kajin, 203
Tagami Yū, 204
Tahrir Al-Suez [*Tahariru aru-suez*] (Suzuki, unfilmed, written 1976), 220–21, 251n14
Taishō period, 75, 86–87, 147–48, 200; anarchists of, 150, 222, 249n24; relative peace of, 149; Suzuki and Taishō romanticism, 148–53
Taishō trilogy films, 10, 99, 113–14, 120, 130, 149, 156, 203–4. *See also Kagerō-za*; *Yumeji*; *Zigeunerweisen*
Taiwan, colonization of, 149
taiyō-zoku (sun-tribe) genre, 33–35, 244n33
Takada Toshie, 160
Takahara Toshio, 166, 169, 176
Takahashi Etsushi, 229
Takahashi Gentarō, 213
Takahashi Hideki, 71, 75, 181, 186, 189, 191–92, 219; in *Fighting Elegy*, 192
Takahashi Hiroshi, 221, 249n12
Takahashi Nīsan, 177
Takahashi Shōji, 206
Takaiwa Hajime, 168, 187
Takakura Ken, 86, 218
Takamine Mieko, 85, 183
Takamura Kuratarō, 189
Takashina Kaku, 162, 164–66, 171, 173, 179–80, 184–87, 189
Takashina Kō, 197–98

Take Aim at the Police Van! ["*Jūsango taihisen" yori: Sono gossōsha o nerae*] (Suzuki, 1960), 79–80, 169–70, 172
Takeda Kazunari, 160, 162–63, 165–68, 170–71, 174–75, 224, 243n8
Takehisa Yumeji, 151, 208. See also *Yumeji*
Takemori Ryōma, 186
Takizawa Eisuke, 64, 69, 73, 166, 171, 228
Takizawa Osamu, 185
Tale of Sorrow and Sadness, A [*Hishū monogatari*] (Suzuki, 1977), 5, 61, 156, 195–96, 200, 221; color in, 247n11; supernatural elements in, 145, 249n12
Tale of Youth at Hirosaki High School, A [*Hirokō seishun monogatari*] (Suzuki, 1992), 144, 209
Tales of Japanese Chivalry [*Nippon ninkyō'den*] (Masuda, 1966), 191
Tamagawa Isao, 66, 185, 187, 191–93, 196, 200, 209, 229
Tamura Taijirō, 11, 30, 185–87
Tanabe Chomi, 160, 163
Tanada Gorō, 177, 185
Tanaka Kinuyo, 68, 160, 183
Tanaka Tokuzō, 86, 95
Tanaka Yōzō, 17–18, 128, 155–56, 191–92, 195, 199, 202, 208, 218–19, 221, 223–25. See also Guryū Hachirō ("Group of Eight")
Tanaka Yūko, 206
Taniguchi Senkichi, 30, 187–88
Taniguchi Toshio, 199
tanuki musicals, 6, 95, 96
Tarantino, Quentin, 39
Tasaka Tomotaka, 68, 167
Tashiro Midori, 78, 179, 183
Tattooed Life [*Irezumi ichidai*] (Suzuki, 1965), 75, 184, 189; color in, 107, 113, 247n11; as *ninkyō* film, 87, 112, 246n57
Taves, Brian, 68
Tayama Rikiya, 14, 15
"Technique, and Ideology: Camera, Perspective, Depth of Field" (Comolli, 1971), 233n2
technology, 108, 123
Teenage Trap [*Jūdai no wana*] (Noguchi, 1957), 163
Teenage Yakuza [*Hai-tīn yakuza*] (Suzuki, 1962), 62, 70, 75, 78, 84, 179–80; objective register of narration in, 135, 136
telephoto aesthetic, 94

television, 4, 67; as competition for films, 75; decline of studio system and, 19, 235n7; *eizō* discourse and, 32
Teo, Stephen, 245n43
Terada Nobuyoshi, 80, 165, 169
That Time It Poured [*An tokya doshaburi*] (Morinaga, 1958), 165
Theater of Life: Hishakaku [*Jinsei gekijo: Hishakaku*] (Sawashima, 1963), 86–87, 89
"Theory of Superflat Japanese Art, A" (Murakami), 57
"There Is a Bird Within a Man" ["Otoko no naka ni wa tori ga iru"] (Suzuki, episode of TV show *The Sands of Kurobe*, 1969), 194
Third Blind Spot, The [*Dai san no shikaku*] (Kurahara, 1959), 79
Third Man, The (Reed, 1949), 39
Those Who Put Money on Me [*Ore ni kaketa yatsura*] (Suzuki, 1962), 62, 75, 84–85, 180
Thus I Dreamed [*Kakute yume ari*] (Chiba, 1954), 64
Time and Place Are Nonsense (Vick, 2015), 10
Todoroki Yuko, 221
Todorov, Tsvetan, 144
Tōei film studio, 220, 243n15; "five-studio system" and, 235n8; *ninkyō* (chivalry) genre and, 75, 86, 87
Tōhō film studio: Art Theater Guild (ATG) and, 235n9; "five-studio system" and, 235n8
Tōkaidō yotsuya kaidan (Tsuruya), 207
Tokyo Drifter [*Tōkyō nagaremono*] (Suzuki, 1966), 2, 3, 17, 19, 31, 71, 75, 137, 142, 184, 189, 190–91, 244n21; color in, 107, 112, 247n11; horizontality in, 59, 61, 242n43; *ninkyō* (chivalry) genre and, 87, 246n57; color in, 90; sound and diegetic boundaries in, 132–33; subjective register of narration in, 135; theme song, 67, 78, 132–33
Tokyo Drifter Continued [*Zoku'tōkyō nagaremono*] (Morinaga, 1966), 192
Tokyo Knights [*Tōkyō naito*] (Suzuki, 1961), 62, 98, 170, 174; color in, 75, 110, 134; diegetic versus extra-diegetic registers, 134; musical numbers in, 78, 132; as kozō film, 84
Tokyo shiratsukagumi (Ichijō), 175

Tominaga Misako, 186
Tomita Nakajirō, 175
Tomoshibi (Ieki, 1954), 80
Tone Harue, 162
Torigoe Mari, 207
To Rogues There Are No Borders [*Yarō ni kokkyō wa nai*] (Nakahira, 1965), 189
Tough Guy [*Akumyo*] (Tanaka, 1961), 86
Touma Fumio, 202
Town of Love and Hope, A [*Ai to kibo no machi*] (Ōshima, 1959), 33
Toyoda Shiro, 234n1
Traces of Rouge [*Beni imada kiezu*] (Shibuya, 1949), 227
Trapped in Lust [*Aiyoku no wana*] (Yamatoya, 1973), 225
Trifoliate Orange Flower [*Karatachi no hana*] (Saeki, 1954), 64, 228
True Story of Shirakawa Kazuko, The [*Jitsuroku Shirakawa Kazuko*] (Sone, 1973), 225
Truffaut, François, 43, 129
Tsuchida Sanae, 202
Tsuchiya Takao, 199
Tsuji Yoshirō, 80, 165
Tsukamoto Kaoru, 203
Tsukiji Rokurō, 162
Tsukuba Hisako, 167–68
Tsurumi Shunsuke, 52–53
Tsuruta Kōji, 86
Tsuruya Nanboku IV, 207
Tsuyama Tsutomu, 176
Tuesday Suspense Theater (television series), 156, 204–5
20th Century Fox studio, 93, 247n7
Twenty-four Eyes (Kinoshita), 29
Typhoon's Festering Madness, The [*Gufū kyōran*] (Suzuki, unfilmed, wirtten 2001), 221–22, 249n24

Uchida Asao, 201
Uchida Hyakken, 151–52, 200
Uchida Ryōhei, 170–71
Uchida Tomu, 95, 99
Ueda Akinari, 138, 146, 195
Ueno Kōshi, 10–11, 20, 128, 223; auteurism of, 60; *Cinema 69* and, 43–44, 155; *omoshirosa* (interestingness) concept and, 41–42, 48–52; on Seijunesque style, 91–92, 130; Suzuki's use of color and, 107, 238n41, 247n11; on yakuza cinema, 45, 48–49; on *zure* (deviation), 12
Uenoyama Kōichi, 172, 182, 202
Umebayashi Shigeru, 208
Umemia Tatsuo, 206
Unbalanced Horror Series (television series), 156
Underworld Beauty [*Ankokugai no bijo*] (Suzuki, 1958), 62, 74, 89, 98, 164
United States, 29
Unrelated Murder Cases [*Furenzoku satsujin jiken*] (Sone, 1977), 225
Untitled (Suzuki, unfilmed, conceived 1967), 216–17
Uraoka Keiichi, 211
Urasawa Yoshio, 6, 197–98, 206, 211, 213
Urayama Kirio, 204
Ushihara Yōichi, 172
Uzaki Ryūdō, 230

Vagabonds from Badger Palace [*Hanakurabe tanuki dōchū*] (Tanaka, 1961), 95
V-Cinema (direct to video), 6, 156, 204
Vertigo (Hitchcock, 1958), 163–64
Vertov, Dziga, 91
Vick, Tom, 10
Vietnam War, 29
Violence at Noon [*Hakuchū no tōrima*] (Ōshima), 18
Virilio, Paul, 233n2
visual motifs, 26, 40, 45, 46, 54, 88
Voice Without a Shadow [*Kage naki koe*] (Suzuki, 1958), 69, 74, 102, 166–67
Volcano's Wind, The [*Umi o wataru hatoba no kaze*] (Yamazaki, 1960), 109
von Sternberg, Josef, 39
Vow of Youth [*Wakōdo no chikai*] (Iwama, 1952), 227

Wada Etsuko, 190
Wada Kōji, 65–66, 69–70, 78, 87, 110, 172–75, 177–81, 186, 190; as "Diamond Line" actor, 74–75; in kozō cycle, 82–85, 98
Wakamatsu Kōji, 16, 18, 22, 221
Wakamatsu Production Company, 18, 30, 37, 157–58

Wakasugi Mitsuo, 166
"wandering gambler" films, 218, 246n56
Wandering Trumpet [*Sasurai no toranpetto*] (Noguchi, 1963), 181
Waseda University, 17
Washio Saburō, 163
Washio Yoshihisa, 168
Watanabe Misako, 66, 165, 170, 178, 182, 195, 216
Watanabe Noboru, 182
Watanabe Takenobu, 10, 73, 79
Watanabe Yusuke, 50
Wataridori (*Rambling Guitarist*) series (Saitō), 83–85, 109, 172
Watari Tetsuya, 1, 75, 78, 191, 217
Way of Karate, The [*Karatedō*] (Suzuki, 1997), 211–12
Western genre, 81–82, 178, 245–46n52, 246n54
While We're Young [*Kono wakasa aru kagiri*] (Koreyoshi, 1961), 176
widescreen, 66
Wilde, Oscar, 150
Wilson, Chuck, 206
Wind-of-Youth Group Crosses the Mountain Pass, The [*Tōge o wataru wakai kaze*] (Suzuki, 1961), 17, 98, 176–77; color in, 75, 110, 238n41; editing in, 116; song, 78; as kozō film, 84
Winner, The [*Shōrisha*] (Inoue, 1957), 71, 108–9, 217
Wolf of Hell [*Ōdo no ōkami*] (Suzuki, unfilmed, written 1971), 219
Wollen, Peter, 44–45, 60, 240n11
Women of the Night [*Yoru no onnatachi*] (Mizoguchi, 1948), 79
Wonderful World of Nikkatsu Action Cinema, The (Watanabe), 73
Wong Kar-wai, 208
Wood, Robin, 42, 43, 45, 60, 240n11

Yagi Yasutarō, 178, 183
Yagyū Kazuo, 160, 167
Yahata Kaoru, 222
Yakushimaru Hiroko, 213
yakuza films, 41, 45, 85, 136–37, 157; *omoshirosa* (interestingness) concept and, 48–49, 51–52
Yakuza Hooligans 893 [*893 gurentai*] (Nakajima), 18

Yakuza's Song, The [*Yakuza no uta*] (Masuda, 1960), 170
Yamada Ichio, 202
Yamada Junsei, 200
Yamada Yasuo, 197, 205, 207
Yamaguchi Sayoko, 212, 226
Yamaguchi Seiichirō, 18, 191–92, 223. *See also* Guryū Hachirō ("Group of Eight")
Yamaguchi Takashi, 212
Yamamoto Kōichi, 193
Yamamoto Tarō, 213
Yamamura Eiji, 224
Yamamura Sō, 64, 79, 183, 228
Yamanaka Sadao, 44
Yamane Sadao, 10–11, 42; auteurism of, 60; *Cinema 69* and, 43–44, 155; on Suzuki, 52
Yamanouchi Akira, 185
Yamaoka Hisano, 162, 171, 175, 178
Yamashita Kōsaku, 86
Yamatoya Atsushi, 17–18, 128, 156, 193, 195–97, 205–6, 216–19, 221, 223–26. *See also* Guryū Hachirō ("Group of Eight")
Yamauchi Akira, 189
Yamauchi Ken, 183, 188
Yamauchi Ryōichi, 170
Yamaura Hiroyasu, 193
Yamaya Hatsuo, 200
Yamazaki Iwao, 162, 173–74, 181, 202
Yamazaki Tadaaki, 181
Yamazaki Tokujirō, 109, 173, 175
Yamazaki Yoshihiro, 165
Yanagawa Takeo, 161
Yanagita Gorō, 162
Yanai Jun, 209
Yanase Shirō, 172, 183, 185
Yaome Kenji, 210
Yasuda Michiyo, 200, 203
Yoda Yoshikata, 128
Yokomitsu Riichi, 149
Yokoyama Yasurō, 171
Yomota Inuhiko, 231
Yoshida Kijū, 8, 16, 21, 23, 33–34, 237n28; on subjectivity and fiction cinema, 238–39n58
Yoshida Shigetsugu, 197, 205–7
Yoshida Tsuyoki, 191
Yoshimoto, Mitsuhiro, 35
Yoshimoto Takaaki, 30, 47, 60

Yoshimura Nozomi, 179
Yoshimura Ren, 162, 185
Yoshinaga Sayuri, 71, 172–73, 176, 183, 186
Yoshinaga Yokō, 181
Yoshiyuki Kazuko, 171
"Yotsuya Kaidan" (Suzuki, variety show segment, 1987), 144, 207–8
Young Breasts [*Aoi chibusa*] (Suzuki, 1958), 10, 69, 70, 74, 165–66; character subjectivity in, 129–30; editing in, 116; film-within-a-film in, 125–28, 138, 140; as melodrama, 80
Young Samurai in the Moonlight, A [*Gekka no wakamusha*] (Fuyushima, 1957), 246n4
Young Wife's Greatest Victory, The [*Waka okusama ichiban shōri*] (Mizuho, 1952), 227
Young Woman's Promenade, The [*Ojōsan no sanpomichi*] (Horiike, 1960), 171
Youth of the Beast [*Yajū no seishun*] (Suzuki, 1963), 10–12, 15–17, 54, 75, 128–29, 136–37, 142, 181–82, 189, 246n57; color in, 247n11; diegetic versus extra-diegetic registers, 134; film-within-a-film in, 40, *41*, 138; flatness and depth in, *3*, 55, *57*, 59, 61

Yukioka Keisuke, 167
Yuki Saori, 213
Yumeji (Suzuki, 1991), 113–14, 208–9, 243n13; editing in, 120–21, *122*; supernatural elements in, 144–45; Taishō-era romanticism and, 151–52. *See also* Taishō trilogy films
Yumi Azusa, 161
yūrei-zu (ghost paintings): defined, 249n30; in *Kagerō-za*, 114, *147*, 151–52, 203

Zahlten, Alex, 12, 66, 243n15
Zatoichi series, 246n56
zengakuren student movement, 28–30
Zhang Ziyi, 6, 213
Zigeunerweisen [*Tsigoeneruwaizen*] (Suzuki, 1980), 148, 156, 189, 195–96, 199–200, 220, 243n13; color in, 113; nested diegetic registers and, 138; supernatural elements in, 144; Taishō-era romanticism and, 151–53. *See also* Taishō trilogy films
Zinneman, Fred, 65
zure (deviation) concept, 12, 52, 92, 130. *See also* Seijunesque style

GPSR Authorized Representative: Easy Access System Europe, Mustamäe tee
50, 10621 Tallinn, Estonia, gpsr.requests@easproject.com

www.ingramcontent.com/pod-product-compliance
Lightning Source LLC
Chambersburg PA
CBHW031235290426
44109CB00012B/303